**Space Ships!
Ray Guns!
Martian Octopods.**

Space Ships!
Ray Guns!
Martian Octopods!

Interviews with Science Fiction Legends

INTERVIEWS BY
Richard Wolinsky, Richard A. Lupoff & Lawrence Davidson

COMPILED AND EDITED BY
Richard Wolinsky

TACHYON PUBLICATIONS | 2025

SPACE SHIPS! RAY GUNS! MARTIAN OCTOPODS!
Interviews with Science Fiction Legends

Interviews by Richard Wolinsky, Richard A. Lupoff, and Lawrence Davidson
Compiled and edited by Richard Wolinsky
Copyright © 2025 by Richard Wolinsky

Introduction "The Probabilities Interviews" © 2025 by Richard Wolinsky
Foreword copyright © 2025 by Richard A. Lupoff
Cover design by Elizabeth Story
Cover art by Yoshi Vu
Interior design & composition by John D. Berry

Tachyon Publications LLC
1459 18th Street #139
San Francisco, CA 94107
415.285.5615
www.tachyonpublications.com
tachyon@tachyonpublications.com

Series editor: Jacob Weisman
Project Editor: Jaymee Goh

Print ISBN: 978-1-61696-442-9
Digital ISBN: 978-1-61696-443-6

Printed in the United States by Versa Press, Inc.

FIRST EDITION: 2025
9 8 7 6 5 4 3 2 1

DEDICATED TO THE MEMORY OF
Richard A. Lupoff, Lawrence Davidson, and Frank M. Robinson.

With special thanks to Bill Pronzini, Lisa Goldstein, the late Shelley Singer, and everyone involved with the *Probabilities* radio show, particularly Jim Bennett, Susan Stone, and the staff members at KPFA over the years.

CONTENTS

FOREWORD

Richard A. Lupoff

This foreword was written and revised several times, most recently in 2019. Dick Lupoff died at the age of eighty-five on October 22, 2020. He was the very first guest on the very first show in February 1977, which was a one-off titled Probabilities Unlimited, *hosted by Lawrence Davidson and also featuring author Michael Kurland. Richard Wolinsky was at the controls, not knowing what the hell he was doing. It's not clear exactly when Dick Lupoff joined the show, maybe a year later, but he sat in on some of the interviews in the fall of 1977. He retired from interviewing in 2001 but continued cohosting book review programs for the next couple of years.*

The red brick Pennsylvania Railroad Station in Trenton, New Jersey, is a dank and miserable building. At least, it was in the early spring of 1952. The lobby was dark, the platforms were cold, the trains were dirty and ran late, and the unpleasant smell of cold steam mixed with coal smoke filled the air.

It was not a nice place to be, but there I was, about to board a train for a ride I did not really wish to take. But I had a few coins in my uncomfortable woolen trousers and just enough time to stop at the newsstand and buy a magazine to keep me occupied as I rode through the polluted industrial wasteland of northern New Jersey. I bought a copy of the April *Startling Stories* and, to coin a phrase, it changed my life.

The lead novel in the issue was *The Glory That Was*, a time-travel tour de force by L. Sprague de Camp. There were stories in the issue by Leigh Brackett, Oliver Saari, Charles E. Fritch, and the young Frank Herbert, a decade before *Dune* and glory. But what intrigued me most was the magazine's letter column. Readers kept complaining that Murray Leinster's "Journey to Barkut" (in the January issue) might have been a darned excellent yarn, but it was fantasy, for heaven's sake, *fantasy*, and what in the world was it doing in *Startling Stories*, a science fiction magazine?

I was impressed not that readers might have such ideas, but that they could write to the magazine complaining when they were unhappy, and the editor would actually publish their letters and pay serious attention to them. This was a revelation to me. As a teenaged schoolboy and omnivorous magazine reader, I'd always thought that editors were godlike beings who dwelt on some remote Olympus and spoke to readers only when they felt like it. But readers would hardly dare speak to them.

It seems to me that this is a large portion of what makes magazines appealing. A book, once it is written and published, is frozen in time. The author may speak to generations of readers, but even if they respond and

engage the author in a written correspondence, the book itself remains as it was.

It lives, in a sense, as long as it remains in print and is read, or for that matter, as long as copies survive and are read, even if the book is out of print. But the communication between book and reader is one-way. The book may not be dead but it isn't really totally alive either. It is, to borrow a phrase from another realm, un-dead.

But a magazine is a living organism. A story appears in one issue, and readers comment, and the editor publishes their letters in the next issue (or the one after that or the one after that). Other letter writers get into the act. The editor himself takes note of what's going on. Eventually the readers' voices have a real impact on the magazine and on the editor's policies.

I'd been reading fiction since I first learned to read, and that was at a very early age. Initially I'd read comic books and then "real" books, and I used to see copies of slick magazines like *The Saturday Evening Post* and *Collier's* that ran a good deal of fiction.

But magazines like *Startling Stories* — pulps, although I didn't know their name at first — were another matter altogether. They clearly weren't comic books, but they weren't those boring oversized things that my parents doted on, either. They were something different.

Garish covers.

Sensational titles.

Exciting adventure stories.

What a find!

The pulps were already in their decline when I started reading them. They'd been around since the 1890s and would stagger onward into the 1960s before expiring. They hadn't sprung full-blown from the brow of Frank A. Munsey but evolved from the earlier story papers, dime novels, and popular magazines. And when they disappeared they didn't just disappear, they gave way to the smaller digest-size magazines and the larger neo-bedsheets, but mostly they gave way to mass-market paperback books.

But they were great while they lasted.

Nobody knows exactly how many pulp magazines, all told, ever existed. Surely many hundreds. I'm talking about different titles, mind you, not individual issues. Maybe as many as a thousand. There were the general pulps that offered a potpourri of detectives, cowpokes, jungle kings and queens, pirates and foreign legionnaires, cynical newshounds, boxing champions and baseball and football stars, virtuous heroines, courageous heroes, scurrilous villains and tireless horses and loyal dogs.

There were category pulps. In the early decades of the pulp era, the dominant types were mysteries and westerns. In later years, the number of science fiction pulps increased, until, by the 1950s, there were as many spaceships and ray guns on the newsstands as there were cayuses and

six-shooters or prowl cars and gats. And there were magazines to fit every conceivable niche and personal interest, from *Wall Street Stories* to *Ranch Romances* to *Harlem Stories* to the legendary — but very real — *Zeppelin Stories*.

And there were "character pulps," presenting some archetypal figure in a new adventure in every issue — the Shadow, Captain Future, Sheena, Doc Savage, Dan Turner: Hollywood Detective.

A number of writers spent their lives in the pulps, but most of the really talented ones graduated to the slicks, which paid much better, reached far larger audiences, and carried more prestige than the pulps. A great many pulp writers also sold books, or wound up in Hollywood crafting screenplays.

Work your way through a stack of old pulp magazines and you're likely to find stories by Louis L'Amour, Rex Stout, Howard Fast, Tennessee Williams, Robert E. Howard, Dashiell Hammett, Raymond Chandler, Edgar Rice Burroughs, Robert A. Heinlein, H. P. Lovecraft, Ray Bradbury, Richard Matheson, and Jim Thompson.

Incidentally, if the pulp field sounds like an exclusive boys' club, it wasn't. There were female pulp editors (Mary Gnaedinger, Dorothy McIlwraith, Bea Mahaffey, Daisy Bacon) and female writers, from Mary Roberts Rinehart to Leigh Brackett to Catherine L. Moore and many more.

My own favorite reading in the 1950s was science fiction, and I battened on the last surviving science fiction pulps: *Startling Stories*, *Thrilling Wonder Stories*, *Planet Stories*, *Amazing Stories*, and a few others. I was even more taken with some of the digests: *Galaxy*, *The Magazine of Fantasy & Science Fiction*, *Other Worlds*.

Segue some years into the future and I'm a college senior, starting my career as a writer by cranking out daily news shows for WIOD in Miami. A few more years and I'm in the Army, then back in the civilian world, at first working for a giant corporation, then on my own once again, writing books.

I still had my affection for the fiction mags, and even if the classic pulps no longer existed, I was able to sell to their successors in their larger or smaller formats: *Amazing Stories*, *F&SF*, *Ellery Queen's Mystery Magazine*, and finally even the venerable *Weird Tales*. What a pleasure!

In the meanwhile, I retained my interest in radio and was happy to accept an invitation to be a guest on the first *Probabilities* show, conducted by Lawrence Davidson, with Richard Wolinsky at the controls on KPFA in Berkeley. It didn't take me long to go from guest to guest host, then to regular cohost. (And then to host emeritus, but nothing lasts forever, does it?)

This job gave me the opportunity to meet and interview many of the heroes of my childhood. Week after week, I would sit down with Stanton A. Coblentz, Horace L. Gold, John D. MacDonald, Frank Belknap Long, Theodore Roscoe, with nothing between us but a clipboard of prepared ques-

tions and a live microphone. Most of those living legends are gone now and the few survivors, the younger writers, are very old.

But through a stroke of luck or miracle of foresight, Richard Wolinsky and Lawrence Davidson and I — mostly Richard Wolinsky, let's be honest about this — saved tapes of every interview we ever conducted. Well, almost every one. A few may have slipped between the cracks, but if so, there are very, very few that did.

As Richard Wolinsky points out in his preface, we eventually shifted our focus on the radio show away from science fiction in particular and the pulps in general, and placed it more on the important—or at least better known—figures in the literary world. It's hard to turn your back on the opportunity to sit down and schmooze for an hour with a Joseph Heller, a Margaret Atwood, a Norman Mailer, a Fay Weldon or a John Mortimer or a Michael Frayn.

Also, over the many years that we've been doing this work, we've been approached by several publishers interested in bringing out a book or even a series of books based on our interviews. On occasion it was we — Wolinsky, Davidson, Lupoff — who did the approaching. We got a very positive response, and several times it looked as if a deal was actually in place, but each time it fell through.

Sometimes the publisher backed away. A couple of times, it was Wolinsky, Davidson, and I who stopped just short of signing a contract because we had developed qualms about the job our prospective publisher would do with our material.

At last, the time seems to have arrived for this book to happen. The stars are right, the pieces have fallen into place, and the book is finally here. We believe that we have found the right publisher, and the right publisher has found us. Richard Wolinsky deserves immense credit for the endless hours he spent transcribing and editing tapes and arranging the material in this book as it now appears.

The late Lawrence Davidson deserves recognition and thanks as our founder, and for the work he did in the early days of the radio show. I'll take a bow (if anyone asks me to) for conducting a good many of the interviews, some of them solo and some of them in tandem with Davidson or Wolinsky.

We received encouragement, support, and sage advice from a number of people. In our early days at KPFA, we had the support of Erik Bauersfeld. Then later, our cheering section was led by the truly wonderful Susan Stone. And throughout the years, we have had the wide guidance of one of the world's leading pulp mavens, Frank M. Robinson. But if this book is anybody's brainchild, the product of anybody's intelligence and unstinting effort, it is really Richard Wolinsky's book.

THE *PROBABILITIES* INTERVIEWS
Richard Wolinsky

Probably the most startling announcement any president ever made came on May 25, 1961, when President John F. Kennedy told Congress we would go to the moon before the end of the decade. At that moment, science fiction was no longer the private playground of a small coterie of writers and readers. Now it had become part of everyday life for everybody on earth. As a genre, science fiction quickly grew from a few books and magazines with a cult following into a pervasive phenomenon, accounting for thousands of literary titles and many of the most popular films and television shows of all time. By the end of the twentieth century, science fiction had accounted for ten percent of all books published, and numbers two through five on the all-time box office list, two *Star Wars* films, *E. T. The Extra-Terrestrial*, and *Jurassic Park*. A quarter century later, the genre itself has split into genres. There's space opera, comic book superheroes, post-apocalyptic, near future ... unfilmable series like Asimov's *Foundation* books have found a home on streaming television, and so on.

Science fiction had become reality because it was a literature of ideas and of speculation about what the future might be like. The fifteen-year-olds who read *Amazing Stories* and *Astounding* magazines back in the 1920s or 1930s became the scientists at Cape Canaveral and Houston. The moon was not a mystery to them because they'd already been there in their minds' eyes, reading the works of Heinlein, Williamson, Brackett, and so many others.

It was no accident that one of the hotbeds of science fiction reading in 1945, according to circulation reports from the leading magazines, was Los Alamos, New Mexico, site of the top-secret Manhattan Project. Nor was it any accident that science fiction readers knew the names Wernher von Braun and Willy Ley long before they became famous for their work in the space program.

The first modern era of science fiction began in the 1920s, with the birth in 1923 of *Weird Tales*, often a repository of science fiction stories, and with the advent of Hugo Gernsback's *Amazing Stories* three years later. The first era clearly ended that day in 1961, when John F. Kennedy made science fiction a reality and a mass phenomenon.

This book is devoted to that era, a time when the scientists and technicians who transformed the world began to read, to dream, and to imagine.

When Lawrence Davidson hosted our very first *Probabilities* program (as *Probabilities Unlimited*), on KPFA-FM in Berkeley in February 1977, that second era was just about to end. Three months later, the first *Star Wars*

film (now subtitled *Episode IV — A New Hope*) would hit the theatres and yet another era would begin.

A single science fiction shelf in a 1960 bookstore became a bookcase by 1970, three bookcases by 1980, an entire wall by 2000. A quarter century later, in our fractured cultural universe, while genre-specific readers and imprints still exist, in the mainstream publishing world, it's ubiquitous. Where do you place a book by Margaret Atwood, or Cormac McCarthy, or Richard Powers either in a bookstore or online?

In January 1977, Lawrence Davidson was the science fiction buyer for Cody's Books, the legendary bookstore on Telegraph Avenue in Berkeley, California. He was approached by Padraigin McGillicuddy, Drama and Literature Assistant Director at KPFA-94.1 FM, the Pacifica Foundation's flagship station in Northern California, to host a new science fiction interview program. The station's last regular science fiction show had disappeared from the airwaves several years earlier, and Padraigin was casting about for a new one.

At the time, I was volunteering my services as receptionist and press assistant to the station. Lawrence, whom I'd known in New York, asked me to come to the station's Shattuck Avenue digs with him and his two guests, up-and-coming writers Richard A. Lupoff and Michael Kurland, just to make sure everything functioned smoothly.

It's a good thing I was there. Padraigin said she'd booked studio time. But the off-air studio was locked. She said an engineer would be waiting; the place was deserted. The only person in the entire block-long warren of offices and studios was the on-air disc jockey, a red-headed seventeen-year-old named Kevin Vance. I flew into the control room and asked Kevin to unlock the studio and set up the tape. He quickly cued up an extended Bob Dylan cut, and together we ran down the hallway to the other end of the building where Lupoff, Kurland, and Davidson stood in the dark. Kevin unlocked the door, turned on the lights, cued the tape, and set the microphones and sound levels. While the three participants waited, Kevin lectured me on how to engineer a program: "This is how you start the tape. This is how you stop it. Just make sure the meters don't go into the red." He fiddled with some dials while I looked on blankly. "Good luck," he added, and disappeared into the darkness. I was alone, faced with half a dozen dials, a group of glaring meters, and three aficionados on the other side of the wall, yakking about the history of science fiction and how Gollum of *Lord of the Rings* was probably a Christ figure.

Somehow it all worked, and later that week Lawrence and I edited the tape for broadcast. By the second program, I had joined Davidson on the other side of the microphone. As a rabid science fiction reader, I was up on all the latest writers and trends. Davidson, on the other hand, was a pulp junkie. Ask me for a recommendation, and I'd say *Dune* or the latest Ursula

Le Guin, or perhaps something by Phil Dick or Alfred Bester. Ask Davidson, and he'd talk about a story or book that had been out of print for thirty years. I was a child of the second era of science fiction, but Davidson was an atavistic throwback to the first. Fueling his obsession was a growing friendship with the older Lupoff, who had been reading the pulps since he himself was a kid in the 1940s. The two of them would sit there for hours and discuss writers and editors only a handful on the planet would remember.

Thus it was no surprise that Davidson walked in one day with an ecstatic smile on his face. "I found Stanton Coblentz," he said. "He's living an hour outside San Francisco. Let's go talk to him." A beatific look came over Lupoff's face. The messiah had arrived.

"Who?" I asked.

And they'd patiently explain that Stanton A. Coblentz was one of the masters of 1920s and 1930s science fiction, author of gentle satires and a poet of note to boot.

Before long, Lupoff had joined the program on a regular basis. For every Coblentz whom Davidson unearthed, Lupoff discovered a Frank K. Kelly. For every Ed Earl Repp whom Davidson found lurking in Paradise, California, Lupoff retrieved an E. Hoffmann Price somewhere on the San Francisco Peninsula.

Gradually over the course of several years, a history of science fiction in the middle of the twentieth century began to emerge on tape. Stuck in among the hoary old-timers were younger writers like John Varley, Elizabeth Lynn, Stephen King, and Clive Barker, and younger editors like the late David Hartwell.

By the mid-1980s, we'd spoken with many masters of the field, both writers and editors. As science fiction integrated itself with the cultural mainstream, so did we. The show took a different tack. Over time, Lupoff and I branched out into mysteries and Davidson gravitated to the Old West. By 1990, some thirteen years after we began, Davidson had left the show to pursue other interests, Lupoff was forging a career as a mystery writer, and I was a stalwart KPFA employee, editing the station's monthly program guide/magazine and then finding myself a day job as an elections specialist. Though none of us had lost interest in it, science fiction had become part of the larger world.

Dick Lupoff retired from interviews at the end of 2001, and from live review programs a couple of years later. By then the program had gone through name changes and become *Bookwaves*. As I write this, many of these old interviews are being digitized, remastered, edited, and aired on what's now the hour-long *Bookwaves Artwaves* on KPFA-FM and kpfa.org, the half-hour *Bookwaves* via Pacifica Audioport syndication with longer versions on the Radio Wolinsky podcast at kpfa.org. Podcasts for *Book-*

waves Artwaves and *Radio Wolinsky* as of this writing are still available through iTunes.

For many years, the three of us toyed with the idea of presenting these interviews in print. It was the late Frank M. Robinson who suggested the current form of an integrated oral history and was enormously helpful in both vetting the contents and offering his sage advice. We chose to set the framework of the book between 1920 and 1960 because that was the first era of science fiction, when the field was largely unknown to the casual observer or reader. You can find the complete list of interview subjects in the back of the book.

Twenty years ago, Julian Francis Clift loaned me his transcription machine, saving time, money, and effort in the process. Support also came from Patricia Lupoff, Tom Lupoff, Suzette Davidson, and Bret Cherry. More recently, special thanks to Jacob Weisman, Jaymee Goh, Kara Wuest, and the staff at Tachyon Books.

A couple of quick notes:

ONE: This book represents three eras, separated by a quarter to half century. The first was the pulp era, as these writers and editors discuss their early lives; the second when the interviews were conducted, and the third, as the book is being published and read. Three eras, and three different visions of America and the world. That vision includes race and gender.

The pulp writers of the era were all white, almost all male. Diversity, as we know it, did not exist on the content pages of these magazines. Women hid behind pseudonyms, initials or names that could be either gender. People of color were presented in the most stereotypical ways possible, if presented at all. Squishy aliens often got a better deal, and as noted in the book, some editors or publishers would have it no other way. Jim Crow wasn't just for the American South.

People of Asian descent had it little better, as "orientalism" ruled in the fantasy and horror realm.

The original title of this book, *The Girl in the Brass Brassiere* (noted by Margaret Atwood in her collection of essays, *Writing with Intent*), based on some generic covers, attests to the rampant sexism of the pulp era and its devotion to the sexual yearnings of (straight) fifteen year old boys.

TWO: While most of the comments were transcribed verbatim, care was taken to correct dates, magazine and story titles, and proper names when mentioned by the various interviewees. Exceptions are noted. It's possible that reference sources are incorrect, of course, and that memory wins. That's a battle that won't be fought on these pages.

Space Ships!
Ray Guns!
Martian Octopods!

How should one read this book? As George Plimpton explained in his oral history of the life of Truman Capote, imagine that you're at a giant cocktail party, and the guests are milling about in small groups. You've grabbed yourself a drink and a couple of pigs in a blanket, and now you're wandering around, overhearing the conversations.

Hey look, off there in the corner, there's Anne McCaffrey and Jack Williamson. They're talking about the early days of the science fiction magazines. Let's listen in ...

Chapter One
Space Ships! Ray Guns!
Martian Octopods!
Science Fiction in the 1920s

THE CAST OF THE BOOK (IN ORDER OF APPEARANCE)

Anne McCaffrey (1926–2011) Author of the highly acclaimed *Dragonriders of Pern* series and other best-selling works.

Jack Williamson (1908–2006) Author of the *Humanoids* series and many novels.

Ed Earl Repp (1901–1979) One of the most prolific pulp authors of the 1930s. Primarily a writer of westerns.

Charles D. Hornig (1916–1999) Editor of *Wonder Stories*, 1933–1936, later a CPA in California.

Frank K. Kelly (1914–2010) Science fiction writer in the 1930s, war correspondent during World War II, speechwriter for Harry S. Truman during the presidential campaign of 1948, later one of the founders of the Center for the Study of Democratic Institutions.

Frank Belknap Long (1901–1994) Writer of science fiction and fantasy from the 1930s into the 1970s, one of the stalwarts of *Weird Tales*.

Basil Wells (1912–2003) Science fiction and fantasy writer from 1940 to the late 1950s, contributed to *Planet Stories*, *Weird Tales*, and other magazines.

Richard Wolinsky (1950–) One of the interviewers for this book; cohost/producer of *Probabilities* radio program, 1977–1995. Later renamed as *Cover to Cover*, *Bookwaves*, and then *Bookwaves/Artwaves*, to present. *Bookwaves* continues as a syndicated half-hour program at Pacifica Audioport. Also host of two podcasts, *Radio Wolinsky* and *Bay Area Theater* at kpfa.org

Richard A. Lupoff (1935–2020) One of the interviewers for this book. Science fiction, fantasy, and mystery novelist and short story writer, cohost of *Probabilities* 1978–1995 and *Cover to Cover* 1995–2001.

Stanton A. Coblentz (1896–1982) Poet, active as a writer of satiric science fiction from the 1920s through the 1970s.

Richard Tooker (1902–1988) Science fiction writer from the 1920s through the 1950s.

Raymond Z. Gallun (1911–1994) Science fiction author whose greatest success was during the 1930s, though he continued to write into the 1980s.

E. Hoffmann Price (1898–1988) Pulp magazine writer whose career extended from the 1920s to the 1980s, known for fantasy stories and works

that appeared in "general" pulp magazines such as *Argosy, Adventure,* and *Blue Book,* as well as specialty magazines, most notably *Weird Tales.*

Frank M. Robinson (1925–2014) Novelist (*The Power, The Glass Inferno, Waiting*) and noted pulp historian.

Forrest J. "Forry" Ackerman (1918–2008) Science fiction fan and historian, best known as the editor of *Famous Monsters of Filmland* from the 1940s through the 1990s.

Harry Bates (1900–1981) First editor of *Astounding Stories,* and science fiction author during the 1930s.

A. E. van Vogt (1912–2000) Author of *The World of Null-A, The Voyage of the Space Beagle,* and many other science fiction novels from the 1940s through the 1990s.

Isaac Asimov (1920–1992) Considered, along with Robert A. Heinlein, Ray Bradbury, and Arthur C. Clarke, one of the four greatest science fiction writers of the twentieth century, and prolific author of well over three hundred books on many subjects.

There was science fiction before the 1920s. Some say the genre began with H. G. Wells and Jules Verne, others go back to Mary Shelley and her creature, still others say it started with Homer and the Greeks. The modern era began, however, with Edgar Rice Burroughs and others published in the general fiction pulp magazines of the twentieth century's first two decades. It wasn't until 1923 with the birth of *Weird Tales* (see next chapter) and 1926 with the start of *Amazing Stories* that the genre really took off.

Birth of a Genre

Anne McCaffery: It's an interesting fact to know that the first issue of *Amazing* came out in April 1926. I was born in April 1926. I don't say this was a coincidence or it had any prenatal influence on me, or postnatal influence on me. Just one of those coincidences that one happens upon and chuckles over.

Jack Williamson: I was out of high school in 1926 with not much of anywhere to go and a friend of mine showed me a sample copy of Hugo Gernsback's *Amazing Stories,* then about six months old, and I was pretty much fascinated then. The copy wasn't mine but I raised money to subscribe eventually. First I got a sample copy of the March '27 issue with a beautiful picture of a space ship taking off for Jupiter, "The Green Splotches" by T. S. Stribling. I've been hooked on science fiction ever since. Science fiction has been part of my life for more than fifty years. When I got into it, it was a very small exclusive club. You had to explain that science fiction was adventure stories with a science background. In fact, I sold my first story the year before Gernsback came up with the term "science fiction."

Ed Earl Repp: I ran five theaters in Los Angeles and promoted a Tarzan story at one of the movie theaters in 1922, 1923, something like that. Edgar Rice Burroughs made a personal appearance down there. I had him come down to do that, to draw people in to see him. That's when I talked to him and told him I wanted to be a writer and I was working at it and I was storing up some ideas back there. That's when he said that science fiction was the top thing of the day. Zane Grey said the same thing about westerns. I can't remember Burroughs too well. Remember, he was an old man when I was just a kid.

The Early Pulps

Charles D. Hornig: When I was a kid we had four [science fiction] magazines, that was all we had to worry about. No paperbacks, very few books. It was easy to keep up with the field. I tried to collect, back in the very beginning. At one time I owned every magazine that ever published. But that was in 1932. By that time there still weren't that many published. I had five or six hundred. I had *Weird Tales*, all the way back to March 1923. There was about eight or nine years of *Weird Tales*. It was hard to get some of those, and even in those days they were expensive, and that's when some of the early science fiction came out, some of the writers started in *Weird Tales*. I eventually got *Amazing*, and *Wonder*, and *Astounding* all the way to the beginning. I was proud of my complete collection. Then I moved so much I had to get rid of it. It just was too cumbersome.

Frank K. Kelly: *Amazing Stories*, yes. I used to get every issue as soon as they came out. There'd be one copy at the drugstore I could find, my neighborhood drugstore. I'd get that one. *The Skylark of Space*. That was one of the early ones, wasn't it? E. E. Smith. I was very impressed by those. And A. Merritt, I read a lot of A. Merritt. I thought A. Merritt was a good writer, although in rereading him in later years, I found his style was a little overblown. *The Moon Pool* was one that made a big impression on me. Jack Williamson was another that I liked very much.

Frank Belknap Long: I didn't read those early pulp magazines to any extent. I read *Argosy*, of course when I was much older, after I had met Lovecraft and started writing myself. I read all those magazines but I don't think anything in the early pulps influenced me to any extent. I never thought of myself as a pulp writer. That's the point, you see. I wish you'd emphasize that, because so many — all this hearkening back now to the early days of the pulps — but I think a great amount of that material was pretty crude, you see. I don't really like to think of myself as a pulp writer. The thing is, the so-called pulp markets were absolutely the only outlet for a writer with my inclinations at the time. Perhaps up until 1930 or so.

Basil Wells: I read some of the early *Amazing*s when they came out. I think what introduced me to them was the one about the Master Mind of Mars, that one big one that they put out, the *Amazing Stories Annual* in 1927. That introduced me to it, and then I turned to reading them. Then I gradually expanded into the other ones as they came along. Of course, *Argosy* and *Adventure, Blue Book*. There were all sorts of things like that.

Frank K. Kelly: When Lindbergh flew the Atlantic in 1927, I knew that some day man could fly to the moon and to the worlds beyond. I'd read H. G. Wells and Jules Verne, and I was sure that man would soon escape from the boundaries of the Earth. In 1927, when Lindbergh made that journey all by himself, from New York to Paris, I was thirteen years old. I'd already written several stories about lonely heroes who soared to Mars and Jupiter, but I'm afraid the writing was not as good as it became later.

Hugo Gernsback & *Amazing Stories*

Richard Wolinsky: The modern era of science fiction starts, in a sense, with Hugo Gernsback. While what we would call science fiction stories predate his magazines, it was Gernsback who created the very first publication that focused exclusively on the genre.

Charles D. Hornig: When Hugo Gernsback first came over from Luxembourg, his first publication was called *The Electrical Experimenter*, I think. That started in 1905,[1] and it was a revolutionary magazine at the time. Electricity was fairly new in 1905, especially doing anything except lighting. In the twenties, he had a radio station, WRNY, but I don't remember if he still had it when I was with him. He had a number of scientific publications. In fact, he started some that went on to other publishers. I think he started *Science and Invention*, all kinds of science and radio magazines. He had a number of good technical people working for him. He had a magazine called *Television* in 1927, twenty years before anyone had television, and they were showing people how to build television sets.

Richard A. Lupoff: Gernsback often ran science fiction stories in his magazine *Science and Invention*. They were so popular that he tried out an "all fiction" issue, and the response to that was so positive that he finally took the plunge with *Amazing Stories*.

Jack Williamson: I started writing my own stories on an old Remington basket typewriter, which typed on the underside of the carriage, and sent these stories off to Hugo Gernsback at *Amazing Stories*. One of them had a misspelled word in the title. The first two or three came back with rejection slips and then, in 1928, I did one called "The Metal Man" that didn't come

1 *The Encyclopeda of Science Fiction* (Clute & Nichols) lists the date of *Modern Electrics* as 1908. The date is variously listed elsewhere as 1910. The name was changed to *The Electrical Experimenter* in 1913.

back. Eventually I was going by a newsstand and I recognized my metal man on the cover of the magazine, and I was elated beyond imagination. I've been a science fiction writer ever since. I didn't know he bought the story, and had no check until some time the next year. I'd written a couple of pathetic letters, and then the check was twenty-five dollars.

I had by then entered an editorial in an *Amazing Stories* contest for which the prize was fifty dollars. This editorial appeared a few weeks before the story came out. I eventually got my fifty dollars too. He was in no hurry to pay that either.

Stanton A. Coblentz: The science fiction field in 1928 was like nothing it has ever been since. The magazine that I had my first publication in was *Amazing Stories*, and I had a rather peculiar experience with them before publication.

I had written a book called *The Sunken World*, which was about 90,000 words in length, and I'd written it before I knew there was such a thing as science fiction or a science fiction magazine. The conservative publishers of those days didn't seem very inclined to invest in *The Sunken World*, and so when I read in the paper of the publication of a new magazine dealing in fantasy and fiction concerned with science, I thought I would go down and see them. I went down there and brought my manuscript, which was taken in the hands of a girl who gave me the usual receipt and I proceeded to forget it for the next two or three weeks, when I had a word from the magazine. If I would care to reduce the manuscript to 30,000 words from 90,000, they would be pleased to publish it. Well, I felt I wouldn't be pleased to have them publish it under those circumstances and I didn't see how I could reduce it that much anyhow. It would be like taking a three-hundred-pound man and stripping him down to one hundred pounds. It just couldn't be done, so I called the office and got my manuscript back.

And while I was trying to figure out what to do with it now, which was quite uncertain, after several weeks I got another letter from them, that they would have more space than they had contemplated, and if I still had the manuscript, they'd like to see it again. Well, I thought I would give them the privilege of seeing it again, so I hastened down to their office and left the manuscript there.

Within a short while, they sent me a letter saying they wanted to publish it, for which they offered a price that would seem niggardly[2] nowadays, but seemed big to me then. It was three hundred dollars. A third of a cent a word. It got published and was so popular with the readers that a year or two later they reprinted it in entirety in the magazine, or rather in the supplement they called *Amazing Stories Quarterly*.

2 "Niggardly" is defined as stingy or ungenerous. It has no relationship to similar sounding words.

Richard Tooker: I wrote science fiction, considerable science fiction, and Gernsback was probably one of my favorite markets. One of the best markets, it would buy almost anything I wrote. I did have the honor of appearing in the only slick magazine ever printed in science fiction by Hugo Gernsback. It was called "The Ultimate City" in *Science-Fiction Plus*. The old *Amazing Stories* is what we'd call the real thing in science fiction.

Charles D. Hornig: Hugo Gernsback was very cheap.[3] He'd get everything as cheap as he possibly could, but in fact, even though he was a genius in his field, he killed an awful lot of projects by underfinancing. He lost a lot of good men among his staff that way. Of course, he also paid the lowest rates, something like half a cent a word. Except Fletcher Pratt, who got three quarters of a cent. One cent was good in those days. *Astounding* was paying that. That was good. Two cents for very good authors. That was really hot.

If you have a file of *Wonder Stories*, you'll know there was a lot of stuff printed by Stanton A. Coblentz, a lot of novels in the *Science Fiction Quarterly* we were selling, and a lot of Ed Earl Repp. I think Gernsback did pay them better and promptly. If he really wanted stories from somebody, I think he knew he had to pay them in order to get them. He also liked these people. I don't know if he ever met them, because they were on the West Coast.

Of course, I didn't know all the financial ins and outs, but I think his science fiction magazines were not doing too well financially and he had to make a choice. Maybe he actually did lose money when he paid all his bills, and that's why it was hard for him to pay his bills. But by the thirties, he had a reputation for not paying promptly, or not paying until people got pretty insistent about it. In fact, a lot of his employees were carrying around checks, week after week, without being able to cash them. I visited him a couple of years after I'd left his employ, and one of the men working there said he had six of his checks on hand and he wasn't able to cash them because there wasn't any money in the bank. That's long after he left science fiction. He always operated that way.

Raymond Z. Gallun: Gernsback was a tightwad when it came to paying his writers. I know I'd run up a considerable bill with him when finally he paid me back at the rate of fifteen dollars a week. Of course in those days, fifteen dollars a week, well you can multiply that by at least five to get the relative amount of money in our present day terms. So I was able to live those weeks while he paid me the $280 or so that he owed me.

3 As noted elsewhere, Gernsback was not exactly popular with his writers, or his creditors. His publishing company went backrupt in 1929, and his finances were always dicey. Dr. Andrew Baer, grandson of Hugo Gernsback, writes in 2015 on the Goodreads site, "I have no doubt that he probably was borrowing from Peter to pay Paul, and failed to meet his obligations to his writers, perhaps in failing to pay them on time or less than he should have ... The famous bankruptcy which was brought about by minor creditors made it all the way to the Supreme Court. I doubt the truth with respect to what was behind it will ever be known."

I remember once I was in Germany staying with Walter Ernsting,[4] who was of course the *Perry Rhodan* man. Mr. Gernsback was at that time in Switzerland, I think there was a gathering of some kind of science fiction people there. I couldn't at that time go down to Switzerland but Walter went and he mentioned my name to Gernsback. When Walter came back, he said the first thing that Gernsback said when he mentioned Raymond Z. Gallun was "Do I owe him any money?" Well, at that time he didn't, but maybe I should have said so for the trouble I'd gone through collecting the previous money from many years before. But I bear him no ill will at all.

Stanton A. Coblentz: Hugo Gernsback was a very forceful looking man. I knew him when he was in his prime. He wasn't a warming character. You didn't fall over him with embraces.

Richard A. Lupoff: The story is that Gernsback always lived very, very handsomely. Someone told me that he had an electric car with a chauffeur, an electric limousine.

E. Hoffmann Price: Hugo Gernsback? That son of a bitch. I never dealt with him, not with the rates he paid. Every time I see someone being awarded a Hugo, I see the biggest fraud, swindler, chickenshit fucking scoundrel ever in the business. He's the only editor I've ever known, or known of, who so fully deserved these understatements of mine.

Richard A. Lupoff: Lovecraft referred to him as Hugo the Rat.[5]

E. Hoffmann Price: Lovecraft was a gentleman.

Richard A. Lupoff: Sidney Gernsback was Hugo's brother. He's sort of a legendary character listed on the masthead as business manager. I've never been able to find anybody who ever met Sidney.

Stanton A. Coblentz: No, I never met Sidney Gernsback. I'm sorry I can't be the first.

Frank Belknap Long: No, no. I knew nothing about him. Never met him or anything. I just heard the name mentioned a couple of times, that's all.

Frank K. Kelly: No, I had no dealings with Sidney Gernsback. I had with a man named David Lasser. He was my editor most of the time. I rarely heard directly from Gernsback, but David Lasser was very encouraging. He was the one who sent me the contract.

Charles D. Hornig: I believe there was a Sidney Gernsback. I really believe there was. I heard enough about him and I think I even heard people talking to him over the telephone, and other people had said that they had seen him. In those days, I really believe there was a Sidney Gernsback. But

4 Walter Ernsting (1920-2005) was one of the creators of the German *Perry Rhodan* series. Wikipedia states that because German authors in the early 1950s could not sell science fiction stories, he invented a British pseudonym, Clark Dalton. The incident described here would have happened some time between 1952 and Gernsback's death in 1967.
5 The Nazis often referred to Jews as vermin, and Gernsback was Jewish. But Gernsback also, as noted, was not a trustworthy character.

he wasn't at all visible. The original invisible man. In two and a half years, I never saw Sidney Gernsback. I don't know whether he came over in 1905[6] when Gernsback did, or what, but I never did get to see him.

Even getting to see Gernsback wasn't too easy sometimes. Hugo Gernsback was quite formal in the office. You didn't ever call him Hugo, because everybody called him Mr. H., which is the nearest you could get to Hugo. There's Mr. H. and Mr. S., although Mr. S. was never there. He had a very quaint German accent. He was from Luxembourg, and he had a delightful accent, I thought.

Richard A. Lupoff: There's been a lot of controversy over the years about how Hugo Gernsback lost *Amazing Stories*. There was the official party line that came out of Gernsback and his semiofficial spokesman, Sam Moskowitz. But more recently a fan named Thomas Perry went and actually did some research in court records and legal records and old newspaper files in New York about these incidents in 1929 or so. Gernsback's party-line version is that Bernarr Macfadden was this scheming malefactor who, for some reason, just didn't like Hugo and they had a personal feud, and Macfadden discovered under some bizarre technicality of bankruptcy law, he could force Gernsback into bankruptcy because Gernsback had been late on paying a bill. This succeeded as a legal maneuver but that it was all basically a dirty trick using a peculiarity of the law, and that law was later corrected to prevent this happening again. The whole thing was almost fraudulent, with Gernsback as the victim. That's the Gernsback version. The version the fan unearthed was that this whole thing just was not so, that it was an ordinary, straightforward bankruptcy proceeding. Gernsback had more bills than he had money, and he went into receivership. Period.

Charles D. Hornig: I can't imagine why Macfadden would have wanted *Amazing Stories*. It wasn't all that much of a success. It wasn't making a lot of money. Macfadden had a lot of successful magazines. Why would he want *Amazing* unless it was an easy deal? Gernsback was very late in paying bills, and he wasn't beyond a little trickery himself. I can't see anybody busting a gut about it. It wasn't really very important, and frankly, I don't see why people are so interested in it. It's a minor thing. Macfadden never did publish *Amazing* anyway. Evidently Gernsback gave up the idea of science fiction, but not for long, because he started *Wonder Stories* almost at once.

Frank K. Kelly: One winter day in December 1930, when I was sixteen, I wrote a story about two scientists who had developed a device to bend light waves and entered another universe where they were attacked by monsters. I called it "The Light Bender" and sent it to Hugo Gernsback, who had begun to publish *Wonder Stories*, which he had described as "The Magazine of Prophetic Fiction." I was then working in a box factory, twelve hours a day for twenty-five cents an hour. My father had lost his job in the Depression,

6 *Life* magazine says 1904; confirmed by Clute/Nichols.

and I'd been forced to go to work as soon as I finished high school. I was lucky to have a job, I suppose, but I hated it.

Four months went by, and I thought my story had been lost in the mail. The world for me was more dark and dreary. Then I got a letter from Gernsback, with a check. The world for me was bathed in light again. "The Light Bender" appeared in the June 1931 issue of *Wonder Stories*, with this statement by Mr. Gernsback:

"Man with his tremendous development of science may be considered as a child fumbling about in the dark of a great cavern. He stretches out his hand and finds things that he puts to his own use, and they serve him well. But the nature of the things that he finds and uses is still a mystery to him. As he plumbs deeper and deeper into nature's laws to find new devices for himself, he may be intruding into a world that he does not understand. So science may easily prove a boomerang to man and destroy him in the process of civilizing him. Our young author has taken this theme and woven it into a finely conceived, gripping story."

Writers of the Twenties

JACK WILLIAMSON

Richard Wolinsky: Just as very few actors and actresses from the silent days of film survived the advent of sound, so most of the science fiction writers of that era disappeared when the field became more sophisticated in the 1930s and thereafter. Writers such as Miles Breuer, Otis Adelbert Kline, and Victor Rousseau are largely forgotten today, though in their heyday they were giants to pulp readers. There is one exception, and his name is Jack Williamson. His first story was "The Metal Man," which was published in *Amazing* in 1928.

Frank M. Robinson: I have enormous respect for Jack Williamson. When I first met him, Jack was one of the old guys and I wanted to talk to him about the good old days.

"What was the editor Robert O. Erisman like at *Marvel Science Stories*?"

Jack thought about it for a long moment and looked at me and said, "What kind of word-processing program do you use?" Right away I got the picture. This is a guy who never grew old between the ears. He constantly reinvented himself. He is writing today, in the year 2000, only because of that ability to reinvent himself.[7] He is not like Stanton Coblentz or some of the other guys doing business at the same old stand until somebody knocked down the stand.

7 Jack Williamson died in 2004 at the age of ninety-eight. His final novel, *The Stonehedge Gate,* was published posthumously in 2005.

Jack Williamson: Miles J. Breuer was an attorney [science fiction bibliographies list him as a physician — Ed.] practicing in Lincoln, Nebraska who took his fiction seriously and was writing short stories that I admired. I got in correspondence with him and persuaded him to take me on as a sort of apprentice. I did most of the writing and he wrote long letters of criticism and so forth. I think I learned a good bit from Breuer about dramatic values and story construction and restraining some of my impulses to be a little bit too wild and fantastic. We did a short story that was published as "The Girl from Mars" that Gernsback did in a little booklet in 1929. Then a novel, *The Birth of a New Republic*, which was a future version of American history set on the moon with the moon colonists revolting as the American colonists revolted. That I enjoyed doing. It was published in *Amazing Stories Quarterly*, Winter 1930.[8] I think it worked out pretty well. I thought at the time that Breuer was insisting on paralleling American history a little too closely with identifiable characters, Washington and Franklin and so forth, and I think it probably would have been better — well, Heinlein did the same thing later in *The Moon Is a Harsh Mistress*. In fact, I think he'd given credit to me. I think with the variations he put in it, it was far more successful.

CLAIRE WINGER HARRIS

Forrest J. Ackerman: Claire Winger Harris got second or third prize in the Gernsback *Amazing Stories* contest way back in 1927 or '28. Frank R. Paul had a cover around which one was asked to write a story, and I think hers was called "The Fate of the Poseidonia," and she did a book during her lifetime [*Away from the Here and Now*, 1947, a collection of short stories. — Ed.]. She had stories in *Weird Tales* and *Wonder* and she finally discovered the Los Angeles Science Fantasy Society and came to a meeting. She was just a nice middle-aged hausfrau, nothing particularly outstanding about her other than her imagination.

VICTOR ROUSSEAU

Harry Bates: I was one of the last people to see Victor Rousseau alive. He came here on his way to Washington. A feeble old man got off the bus, came up the stairs. I happened to have a bottle of wine and I went out for some rye bread and we had an old-fashioned meal on that sometime artists' food, wine and rye bread, you know, such as we hear they had in Paris in a certain period. Oh, and he loved it. He hadn't had it for so many years. He was so feeble. He went down the stairs. I watched him cross the street because the bus stop is just across the street, and he got on. But I know now how he

8 Actually, Winter 1931, but the contents page says Winter 1930.

felt then,[9] because I am it now. Different. I don't know what was the matter with him. He was quite elderly, but I know the feebleness and the tentativeness and all that.

OTIS ADELBERT KLINE

Frank Belknap Long: Otis Adelbert Kline was one of my oldest and best friends. I don't like to talk too much about his writing. He had a tremendous following, tremendously admired. I don't think it was literary. That about sums it up.

E. Hoffmann Price: Kline was a character. I met Kline the same day I met Farnsworth Wright, the editor of *Weird Tales*. The minute I stepped in, Wright handed me the cover illustration for "The Peacock's Shadow." That was 1926. Then he got on the phone, told Kline that E. Hoffmann Price was in town. Kline promptly pulled the switch in his office. He was one of Massey & Massey's partners in the spice, flavoring, and extract business.

Kline used to travel all over the country. He used to sell, oh, when I say a carload of vanilla extract for a year's supply of ice cream in New Orleans, I don't know whether they sell vanilla in carload lots. I mean, tank car lots. Kline never chickened around. He knew substantial people.

Once, for about a week he was arranging, New Orleans style, selling to Mr. Brown. Mr. Brown was too goddamn wealthy and important to live on St. Charles Avenue. He lived on a privately owned street. The street belonged, goddamn it, to Mr. Brown, and to Mr. E. A. Parsons, and two or three other fashionable folks. They had a sentry there in a sentry box. And you bloody well didn't get in until you were cleared. So the deal was all closed. We went to dinner. Robert Spencer Carr and I were included with Kline, and after dinner, Mr. Brown herded us all out of the house.

The dinner was served in the home, and that was the end of that. We ended up — he had chartered a whorehouse for the evening. So here was a quiet, modest, sedate, unspectacular whorehouse, Mr. Brown, Mr. Kline, presumably discussing vanilla extract. And Robert Spencer Carr and E. Hoffmann Price. So here was a half a dozen whores sitting around, not soliciting business. And there was no business to solicit. The way it worked, everything was on Mr. Brown. He had bought the place for the evening. Whatever you wished to drink or whatever other amusements you fancied, you'd merely use sign language or English or whatever you spoke.

So naturally I drifted to the flock of whores and I began telling them Barbary Coast stories.

9 Lawrence Davidson said he conducted the interview while Bates was lying down, with a bucket of excrement nearby. Bates was very raspy. Portions of the interview can be heard as a special feature created for the 2008 reissue of the original 1951 *The Day the Earth Stood Still* DVD, titled "The Astounding Harry Bates." The DVD is available through Amazon.

"Did you young ladies ever hear of the fellow who was walking down Bartlett Alley with an awful hangover about 11:30 or noon on a Sunday morning?"

They've all heard of the Barbary Coast. That was a catchword. So they're sitting on the edge of their chairs, intensely interested. I said it this way:

"He was walking down, hung over, stumbling, feeling kind of, well, all extended and out of sorts, and a lady tapped from a second story window.

" 'You hoo, dearie.'

" 'Oh, shit.'

" 'Come on up, dearie. Show you a good time. Three ways for a dollar, dearie.'

" 'Suck my ass, you old bitch.'

" 'That'll be two bits extra, dearie.' "

Well, those girls. Jesus Christ, none of them could have been pregnant, or they'd have had a miscarriage. And everybody howled with glee. But for Otis Adelbert Kline, I would never never have been that bright sparkle in the eyes of that handful of whores.

Kline was more and more inclined to get out of the fiction business because he was selling all this stuff, hardcover and magazines, but he was not a sufficiently fast producer, and the word rates were not compatible with the style in which his family had, over the years, from the earliest days, become accustomed to. So he became an agent. He liked, however, to have a hand in fiction as a matter of sentiment and fun. He always liked to write.

So he sent me a synopsis, and maybe a first chapter. So I wrote it. The end product, *Satans on Saturn*, was a combination of the worst of Kline and the worst of Price. Master salesman though he was, he could not find a customer for that dog of dogs. *Argosy* was one of the first rejectors. Several years elapsed. Finally, reaching the end of the trail, Otis offered the script to Leo Margulies, chief of the *Thrilling* publication chain. Otis asked for $250.

Leo shook his head. "I would not publish this goddamn blob if you paid me $250."

Months passed. There was a new editor at the *Argosy* desk. They met in the editorial room and by now the newcomer had heard all about Kline's persuasive salesmanship.

"Seven-hundred-fifty dollars," he said menacingly, "and not a fucking cent more. Take it or shove it up your arse."

Kline kept a straight face until he got in the elevator, then he ran for the bank.

Richard A. Lupoff: I think I'm one of the few living persons who actually read *Satans on Saturn*. It wasn't really that bad. A pretty routine space opera, and the "satans," I've always suspected, were the inspiration for the "guardian aliens" in Arthur C. Clarke's great novel *Childhood's End*.

E. E. "DOC" SMITH

Richard A. Lupoff: Of the really great space opera writers, I had the good fortune to know the Big Three, "Doc" Smith, Jack Williamson, and Edmond Hamilton. In fact, I had the privilege of editing Doc Smith's novel, *Subspace Explorers*, and working pretty closely on it with Doc.

A. E. van Vogt: E. E. "Doc" Smith really launched us into outer space, and me too. In 1928, he wrote the first novel that I read of his, *The Skylark of Space*.

Isaac Asimov: Doc Smith wrote *The Skylark of Space* in 1928, which was ten years ahead of its time; and in 1937 wrote *Galactic Patrol*, which was one year ahead of its time; and ten years later was writing stuff that was ten years behind the times.

Richard A. Lupoff: Actually, Doc told me that he wrote *The Skylark of Space* in 1915. He started sending it around and collecting rejection slips. Nobody would touch the story until Hugo Gernsback bought it for *Amazing Stories* in 1926. Doc said that Hugo paid him $150. Hugo was famous for paying as little and as late as he could. Writers like Doc Smith and Jack Williamson would start off writing for Gernsback, then move on to better paying markets.

The Other Magazines:
Argosy & the Bottom Feeders

Jack Williamson: I was anxious in those days to sell to the old *Argosy* and I wrote a couple of stories that were constructed in the *Argosy* serial pattern, that is, six 10,000 word installments with a dramatic curtain in each one. The first one was "Golden Blood," which *Argosy* didn't buy but *Weird Tales* did, and the second was *The Legion of Space*, which *Argosy* didn't buy. I had the manuscript when F. Orlin Tremaine and Desmond Hall started up the Street & Smith version of *Astounding*. I sent it to them and they paid a cent a word for it. Six hundred dollars in them days was a fortune.

Argosy was a grand magazine in its time. When I started writing, A. Merritt was my idol and he agreed in an ill-advised moment to collaborate with me on a novel. I wrote 20,000 words over one Thanksgiving vacation at school and sent it to him. That was the end of the collaboration, but Merritt told me they were paying five or six cents a word, which would have been a strike indeed if they'd bought a collaboration with A. Merritt.

Richard A. Lupoff: Then there were the real bottom-feeder markets. *Weird Tales* was a special case. They were strictly poverty row. But a number of people really loved that magazine. And there were the "Spicies" — *Spicy Mystery, Spicy Western,* and the like — that were sort of borderline porn but could be used as a salvage market for stories that didn't make it

anywhere else. Just add a little sex to your manuscript and send it in. Or so I've heard. They were before my time.

Frank M. Robinson: The Spicies were known to pay around two, three cents a word. They were not a cheap market. The reluctance to write for Spicies under your own name was the nature of the material. A lot of guys took adventure stories and mystery stories they hadn't sold any other place and sexed them up. For Spicy, that meant "creamy white thighs" and "heaving bosoms," all of the titillation stuff of the thirties, which is pretty mild.

E. Hoffmann Price: The Spicies made groceries. I used to send a story out on a Saturday. Rural delivery mail service. The following Saturday I'd go to the box and pick up a check. One day there was no check. Well, I said, it might have been a drink too many. The second week, no check for that story. Well, I waxed exceeding wroth. They can screw themselves and bugger each other if they please. But I will not write for their goddamn present participle magazine. Never. They can't insult me this way! So I wrote for other people. Until one day, what do you suppose I found on my desk? The manuscript. I'd never mailed it. So I mailed it and got my check.

Chapter Two
The Story of *Weird Tales*

THE CONTINUING CAST OF THE BOOK
(IN ORDER OF APPEARANCE)

Hugh B. Cave (1910–2004) Horror, adventure, and fantasy author from 1929 to 2004, his best-known work is *Murgunstrumm*.

Robert Bloch (1917–1994) Fantasy and horror writer from the 1930s through 1990s, best known for his novel *Psycho*.

Fritz Leiber (1910–1992) Fantasy, horror, and science fiction novelist and short story writer; author of *The Big Time, Gather, Darkness!,* and *Conjure Wife.*

Ray Bradbury (1920–2012) Poet, short story writer, and novelist, one of the masters in the field; among his works, *The Martian Chronicles* and *Farenheit 451.*

Frank Kelly Freas (1922–2005) The leading illustrator/artist in the world of science fiction; his career extended from 1950 to the end of his life.

Joyce Carol Oates (1938–) Noted author of mainstream literary fiction, including *Them, Because It Is Bitter, and Because It Is My Heart,* and *Blonde.*

L. Sprague de Camp (1907–2000) Fantasy and science fiction novelist and short story writer from the 1930s to the 1990s, both solo and in collaboration with Fletcher Pratt, and biographer of H. P. Lovecraft and Robert E. Howard.

Julius "Julie" Schwartz (1915–2004) Fan, agent, and editor; comic book editor from the 1940s through 1980s.

Wanda Hoffmann Price (Dates unknown) Wife of science fiction/fantasy writer E. Hoffmann Price.

Weird Tales was arguably the first magazine devoted to science fiction. In the magazine's early years, its contents were divided into "weird scientifics" and "weird supernaturals." In later years, with the emergence of numerous science fiction magazines, *Weird Tales* eliminated science fiction from its contents. It was a long-lived magazine, beginning publication in 1923 and continuing unabated until 1954, though it has been revived repeatedly since its demise in 1954. Its heyday was during the editorship of Farnsworth Wright, from 1924 until 1939.

Mad Scientists & Monsters

Hugh B. Cave: *Weird Tales* was definitely what you call a ghost story magazine, that type of thing. It was fantasy. In horror, you pretended everything

was happening through some sort of occult power, but you always had an explanation at the end, a logical explanation. You might have the monster coming all around and doing terrible things throughout the novelette. Most of what I did were novelettes. But at the end, it had to be rationalized. It had to be somebody in a costume, or somebody who had been deformed in a fire, or something of that sort. It was not a ghost, it was not anything occult. That was the difference between *Weird Tales*, the classic magazine *Weird Tales*, and such shudder magazines as *Terror Tales*, *Dime Mystery*, *Horror Stories*, and, oh there were many, many others, *Sinister Stories* and whatnot. That was the prime difference. Those magazines, the shudder stories, did not use ghost stories.

Robert Bloch: There were two separate branches of writing, and science fiction writers, being more organized, members of clubs and having a certain communal interest, tended to do a little one-upsmanship on the fantasy writers, and say "Fantasy is just a branch of science fiction," but today, with so-called "speculative writing," it's turned around because much of what is classified as science fiction today is fantastic in its premises and in its execution, and above all, in its flamboyant style. But I didn't know anything about that then.

Fritz Leiber: There was the story that E. Hoffmann Price told about entertaining Seabury Quinn once in New Orleans and taking him into a bordello, and the girls working there all read *Weird Tales*. They were so delighted. My God, their favorite authors. You know, it did have that reputation. I remember looking for it at one magazine stand and being told, "Yeah, we have it." He probably didn't use the term, but he said "Lot of weirdos buy it. Jazz musicians and so on."

It Came from Indianapolis

Richard Tooker: I was fifteen years old in 1917 during the war. I could play the trumpet and I remember I was in the home guard and I played for the boys who came back who were buried. More of them died from influenza than on the battlefield. And that was when I first dreamed of writing. And when I came downstairs I felt about ten feet tall. My hair was falling out because I had a relapse of double pneumonia, see, and I almost died from it, and that's when I wrote what I called "Mars Mysterious," and it was later published in *Weird Tales* in February 1924 by Edwin Baird. One of the first issues of *Weird Tales*, I believe it was. It was called "Planet Paradise." I was writing under the name of Dick Presley Tooker. Baird liked that because science fiction was almost unknown in the United States at that time. And all I can say for it is it was a story of retroactive flight projection into outer space to Mars. But it's terrible. You couldn't sell it today.

Richard Wolinsky: *Weird Tales*, the legendary fantasy pulp magazine, began quietly in March 1923. It was published by Jacob C. Henneberger, and its first editor was Edwin Baird. The editorial office was in Chicago but the company was headquartered in Indianapolis. Baird had been hired to work on its sister pulp, *Detective Tales*, and had little interest in fantasy, horror, or science fiction. Even so, Baird did publish H. P. Lovecraft (Howard Phillips Lovecraft), Seabury Quinn, and Clark Ashton Smith during those early days.

Frank Belknap Long: Lovecraft didn't have too high an admiration for Henneberger. He thought of him as a kind of a Babbitt. Henneberger did have a cultivated side to his nature. He read quite a deal, he could discuss a number of writers, but Howard always thought of him as a businessman, a business type, an opportunist who was just interested primarily in making money.

Lovecraft admired Baird very much, and liked Baird. As a matter of fact, right after Baird accepted his first story for *Weird Tales* and they exchanged letters, he wrote one of the most intimate letters that I've ever heard of to Baird, who was a comparative stranger, telling Baird how miserable he was, and how he wouldn't care if he died tomorrow, that sort of thing. A more personal letter than he probably wrote to any other correspondent. He'd never met him, and yet wrote this letter baring his despairing attitude. His first letter to Baird was one that would have caused most editors to instantly reject the story. "You may not touch this, not one comma." That's a classic.

Richard Tooker: Edwin Baird was what you'd call a very typical city man, I would say. Not typical in the fact that he didn't know anything about writing. He knew writing. But you'd see him. This is the man you'd see in the city and I wouldn't call him a city slicker because I liked him too well, see. But he had all those things that the city man had and I didn't. I was just a farm boy, you know, and I had been in the Marines at that time. Spent sixteen months in Haiti in 1925, and that was about all the experience I'd had. I wrote some stories on voodoo after that, which sold. Baird once invited me up to his apartment in Chicago and he had a player piano, a grand piano, and he played his favorites. I listened to that and I thought, Oh boy, this is the life. He had *Detective Tales* and he had *Weird Tales*, and I sold to both of them.

Frank Belknap Long: My first appearance in professional journalism was in *Weird Tales*, in 1924, with a story called "The Desert Lich."[10] H. P. Lovecraft had sold four stories to *Weird Tales* and, of course, I saw them. I was already corresponding with Lovecraft, and when he came out again, he invited the owner, Henneberger, to call up my home, and he talked so highly

10 Long conflates journalism with this tale of a wife-seller in the Arabian desert which combines lines like "fool, fool, fool" with orientalist gibberish, camels, pomegranates and necrophilia. A robotic reading of the now-public domain story can be found on YouTube. Long's byline was "Frank Belknap Long, Jr." and he thought so ill of this story that his 1975 collection, *The Early Long*, fails to include it.

of my stories that from that time on, I was accepted for *Weird Tales*. Farnsworth Wright wasn't the editor then, it was Baird. And then the magazine had some financial difficulties, and Baird ceased to be editor, and Wright took over. Wright had no stories, and he wrote me very enthusiastic letters.

Richard Wolinsky: In 1924, publisher Henneberger chose to sell *Detective Tales* in order to focus his energies on *Weird Tales*, which remained on rocky financial shoals. He replaced Baird with Farnsworth Wright for the November 1924 issue. Wright was a former reporter and a poet, perhaps an unusual choice for editor of such a unique pulp magazine. He would remain editor at *Weird Tales* until 1940.

Jack Williamson: I guess one forgotten thing about Farnsworth Wright was the fact that he was a Shakespearean scholar, and once he launched Wright's Shakespeare Library and published his own edition of *A Midsummer Night's Dream* in a pulp format and was going to do all of Shakespeare, I guess, if it had succeeded, but it must not have sold too well. I still have my copy of his magazine. That's probably a pretty rare treasure nowadays.

Charles D. Hornig: Farnsworth Wright doesn't get enough credit for being an active early figure in the field, back in the mid-1920s. He was putting out more fantasy than anybody else, science fiction and weird stories, before Hugo Gernsback. Wright had Parkinson's disease, which made it very difficult for him to talk, or to write, or to function very well. His mind worked beautifully, but he couldn't do anything physically. He was really the one who formed *Weird Tales* policy. He couldn't do too much because of his ill-health, personally, just that one magazine, but he did start a lot of writers who became famous later, like David H. Keller and Ray Cummings. Cummings also used to write for Gernsback even before Gernsback had science fiction magazines. He wrote science fiction stories in the science magazines.

Jack Williamson: Wright was a very likeable and interesting person. He had this Parkinson's disease that grew progressively worse. Editing the magazine in spite of it must have been an heroic effort. Gradually he got so that his signature would be just a wiggly line, and his face was becoming sort of rigid. But he liked to tell good, earthy stories and he had, let's say, a wonderfully warm attitude toward *Weird Tales* and literature in general. I met Farnsworth Wright a number of times. I had read a story in *Weird Tales* that struck me as so bad that I could surely do as well. So I wrote a story for him that he bought and he was always very nice to me. I visited him in Chicago a couple of times, once had dinner at his home. Another time I was there when Edmond Hamilton was there, and there was a party at Otis Adelbert Kline's, who was an agent as well as a writer.

Frank Belknap Long: *Weird Tales* didn't pay very much. Even in those days, they paid a cent a word at the most. Because a cent a word then would be equivalent to three or four cents now, which wasn't too terrible. But they didn't pay as high as the better pulps. They didn't pay as high as, let's say,

Argosy. They certainly didn't pay as high as *Adventure* or *Blue Book*. But they did pay a cent a word and usually, sometimes, I would get it within a few weeks, and other times you'd have to wait until the story came out.

There was nothing that you could count on to any extent to help you make a living. I was a freelance writer in those days. I did do some ghostwriting. I had some revisory clients. Lovecraft and I had a ghostwriting bureau between us, and we revised a lot of material for these clients. I revised some stories for Zealia Brown Reed [Zealia Bishop].[11] HPL collaborated with her on "The Mound," and I also revised three or four of her stories.

I wrote thirty-five stories for *Weird Tales*, over the course of years, and then when the old science fiction field more or less exploded, there were magazines all over. Well, then, I switched to science fiction magazines.

Fritz Leiber: I was once introduced to Farnsworth Wright at a chess match, of all things. The University of Chicago team was playing the Marshall Fields Garden Apartments team, and I was on the first team, and Farnsworth Wright was on the Marshall Fields team. But we didn't play chess with each other. We were on different boards. But I did meet him at that time. I remember him as a rather small, gray man with a tremor. I didn't know at the time it was Parkinson's disease. The one acceptance I have from Farnsworth Wright, the one acceptance letter from the story "The Automatic Pistol," which was the first story I sold to *Weird Tales*, his signature has that fine tremor in it. But I never knew the man, and besides that, I just have a few rejection letters from him.

Robert Bloch: I started reading *Weird Tales* in 1927 when I was ten years old. Picked up a copy in the Northwestern Depot in Chicago. My aunt had offered to buy me any magazine I wanted on the stands. The Northwestern Depot at the time had a newsstand that was possibly a hundred feet long and twelve feet high. Every space on the stand was occupied by a pulp magazine. There were more pulp magazines in those days than there are porno magazines today. And she said, "Any magazine you want, you can have, read on the train." So I zeroed in on the one with the cover of the naked lady. I was a precocious child, and it was also the only pulp magazine that cost twenty-five cents. She turned a little bit pale, but she was brave and she got the magazine, and I started to read it. I bought the next couple of issues, or had my parents buy them for me because I was too small at that time to reach up to the top of one of those stands and steal a copy. So they bought them, and I discovered H. P. Lovecraft. I was quite impressed. I had been reading fantasy, not science fiction as yet, and I'd read Poe and Arthur Machen and was beginning to read M. R. James, but Lovecraft really turned me on.

Frank Belknap Long: Wright was a very wonderful guy, you see. A very good editor, but he had a few blind spots. He got Lovecraft very angry at times because he didn't see some of his strongest stories, what Lovecraft

11 Long appears to be referring to Zealia Brown Reed, a variant of Zealia Bishop.

felt were his best stories. And Lovecraft turned against him at times and said sarcastic things about him. But in the end, I think he was rather fond of Farnsworth. Wright had Parkinson's disease and very foolishly underwent this new operation. At that time, it wasn't always successful. He died, you see. But a year and a half, two years before that, he gave up the magazine, and then Dorothy McIlwraith took over.

Fritz Leiber: *Weird Tales* was sold around 1938. Wright was out, and he died shortly afterward. It was bought by a small chain that also had *Short Stories* magazine, for which they had this Dorothy McIlwraith editing it. A great name, McIlwraith. I never visited the *Weird Tales* office, although I lived in Chicago, which was the home of *Weird Tales* during the 1930s, at any rate. Somewhere in the mid-1940s it moved to New York. I never met her but according to Henry Kuttner, she was a sort of clubwoman type. She and her assistant, they had a vague idea about wanting the traditional sort of ghost story. They were down on sword and sorcery, and stories had to have very definite plots, most of them, so I had trouble selling to them.

Once I looked at it in a humorous and a cold-blooded way. I had an older friend who had sold his first western story by trying to put in it everything from a western story, every incident, you know surefire incidents from western stories he read, as a joke, you know. And of course they loved it. They bought it, and so I said to myself, "Well, what about *Weird Tales*?"

I worked it out. It had to have wealth in it, or had to have descriptions of wealthy living, and it had to have sex, and it had to have some sort of violence, and it had to have a mad scientist and a giant spider, or some equivalent of that. And especially they liked wealth, if it was a decaying, wealthy Southern family, Southern plantation. And God help me, I got racial. It had to have a comedy Negro in it, who was scared of "ghostseses." So I wrote a story called "Spider Mansion" with all those things in it. And of course they bought it. Even Farnsworth Wright, I'm sure, would have bought it, in that case, because it was a real cliché story.

And then I remember I got mad — well, not mad, but sort of inwardly mad at a friend of mine who was very much the intellectual, literary type. His writing career actually consisted of, he sold one story to the *New Yorker*, and that was all he ever did. But he did do that, you know. He enthused over this story, "Spider Mansion," and I got the feeling "He thinks that at last, I'm writing the sort of crap that should be in those magazines" — frankly sensational rather than trying to make some obscure point. I never did sell a great deal to *Weird Tales*. I kept trying, and two of those stories for *Weird Tales* were on medical topics — you probably should add that to *Weird Tales*, that they always went for the curiosities and oddities of medicine.

Ray Bradbury: The short stories I sold in the late 1940s were for ten dollars apiece, fifteen dollars. And when I was lucky, twenty-two dollars to *Weird Tales*. They paid a penny a word. When I asked for a raise to a penny

and a half, there was big trouble. They almost fired me on the spot. But all those stories are beautiful stories, almost all of them. And I didn't know what I doing, thank God. I didn't know I was excellent. I was just writing because I loved what I wrote. All those stories are still around, they're in *The October Country*, they're in *Dark Carnival*, my first book. They're on my TV series now, the ones that I sold for twenty dollars apiece. So I guess the success was in the excellence of the stories. I was successful and didn't know it.

Frank Kelly Freas: My first national sale in November of 1950 was in *Weird Tales*. It was a little painting of Pan dancing in the moonlight, and he was supposed to be playing a clarinet, but I didn't have any reference material on the clarinet so I just sketched it in as a sort of horn. It looked more like an ear trumpet than anything, and they practically snatched it out of my hands. One of my friends came back from New York, got a look at it, and said, "This is exactly what Dorothy McIlraith would like for *Weird Tales*." "I've got some stuff I want to do on it," I said. "No, mail it. Now." So I shot it off to her, and she was real happy with it. Only one minor change. She wanted the figure framed a little bit in lighter colors. They were reproducing her stuff with three-color processing at the time, and she wanted the figure brought out from the background a bit, so basically the sparkles around the little dancing faun were Miss McIlraith's ideas. And she paid me the princely sum of fifty bucks for it. And the next one was exactly one year later, which was another cover for *Weird Tales*.

H.P. Lovecraft: a Twentieth-Century Poe

Frank Belknap Long: I think there's a power in H.P. Lovecraft that transcends his defects, and he will become an important literary figure. I think he will be comparable to Poe in another twenty years. In America, Lovecraft's name isn't remotely comparable the way it is right now in Italy and Spain and France, particularly. He's an established literary figure in Europe and South America. In America, he is still largely a cult figure. But it's growing. People are paying more and more attention. Right now I think there's no one who can compare with him except Poe.

Joyce Carol Oates: Lovecraft was a wonderful writer, but very poetic and he wasn't moving us as swiftly along as say, Edgar Allan Poe or Stephen King, and that's why he didn't make very much money for his work. He was just too ornate.

Hugh B. Cave: I lived in Providence at the same time H.P. Lovecraft did. I'm quite sure that he wrote to me first. He saw a story of mine in *Weird Tales*, I think it was the first one I ever sold in the magazine, "The Brotherhood of Blood," a vampire story that's been reprinted many times since. He wrote to me and I answered him as one writer would to another. You've got to remember that at this time, I was already selling to many other kinds of

pulps and Lovecraft was not. Howard was writing only for *Weird Tales*, and he wasn't that interested in me because I was not one of the "inner circle." For him, I was what you might call an outsider who had happened to sell Farnsworth Wright a story. When I wrote to him about some of the other pulps, and I made some dumb crack, quoting someone who said, "Nobody but a fool writes but for money," Howard wrote back, and decided that I was a philistine. He didn't like me, I'm sure, because I was making good money. You've got to realize I was a lot younger than Lovecraft and I was selling, at that time, to at least twenty or thirty different pulps that were paying better than *Weird Tales*. And he was writing for *Weird Tales*. He was starving, and I was high off the hog there. I was making a hundred dollars a week.

Robert Bloch: Lovecraft did a lot for me. Not only did he give me the necessary support and the flattery — and it was flattering to have the interest of somebody that I admired so greatly — but he also introduced me, through correspondence, to many of the writers of that circle. I thus came to know Clark Ashton Smith and Donald Wandrei and E. Hoffmann Price and August Derleth, who lived a hundred twenty miles away from me, in Sauk City, Wisconsin. I went up to visit Derleth after about a year, and he was all a writer was supposed to be in those days. He received me in his home in a velvet smoking jacket, which impressed me tremendously, all the more so because he didn't smoke. This is what writing was all about. He was six or seven years older than I was. I could see that in his infinite wisdom and maturity of his middle age — he must have been pushing twenty-three or -four — maybe in some day I could aspire to that kind of eminence. That encouraged me too. Derleth was not so sanguine about my writing. Matter of fact, before I had made a sale, he looked at one of the stories I'd sent to Lovecraft — Lovecraft had sent it to him — and he wrote to me. He said, "In all kindness, I must tell you right now, you will never be a writer." Of course, he was slightly in error because he published my first collection of short stories a few years later.

Frank Belknap Long: There was an amateur journalist out West, Paul Campbell, you see. Incidentally, he later became quite a successful oil well promoter, and he saw a story that I wrote in a competition for a boy's magazine. I won the first prize. I believe it was called *The Boy's World*, and he wrote me, asking me to join the United Amateurs, you see, which I did, and then I wrote a short story for the first issue of the *United Amateur*. That would be about 1920. Lovecraft saw it, and wrote me quite enthusiastically about it. He said it reminded him of Poe's "Shadow — A Parable," and so forth. So that's how I first became acquainted with Lovecraft. I was the first one to receive a fan letter from Lovecraft, except that it was more of a guidance letter in which he very graciously saw that I did have some talent. Well, he wrote it on a postcard. I always think it was a letter because his handwriting was so small. He crammed so much into one small space. I

think I refer to it in *The Early Long* as a long letter, but it wasn't. It was just a very long postcard.

L. Sprague de Camp: The first Lovecraft I ever read, as far as I know, was "At the Mountains of Madness" when it appeared in the old *Astounding Stories* in the middle 1930s. And the story impressed me, but not to the point where I made any particular notice of who the author was or anything. I was just a desultory, an occasional reader of the science fiction pulps at that time, and I didn't really begin to get into the Lovecraft business until after the Second World War.

Hugh B. Cave: You look up some of those old copies of *Weird Tales*. Howard Phillips Lovecraft was not their favorite author, not by any means. The fans did not like him that much. Their favorite author at that time was the author of the Jules de Grandin stories, Seabury Quinn. And it wasn't until August Derleth made noise about Howard Lovecraft many years later, and reprinted him in Arkham House that Lovecraft became Lovecraft. He was ignored at the time he was writing those stories, except by writers like Clark Ashton Smith. He was tutoring some of those writers and he loved it. He loved to give advice. He was an older man. He had been writing and he was a good writer.

Richard Tooker: Oh, I liked Lovecraft. I thought he was a master of the horror story. He was. The story he wrote about the man who was preserved by ice, "Cool Air." Nothing to the plot, but it was Lovecraft the way he could write. Oh, the reality of it. Such writing. Some of his best stories, the plots didn't amount to much. It was just the way he did it.

Hugh B. Cave: I don't like Lovecraft's Victorian imitation-Poe style, but he had a marvelous imagination. My God, what an imagination that man had. He created that whole Cthulhu mythos, all those gods and so on. This is what he should be remembered for, and I'm not the first to say this. Robert Bloch said this in a speech that I listened to. I have it on tape. He said the young writers are imitating Lovecraft for the wrong reason. They shouldn't be copying his style, which was atrocious. They should be copying his ideas, his imagination, which were top-of-the-line. He's going to be remembered long after I'm forgotten. I know that. But he's going to be remembered for the wrong things.

Robert Bloch: Imitation is the sincerest form of flattery, and naturally I imitated Lovecraft when I began. Many writers did. So my old stories were very, very derivative. And being a beginning writer, I thought it was a smart thing to do, to be polysyllabic and use sesquipedalian techniques. I think I'll exist as a footnote to Lovecraft because, after all, he did kill me off in a story, and that gives me some claim to literary fame.

E. Hoffmann Price: The minute they discuss Lovecraft, they all get ecstatic, become sincere artists, pompous pretentious fucking stuffed shirts.

Nobody could ever see Lovecraft as a man of whimsy, sparkle, humor. A very human person.

Well, so here we were. I was like a cat walking on eggs when I went to meet him that day in New Orleans. I had heard all the horror stories about his being a goddamned bloody bluenosed charlatan. I'd seen that awful picture of him. He looked like a cross between Dracula and a ghost. It is one that shows an abnormal amount of white, giving an acute spectral stare. His eyes never did look that way.

So, before I walked more than a block from the Lafayette Hotel right near the Lafayette Square and the old post office in New Orleans, on St. Charles Avenue – we were walking into the Vieux Carré. Before we got to the rim of the Vieux Carré, I found Lovecraft to be one of the most congenial characters and that his bookish way of talking, if he had spoken any other way, it would have been a forced and unnatural effort. I quickly got accustomed to his stately, eighteenth-century diction. We got along fine.

You've all heard of the famous *Necronomicon*. Well, my conversational Arabic at Salim Hessler's restaurant in the Vieux Carré of New Orleans, not Damascus, had set me kind of pondering. Dr. Taylor's two-volume work on an introduction to the study of Arabic also set me thinking. Lovecraft was a guest and a very learned man and I didn't want to be a goddamned ignoramus, so I was picking my way cautiously.

So I said, "Now, that *Necronomicon*. There's something about this title, the author rather, Abdul Alhazred. I grant that Professor Taylor does take cognizance of the quadriliteral Arabic root, and that is, you're familiar with that well-known monograph by Dr. Bernard Stoddi on quadriliteral Amharic roots." He was such a scholarly character, I had to hold my own. "Well," I said, "This is what has me baffled. Ordinarily, the triliteral root is almost universal. Dr. Taylor has an interesting doctrine on the quadriliteral root. This thing, Abdul, servant-of, should be tied into the succeeding word. Now here we have Alhazred, we have a redundant definite article and we also have four consonants."

And I noticed he was getting more and more, kind of sitting forward in his chair. I noticed a peculiar glint in the eye. I thought, No, he isn't offended. There's something odd about his expression. So I said, "I am not questioning your authenticity, your honesty, or your competence at Arabic. But frankly, I would like to have you explain that quadriliteral root."

Then he busts laughing right out loud and lets out that it's a whole goddamned hoax. He cooked up the name Abdul Alhazred when he was about six years old, writing a boy's version of the Thousand Nights and One Night, and he felt that was one of the best things that ever happened in a long lifetime, how many people – he really enjoyed the bewilderment of the readers – how many of them took it seriously.

Frank Belknap Long: Well, E. Hoffmann Price has his conception. Lovecraft was a very wonderful human being, but Price doesn't really realize that he's also a mad genius, and an extraordinary writer as well. Price, to me, doesn't recognize the fact that he wasn't just a regular guy. He was a mad genius. To Price, he was just a wonderful guy to meet and talk with, and he was. There was no pretense about Howard.

Charles D. Hornig: On my birthday, in 1934, I went up to Providence and spent the day with Lovecraft. That was the only time I ever met him. He was gaunt, he really did look like one of his characters in his stories, like an undertaker. The nearest thing I can see is John Carradine. He had a very pleasant way about him, but he was very very much of an introvert. He lived with his aunt at that time. He was already about 44 years old, but he had evidently very little contact with women. He didn't seem to be interested in anything except antiquity. He took me to places in Providence where you could say — except for the automobiles — everything you see is over two hundred years old. He hated anything modern. He'd never go downtown Providence, but he stayed up by the old houses of the town and the graveyards. In fact, in one of the oldest graveyards, we rapped on a crypt and got no answer. I figured if anybody could, Lovecraft could.

We had a very nice day, and with us we had a young man named Kenneth Sterling, who was a genius in those days. He was about ten years old when he sold a story to me. I didn't know how old he was at the time. "The Brain-Eaters of Pluto," it was called. It was a spoof on science fiction, and as a spoof it was very good. He entered Harvard when he was about fourteen, and became a famous surgeon after that. I had no further contact with him. But he was with us most of the day.

I think Lovecraft was the nearest thing to Poe that's come along since Poe. People are starting to recognize that. But he didn't have to drug himself to do it the way Poe did. I can't imagine him drinking particularly. He wasn't the kind of person who needed any kind of stimulant. You might think because of the stuff he wrote, he might have gotten high on some kind of drug or liquor, but I don't think he used anything in order to develop his themes.

At that time, he had a god, his famous god Cthulhu. We asked to him to pronounce it, and he could pronounce it like nobody else. It's not a human sound, but he could make it. I said, "How do you pronounce this?" and he could do it, from way down in the bottom of his throat, and it's supposed to be, you know, the sort of sound only the god could really make who lived under the earth. "Kathulu" is the nearest I can get to it, but it's a little different from that.

E. Hoffmann Price: Lovecraft and I were drinking coffee, not rum and wine. As you know, he was quite a teetotaler, and one thing led to another. I suggested that he and I team up and follow Randolph Carter in his adven-

tures going through the gates of the Silver Key and I proposed having him return and tell us about it. This was all for fun. So this was in June. We sat up there about twenty-eight hours having more goddamned fun that you could — people don't see Lovecraft as a man of fun, whimsy, and sparkle. I wish you could have seen him.

So I sent him a 16,000-word first draft of "Through the Gates of the Silver Key." He scrapped all but about fifty of those words, and wrote 13,950 other words that were remotely related to what I had written.

Farnsworth Wright rejected the thing, which distressed Lovecraft. In 1933, when I was the guest of Otis Kline[12] in Chicago, I went to pay my respects to Farnsworth Wright. Mrs. Wright began needling him about it.

"Farnsworth, why don't you buy that story? You know you like it."

And then he said, "My dear, of course I like it, but with the financial situation as it is, and with a 14,000 worder ..." and then he said, "Well, what do you think of it?"

I said, "Sir, I have something at stake there. Count me out. You're the editor of the magazine. I'm not."

Well, they haggled back and forth. I wouldn't participate. To cut it short, he did accept the thing, published it, and the magazine lasted many a year thereafter.

I finally got the check. One hundred and forty dollars. I heard a lot of stuff about Lovecraft getting a preferred rate. I've never heard any actual evidence of it. Lovecraft hated very much to discuss the crass financial details of any deal. He just didn't know what to say about it. Well, the way it went, I knew most of these sons of bitches always shortchanged and robbed him unscrupulously. They were a bunch of chickenshit, half-assed bastards who could no more write than I could fly. So they got him to rewrite stories bodily. He would charge them a nominal sum for a writerly collaboration, rebuild the thing, and they would always settle for that 10% or something. Well I said to him, "There's a hundred and forty dollars. I had to read fourteen thousand of your jeweled words, and put them into typing. I'll take thirty-five bucks. You take the remainder." I said, "I'm getting a reasonable reward. I had the fun. I planned it with you. And you were using at least fifty of my words." So for the first time in history, Lovecraft was not robbed blind.

Julius Schwartz: About 1934 or so, I was invited to a party being held by Donald Wandrei, who was a science fiction writer. He said a friend of his was coming to town and everyone would like to meet him. So he invited Otto Binder, Otis Adelbert Kline, Mort Weisinger, myself, and maybe a few others. And the visitor to the town was H. P. Lovecraft.

So during the course of the conversation, I asked him, "Have you any stories that you've not been able to sell because I think I can have a market for you."

12 Otis Adelbert Kline (1891-1946) author, songwriter, literary agent.

He says, "Yes, I do have a 35,000-word story, which Farnsworth Wright, the editor of *Weird Tales*, just would not buy." He didn't like it, whatever.

I said, "If you give me that story, I think the chances are very good I can sell it."

I went up to F. Orlin Tremaine and I said, "You've been saying you'd like to get some of those writers from *Weird Tales*. I have one of the top writers. I have a story by him."

"Really?"

"By H. P. Lovecraft."

"Really?"

"Here's the story. It's called 'At the Mountains of Madness.'"

He said, "You'll have a check by the end of the week."

I thought to say, But you haven't read it yet. Obviously, he was going to buy it no matter how it looked. And I did get a check for $350, and after taking out my $35, my 10% commission, I sent $315 to Lovecraft, and it was the biggest check he ever received in his life.

E. Hoffmann Price: In New Orleans, I made a great big pot of chili. Lovecraft ate bowl after bowl of it. It would raise blisters on a pack saddle. He admitted it would, but it was just right. So he said, "When you're my guest in Providence, possibly you could be induced to cook," or words to that effect. I said, "Yes."

When I got there, first he said, "I've invited a guest this evening." I said to myself, this is tough shit. I didn't want Lovecraft's presence and company diluted. I didn't say so of course. He said, "It is the keeper of a local madhouse." I said, "Fine, I know I will like this." This keeper of the madhouse was a psychiatric trainee at Butler Hospital. Whether Butler was purely psychiatric or whether it was a general hospital, I don't know. This man knows probably more about H. P. Lovecraft than any other man living or dead. He and H. P. were neighbors and close friends for five years, the final five years of HPL's life. Harry K. Brobst,[13] now Professor Emeritus in Psychology, Oklahoma State University. I've been seeing him quite frequently the last eleven years. We met thirty-five years later.

So, then it was proposed that — I think it was a balmy evening, but let's not split hairs — I would prepare this curry. And Harry wondered if it would be okay if he went out and got some beer. HPL said, very seriously, "Since that would no longer be a violation of the law of the land, I could not object." So in the meanwhile, we had mutton. There was rice. All the spices of Araby and Ind. He couldn't say "India," by God. That would not have been good eighteenth century. I said fine. I said, "Now, if you young white folks would stand by, and we will taste this at intervals." I'd been making the sauce. I dipped in a spoon. I said, "A bit bland, wot?" I dunked in more spices. There

13　Harry K. Brobst (1909–2010) Lovecraft scholar who taught psychology at Oklahoma State University from 1946 to 1974.

was an improvement. I dumped in more, and rectified the seasoning — you add so much more, you need another pinch of salt to bring it all into a balance again, or a dash of this or a dash of that. And finally, they agreed. No, it would not raise blisters on a cordovan boot but it would come close enough. Let it be.

Then, this beer. Lovecraft couldn't restrain his well-bred curiosity of a country gentleman: "And what do you propose doing with all that beer?" Harry said straight, "Ed and I are going to drink it, and you're not." HPL regarded me. He regarded Harry. If Count Dracula had stepped in, he wouldn't have blinked. If the Insidious Dr. Fu Manchu came in, he would've said, "Please have curry with us." But two people blandly proposing to kill a six-pack of beer between them? That was too damn much. He didn't want to call us goddamn liars and braggarts. He wanted to see what happened. As Harry and I each was drinking his own third bottle of beer, HPL was kind of wondering when we would become homicidal maniacs, or drunk somewhere, complete sottish, sodden, quasi-corpses he might have on his hands for days of unconsciousness.

Frank Belknap Long: Lovecraft wasn't prejudiced in regard to his personal friends at all, you see. But he did have this Nordic supremacy thing,[14] that was very strong up to say, almost the 1930s at least. He read all these books by Stoddard and Grant and all the fanatical racists. They were in all the public libraries and even so distinguished a scholar as Osborne of the American Museum of Natural History fame was more racist than Howard. He swallowed this whole thing about the supremacy of the Nordic race, you see. And there were quite a few Americans who did, quite prominent ones in the scientific community and literary circles. People have no idea today how strong this racial prejudice was up to about 1925 in America. Long before the Holocaust and everything else. You don't even find it in the journalism or the magazines. You had to live through that period to know how common this was. Lovecraft changed his attitudes, though. He turned against fascism. As soon as a schoolteacher friend of his came back to Providence from Germany and told him what was really happening over there, why, he became very violently anti-fascist.

E. Hoffmann Price: Lovecraft loved maps, as you may know. Well, when I wrote "The Surveyor General of Egypt," I had sent to me the whole shmear of thousand-to-one scale street guides of Cairo, filling stations, every fire hydrant, quite useful for writing realistic spy stories of Cairo. And of Kemet, that dark land, that was always a good line, writing of Egyptian magic. I got to be quite adept at Egyptian magic. Writing about it.

So, then I got the five-thousand-to-one sheets, the fifteen-thousand-to-one sheets.[15] Then I got some of the acropolis at Thebes. I got one in Latin,

14 Oy.
15 It appears Hoffmann is taking about 5000:1 and 15000:1 scale maps.

an old one, for HPL. And the other one. I said, what the hell, I'll give him both of them. And then in our correspondence, we decided we should orga-nize a necropolitan police force, to keep drunken, bawdy mummies, the more lewd fellows annoying female mummies as they're prowling around by moonlight in the necropolis, away. I ended by sending him a couple of tickets to the annual necropolitan police ball.

This is Lovecraft on the hoof. There was whimsy. Delightful character, delightful. That's why I get so goddamn fucking fed up with these long faced, solemn — some of them are delightful persons as individuals — but they want the significance of every thing Lovecraft. It had no goddamn signif-icance, the lot of it. It was just the fun of the moment. They can't get that through their pointed little heads, though.

Julie Schwartz: L. Sprague de Camp made a monumental boner because he wrote a biography of Lovecraft and he mentioned my name as a young agent from Brooklyn. Man, I was brought up in the Bronx. You go to Brooklyn to die.

Clark Ashton Smith: the Bard of Auburn

Charles D. Hornig: I met Clark Ashton Smith in Auburn in 1938. That's the only time I saw him, in a cabin where he lived above the town. He lived all by himself. He had a wider kind of experience than Lovecraft, but his cabin — you know, he was an artist as well as a writer, and a sculptor. He would find rocks in the neighborhood and sculpt them into all kinds of gargoyles and monsters, and he had a rock garden for these things in front of his cabin. It was quite an adventure just visiting his cabin. We talked mostly about the type of things he was writing, the weird stuff. But he wasn't totally absorbed in it, the way Lovecraft was.

Stanton A. Coblentz: I knew Smith fairly well. You would expect a flam-boyant man but he was quite the opposite. He was a very mild, meek-looking retiring person and when he saw you for the first time, you had great diffi-culty coaxing him into conversation. I know another friend of ours brought him to our house in Mill Valley and we tried to include him in the conversa-tion but he just sat there and wouldn't talk. When he paid subsequent visits to our home, he relaxed a good deal. You could talk to him, as to any other man. But you had to face off that icy barrier before you could reach him. I suspect it was just shyness. I don't think he had any of that haughty sort of reserve. I think he was used to living by himself in solitude. He just couldn't get used to these strange beings, people.

He was a man of talent. I think that he got too far-off in mystical realms where the average reader couldn't follow. He also had a real flair for poetry, but some of them again, like his stories, were too involved in the realm of the mystical, and it was very difficult sometimes to fathom his meaning.

Portraits of the Writers

ROBERT E. HOWARD

E. Hoffmann Price: Robert Howard and I, he was ahead of me by a year or so. We crashed the magazines in the same order. *Street & Smith's Complete Stories, Top-Notch*,[16] and then *Argosy*. If he hadn't blown his brains out, he too would have been a great and famous writer. I mean a good writer. He's great and famous, yeah, yeah. Quote me on that.

 Frank Belknap Long: I never met Howard. I never corresponded with him, but Lovecraft sent me all of his letters, so I feel as if I knew him. Huge letters that he wrote, sometimes up to ten or fifteen pages.

SEABURY QUINN

Fritz Leiber: The stories Seabury Quinn wrote for *Weird Tales*, superficially they were very conventional stories, but there was always some kinky sex lurking around in the background.

 Frank Belknap Long: Seabury Quinn was very wonderful guy, soft-spoken, very knowledgeable. I met him about, I think, when Lovecraft was here for one of his visits. He took me over to Quinn's place, and we had a long talk, as I recall. I never saw him after that.

 E. Hoffmann Price: Seabury Quinn was one of the greatest. Not literally, but emotionally speaking. In 1933, my ass was drying in the dust. I was in New York. I had sold every blasted crime story in my inventory. I bought a car, the child bride and I. I headed for New York to meet the editors. If you could ever hear of a hardware dealer or a grocery dealer who sells out his whole damned inventory, picks up his profits instead of replenishing his inventory, you figure you should lock the son of a bitch up. Well, nobody locked me up. So I landed in New York and the inevitable happened, what with nobody paying off. I should have been in New Orleans, building up an inventory.

 When I was in that mood, I went happily enough to *The Casket and Sunnyside* [the undertakers' trade journal that Quinn edited — Ed.]. Well, Seabury Quinn was one of those magnetic presences. He invited me to dinner at the house. We had a delightful visit, and somehow my prospects had not improved one goddamned bit, but I walked away feeling kind of optimistic, like the conquering lion. Seabury Quinn bucked up the morale without ever endeavoring to do so. He was too tactful to ever suggest, "Sir, your morale needs a bucking." Oh no no no. We corresponded with each other for many a year.

 Wanda Hoffmann Price: We met Quinn thirty-five years later in Boston. He was just a little bit of a fellow. By that time he was so ill that he could

16 Our copyeditor could not find listings for either author in these magazines.

hardly walk really, and they were staying in an apartment, one of these high-rises, and it was right on the edge of a new development of music and arts and all that sort of thing. The way they had designed this area, they practically made a wind tunnel out of the street, going through the buildings. Of course, the architects and engineers were now sitting around, scratching their heads, trying to figure out how they could correct it. And here's little Seabury. I don't think he ever was a very big man, and he had been ill and everything, and he just barely staggered along with a cane. And we had to hold on to him to get to the restaurant we were going to.

But a very delightful character, a very wonderful personality. So little strength left, and we only had about two hours with him perhaps. We had lunch up on top of this hotel, like Top of the Mark, glass all around. You could see the whole of Boston. We had a delightful lunch up there, the four of us,[17] and then back to his rooms and his apartment. By that time, he was just pretty well shot, and so we had to leave. He died not too long after that. Such a frail man, and yet the personality shone forth. It was really worth meeting him. You couldn't forget him.

E. HOFFMANN PRICE

Frank Belknap Long: E. Hoffmann Price came out to New York, I think it was about 1930 or so, in a little ramshackle Ford. That's when I first met him, then he went up to Providence to meet Lovecraft, that was his first trip here. Then I didn't see him for thirty years. Recently, he came out again, three or four years ago, in very much the same kind of car. He roared across the continent, even though he's about three or four years my senior. He's just as exuberant as he was thirty years ago. Every other year he comes east and visits his old friends. He's a graduate of West Point, as you perhaps know, and he has a kind of West Point reunion with his old soldier friends. He's very candid. He writes letters which would shock some people. A little bit like Seabury Quinn, in the way he boasts of his adventures in New Orleans cathouses.

E. Hoffmann Price: I got an acceptance from *Weird Tales* in about the middle of March of 1924 for "The Rajah's Gift." Now that did not appear on the newsstand until December first of 1924, that is, the January 1, 1925 issue. I forget when I got my check. Now my hair wasn't as white though, but it took a long while to get that check. Then I sold them "The Stranger from Kurdistan," that same month for their new low, low rate of one-half cent a word. Down from one cent. You see why I was not so goddamn fucking dedicated

17 Who was the fourth person? Mrs. Quinn, most likely. Mr. and Mrs. Price were quite a pair. He spoke with an archaic syntax; she looked down on Dick, Lawrence and me with several disapproving expressions. When Price showed us tiny figurines carved by Clark Ashton Smith, he mentioned that we shouldn't have sticky fingers. I did not know what he meant until later.

as a fantasy writer or as a science fiction writer. I wrote only because I was too much of a blundering clown and couldn't write well enough to make a good magazine.

FRANK BELKNAP LONG

Richard Wolinsky: When I interviewed Frank Belknap Long, he was living with his wife Lyda in a run-down apartment in New York's Chelsea district. His hallway was a mess, junk piled everywhere. His German shepherd used the bathtub as a toilet and it was impossible to tell where Lyda and Frank cleaned themselves. But Long himself came to the door dapper and impeccably dressed. He treated me to a glass of sherry, and we sat in his long hallway talking about Lovecraft, Wright, Clark Ashton Smith, and others as well as about his own work. How he came to write, what his favorite tales were.

Frank Belknap Long: It's hard to say what are my favorite stories.[18] There are four or five I like very much. One is called "Humpty Dumpty Had a Great Fall" and the other is "The Hounds of Tindalos," which is very famous. And "Second Night Out" and "A Visitor from Egypt." "The Black Druid." I've had fifty stories in major publisher anthologies. Scribner's,[19] Doubleday, all the groups. Almost every major anthologist in the field, fifteen or twenty, have included one or more of my stories in anthologies, and most of those are in hardback. And half of them are quite recent, books like *Dying of Fright* for Random House, *Alfred Hitchcock Presents: Stories for Late at Night*, and *Davy Jones' Haunted Locker*, and so forth. And all the Derleth anthologies, about seven or eight of those. *Science Fiction Across the Ages*. And I've also written some mystery stories for anthologies. I had a story on TV, called "The Guest in the House" on CBS-TV. And that is one of my best stories. In the list, that should be included.

I think probably my best supernatural horror story is "Second Night Out." That has been anthologized quite a bit. I like "The Flame Midget," one of my science fiction stories, very much. The amazing thing about "The Hounds of Tindalos" is — way back in 1929 when it was published — it's a kind of 1960s psychedelic drug sort of thing. All that use of mysticism, long before even Aldous Huxley made so much of that sort of thing. It seems to me that story's kind of prophetic, in a way. But not particularly to my credit. It just happened, just rolled up from my subconscious. It's almost as if I had written a 1960s-type story in 1928. And two and three of the young fans have said they can't understand this. They thought it was written about 1965, and so forth, because it does represent the drug culture and all that. The Eastern concept that all existence is one. I think it's an unusual story. I'd put it as one

18 Much of the information in this paragraph could not be verified by on-line sources.
19 Charles Scribner's Sons was the publisher.

of my best stories, in a way. But I don't think the style is quite up to some of my other things.

Fritz Leiber: Long did his best work in the field mostly in the early days. It's like his reminiscences about Lovecraft. He got out a book about Lovecraft that Arkham House published [*Howard Phillips Lovecraft: Dreamer on the Nightside* – Ed.]. I was disappointed in the book myself because he had written a great deal of it in articles, and it added up to three or four fairly detailed individual reminiscences about a day with Lovecraft, and he didn't try to give a full picture, because for several years they had an editorial agency and worked as editors and revisers and ghostwriters, and he doesn't have any of the details of that. I think that by the time he wrote that book, he must have been as old as I am now, and I don't think he wanted to tackle a full job. He preferred to tell these three or four or five treasured memories that were little complete pictures in themselves.

Frank Belknap Long: My book on Lovecraft has been very highly praised. I can't complain on that score. But it's also been attacked on the basis that it's too rambling. These young fans who attack it on that basis know nothing about the tendency apparently of modern biography, which has become more informal over the last thirty or forty years. You have to realize that you just simply sit down, and you remember things, and it has more validity sometimes than if you try to organize something very carefully and make a decent biography out of it. That was deliberate. This skipping around, this rambling. That was deliberate, you see. I've been criticized for that but that's the way I wanted it. That's the way I wrote it.

FRITZ LEIBER

Richard A. Lupoff: Fritz Leiber's early stories carried the byline, "Fritz Leiber, Jr." There was a Fritz, Sr. – a famous Shakespearean who ran a traveling theater troupe. "Our" Fritz grew up backstage, and onstage, and I think you can see the influence of the theater in general and Shakespeare, in particular, in the way he constructed his stories and told his stories.

Fritz Leiber: Farnsworth Wright rejected the story "Adept's Gambit," which was the first Fafhrd-Mouser story I completed, a 25,000-word novelette or novella. He rejected it on the grounds that it was stylistically too experimental for such a long story. It was only submitted to him once. You know, he is said to have had a tendency to reject stories the first time, and then buy them on the second or third submission. I never gave him a second chance on "Adept's Gambit," merely because I didn't know that he had that quirk. Then later on, while I was selling a few of the stories to *Unknown*, why, I also tried to sell Fafhrd-Mouser stories to *Weird Tales*. After *Unknown* failed and went out of business, I submitted several Fafhrd-Mouser stories to *Weird Tales*. But under Dorothy McIlwraith, they published very little

sword and sorcery. They almost seemed to have a prejudice against that particular sort of fiction.

Frank Belknap Long: Fritz Leiber is a great writer in the field, no question of that. One of the best.

Frank M. Robinson: In the late 1950s, a friend told me there was an opening at *Science Digest*. I knew Fritz Leiber worked there. So I paddled up there and Fritz interviewed me. I thought, This is gonna be great. I'll be working with Fritz Leiber. When I reported for work, Fritz was nowhere to be seen. The story was that Fritz had a drinking problem. They discovered him asleep in the john one too many times, and they let him interview for his own successor. And he was gone, and I felt guilty about that for years and years, although I certainly had nothing to do with it.

ROBERT BLOCH

Richard A. Lupoff: Robert Bloch had the odd fortune to be known for half his career for one story and for the other half, for another. He wrote "Yours Truly, Jack the Ripper," for *Weird Tales* in 1943, and thereafter no matter what his other accomplishments, he was dogged by the line, ". . . author of 'Yours Truly, Jack the Ripper.'" Finally he wrote a short novel of psychological suspense, *Psycho*, and people forgot about "Yours Truly, Jack the Ripper."

Robert Bloch: I read *Weird Tales* off and on after 1927. About 1933, I was sick in bed and somebody presented me with another issue, and there was Lovecraft again. I read in the letter column about stories that had been published in previous issues. But you've got to remember that in those days, that there were no paperbacks, there were no hardcover anthologies during that entire decade. From 1930 to 1940 there were all of three collections of fantasy fiction published in the United States, one of them edited by Dashiell Hammett, one of them by Phil Stong — God knows why — he was the man who wrote *State Fair*. And a third one, the editor whom I forget. But there was no place where you could find this stuff. It would appear on the stands one month then disappear forever, into limbo. So I decided I would write my first fan letter and I wrote to Mr. Lovecraft care of the magazine, and asked whether he knew where it was possible to secure back issues. He wrote back to me, said "Here is a list of all my stories that are in print, or were in print. I'd be happy to lend you tear sheets of any or all of them to read." That was pretty heady stuff for a kid my age, that an important world-famous author living in the fabled East, rather than the Midwest, responded to my letter. I took him up on it. Along about the fourth exchange of letters, he said in effect, "Something tells me you might want to try your hand at writing some of this material yourself. If you do, I'd be very happy to read it and comment on it." Again, I was very flattered and thrilled, so I sat down, wrote a story, sent it to him, and he didn't rewrite it. He noted a couple of errors in geography because I knew nothing about New England. He corrected them.

But instead of criticizing, he encouraged me, and that's what I needed. Over the next year, I wrote maybe four other stories, sent them to him. Two of them were published in fan magazines in 1934.

Chapter Three
the Years of the Depression:
Triumph of the Pulps

THE CONTINUING CAST OF THE BOOK
(IN ORDER OF APPEARANCE)

Damon Knight (1922–2002) Science fiction novelist, short story writer, editor, and critic; editor of *Worlds Beyond* and *If* magazines and of the long-running *Orbit* anthology series. Founder and chief driving force in the early years of Science Fiction Writers of America.[20]

Philip Klass (1920–2010) Noted short story writer under the name of William Tenn.

Frederik Pohl (1919–2013) Agent and writer, who gained his greatest success as a science fiction novelist in the 1970s and later as author of *Man Plus* and *Gateway*; editor of *Galaxy Magazine*, *If*, and several other science fiction and fantasy magazines, and of the highly influential *Star Science Fiction* anthology series published by Ballantine Books.

W. Ryerson Johnson (1901–1995) Editor and pulp writer of the 1920s through the 1950s, focusing mostly on westerns, "northerns," and mysteries.

Theodore Roscoe (1906–1992) Pulp writer of the 1930s and 1940s.

Poul Anderson (1926–2001) Prolific short story writer and novelist, author of *Brain Wave*, the *Flandry* series, *Tau Zero*, and other works.

Theodore Sturgeon (1918–1985) Prolific short story writer, best known for his novel *More Than Human* and his various collections of short fiction.

Louis L'Amour (1908–1988) Pulp western writer of the 1930s and 1940s who later became America's best-known author of western novels; earlier in his career he wrote in a number of fields, ranging from hard-boiled mysteries to air-war adventures.

Horace L. Gold (1914–1996) Short story writer; later editor of *Galaxy Science Fiction*, the *Galaxy Reader* series, and *Beyond Fantasy Fiction* during the 1950s.

Stuart J. Byrne (1913–2011) Science fiction writer primarily of the 1940s and 1950s, chiefly associated with editor Ray Palmer, initially at *Amazing Stories* and later at *Other Worlds*.

Lawrence Davidson (1949–2016) One of the interviewers for this book; cohost of *Probabilities* 1977–1989, coauthor of *Pulp Culture*, a history of the pulps.

By 1930, other science fiction pulps such as *Astounding Stories* began to invade the newsstands, and within a short time, the field was booming.

20 Today known as Science Fiction and Fantasy Writers Association.

New writers began to see their works published and new editors started to make their marks. *Brave New World* by Aldous Huxley had been published in England in 1932, but in the United States, with magazine racks teeming with pulps, it was a brave new world for science fiction writers and readers.

On the Racks in the 1930s

Hugh B. Cave: When you walked into a drugstore, any drugstore in those days, just as you walked in the door, there would be a rack of pulp paper magazines with all these beautiful, glossy, exciting colors. There must have been over two hundred titles at one time. You're talking about adventure magazines, detective stories, and for the women, there were love stories and confession magazines. There was *Weird Tales*, of course, and how many others? What we now call the "shudder stories," the dime mystery terror tales, horror stories. There were just so many in all the different — westerns — all the different adventures. Many, many titles. Some came and went, some lasted only a few months, and others became classic names.

Damon Knight: In those days, when you picked up a science fiction magazine if you were a nine-year-old kid or whatever, every story had a brand-new startling idea in it. My first science fiction magazine was the August–September 1933 issue of *Amazing Stories*, a great big bedsheet-sized thing, and the cover story was "The Meteor-Men of Plaa" by Henry J. Kostkos. The cover was a dim pastel blue and pink depiction of a couple of guys in aviator suits pointing pistols at several aliens armed with spears.[21] And they're all standing on this cloudy surface. When you read the story, you find out that what it's about is these two aviators flying too high, and they go through the Heaviside layer and land on the top of it. The Heaviside layer is this layer of rubbery spongy cloud, and the waags who live there make everything they need out of cloud, you know beer cans or clothing or whatever — they don't wear any clothing, I don't think. And then after they find out about the strange civilization, the waags become incensed for some reason and attack them. The aviators fire a pistol at them, which sets the Heaviside layer on fire. It all burns up and the aviators escape in their airplane. The waags fall to earth to earth as flaming meteors, thus the title "The Meteor-Men of Plaa." And that was the greatest thing I'd ever struck. I was instantly aware that this was the right stuff, this is what I'd been looking for all the time.

21 Damon Knight recounted this memory several times, most notably in an essay in 1972 where he lamented the loss of old-time science fiction authors, like Henry Kostkos, author of "The Meteor Men of Plaa.". One would have to track down the original story from the August-September 1933 issue of *Amazing Stories* to find the correct spelling. The pronunciation of "waag" is "wog," a racist term used by the British toward Indians, and by Australians toward the aboriginals. There were no aliens with spears in the artwork.

Philip Klass: I remember the first science fiction magazine I ever read. I stumbled upon it at the age of nine or ten. It sat on the running board of a car — it was *Science Wonder Stories*. I was dazzled by the stories in there. I was also was vaguely excited because I was beginning to have trouble with my gonads in those days, something I've never really recovered from. There was an illustration of Jovians enslaving the human race, leading them in ships going off to Jupiter, and all of the people were naked. My God, the drawings of those naked women! Of course, there were equally sexually exciting illustrations elsewhere about giant insects, which affected me roughly the same way. I'm a complicated fetishist, always have been. I was entranced by the imaginative quality of these stories. And when I could encounter them, I read these science fiction magazines as much as I was reading anything I could find in those days.

Writing for the Magazines

Frank K. Kelly: It's mysterious to me how these stories came out of people's minds. Every story that I wrote, I wrote at top speed. Of course, I was very young and I had a lot of physical energy. I wrote one novelette, I guess it was around 16,000 words, in one day, and I couldn't possibly do that now. I started early in the morning, went on until late that night, and I mailed it off, I think it was to *Astounding Stories*, and they bought it. And I never revised it, never changed a word of it. Neither did they. I couldn't possibly do it now. You get started on it, and it just unfolds.

Frederik Pohl: In the 1930s, I think it was easier to break into the field of science fiction for someone who had relatively little sophistication about writing and publishing. There only were magazines, and you could copy the address out of the table of contents and mail the story off. And most everybody can figure out that that's something they could do.

A. E. van Vogt: The business of writing was very easy during the Depression. That's when I was in my late teens and early twenties. At that time there was nothing else to do. You couldn't get a job. You couldn't do anything. There was no way of earning any money. And so I was a writer at home, though I was the only one. I don't know why the other people who didn't have jobs didn't do that. It seemed so natural to me, spending my spare time trying to write, and I was trying to write stories for *Liberty Magazine*. They had these one page short-short stories, and they all failed. I never could write a short-short story.

W. Ryerson Johnson: At *Detective Tales* and *Dime Mystery*, we had two piles with 2,000 manuscripts, one pile from agents and writers we had bought from before, and then the slush pile, which sometimes reached the ceiling, stories that came in cold, that nobody'd heard of this person before and you don't know what his record is, or hers. Work was pretty intense.

When you got time you'd grab a few from the slush pile. You could tell from the first and the last page, so you would tend to do that. If they held up, then you can dip into it and read the rest. I myself had bad experiences with slush pile writing, so I said I'll do something to let the guys know where they stand. So I wrote something on every story I sent back. "Try this again," or "Try somebody else" or "Too much conversation" or "Not enough conversation." Some little thing, to let them know somebody was there.

Hugh B. Cave: Not many stories of mine were rejected and when they were, I generally put them in a pile. If there were any suggestions saying how to fix them up, of course, I would make the changes, if I agreed with them, and I usually did. They were good editors, you know, they knew what they were doing. They knew their market.

Theodore Roscoe: *Liberty* was a slick, and it would pay up to ten cents a word, eight to ten cents. *Argosy* would pay five. Edgar Rice Burroughs got ten or something out of them, but their average for a storyteller was three to five cents a word. *Adventure* was about the same.

Frank K. Kelly: The Gernsback magazines were very slow about paying, but their pay was low, a half a cent a word, something like that.

E. Hoffmann Price: If a man couldn't make a living writing — whenever two or three people got a skin full of illegal liquor, they would launch a magazine — if you couldn't make a living writing then, son of a bitch, you never could. The rates weren't high, but there was plenty of bacon. [There were lots of magazines to be sure, but very few of the science fiction variety. — Ed.]

Fritz Leiber: In those early days, there were still so few magazines, really, especially before World War II. A lot of the writers had read everything that had been published in the magazines, so there was a lot of this sort of business of, "Here's a plot," "Oh, no, you can't do it, someone else did it." A great deal of feeling that you knew all the stories, that you really had to get something original, different from all three or four hundred others than had been published in the magazines so far.

The Future Is Today

Ed Earl Repp: You know, we used to write about television as something that was going to take place in a hundred, two hundred years from now, and here we have it. And we used to think going to the moon, someone was crazy. And they've been there.

Poul Anderson: All these science fiction concepts that used to be so far out — robots, space travel, time travel, androids, cloning, the whole works — these are common currency nowadays.

Stanton A. Coblentz: I remember going to a meeting once in which people who were considered as a form of mild maniacs were discussing the

possibility of sending a man to the moon, and they were earnest scientists. Not only science fiction writers, but earnest scientists who were taking the matter quite seriously at a time when they were regarded, to say the least, as a bit loony. It must have been about 1936 or 1937, somewhere along there.

Richard A. Lupoff: I think that *I'll Grind Their Bones* by Theodore Roscoe is a particularly interesting book. It's a future war novel about World War II published in 1936.

Theodore Roscoe: I had flying bombs in that book, and a couple of Germans who lived in the hotel where I wrote the thing came to me one time and asked me how I got this information on what became buzz bombs. They wanted me to write a piece on those things, which of course I wouldn't do.

Frank K. Kelly: In my story, "The Light Bender," I wrote, "It had been born in an inspired time, the years immediately following the holocaust of the Third World War of 1990." I often wonder why did I, in a story written in 1930, long before the rise of Hitler to power in Germany, long before the outbreak of World War II, assume that there would be a holocaust and that there would be three world wars?

Another of my stories was called "Red April, 1965." It was in *Wonder Stories* and was published in 1932. It dealt with a possible war between the United States and the Soviet Union in 1965, using long-range rockets and robot armies instead of soldiers. You had a mechanized battlefield, what General Westmoreland was talking about at the end of the Vietnam War. It's often baffled me. Why did I write a story projecting a possible war with rockets and ballistic missiles between the United States and the Soviet Union back in the early 1930s? Just something that my imagination picked up. I'm glad that it didn't happen.

Richard A. Lupoff: Frank K. Kelly was astonishing in several of his predictions, all written in the early 1930s. The Germans marching through the deserts in Africa and the Japanese attack in World War II. Climate control. Color organs, similar to the light shows of later years. Permanent space stations of the L5 type. Prohibition of the use of tobacco. Use of solar panels to collect energy. Mind control by psychological conditioning, hypnotic gas, the electronic harness, and by psychosurgery. Videotape recording, and in one story, videotape recordings being played back in a courtroom and entered as legal documents. The use of reading spools to replace books, which later became the concept behind the microfiche. The big one, of course, was the Sinkhole of Space, which was exactly a black hole, along with the accompanying time and space distortions. Absolutely remarkable.

Frank K. Kelly: All my friends said I should sue all these science fiction movie producers because all the ideas in their films, like the ones they used in *Star Wars* and *Close Encounters*, were foreshadowed in my stories years ago. It's a little late to sue anybody.

Richard A. Lupoff: Richard Tooker's book, *The Day of the Brown Horde*, probably his most famous work, published in 1929, was reprinted in *Famous Fantastic Mysteries* magazine in 1944. He had a letter in the same issue in which he said, "I expect to live to see the moon circumnavigated by the hero of tomorrow's adventure scene."

Richard Tooker: They not only circumnavigated the moon, they landed on it in 1969. It was nothing so unusual to me because I had anticipated it. I thought you could do it if you spend the money. That's the point. Kennedy spent the money.

Wonder Stories, Charlie, Mort & the Gang

Stanton A. Coblentz: Hugo Gernsback gave me a real surprise one day after I had been writing science fiction for several years. He asked me if I wouldn't come down to see him. He had something of importance to talk over with me. I came down to his office and he offered me the editorship of his science fiction magazine, *Science Wonder Stories*. I figured that I aimed to be a writer, not an editor. If I tied myself down to looking over manuscripts and trying to drum up subscribers, I wouldn't get very far with my writing, so I regretfully declined.

Frank Belknap Long: I sold a couple of early stories to the old *Wonder Stories* magazine. That first story was a time-reversal story. A time machine, as I recall, and they made a drawing of me but it didn't resemble me in the least. That was before Charlie Hornig took over.

Charles D. Hornig: In 1930, I picked up my first copy of *Amazing Stories*. There was a picture of the Woolworth Building being uprooted and fire all around — it was exciting. I was fourteen years old. This was Elizabeth, New Jersey. That's where I was brought up. I had a quarter and I was supposed to go to the movies, and there was no movie I wanted to see. I was instantly an avid fan. I was hooked completely, and it was a real addiction with me. I'd never even thought of these things before, and there was a whole universe.

The first thing I did was take the magazine across the street from the newsstand to the public library. I was thrown out in about ten minutes for having trashy literature. Now, of course, that same library has a complete file of *Amazing Stories*. I got a magazine for every nickel I could collect. In those days, you could get magazines for fifteen or twenty-five cents.

There were no fan magazines, but I thought there ought to be one ... well, there was one, and that was called *The Time Traveller*, the very first,

put out by Julius Schwartz and Mort Weisinger and Allen Glasser[22] in about 1932. It was printed by a fan [Conrad Rupert] in Jamaica, New York, who had a printing press and would hand-set everything. There were no other real fan magazines at all, except tiny little things that probably no one ever heard of.

I got the idea I wanted to put out a fan magazine in 1933, and through various means I got the addresses of various writers, wrote to them and said, would you send some material, information about forthcoming stories, and so on. I gathered the material together, and they also were kind enough to send me stories they couldn't sell, H. P. Lovecraft, Clark Ashton Smith, David H. Keller, Otto Binder, quite a few of them. These were stories that were pretty good stories, but no editor had bought them yet. They were later anthologized many times, especially Lovecraft. I put them out without copyright so they were in the common domain instantly, and anybody could print them. I put out this thing called *The Fantasy Fan*. The first issue came out when I just turned seventeen. I had 250 copies of it, and I wish I had some to show now, but I don't. I think I had to pay Connie Rupert ten dollars for this. All hand-set, took him all week to do it.

Julie Schwartz: Now Charlie Hornig got his job with *Wonder Stories* in a very interesting way. He put out a fan magazine called *The Fantasy Fan* and he sent it around to the various editors and Hugo Gernsback happened to pick it up, looked at it, and his managing editor named David Lasser was leaving, and Gernsback needed someone to do reading on the manuscripts, so he asked Charlie Hornig to come in and be interviewed. He was astonished to find out he was only a seventeen-year-old kid. But he was impressed by what Charlie said, and how he said it, and he hired him.

Charles. D. Hornig: Saturdays, I would go to Jamaica, New York, which was around twenty-five miles from where I lived, and Julie Schwartz would go there, and Mort Weisinger, and a number of others, and we would collate and fold and staple these printed magazines so Connie wouldn't have to do everything. I sent the first issue to everyone I knew, hoping to get subscriptions at a dollar each year, ten cents a copy, and I sent them to all the editors, including Hugo Gernsback.

At that time, I had a summer job working for a lawyer as a typist in his office for five dollars a week. There wasn't much work to do in the summer anyway; his secretary was on vacation. And while I was there I got a telegram from Hugo Gernsback in New York, saying, "I have a proposition I think will interest you. Please see me as soon as possible." I didn't have a telephone so he couldn't call me up.

22 Allen Glasser (1908–1971) was an author and editor, whose claim to fame, along with *The Time Traveller*, is a story from the August/September 1933 *Amazing Stories*, "Across the Ages," which turned out to be plagiarized from a 1929 story, "The Heat Wave," by Robert Ord and Marion Ryan, published in the April 1929 issue of *Munsey's Magazine*. We will hear about this event again.

The first thing, he looked a little dejected and disappointed when he first saw me. He didn't think I was so young to begin with, even though I looked much older than my age. So he said, "Well, we're in the market for an editor." David Lasser, who was his editor — he didn't tell me this, I found out later — was getting too interested in socialism. He was very active in the Socialist Workers Party, and wasn't putting much attention on the magazine, wasn't doing his editorial job. So Gernsback said he was looking for an editor, and he said, "How old are you?" and I told him I was seventeen. He said, "I thought you were much older than that," and I said, "Well, I'll be happy to finish high school in the evening," as far as that was concerned. Well, he wasn't too sure but he had a novel in manuscript, and he said, "Well, here's a story and here's a sheet listing all the proofreader's rules. Now go through the manuscript and proofread it, bring it back Monday morning. Talk to your parents in the meantime, see what they say." It was the translation of a German novel, translated by Fletcher Pratt, but I can't remember what it was. Gernsback got a lot of those because they were real cheap, and he actually paid Fletcher Pratt more to translate it than he paid for the novel.

Well, I was kind of in a daze. This was a Friday afternoon, and the first thing I did was get on an el train and go up to the Bronx to visit Allen Glasser, who was very active in those days as a fan. He passed out of fandom a year or two later because he plagiarized a lot of stories, was in a lot of legal trouble. I showed it to him, he couldn't believe it. Then I went over to the East Bronx and visited Julie Schwartz. This is an amazing story, and here I was, going to be editor of *Wonder Stories*. They may have felt they were more well-known in New York and had longer backgrounds. They felt maybe that they should have gotten it. Anyway, I went home.

My parents were very happy to have me earn twenty dollars a week. I could have had more if I'd known Gernsback better, but I didn't know that Gernsback was very cheap. I went back on Monday. At that time, I guess I didn't know how much he was going to pay me. He said, "You're young, you're just starting. How much salary do you think I ought to pay you for this?" So I very meekly asked for twenty-five dollars a week. He said, "Let's say twenty to start." Well, this is more than a lot of men were making who were supporting families and working for the WPA. It was in the depths of the Depression. Everything was very very cheap, so twenty dollars a week was a lot of money. I found out later that the main reason he let Glasser go was he was paying seventy-five dollars a week to him.

In about six months, I wrote a note to Gernsback which said, "Well, I think I've done an adequate job, at least you told me I have. I'd like to have a real salary now. I'd like to be paid at least fifty dollars a week." So he called me up and we had a laugh over it, and he gave me a five dollar increase. I never did get the fifty. I did get $27.50 before I left, though.

Frank Belknap Long: See, Hornig was a kid. He was only about seventeen. He was the youngest editor in America at the time.

Jack Williamson: Charlie Hornig bought a story or two of mine. Of course, he was a well-known fan. I met him at conventions and so forth. When he was editing a magazine, he wasn't as good an editor as, let's say, John W. Campbell [who became editor of *Astounding Stories* in 1937], and wasn't paying as good rates. I think he published just one or two shorts.

Charles D. Hornig: In one of Isaac Asimov's books, he said that as far he knew, Charles Hornig was the only one in the field with absolutely no talent. I reminded him of that when I saw him in New York. I said, "You really hit it on the head. I never had any talent for it, that's why I was an editor." He said, "Well, you know ..." He tried to brush it off. But it's true. I never felt I had any particular talent. I had a lot of enthusiasm and interest, but I couldn't really write science fiction. In fact, not many editors can. Doc Lowndes [who edited *Future Science Fiction* and other magazines from 1941 through 1970. — Ed.] can do it pretty well. But what Gernsback wanted was somebody with enthusiasm. Now David Lasser had no enthusiasm, and he was paying him a lot of money. He knew I would be interested in what I was doing, and do the best job I could. And after all, he could have approved or disapproved anything that I did. And it was the same way with Silberkleit.[23] But I really had nowhere to go in science fiction. I couldn't write it. Except for fandom, there wasn't any place unless it was editing.

Richard A. Lupoff: As the Depression deepened, Gernsback's publishing company foundered. In the last throes of *Wonder Stories*, Gernsback was trying to float some bizarre schemes for mail-order sales, cutting out the discounts and the wastage that went with newsstand distribution.

Charles D. Hornig: Gernsback had that right in the magazine. He announced that that's what they were going to do for the next issue, and of course it never went through. He wanted to eliminate all the expensive distributing through United News, and sell it only by subscription, and he didn't get enough response to that. So he had to do away with it. In those days, circulations weren't very large. A good circulation would be 50,000. We were probably doing 20,000 to 25,000 at the time that it was sold to Standard, and that was too low.

Richard A. Lupoff: When his various schemes failed, Gernsback sold *Wonder* to the Standard chain and it became *Thrilling Wonder Stories*. Hornig was left high and dry for several years, then was hired by Louis Silberkleit, a friend of Gernsback's, who was starting a new string of science fiction pulps.

23 Louis Silberkleit (1900–1986) was a publisher who employed Hornig in the 1940s. Among his many publishing ventures over the years was MLJ Publications, best known for Archie Comics.

Charles D. Hornig: After I left *Wonder Stories* in 1936, I was out of the field. I was trained in bookkeeping school, so I went into bookkeeping and accounting for a couple of years, and then back in the end of '38, that's when I started with Louis Silberkleit and *Science Fiction* and *Future Fiction*. That was all freelance. He would pay a hundred dollars an issue and I did my work at home. I didn't have an office. I would collect the stories once a week or something like that, and go home and read them. Dummy up the copy. I was living in New Jersey, in the suburbs. I stayed there for a couple of years.

I left because I had come to be more of a California resident by that time, and I was spending so much time out here — like more than half the year — that I was given a choice: either I have to stick around here where we can get in touch with you quicker, or you'll have to give up the magazine. So I decided I'd rather live in California. But I was doing it not only free-lance, but by remote control by 1940. That's when I had this office in Los Angeles and I was also doing some writing criticism. I used to have ads in the *Writers Journal*. I did a little editing for people in general. I lost interest in editing by the early 1940s. I didn't have the enthusiasm anymore. I never lost my interest in science fiction, but maybe my taste got refined a little bit and I just couldn't read all the junk that came along. When you're fourteen years old, it's all wonderful. You don't know good writing from bad writing. So all of the stuff sounded great to me when I was a kid. But I became more discriminating in my taste, and I only read stuff that I thought was going to be really good, mostly anthologies.

Richard A. Lupoff: When *Wonder* was sold, Hornig left science fiction, returning only briefly in the employ of Louis Silberkleit. Hornig's friends, Julie Schwartz and Mort Weisinger, continued to find their own way through the science fiction world, becoming agents.

Julie Schwartz: I was still in college and Mort Weisinger and I got this idea. Well, when I say we, sometimes Mort and I, we thought terribly alike. It was embarrassing. And we said, since we know all these writers ... You have to understand. Back in the days of the pulp magazines, a fellow like Edmond Hamilton would sit down at a typewriter and dash off a story. Whether it was six thousand words or twelve or eighteen thousand, it didn't matter. He wrote this story and sent it off some place. After a month or two the story would be accepted or come back. Well, Mort and I said to Hamilton, "This is crazy. You should know from the editor what kind of story he wants. Wouldn't it be nice to know that the editor is looking for an eight thousand word time-traveling story? 'Don't do any Martian stories because we have four Martian stories in the house.' You haven't got a chance." So we'd write back to these writers and say, "We'd like to be your agents and we will tip you off as to what the editors are looking for." I was nineteen by this time, getting close to the big two-oh. This was '34. Mort and I did it, but that lasted very briefly because Mort got a job with Standard Magazines, which in due

time took over *Wonder Stories* from Gernsback, which became *Thrilling Wonder Stories*. And since Mort was buying material, he couldn't buy it from himself. So I did it all by myself.

Charles D. Hornig: I stayed with Gernsback at *Wonder Stories* for two and a half years before he sold the magazine to Standard. The first intimation I had of the sale was that I had gotten a letter from Finland asking if they could publish some of our stuff in the Finnish language. So I went in to Mannheimer, who was the business manager, and I said, "Is it all right if we let the Finnish publisher have these stories?" He said, "Yeah, okay, we'll make arrangements." And then, in my usual line, I said, "Well, I guess that's the Finnish of *Wonder Stories*." He said, "You said it. It's the finish of *Wonder Stories*." And it was, within two or three months. So my pun came back to me.

I was satisfied with the work, of course, and they said Standard was buying it, and I think it was Mannheimer who said, "Well, why don't you contact Leo Margulies, who is the editor in chief, and let him know that … I think he'd be willing to put you on his staff."

Theodore Sturgeon: Leo Margulies was quite a character. I liked him very much. He had the aspect of a New York cloak-and-suiter, and I'm not putting down cloak-and-suiters either. He was hardworking, he was professional, he was very honest. Some people have told stories about Leo that he was kind of swift with a deal and would shift and change and so on, but I always found him impeccably honest. I remember once there was some kind of a situation, I completely forget the details, but it had to do with getting a tax credit in some way or other. I went to Leo to ask him about it, and he got angry at the very idea that I would even think of cheating the government, which I didn't intend to do. Very decisive too. He was an executive-type editor. I understand that he paid his editors very poorly, and worked them terribly hard. A guy would be the editor of love romances and he'd suddenly find himself also the editor of air war stories, and he could take it or he could quit, one or the other. He was fairly hard-nosed.

Louis L'Amour: Leo was editor for a whole string of pulp magazines and a very, very good man and a very good editor. I can't imagine any writer in his right mind not liking Leo Margulies. My first story that I sold him was for a magazine called *Thrilling Adventures*. I wrote some boxing stories for him. I wrote a couple of football stories and a couple of air stories, and he wanted some westerns. He talked to me a bit, so he knew I knew the field. So I finally wrote some.

There was one reason I stayed with the pulps as long as I did — I could have been selling to the *Saturday Evening Post*, I could have been selling to *Collier's*, as I did later — I could have been selling to a lot of other magazines. The thing about Leo that made him so great for writers was you sent in a story, you got a check. If he bought it, he didn't fool around. He sent you the

money right away. It was a godsend for me because I was eating from check to check. And if the check didn't come on time, I didn't eat for a while.

Frank Belknap Long: Leo Margulies was one of the first to buy my stories for the Standard Magazines. He bought a number of stories for *Thrilling Wonder* and *Startling Stories*, and so forth. He was one of my closest friends, and he used to get me checks even if the story was rejected. He asked me if I wanted to put that one toward the next one, and so forth.

Richard Tooker: Margulies was one of the great pulp editors at that time. He was a good man, bought a lot of my stories. He came out one time. He was going to relocate in Phoenix, he was, and he had some literary genius that came out, his foreguard or his vanguard. They talked to me down here in the hotel. I guess it was over my head. In the end, he was mad because I didn't cooperate anymore with him. Margulies never did move out here.

Charles D. Hornig: At Standard under Margulies, they had seven or eight editors who would edit all of the magazines. There was no one editor for one magazine. Stories passed from one to the other. I wasn't particularly interested in reading detective stories and stuff. I just wanted science fiction. So I would have taken a job there because I had no other job after Gernsback left. It would have paid probably better than Gernsback. So I called up Leo Margulies and he was very enthusiastic about it, and he says, "Call me back on Friday," etc. etc., it sounds good. I thought it was great, and then I started thinking, Weisinger works for Leo Margulies. I thought, Now if he has Mort Weisinger there, unless he needs a larger staff, he wouldn't really have to hire me because he has somebody else there who knows science fiction. So I called Margulies back and I said, "Well, how do things look?" He says, "It's all off, it's all off." And I said, "Well, what did Mort have to do with it?" He says, "None of your business, son," and he hung up the phone real sharp, you know. I thought that was not a very tactful thing for me to say, but within the back of my mind I knew he had Mort Weisinger and he wouldn't need me. So I didn't speak to Margulies for three years, until the first World Science Fiction Convention, and we could be friendly again and everything had passed over. I said, "I shouldn't have asked you that." "Ah well, forget it." So I never did get with Standard.

Horace L. Gold: I had written a story that John Campbell at *Astounding* didn't want about the first man to return from Mars, and he is such a stinker and such a loathsome bastard, such a greedy, publicity-hungry character that the equivalent of NASA gets rid of him by shooting him back to Mars. And I submitted it to Mort Weisinger, and Mort never was one to leave well enough alone. He wanted it to be a tearjerker, four handkerchiefs. So I wrote a four-handkerchief story called "Hero." And it was such a tearjerker, it brings up your breakfast. Last Tuesday's breakfast.

Richard A. Lupoff: In 1939, Mort Weisinger hired Horace Gold as his assistant. Gold had been selling science fiction and fantasy stories as early as 1934, and under his own name beginning in 1938.

Horace L. Gold: I got married on September 3, 1939 and Mort Weisinger, by this time, he was my best man and he had us out to his house for the weekend for our honeymoon in New Jersey. I was doing badly economically, and Evelyn wasn't doing much better working for an automobile dealer. Suddenly, Mort asked me how would I like a job working at Standard Magazines. I said I'd love it, and that's how I met Leo Margulies, and he hired me. Leo had set up a system at Standard Magazines with *Thrilling Wonder*, *Captain Future*, and all the other magazines. They had the Thrilling group, and then they had the Popular group. This was on West 48th Street, across the street from Rockefeller Center, and I was Assistant Deputy Assistant to the Deputy Assistant to the Deputy. I was one of the trained seals. He paid me thirty dollars a week.

I became Leo's prize copy editor. I wanted to read stories. I didn't want to go working over other people's stories. I discovered the more editing I did on a story, the blacker the copy, the better Leo liked it. The printer begged him to please make me use a pen or retype it so it wouldn't smudge so badly. I would cross out a line heavily, very heavily, very black, and write above it exactly the same line.

Mort was the best creative editor I've ever known. Jack Schiff was the best structural editor. But each of us had our own way of greasing Leo. Jack, for example, would make a big circle around the first two paragraphs of page one and mark it "page three," and circle another group of paragraphs and label it "two," and another page, "one." So the compositor had to go to one, shift back to two, and then three. He just shifted the opening around. That pleased Leo.

Mort was a tremendously creative guy. He also was so proud of everything he produced and how much it paid. I worked with him and Leo and Jack for two years. Then my wife became pregnant and it took me a week to edit a 10,000-word story, and I still wasn't finished, so Leo fired me. I begged him, "Please don't fire me. My wife's pregnant and I can't get by on thirty bucks a week, and I'll never do it again." And he gave me a five-dollar raise.

Julie Schwartz: Mort got the idea of initiating a contest for new writers for *Thrilling Wonder Stories*, and he was offering a prize, either $25 or $50, I don't recall. So Mort looked through the scripts and he picked out a pretty good story. It was called "The Broken Axiom." He liked the story but he thought it wasn't quite right and he asked the author to do a little revision on it. This fellow had never written anything, being a new writer. He did rewrite the story and won first prize. His name was Alfred Bester. Another writer wanted to submit a story but he found out that if he won top prize, he'd only get $25 or $50, which wasn't enough because his story was maybe

eight thousand words long. And if he sold it to *Astounding* at a penny a word, he'd get $80. Now $30 in those days was a lot of money. He did indeed sell that story to *Astounding* and it was accepted. And his name was Robert A. Heinlein.

Richard Wolinsky: When Gernsback sold *Wonder Stories* and it became *Thrilling Wonder Stories*, people in the science fiction community felt that the magazine would be degraded, dumbed down. Under Leo Margulies and Mort Weisinger, to some degree, they were right. But in retrospect, those stories remain a great deal of fun. Sadly, Weisinger stayed with *Thrilling Wonder* for only a short time, before another format beckoned.

Julie Schwartz: Mort Weisinger was editor at *Thrilling Wonder Stories*, *Thrilling Love Stories*, *Thrilling Ranch Stories*, *Thrilling Western*, *Thrilling Thrilling Stories* for all I know. And he got an offer to work for DC Comics, and he accepted the job, and did *Superman*, *Batman*, and many other features at the time.

Horace L. Gold: Mort Weisinger showed me the first issue of *Batman* and the first issue of *Superman*. And *Batman* had a Batmobile that used machine guns, and it was bloody as it could be, and just plain violent. Stupid violence. And *Superman* consisted of four pages. Superman is from a big heavy planet and he could jump over a building, and he can lift a ton. The mythos of Superman, that was entirely the work of Mort Weisinger, and when Siegel and Shuster sold all rights, they really had nothing. It was Mort who thought up Krypton and kryptonite, the whole thing. And for Batman, introducing Robin and the Trophy Room and the Batmobile and the Batarang. All this. Mort was immensely creative in a completely trashy, pulp way. He was the most creative editor I've ever known, outside of myself.

Julie Schwartz: A year or so after Mort was hired, he went into the Army. In 1945, the war was over and Mort came back to work. He said, "I'm not going to last too long in these comics. I want to become a writer." And he did, he became one of the top fact article writers. He wrote a book that's still going strong, *1001 Valuable Things You Can Get Free*. But he wanted to write a novel, and he kept threatening to quit. Every time he went into Jack Leibowitz's office, he said, "Jack, I really want to leave." Jack said, "No, no, you can't leave. Who'll edit *Superman*? Here's another thousand-dollar raise." Well, this kept on for years and Mort said, "Julie, some day I'm going to leave and you're going to take over *Superman*." But finally, in 1970, Jack Leibowitz left, and Mort saw his opportunity. He left, and that's how I became editor of *Superman*.

Astounding: from Bates to Tremaine

Richard Wolinsky: Clayton Magazines first hired Harry Bates as editor of an adventure pulp in the 1920s. A few years later, Bates was asked by the

company's founder, William Clayton, to start a historical adventure pulp. Instead, Bates proposed a magazine to go head-to-head with *Amazing Stories*. Titled *Astounding Stories of Super-Science*, his new pulp went on the stands in January 1930. In September 1931, Bates also began editing *Strange Tales of Mystery and Terror*, which was designed to rival *Weird Tales*. The latter magazine folded after seven issues, and the former was bought by Street & Smith in 1933 after Clayton Publications went belly-up. Harry Bates was let go at that time, but assistant editor Desmond Hall continued on in the same capacity under new editor F. Orlin Tremaine.

Harry Bates: *Astounding* was a new magazine, it just suited me. I was the one who suggested the topic. I had other magazines. I had to keep going and I didn't have any help at first. They got their editorial costs free, they got their office space free, they got other things free. Promos were almost free, like that corner of the sixteen-page color proof.

I didn't buy for a long time any stories on my own. Clayton read them too. In fact, he was a big buff. He would come in my office and raid my stacks of manuscripts, even the rejects. Even stuff that I'd turned down, if necessary, just to read it. That's not good. And of course we agreed on almost all the other stuff. So it worked out all right, but he was a buff and I had to be very careful not to let him try to buy anything that I had turned down. It happened, but hardly ever. I had to be on the watch.

He had his peculiarities about insects. I think one of our first covers had an insect on it, a ladybug. He bought that one because Victor Rousseau reached his ears, independent of me, and that happened in some cases. In fact, there was a couple of cases in which authors got to him before they got to me and not only got the two-cent minimum rate, but four cents. Now that's a lot of money in those days. That was a tremendous amount of money. If it hadn't been for that, the magazine would have been making a profit, I believe, from the very first issue.

I didn't know the circulation of *Astounding* for many months. Clayton was a little close about telling me, but they finally came out. It had been running just at the payoff line, in spite of heightened amounts going to authors, some, and it pretty much stayed there. I had, you see, to capture the *Amazing* audience, which I apparently did. But I had, in addition, to capture a percentage of the readers of "straight adventure," which were the contents of magazines I also edited, and everybody else in the place too, because Clayton was an "adventure" man.

I had to fill *Astounding*. I had, every month, all those pages to fill with print, and there was nobody to write them. There was nobody. Oh yes, once in a big while a Ray Cummings would be there, and would have to be rewritten, by the way, and once in a while, Charles Willard Diffin would be there, who would have to be rewritten, and there were smaller items which also had to be rewritten, except one or two. I don't think S. P. Meek had to be

rewritten. I know that Sewell Peaslee Wright did not have to be rewritten. And there were others who did not have to be rewritten, whose names I have unfortunately forgotten.

Hugh B. Cave: Harry Bates was brisk, very competent, very dapper. He talked to me, as I remember, for a couple of hours. And he talked about — not about my work, which was strange — but about the work of other writers who were being published at that time in *Strange Tales*. Now August Derleth was appearing, at that time, in *Strange Tales*, and the name came up somehow, and Bates, for some reason or another, went on with it. Because I didn't know August Derleth. I never met him. I knew who he was because Carl Jacobi knew him well and Carl was a friend of his, and I knew what he was writing. He had written for *Weird Tales* and so on. But Bates said, "You know, you know, he sent me a story, I think, nine times. And I didn't tell him to revise it but every time I'd return it, he would rewrite the story and send it back with a little note saying 'You are the teacher and I am the pupil. Tell me what I am doing wrong.'" And Bates said, "We finally bought the story out of pity for the poor guy."

Well, I wasn't sure about Bates because I don't think, I hate to say this, but I'm not sure Bates was running *Strange Tales*. I think Dr. Douglas Dold was running *Strange Tales* and Bates was something of a figurehead. But I never met him except that once. We did not, I might say, hit it off to the point where we ended up calling each other for a weekend together in the country. I was a writer, he was an editor, we talked. He talked and I listened. And that was it.

Raymond Z. Gallun: I never met Harry Bates. When I first had contact with him, he was still with *Astounding Stories*, I think it was called *Astounding Stories of Super-Science* to begin with. I sent a couple of stories to Harry Bates and he wrote some letters to me. He had very interesting handwriting, particularly his signature. It was not by any means chicken scratch, and wasn't that flourishing type that you would — some people are very flamboyant in their gestures — but it was sort of an austere sort of writing, and I think in one letter I wrote to him I mentioned that he had a very interesting signature. So not too long later, when he was again a private citizen, he wrote me a letter completely in longhand. Now I wish I had this letter. It would be a real collector's item because it's been lost out in Beaver Dam, Wisconsin many years ago, but Harry Bates seemed to have a completely different symbol for every letter of the alphabet. In other words, it was a true cryptic handwriting. I had a very great deal of difficulty translating the letter, reading the letter on account of his strange and rather charming handwriting.

W. Ryerson Johnson: I wrote modern police stories for Clayton. Harry Bates was my editor. Everybody liked him. I didn't know him very well, but I'd see him in the office now and then. The Clayton chain was the only one

that I knew that paid you a tenth of a cent a word more for each story you sold. It started at two cents. You sold them ten stories, you're making three cents, which is big money for the pulps in that day. They bought largely my modern police stories and then some westerns. Then, I don't know why, all of a sudden they failed and stopped publishing.

Richard Wolinsky: In March 1933, Clayton Magazines went belly-up, the magazine folded, and Harry Bates was out of a job. *Astounding* was resurrected the following October under the aegis of Street & Smith Publications.

Frank M. Robinson: Clayton, for one reason or other, got into financial trouble during the early days of the Depression, about 1933. He had asked for more time from one of his creditors. I think the others would have given it to him, but one of them was adamant. So the Clayton titles went up for auction. *Ranch Romances*, which I think was a biweekly at the time, was selling very well, probably in excess of a hundred thousand an issue. That was sold for ten thousand bucks, a lot of money back then. *Astounding* sold for a hundred bucks. That was it. It was knocked down to a hundred bucks through some kind of intermediary, someone nobody ever heard of, who apparently later on resold it to Street & Smith, along with *Clues Detective*. As far as I know, those were the only two titles that Street & Smith picked up.

Raymond Z. Gallun: Bates had two of my stories on hold at *Astounding* at the time. I don't know whether he signaled any signs that *Astounding* might be folding, but finally I wrote a little short story, about 3,500 words, called "The Flight of the RX-1," a moon rocket story and just a very brief one. I was working in a shoe factory at the time and that was one story which I didn't write down. While I was working at cutting out shoes, I memorized this story and then wrote it down later — then all of a sudden he sends all of my three stories back and he says, "I'm sorry that I have to turn this back, and 'The Flight of the RX-1' is a story I really like. Now I have to send it back to you because the magazine is folding." Well, that's one of the blows for a young writer, you know, that hurts a little bit.

Harry Bates: At the end, we were switching around, trying to change our formula a little bit. Not too much, so that we could accommodate some of the big names in the field, I think Doc Smith being one, and maybe I bought one of his. We always bought and paid for on acceptance, but in the last couple of months there, things were so upset that I said I would buy something, and actually did not pay out money for it, as I recall. Now that was true of a story by that weird genius, Lovecraft. I even got my publisher to buy a short story of Lovecraft's. We didn't pay for it. We accepted it, and would have paid for it normally but it was at the end there. Things were mixed up. And he didn't get paid, and I had to send it back to him. What a pity. Well, it's not that he was the only good author but things did get a bit mixed up there at the end.

In fact, I got fired — well, that's a hard word. The magazine was discontinued. But there was enough material left for another issue, so after a month or so, I was called back to use up that material. That's how close the line was between profit and loss. Most or all the stories got used up in that way.

Richard A. Lupoff: When *Astounding* came back to life, Bates may have been gone, but his assistant, Desmond Hall, remained with the magazine.

Harry Bates: Desmond Hall was, in a small way, a genius in that, at the age of about twenty-one, he met this commander of a submarine in the First World War, and sold to me perhaps a dozen installments of adventures of that submarine. He was an expert typist and his English was good and he could do it. He did do it, at the age of twenty-one, which is fairly remarkable. However, at that point, his remarkability ends. He knew not a word of science, not a word, and when I came to have to have some assistants because I was carrying the load of several magazines all at once, and in addition that new kind of thing for which there were no authors — there were no authors for science fiction, except those terrible amateurs that were publishing in Gernsback's *Amazing* — so I had to have help, and he was a nice guy. I called him in and sat him in a chair and he became a copy editor. That is the exact word for what he was. I'd stick a manuscript at him and he would make it literate where necessary, and he also read some of the stuff that came in and I don't believe he ever was successful in putting over a point of view or selling me something that I didn't want. But he was useful. He would get rid of what is commonly, and most unfairly, called the "slush pile" in those offices. Now, it's not slush. These poor guys, they write, they do their best. They may not be good, but from the editor's point of view it may be slush, but that's not a nice name. I never used it. It was that kind of pile of stuff that he would be of some use around. And that would be it. That was all. Because the writers seemed to think that it was going around, the impression that Hall was a dominant figure in the magazine under me. He was nothing but a kind of a well, a secretary. No, not that. He edited stuff I stuck at him, that's all.

Frank K. Kelly: When I wrote for Street & Smith's *Astounding Stories*, I got a letter with a check accepting a story. It was from Desmond Hall. I was very thrilled. I wrote a 20,000-word story, got a check for $200. One cent a word. You know, in 1933, that was a lot of money. Two hundred dollars then was probably equivalent to two thousand now, don't you think?

Horace L. Gold: I first sold a story to *Astounding* in 1934. Desmond Hall was the editor, and it was Desmond Hall who wrote the letter of acceptance and I went to see him. At that time, F. Orlin Tremaine was in charge of a group of Street & Smith magazines, of which *Astounding* was one. Street & Smith was a pulp house, the biggest. They had *The Shadow* and *Doc Savage* and *Wild West Weekly* and *Love Story Magazine*, a whole slew of magazines.

Then they started *Mademoiselle*, which was in a completely different location, it was uptown — as a matter of fact it was in Rockefeller Center, which was about three-fourths unoccupied at the time. Rockefeller Center was known as Rockefeller's Folly because they couldn't find tenants. It changed after the war. But *Mademoiselle* had a suite of offices and a terrace, a big terrace. I think they paid $85 a month for it and Rockefeller Center was very glad to have them as tenants because they had so few. Tremaine put out Volume I, Number 1 of *Mademoiselle*, including the talents of such writers as Wallace West, and it was such a dud that he was called back to Street & Smith, and Desmond Hall was made editor of *Mademoiselle*.

The very first week that Tremaine was back, that weekend he had three million words to read because he had a deadline, a bunch of deadlines, but he especially had a deadline for *Astounding*. Instead of reading the three million words, he went to the Tombs where the fortune teller of the day, an Evangeline Adams, was in jail. She was an astrologer and fortune teller and, for all I know a phrenologist too, and was arrested when fortune telling was made illegal in New York City. She was serving time in the Tombs, and outside her jail cell, the corridor was mobbed with stockbrokers, bankers, and so forth. And among them was F. Orlin Tremaine. The story was that there was going to be a big shake-up at Street & Smith and he wanted to know where he stood. As it turned out, it was true, there was a big shake-up and Tremaine was right to be worried about his job. Then he went home and read the three million words.

Richard A. Lupoff: Horace Gold tells a slightly different story than the one offered in *The Fiction Factory*, Quentin Reynolds's 1955 history of Street & Smith. According to Reynolds, the company was so unsure about *Mademoiselle*, this new magazine aimed at young women of limited means, that they were afraid to give it the Street & Smith imprint. They also, for the same reason, decided to set up shop for *Mademoiselle* at the Columbia Office Building on 52nd Street and Madison, rather than in the Street & Smith offices, or as Gold says, Rockefeller Center. Reynolds states that both Hall and Tremaine were the first editors. He agrees with Gold that the first issue, dated February 1935, was a complete disaster. Afterward, as Gold also says, Tremaine was moved back to the pulps. Hall was then assisted by Betsy Blackwell, an editor brought over from another company.

Horace L. Gold: When he left for *Mademoiselle*, Desmond Hall recommended me to Street & Smith to take his place. I was then twenty-one and he was then twenty-three. I didn't get the job. Hall called me in a fury and said the only reason I wasn't hired was on the basis of anti-Semitism, and he was raging. It's just as well because I really wasn't ready for the job. My life would have been entirely different all through the Depression, when I had a hell of a job trying to find a job. I didn't find one until I was twenty-five. I sold

shoes. I was an extra and couldn't find a steady job selling shoes, and I really wanted to. I was a wonderful shoe salesman.

Jack Williamson: I never actually met Desmond Hall. My first contact with a Street & Smith magazine was a handwritten note from Hall in response to which I started writing new stories and sent him the *Legion of Space* manuscript. I think I sent him the *Legion* manuscript pretty early, but they didn't publish it or buy it until they changed their policy and decided to run serials. That was the first serial. They did publish two or three of my short stories. I was in New York once and did meet F. Orlin Tremaine, and he took me to lunch and he was very gracious.

Raymond Z. Gallun: Tremaine never said a story was anything but good. I mean, he wouldn't go beyond that. He'd say it was bad, but he'd never say it was anything better than good. In the beginning, I was in Beaver Dam, Wisconsin and I'd never met the man. In fact, I'd never met anyone who was interested in science fiction other than myself. His letters were usually very terse. There was a little gray Street & Smith letter paper that he used, and very terse, just a few lines. If he bought a story, you never got a letter of acceptance. It was always just a check on Monday morning, which was mailed out promptly on Friday. He would tell you this story is not quite believable, or some such thing of that sort.

I remember one story, though, a story that I rather liked, in which the hero beat up the heroine. He rejected that story just like that. I wrote to him a little note about that and complained. He said, "By now you should be professional enough so that a rejection does not disturb your temperament." He got a little sharp with me about that one. But other than that, there was no conflict at all. He bought most of the things that I wrote.

Jack Williamson: I think F. Orlin Tremaine was trying hard but he didn't have, let's say, the scientific background in the sense of the future and enthusiasm for it that John W. Campbell later did. He was a good editor in the sense that he understood story values and reader appeal, but he wasn't specifically oriented toward science fiction. He was as enthusiastic about Charles Fort, for example, as he was about solid scientific approaches.

Horace L. Gold: I didn't sell anything at all to F. Orlin Tremaine after he became editor of *Astounding*. I couldn't work with him. It was impossible for him to work with me, or for me to work with him. He didn't try, and I wasn't pushy enough to force him. With Desmond Hall, it was a cinch. I'd really run out of cosmic ideas, and I tried to get on the Writers' Project[24] of the WPA and I just couldn't get on. So I just stopped writing for three years. At that time I was living in Far Rockaway, a seaside resort on Long Island, and it was mobbed in the summer and deserted in the winter. I didn't know

24 The Federal Writers' Project was a New Deal program that employed writers and other professionals to create a history of the United States and provide jobs during the Great Depression.

anything about fandom. If I had, my life would have been different. From 1935 until 1938, I was a floor scraper. I made window shades. I did everything possible to try to make a living. Then I met a girl who became my first wife, and she forced me, she made me go back to writing. I didn't want to. I wanted to sell shoes. I loved selling shoes, and I hated writing. It was the loneliest and most miserable job in the world.

Richard A. Lupoff: According to Horace Gold, when Tremaine was about to step out as editor of *Astounding*, which was in late 1937, Gold was possibly up for the job, and Gold maintains that Street & Smith being an old-line WASP firm, they didn't mind buying his stories, but they didn't want to hire him because he was Jewish. And I don't know of any documentation to support this, but Horace Gold suggested this may have been the reason that he was passed over and John W. Campbell was hired instead.

Richard Wolinsky: Tremaine stayed on at Street & Smith as editorial director for several magazines, but left in 1939 to found his own publishing house, Orlin Tremaine Co., and his own magazine, *Comet*.

Richard A. Lupoff: *Comet* is another one of the magazines that has kind of been lost in history because it existed only for five issues in 1940 and 1941.

Jack Williamson: I wrote one story for *Comet*. When Tremaine was doing *Comet*, I had some correspondence with him and wrote him one story. He wanted a *Legion of Space* sequel at the time and wrote suggestions that were really pretty good. But somehow I never got started on the *Legion* thing for him.

Raymond Z. Gallun: I went out to Hawaii during the war and I worked with the Corps of Engineers and then I transferred to Pearl Harbor out there. I'd picked up a magazine and found Tremaine's name as an author in it. I noticed that the name of the character — he had a character in there called E. Z. Bart — and I mentioned having read that, and he said that name had derived from my name because I had a Z in the middle of my name, and he couldn't imagine what it was. I never met the man until after he had left Street & Smith, and at that time, he was working for Macfadden, and I used to have lunch with him occasionally. He'd take me out to lunch and we'd talk about things, talk about his father, who seems to have been a minister, and he was still quite religious. I remember making some remark to the effect that, "Well, we have only one life to live," and he said, "I'm not quite sure of that." He still was quite believing in that respect. He was a very warm, quiet sort of person. And well, then we sort of separated. I lost contact and found out he had died in a hospital of some kind of lung illness.

Amazing Stories: Santa Claus Sloane & the Astonishing Ray Palmer

Richard A. Lupoff: By 1930 the face of science fiction had changed dramatically. Hugo Gernsback had lost control of the Experimenter Publishing Company — and thus of *Amazing Stories* — in 1929. Undaunted, he simply created a new corporation and launched a new family of science fiction magazines. The monthly *Science Wonder Stories* was the bellwether of the group. There was a *Science Wonder Quarterly*. And there were two odd hybrid magazines — *Air Wonder Stories*, a combination of aviation adventure and science fiction, and *Scientific Detective Monthly*, which combined aspects of science fiction with the murder mystery. The first editor of the *Wonder* magazines was David Lasser, who was later replaced by the seventeen-year-old Charles Hornig.

Amazing Stories, now under control of the Teck Publishing Corporation, went its own, Gernsback-less, way.

Charles D. Hornig: When Teck Publications took over *Amazing Stories*, it got the editor, T. O'Conor Sloane, who at that time was about seventy-three years old, and they made quite a point about it, that the oldest editor was seventy-three, and the youngest was seventeen, and we were competitors.

A. E. van Vogt: *Amazing* became a very poor magazine, however, because it was taken over by that very stuffy editor, T. O'Conor Sloane. Hugo Gernsback had lost control of it, and the second editor had no awareness of what science fiction was. What he was doing editing a science fiction magazine was beyond me. He bought stories that were worthless, seemed like to me.

Charles D. Hornig: Sloane was old enough to be my great-grandfather. He was a very inconspicuous editor. I mean, you never saw him or heard from him in any way. He just did his job, and I don't think he was particularly interested in science fiction.

Raymond Z. Gallun: The story which became my most-loved or -remembered story, "Old Faithful," was originally sent to T. O'Conor Sloane, and I think he kept it for over a year, and then sent it back with a rejection slip. I thought, Gee, well, that's a dead story. They don't even write a letter. It can't be any good. I had already sold several stories to Tremaine at *Astounding* and I thought, Well, I'll take a chance. I mean, it was a story which I wrote mostly for myself anyway. And sure enough, it was bought and at that time it became quite a hit.

Frank K. Kelly: Yes, I dealt with T. O'Conor Sloane at *Amazing Stories*. Had a couple of stories there. Sloane had a beard, didn't he? He looked like Santa Claus.

Stanton A. Coblentz: Sloane was a very remarkable man. He accepted more of my work than any of the other editors. He was, I should say, about

eighty-five or -six. He had a long patriarchal white beard and he had a very good sense of humor because he would say, "You know, I think it's the funniest joke it can be. Here all my contemporaries are gone and here I am straining my eyes over manuscripts and picking manuscripts for a magazine quite out of the field," for which he was originally trained, because he was a scientist. 'Course, to an extent he was trained for it but he wasn't trained for the editorial part. But he was one of the most memorable editors I ever met.

He was a very human man. He would laugh over the stories, quite regardless of whether or not they contained scientific plausibility. He would talk with the authors that came in on subjects away from the themes that he was discussing for publication. He never looked to me like an editor at all. He looked like a typical old-style scientist of the nineteenth century. He was the man I liked better than any other editor I ever had.

Raymond Z. Gallun: I guess T. O'Conor Sloane was a very old man at the time when he was editor. He was upwards of eighty or something at the time, and perhaps he was a little bit tied to the past and wasn't quite flexible enough to be a really good editor of a science fiction magazine. He had very little to say. There were a couple of notes, very brief, he had accepted so on and so on. That's about it as I remember.

Jack Williamson: Once I saw T. O'Conor Sloane through his office door, a venerable gentleman who didn't invite me in or come out to meet me. I can't remember the names of the underlings who did the actual editorial work but as far as I was concerned, he was a figurehead. He was distinguished because he was Edison's son-in-law [Actually, Sloane's son was married to Thomas Edison's daughter. – Ed.] and because he didn't believe that space flight would ever be possible and so on and so forth. I don't think he was very active in the editorship of the magazine.

He didn't give me any feedback. In fact, nobody at *Amazing* ever did. If you sent them a story, why, they would keep it and eventually accept it and eventually publish it and eventually pay for it. But it was a process that often ranged over several years. They never made any editorial suggestions or requests for revision or whatever.

Richard A. Lupoff: Sloane had a rather pedagogical attitude, the old Gernsback idea that science fiction was there to instruct. In 1938, when this little Teck company sold *Amazing Stories* to Ziff-Davis and Sloane finally retired at the age of eighty-seven, Ray Palmer became editor and came in with the notion that it should be a lot of brightly colored, vivid, exciting adventure stories, with no particular attempt to perform any educational function.

Frank M. Robinson: The reason why Ziff-Davis got hold of *Amazing Stories* was because it came in the package with *Radio News*, which is the one

they wanted. *Radio News* was a Gernsback book[25] way back when and had been bought by Teck Publications, which had also bought *Amazing* in 1929. Ziff-Davis didn't care about *Amazing Stories*. I mean, that was ridiculous. But now that they had it, why not do something with it? Bernie Davis[26] had been a student in college when he teamed up with William B. Ziff. Now William B. Ziff goes back a ways. Ziff was an advertising rep in Chicago during the late 1920s. One of the magazines he represented was *Weird Tales*, along with a lot of other stuff. So they approached Ralph Milne Farley to be the editor, but this was much too small potatoes for Farley, who was a rather wealthy man, and it was Farley who recommended Ray Palmer.

Robert Bloch: In their sublime ignorance, Ziff-Davis asked Ralph Milne Farley if he'd like to be the editor of *Amazing*. And Farley, who was a corporation attorney living a very princely existence — he had his own stable of horses, he went all over the world reclaiming tractors and steam shovels and cranes from delinquent customers, and he wrote in a private car, in a compartment on trains, dictating to his secretary. That's how he wrote his stories. So he wasn't exactly turned on by the notion of going into Chicago and making sixty or seventy-five dollars a week as an editor of two magazines. But he suggested Ray Palmer, and Ray jumped at the chance, because that was big money for him.

Forrest J. Ackerman: Ray had contributed to the original fan magazines, both known as *Science Fiction Digest* and later on *Fantasy Magazine*. He had some fascinating articles in those. These were amateur-published magazines in which Julius Schwartz, Mort Weisinger, Ray Palmer, and myself were all involved.

Frank M. Robinson: Palmer had been making a little money writing a little bit of science fiction. He actually had a story out in the Campbell *Astounding*. He used to write confessions, and in-between his writing, he was also a roofer, a sheet-metal roofer. When I first met Ray, I was astonished that he was this little guy, badly hunchbacked. So now, here is this really badly crippled little man, working as a roofer.

Forrest J. Ackerman: Ray Palmer had wrestled with a truck or something when he was a young man, which left him half sized and crippled.

Stuart J. Byrne: Palmer was so small he had to build an extension of the clutch in order to drive a car. But this little fellow — he had a beautiful wife incidentally — up in Wisconsin, he dammed up a creek and he made a lake behind it that served for water power, which drove a lumber mill. And he did bartering with the farmers by letting them use the mill in exchange for eggs and bacon. He was very enterprising. He was almost a saint to me.

25 "Book" refers to a magazine.
26 Bernard G. Davis (1906–1972) was co-founder of Ziff-Davis.in 1927. He sold his share in 1957.

Robert Bloch: So Ray went down there and looked over the backlog. Nothing he could use. So he turned to the Milwaukee Fictioneers for help. Stan Weinbaum, bless him, was long gone, but Ray asked a number of us to write.

Frank M. Robinson: Palmer had carte blanche. He was hired originally on a piecework basis. They would pay him money according to how many copies of *Amazing Stories* actually sold. In other words, he was on a commission basis. As he liked to tell it, and there was probably more truth than not in this, when he started to make as much money as Bernie Davis, they put him on straight salary. At the time Ziff-Davis took over *Amazing*, it was selling 18,000 copies. Ray doubled the circulation with the first issue, and it went up in 5,000-copy leaps after that. I think his first issue would have been June '38, then August '38. Then by either September or November, the magazine was monthly.

Why did circulation go up? First, the magazine improved tremendously in appearance. Ziff-Davis had a terrific art department and because they were putting out all these technical magazines, they had all of these guys who were familiar with machinery. When these guys sat down and doodled out a robot cover or a space ship cover, you can believe it. It was like nothing anybody saw before. It was Rube Goldberg brought down to earth. The price of the magazine was also reduced from a quarter to twenty cents. And finally, Palmer deliberately lowered the audience level for the magazine. If the magazine had been selling to late teenagers and early twenties before, Palmer made sure he was putting out a magazine that appealed to the twelve- and fourteen-year-olds.

Richard A. Lupoff: Palmer's approach to *Amazing Stories* — colorful, exciting adventure stories in a colorful, exciting package — was so successful that Ziff-Davis encouraged him to start a companion magazine, *Fantastic Adventures*, in 1939.

Frank M. Robinson: Palmer was doing great with *Amazing Stories*, and he remembered the great big flat-sized magazines that used to come out from Hugo Gernsback. So he got permission to put out a companion magazine to *Amazing* called *Fantastic Adventures*, which would be that large size. The first issue of that was May 1939. It started as a monthly, ninety-six pages, pulp paper, large size, the usual mix of fantasy and science fiction.

Robert Bloch: He sent me a cover, said, "I want you to do the story for this thing, for the new magazine *Fantastic Adventures*." I did something, a title which I've mercifully forgotten, and it was dreadful, and he bought it, then he bought another one, and then he bought another one. Before I knew it, I was doing science fiction as well as fantasy.

Frank M. Robinson: There is a misapprehension that Palmer did not know what good stories and good writing was. That's simply not so. He certainly did, and later on, he published "Dear Devil" by Eric Frank Russell. He

published Ray Bradbury, he published the first homoerotic story ever written in science fiction by Ted Sturgeon, "The World Well Lost."

Doc Savage: More Like a Comic Book

Richard Wolinsky: Along with the science fiction pulps came the hero pulps, precursors to the superhero comic books of later eras, with such titles as *The Shadow, The Spider, The Phantom Detective, The Avenger*. Among the science fiction-oriented heroes were Captain Future and Doc Savage, the latter usually written by Lester Dent under the pseudonym Kenneth Robeson, although other authors filled in from time to time — Dent was a classic pulp writer, speedy, prolific, and reliable, but even he needed an occasional break.

W. Ryerson Johnson: I ghosted three of the *Doc Savage* stories. Lester Dent began to get tired of writing them, and he was moving into slick paper writing, so he ghosted out quite a few. Some people did ten, twenty. There was an organization for pulp writers in New York and we met every week for lunch, and Lester Dent and a lot of other people were there at the time. I got acquainted with Lester then. He said, "Would you like to ghost a Doc for me?" We talked enough so he knew we had the same pattern of writing as he did. So I did the first Doc, *Land of Always-Night*, about a race of mysterious people living under the North Pole. There's such an anonymity about ghostwriting, I wanted to establish myself somehow there. And they had a governmental organization, I named it the Nonrevid. That's my hometown spelled backward, Divernon.

Julie Schwartz: *Doc Savage* came out in about 1933, and Doc had three or four assistants who worked together as a team. That may have inspired the team ups we later had in the comics in the Justice League. Strangely enough, I never heard Jerry Siegel explain this: Doc Savage had a place called the Fortress of Solitude. Did Jerry accidentally or coincidentally invent the Fortress of Solitude on his own for Superman, or was he inspired? Many people say that the concept of Superman himself was taken from a story by Philip Wylie called *The Gladiator*. But I don't think that's anything unusual. I'm sure that every creator, every writer is inspired by others. I know a few mystery writers who would not read the work of other mystery writers because if they read it and there was a good gimmick in it, ten years later they may subconsciously come up with the same thing, completely having forgotten what it was.

W. Ryerson Johnson: The pulp readers, we figured, were blue-collar workers, taxi drivers. Once I was with Lester in a subway, and there was a little pimple-faced kid across the way. "Look," he says, "You're writing too high, Johnson. Write for him." He exaggerated a bit but that's what he said.

Meanwhile, Back at the Ranch . . .
the Authors of the Thirties

Richard Wolinsky: An earthquake hit science fiction in 1937. John W. Campbell, Jr., became editor of *Astounding*, and the world changed. Campbell's arrival as editor was akin to the transition between silence and sound in the movies ten years earlier. A few stars survived, but a lot more vanished.

Isaac Asimov: You know, there's a tendency to exist in generations. In the 1930s, before Campbell, there's a whole group of authors who were highly regarded in their time, certainly by me. And after Campbell came in, they all vanished. I mean, they didn't die. They just vanished. And a whole new group came in. The same thing happened in 1960, when another whole new group came in. A lot of the old people vanished. Then again, I think that somewhere in the seventies a whole new group came in again. You expect that. There's always some people who remain.

The most remarkable, in my opinion, are Jack Williamson and Clifford Simak, who started in the late twenties and early thirties and who managed to stay on all through the shake-ups. But since I was a teenager, I had greatly admired these writers from the twenties and thirties, and I was aware that they disappeared when writers like myself would come in. I feared that in the next great changeover of eras, that I would disappear. And I used to say to myself, "Will I be the Ed Earl Repp of 19XX?" Why Ed Earl Repp? Not that he was worse than the others, or disappeared more completely, but his name was odd, so that you remembered him more clearly. And my name is odd and I thought that my name would be remembered more clearly and people would say, "Whatever happened to writers like Isaac Asimov?" But I figure by now, here it is 1983 and I'm still around. In fact, on October 21st, I celebrate the forty-fifth anniversary of my first sale. So I figure, with this staying power, even after I pass on to the great science fiction convention in the sky, I'll still be remembered for a while.

ED EARL REPP

Ed Earl Repp: I started when I was eighteen years old in Philadelphia. I did about three hundred of these science fictions and then went into westerns. As a matter of fact, I don't remember any of 'em. I never thought anybody ever read that stuff. It was just a business with me. It should be just a business.

I had a nervous breakdown writing in 1937. The first story I wrote, Gernsback took it and gave me a contract for twenty-four stories a year, right off the bat. I did 'em all, too. Zane Grey was the guy who gave me a lot of pointers, and the guy that wrote *Tarzan*, Burroughs, we lived right close to him down in Tarzana.

I met him through a friend of mine. Went down to his house in Tarzana, lived in a big white frame house out there, if I remember right. And he was a pretty nice fellow. I never got too friendly with him. I figured all those fellows were earning a living at a typewriter, why should I take up their time? And I didn't like people butting up on my time either because it would take me twenty-four hours to get my brains working again, after I was interfered with. You know what I mean.

Burroughs told me, he said, "Look, the biggest thing on the market right now is science fiction," and that's when I hit it, right there. 1929 put me out of the advertising business, that was the Depression. I was doing real good, and overnight we lost everything. Margaret was working and I started to write, wrote in the bedroom. I'm still doing it. But now I have to go easy.

RAY CUMMINGS

Harry Bates: Ray Cummings had written a story called "The Girl in the Golden Atom," published in *Argosy*.[27] Kind of a small miracle, but there it was. And when we came looking for authors — and that was our intense hunt to find somebody who could put words in, to fill the pages that we had in *Astounding* — he was thought of at once, given extra money, and set to doing not a duplication of it, but something in general resembling the other successful story, as I recall. I can be a little off on some of these things, but probably not too much. So, I contacted him. He was a lousy writer. I had to rewrite everything he wrote. And that goes for other names which might be called "big names" for those early days. I had to do the rewriting for lousy writers.

OTTO BINDER

Julie Schwartz: Otto Binder was a science fiction writer who lived in Chicago, interestingly, on North Luna Avenue. He wrote science fiction with his brother, Earl, and it became awkward to say "By Earl and Otto Binder," so instead they took the *E* from Earl and the *O* from Otto and became Eando Binder.

Charles D. Hornig: Otto Binder was a pretty close friend. I knew him as a young man. Really nice guy, really nice guy. He gave me the first glass of beer that I ever really enjoyed. I was starving. I went to Chicago once with Mort Weisinger in 1934. We had to pay a lot more for our train tickets than we expected so we had no money for food, and it was Weisinger's job — because I had already loaned him my extra money — his job to get some

27 *Argosy*'s official title was *The Argosy*. "The Girl in the Golden Atom" was originally published in 1919 in *All-Story Magazine*, which was later absorbed by *Argosy*. It later became one story in the "Matter" section of a trilogy titled "Matter, Space and Time", the latter two entries being published by *Argosy*).

extra money out of people. So he had to ask people like Jack Darrow and fans if they could lend him five dollars. And nobody could, and then we visited Paul Ernst, who was a popular writer of the day, and he was much too formal to ask him for money. Then we visited the Binders, they were real nice people and the first thing Otto did was take us down to his basement, where they had beer in kegs — they were real German people[28] — and so they gave us real German beer right out of the keg. Before that, I couldn't stand the sight of beer but not having eaten for a day or so, why, the beer tasted wonderful. Of course, it went right to my head. And then Mort got the five dollars he needed from Otto Binder.

Otto was living with his parents. He was there, and Jack Binder, the artist, and all over his parents' house there were pictures of them wearing Nazi symbols. At that time, well, Hitler was not in good repute anyway, but he hadn't started his worst yet. But we were a little bit surprised to see all these Hitler things around his house. It wasn't Otto's fault, it was his parents.

CHARLES WILLARD DIFFIN

Harry Bates: Charles Willard Diffin dictated stories himself, he didn't just write them. And he sold them too. Unless you're a genius or a great expert, you can't dictate good narrative stories. Anyhow, it's very amusing. I have kind of wanted this to be known. One of the last things I bought from him was a serial and I had to rewrite it word-for-word all the way through, I had to rewrite that thing. And especially the beginning, the first chapter. That means the sentences had to be connected up, you know, and it had to, on the whole, make sense. There should be some paragraphs in it. Not the kind of wild stuff that he dictated. I learned, to my amusement, many years later that the first chapter, which was hardly his, but mine by the time I got through with it, had been put in an anthology. That's fun. One of the little funny things that happens to make the life of an editor, or anybody, cheerful. I think that was the last thing I bought of his. I think he died not long after.

LAURENCE MANNING

Charles D. Hornig: Laurence Manning was around quite a bit. He lived in New York, or near New York, and came in the office frequently. He was a friend of Gernsback's. We saw him quite a bit. It was his coworker, Fletcher Pratt, who translated these big heavy German novels that Gernsback used to buy and print in the quarterlies. Manning and Pratt wrote together, "The City of the Living Dead." That was before us. That was about 1932. I remember that story to this day, and I can't remember 99% of what I read. That was a very unusual story, it makes us today think of cryonics, that sort of thing, the theory that every nerve in the human body could be connected to

28 Specifically, his family were German Lutherans from Austria-Hungary.

an electrical outlet and fed into tapes. Tapes, this was 1932, tapes of a whole living story. Everything you've experienced comes to your nerve ends, and all you have to do is stimulate the nerve ends and you're living something because you put it on tape. The only thing is, there's no way back. They can't disconnect these wires and bring you back to normal life. So you have to sign yourself away to live forever. They could keep you going for centuries, just feeding you one tape after another. You decide what kind of a life you want to live, soldier of fortune, scientist, adventurer, whatever, and you'd go on forever, reliving these things. That was unique.

C.L. MOORE

Forrest J. Ackerman: I was corresponding with C.L. Moore, Catherine Moore. I was in San Francisco and she was in Minneapolis or some place [Indianapolis]. We corresponded and I was so impressed with her Northwest Smith stories that I dreamed up a plot for one and sent it to her, and we wrote back and forth on it. And finally it was published in 1935 in *Fantasy Magazine*, and it was called the third-best science fiction story of the year in Australia.

MURRAY LEINSTER

Harry Bates: Murray Leinster, he was my favorite. He had at that time wrote and sold stories to *The Saturday Evening Post*, which was then the top, as regards author recognition and high payment and general circulation. That was something, to write for them, but he also — that wasn't enough money for him — he also wrote occasionally for other magazines, but especially when I got one from him, every word was right. Every word was right. I was so used to rewriting nearly everything that came across my desk. Rewrite, rewrite, rewrite. Fast. I remember I even allowed one deliberate science-stupid thing to go into a story. Somebody could see the far side of the moon, I think it was, which is ridiculous.

FLETCHER PRATT

L. Sprague de Camp: Before the war in 1940, or 1939, I guess, John Clark introduced me to Fletcher Pratt because Clark was a naval buff and Pratt was running a naval war game in his apartment, using little model war ships, in which a battleship was about so long, and a destroyer about so long, and so forth. He made these models out of balsa wood, pins, and wires, and everybody was crawling around on the floor, pushing his little model, estimating the range to his target and writing it down. The referees would come out and chase everybody ashore and measure and tell you that you

made two hits with your six-inch gun, and that knocks eleven hundred points off the other ship, and so on.

I became a member of Pratt's war-game group. He suggested that he and I collaborate on the Harold Shea stories. He had this idea of putting his hero into successive mythological worlds, and it worked out quite well. We fleshed out the plot together, and then I'd take a bunch of notes, take them home, write up a synopsis, get his approval on that, write a rough draft, and then he'd do a final draft. When we reversed the procedure, it didn't work so well. We find that it's better to have the younger writer do the rough draft, and the older one the final, because the younger writer is apt to be more facile, words come easier to him. But the older one is more critical, and he can catch errors and inconsistencies that would get by the younger. Pratt was the older one, by quite a few years. *The Carnelian Cube* was written before the war, it was intended for *Unknown*, but then *Unknown* folded because of the paper shortage, and the abnormally high percentage of returns, and it wasn't sold or printed until after.

CARL JACOBI

Hugh B. Cave: Carl Jacobi and I began corresponding back in the thirties. He saw some story of mine in *Short Stories*, I think it was, and he wrote and told me how much he liked it and of course I answered the letter. He was two years older than I, but I had been writing longer, so I was more of a pro than he was. Well, we swapped letters and we still to this day swap letters and we're talking now a fifty-year friendship, almost. Well, we are, aren't we? From 1930? The first letter that he wrote me was dated 1930 and here we are '89. Fifty-nine years! My God! And we criticized each other's stories. We helped each other with ideas. We write very much alike, anyway, at least I've been told we do. And I owe him a lot, I owe Carl a lot. Now, I've never met him. I have never met this man! He lived out in Minneapolis. He wanted to come to visit me in my coffee plantation in Jamaica and almost made it but fell through at the last minute when he got ill. But I've never met him. He doesn't go to conventions anymore because he's now in a nursing home.

STANLEY G. WEINBAUM

Charles D. Hornig: Gernsback never paid very much, so I very seldom got stories from a good author the first time. The famous accident was Stanley G. Weinbaum, of course. Weinbaum died very shortly afterward. He was only about thirty-five and he'd only written a few stories. Well, Weinbaum evidently just decided to write his story and send it to a magazine. It happened to be *Wonder Stories* and it was "A Martian Odyssey."

I just received it in the mail along with everything else. I'd never heard his name before. Neither had anybody else. But immediately when I read

it, I knew it was something very, very special. So I sent it to Gernsback and said, "You just have to read this story." Usually Gernsback would just okay them without reading them if I sent them to him. There was a cover sheet. I would have to describe the story and tell him why I think it should be used, and he would look that over. And if he was satisfied, he'd okay it, and I'd use the story. But this one, I said he's gotta read it. So he read it and he was also enthusiastic, so much that he wrote the blurb for it himself. We printed it.

I think Julie Schwartz has a different story about what happened, but he wouldn't deny it. I was always sort of on the writer's side more than the publisher's anyway, and I never cared for the way Gernsback practiced, although I worked for him and had to do things the way he wanted. Schwartz used some kind of ruse to get Weinbaum's address from me. Well, he has some friends in Milwaukee. Ralph Milne Farley would like to get in touch with him. He lives in Milwaukee, you know. So could I let him have the address, let him have Weinbaum's address. He didn't tell me exactly what he wanted it for, which was "I'm an agent, I can get you more money than *Wonder Stories* is going to pay." So I got two or three others from Weinbaum, then they went to Julie Schwartz, and got into better-paying magazines.

Julie Schwartz: I was an agent, and I went up to see F. Orlin Tremaine, who was the editor of *Astounding*. This was around 1934. And Tremaine said he just read a story, one of the stories, called "A Martian Odyssey" by Stanley G. Weinbaum: "I know he's a great writer and has a great future. If you get me a story by Weinbaum, I guarantee I'll buy it." Well, that's very well, but I didn't know who Stanley G. Weinbaum was. However, I did know who the managing editor at *Wonder Stories* was. He was my lifelong friend. His name was Charles D. Hornig. Well, Charlie's the one who picked out "A Martian Odyssey."

So I went up to Charlie, I think out of fairness, and I said, "Hey, I read that 'Martian Odyssey.' It's a great story. Who's Stanley G. Weinbaum? You don't believe that Stanley G. Weinbaum is a new writer. It obviously must be a pen name of one of our standard professional writers."

Charlie said, "No, no, no."

I said, "Why don't you look up the address and see where that story came from?"

He looks it up and says, "Hah! It came from Milwaukee, Wisconsin."

I said, "Aha, you see!" You know who lived in Milwaukee Wisconsin, don't you? Ralph Milne Farley, who'd been writing science fiction for years. I said, "That must be the pen name of Ralph Milne Farley. What address did Farley give you?"

He says (I'll make it up), "1265 Fairview Avenue."

"Oh," I said, and I remembered the address, wrote to Stanley Weinbaum and said, "If you have any stories laying around, I have a sure sale for you." And Weinbaum sent me his stories, and I sold his next eighteen, maybe.

But you know what happened, about a year and a half later, he died. He had cancer of the throat, I believe, and that was the end of him. I often predicted that if he kept on writing, he would have been one of the greats, along with H. G. Wells and Jules Verne. I really mean it.

After Stanley Weinbaum died, Ray Palmer and I said that we ought to collect his best stories and put them in a memorial volume. And as I recall, it had a black cover, almost looked like a Bible. And Ray wrote the introduction because he knew Weinbaum real well as a member of the Milwaukee Fictioneers. So Palmer wrote a beautiful eulogy, so to speak, and we let Marge Weinbaum, Stanley's widow, read it, and she said, "No, this is too intimate, it has too many intimate details about our life, things he would say to me while we're dancing. I don't think I'd like it to be in print, so I'd rather you don't use it." Conrad Rupert, who printed the magazine for us, who also printed the fan magazines I edited, sneaked in a printed version of Palmer's introduction — there must have been five or six copies and I don't think Marge Weinbaum ever knew about it.

The *Hawk Carse* Stories

Harry Bates: About my collaborations with Desmond Hall: He was an expert typist. He would sit at the typewriter, I would pace up and down. I lived in a penthouse, a modern penthouse, in the Village.[29] I would pace up and down and try out ideas on him, because he was going to make the first draft. I said, "How about a story, something about this ..." and if it wasn't a negative, I would go ahead. "Well, we can start out by having so and so, and so and so. And the point of the story being this ..." He would not object, and if he did, why of course we'd change. But it was a case of my trying out on him ideas which he, the next day, would write up in story form. He had to approve, of course, of what I was suggesting because he had to write it, and if he didn't approve, why, we'd change it around, do something else, try something else. So that's how that was done, in the evening, after work.

Lawrence Davidson: Bates and Hall wrote the *Hawk Carse* stories under the pseudonym of Anthony Gilmore. In most of the books of the era, it's a little hazy why exactly Gilmore's identity was such a mystery.

Harry Bates: Oh, that was a lot of fun, and it was good publicity. We had a lot of fun about that. That was one of the good things, and by the way, they were all hitched to the *Hawk Carse* stories. Anthony was one of Hall's names. He came from Australia only a year or two before I met him and his father was an actor who sort of specialized, as I understood it, in reverend parts, ministers, pulpits. And his name was Desmond Anthony Winter Hall, various combinations of which we used in our collaboration. My name is

29 Greenwich Village, specifically the West Village. Before gentrification, the East Village was known as the Lower East Side.

Hiram, not Harry, Hiram Gilmore Bates. So the Gilmore came from there. That's where the name came from, and we had a lot of fun about that.

Now, it happened, it was my plan. I knew the kind of stuff we were printing. I was editor of other kinds of magazines, and I knew all the plots and all, and I got sick of them. I said, "Here, you guys, you got the whole world open to you. You've got more than the world. This is Superworld. You didn't even have to stick to pure modern science. Let loose. Let's have some scope, some width, something new and interesting in this magazine." And one of the first things to be thought of, of course, was character. So I felt, look here, they don't seem to be able to give me a good character. I'll give them one myself. So Desmond and I, up in my penthouse apartment, he sat at the typewriter and we started the *Hawk Carse* series, which were not only successful among the fans, just because it had a character, and I assume plots that were sufficient, but he became the authors' hero.

Clayton, he went nuts about Hawk. Also the controller. I was a little afraid at first about not telling anybody that we had written it, the first one. But it turned out fine because the controller, he came from his office at the other end all the way back to my office and said, "Gee, this is good." He wanted more. He would have liked to have seen more. He had no say. And Clayton too. They would come back, the envelopes with Clayton's big handwriting on it. I remember one in particular. In those days it was a word commonly used, not anymore. Peach! P-E-A-C-H! So, Clayton and the controller and nobody else, as far as I know, ever knew who wrote the things.

I was very modest. They were by far the most successful things in the magazines but I gave them only two cents a word, which was the minimum, except I think at the very end I raised one story, I went to three, which was still very modest compared with the four cents being given to guys who had to be heavily rewritten like those I mentioned. At any rate, he was a character. He was more than that. He was bigger than life, although small in stature. Well, there were four of the stories. They were later combined by me into a book at the request of a publisher who since has disappeared. I don't know where Greenberg Publishers went to. At any rate, the stories were deliberately made to fit end to end so that they could be made into a book, and they were.

Fu Manchu was quite a big *Saturday Evening Post* name at that time, and no one knew, others have guessed, but no one would think of our villain, Ku Fui, as a rank copy, and he wasn't a rank copy by the way. I later got into some small hassle with authors, with editors or publishers who thought I was denigrating the yellow race by making them the villains. I said, "Hey, you've got to have somebody for the villains in such stories." And what's more obvious than the contrast? It was a denigration to have all these coolies — that was the word they objected to — these coolies of Fu Manchu.

But what better word was there at the time? At any rate, there was no race prejudice there.[30] There may be somewhere else but not there.

The Gentle Satire of Stanton A. Coblentz

Richard A. Lupoff: In the pulp era, in the late twenties, thirties, and forties, most of the writers used science fiction as a vehicle for telling an adventure story, or for making some technical point. Very few of the writers were using it as Stanton A. Coblentz did, to make a sociological or philosophical statement. As he says, he had a very clear and very strong interest in philosophical and political and sociological matters.

Stanton A. Coblentz: If a story had satire, the readers seemed to like that. But if I used a story as a means of conveying a social or political or philosophical impression, that seemed to pass by most readers almost entirely. But this was chiefly why science fiction was interesting to me, not that I didn't like my mind to go exploring strange realms of the unseen, far-off worlds, and different societies, and so on. I enjoyed doing that, but that wasn't the main reason that I was interested in writing a whole series of books in science fiction, along with a lot of short stories.

Frederik Pohl: The Doc Smith stuff stays in print forever. Edgar Rice Burroughs stays in print forever. Some·of the stuff is missing and I wish it wasn't. Stanton A. Coblentz for example. He's not heard of because his books are not in print.[31] I think there will be a revival sooner or later. *Into Plutonian Depths* and all those novels will be available and maybe pick up new readers and maybe go on forever.

On the Water with Ed Hamilton

Jack Williamson: I got in touch with Edmond Hamilton through Jerry Siegel, who later was one of the coinventors of Superman. We were corresponding. I think he sent me a story to criticize, but I can't claim the invention of Superman. He gave me Hamilton's address, and we'd never met until we met in a hotel room in Minneapolis. We originally were going to buy a houseboat, but that didn't turn out to be practical and we got an outboard motor boat and camping equipment and started down the Mississippi River, and we found a friendship that endured as long as Ed lived. We got down the river as far as Vicksburg before we used up the second outboard engine. Stayed in Vicksburg a couple of weeks till we finally failed to get it repaired. It was quite an adventure at the time. Ed went on down the river on the *Ten-*

30 The baked-in unconscious racism of the era was staggering.

31 Several of his books have come back into print in the 21st Century, from smaller publishers, yet Coblentz remains very largely unknown.

nessee Belle, spent a couple of weeks in New Orleans to visit E. Hoffmann Price. An interesting summer.

A year or two later, Ed and I spent a winter in Key West. That was when a hurricane had washed out the highway. In the middle of the Depression, the tourist business was dead. The big hotels closed. We had a house that we rented for eight dollars a month on the beach 'bout a quarter of a mile from Ernest Hemingway's place. Ed got the use of a boat for putting up a mast and sail on it. We sailed and fished and we wrote science fiction, got to know some of the conches — the natives of Key West, seasoned veterans, local people distinguished from the tourists — and it was a nice winter.

There was a Captain Whitehead who was quite a character. I guess he took out fishing trips in better times, and there was an old German who later became notorious. He was a very eccentric individual who was building an airplane on the beach, and he was putting this together month by month. He had plants in it and an irrigation system for them. Clearly, it would never fly. Later, Ed sent me tear sheets from some sensational publication in which it had come out that he'd been in love with a local girl who was dead and whose body was in this airplane. He was apparently crazier than most loons. It was a wonderful place, wonderful times. Things that will never happen again. The place is overrun with tourists now, and it will never be the same.

Ed at the time wrote the first version of his later famous story, "What's It Like Out There?" The version he was doing at that time was not much like the later published version. The thing of mine I did then as a result of an argument with Ed was a story called "Born of the Sun," in which the planets are eggs, the egg hatches, and a monster comes out. When I talked about the idea, Ed laughed and said it couldn't be done, it couldn't be sold. So I thought I'd show him. I did add some unnecessary elements such as an Oriental villain, but Tremaine bought the story, and Isaac Asimov read it and later reprinted it in *Before the Golden Age*.

Ed and I attempted a collaboration once, but it seemed to bring out the worst in both of us. It seems to me the basic idea of the story was a sentient star and we had plenty of wild action and color, but no human interest or plot value. We didn't get more than a few pages of unsatisfactory material.

Theodore Sturgeon Starts to Write

Theodore Sturgeon: I was just a kid at the time. I was an ordinary seaman on a tank ship and I dreamed up a way to make a great deal of money out of an absolutely perfect crime. I researched it. It involved certain factors that no longer exist, like the baggage car of the traveling post office they used to have. Trains used to hook canvas sacks off the side of the tracks, bring the mail in, and they'd throw a sack on it for another town. There was a gimmick

involving insurance and the shipment of jewelry and so forth. I worked out the perfect crime. Once I had the pieces together, I realized I didn't have the immoral courage to pull this caper. So I wrote it as a story and I sent it off to this newspaper syndicate. They used to have daily short-short stories, every day one short story. The ship arrived in New York and there was mail waiting for me, along with a letter from the syndicate saying they had accepted my story. I was so excited about it, I quit my job to become a writer. This was paid for, by the way, on publication, not on acceptance. They would not buy anymore than two stories a week. I flooded them with stories, and I sold one and sometimes two stories for four and a half months. It paid five dollars apiece, and my room cost me seven, and anything that I saved, I could eat. That was 1938–1939. None of them were science fiction as I recall. There were romances and one or two adventure stories.

Philip Klass: I met Ted Sturgeon in '39 or '40. He was then living in a little furnished room, for which he was paying, I think, as much as three and a half dollars a week, and all the roaches he could eat. He was the first man I ever saw to play the twelve-string guitar. About a week after I met him, I met Lead Belly, Huddie Ledbetter, who played a little better than Ted on twelve-string guitar. Ted had just sold "A God in the Garden" to *Unknown*, and was writing "Ether Breather," and had written a novel called *Helix the Cat* for Campbell, which Campbell had rejected because he didn't believe in cats, so Ted was starving. Ted gave me advice on writing. By that time I saw science fiction as a purely commercial field. I had many many ideas which I told Ted about. He was fascinated by the fact that I could spray plots all around the room. I found him interesting. He was writing short-shorts for McClure Syndicate for five bucks apiece on publication. Five dollars when they published the thing. And he lived on those five dollars.

Books of the Thirties

Richard Tooker: When I came back after sixteen months from the Marines, I still wanted to write. I thought, I'm in my mid-twenties, now is the time to do it. I don't know how I became interested in prehistoric man. *The Day of the Brown Horde* was published in 1929 and republished in 1931, and I was probably as proud of that republication as I was of the first time it was published. That was an original book. It was sold in the Woolworth stores, and so forth. One of the reviewers said it was an intellectual Tarzan. That meant it wasn't Tarzan. It was entirely different. I read all the books on paleontology and I was attacked by some college professor for putting some of these saurians from the dinosaur period in with men. Everyone does it. I only had a few here and there.

The Tomb of Time, published in 1933, the idea wasn't original with me. Jules Verne wrote about the center of the Earth. But I said, why shouldn't

there be one in the United States, go down in Colorado? And it's different characters and different stories, and no one has a copyright on a plot. Anybody can write a story about going down to the center of the Earth if you're good enough. If you're Jules Verne.

Jack Williamson: I had a dim view of Shakespeare to begin with. After I had a couple of years at West Texas State Teachers College, I went out to California to enroll at Berkeley. My faculty advisor insisted that if I wanted to write, I should take Shakespeare, and I felt that Shakespeare had nothing to do with science fiction. I didn't enroll. I stayed around about three months and audited a course in astronomy and rode the old Oakland auto ferry. Had a wonderful time, but I didn't take Shakespeare. But the next year at the University of New Mexico, I had a fabulous professor who had a Great Books course, and talked about the Polish novel and Sienkiewicz, who wrote *Quo Vadis*, who used Shakespeare's Falstaff and the Three Musketeers in historical novels about Poland, and it struck me that if it would work in historical fiction, it would work in science fiction. So I went home that summer in the middle of the Great Depression with nine dollars total assets, and bought typewriter ribbons and paper, and wrote *The Legion of Space*. Eventually, it ran in *Astounding* and still gets reprinted now and then.

Richard A. Lupoff: The first contact I had with the works of Jack Williamson was the 1950 Galaxy Science Fiction Novel edition of *The Legion of Space*, and I was fifteen years old at the time, of course. Suddenly these great vistas opened before me and I was completely enchanted. I can remember the exact place and conditions in which I was reading that book. I was sitting in a hamburger joint with a pinball machine playing in the background, and I was sitting there absolutely buried in this Galaxy edition of the book. Barely came up for air, no less water.

Hugh B. Cave: One thing that I hated about my story "Murgunstrumm" was the repetition of the word "lurid." If you read that with a critical eye, you just scream out that you want to edit that story before it's reprinted. I refused to do that because I don't think that's the way to reprint pulp stories. I don't think a writer who's been all through the slicks and through twenty-five books should take an old pulp paper story written when he was, what, twenty years old and rewrite it. That's not pulp. That isn't what it's all about. Pulp is a social thing. You're looking back at a kind of writing that was in existence in those days, and it shouldn't be rewritten. That's a little argument I had with Manly Wade Wellman because when his stories were reprinted, he rewrote them. And I didn't think he should have.

The Pulp Merry-Go-Round

Hugh B. Cave: I lost all my records in a fire and I'm relying upon a man named Robbins who supplied me with my bibliography. Robbins made

indexes of something like two hundred different pulp magazines. But he tells me that I wrote for — his latest count — a hundred and nine of those more than two hundred titles.

It was not hard at all to shift from a western to an adventure story. Of course I read all those different kinds of stories. I was an avid reader and I read in the horror field, in the *Weird Tales* field, I read Poe and I read Machen, Lord Dunsany. In the westerns, I read Owen Wister and Zane Grey. And in the adventure field, Haggard. I devoured Haggard and Stevenson and Conrad. So I'd been reading all this. And besides, let me add this, any pulp paper writer in those days — we were working for a cent a word sometimes. In the early days of the pulps, in the thirties, very few of the magazines were paying anymore than that. If you, as a writer, tried to concentrate on one genre, one class of stories, like nothing but *Weird Tales* or nothing but adventures or nothing but westerns, you were facing a disaster. Because there weren't enough magazines of any one group to buy enough copy to keep you living as high off the hog as we like to live. We were doing pretty well, some of us pulpsters in those old days, back in the thirties, when college graduates were earning eighteen dollars a week and lucky to find a job. Many of us were earning well over a hundred dollars a week writing for the pulps. We were pretty cocky boys.

I tried my very best to make every story I wrote as good as I could make it. I never wrote down to anyone. I don't know how you can write down to anyone, to tell the truth. I put a lot of work into it. I worked hard. There were times there, for days on end, when I worked eighteen hours a day on a typewriter. Remember, these were old manual typewriters, and if you made mistakes, you had to type the whole page over. These were not word processors where you could click a mouse and change everything. I worked hard. I always did send clean copy, and I had a reputation in that time.

Philip Klass: Science fiction never seemed to fit the pulp matrix. But its covers, the bug-eyed monster covers which they stuck on them, that is, the heroine being menaced by a misogynistic entity from Proctyon Four, with a hero arriving in time, these covers interestingly enough were exactly the same covers they had on the other pulp magazines. The adventure pulps always had a goddamn slimy Oriental or Mexican or black man or what have you, the foreigner, the alien, and your misogynistic bug-eyed monsters lusting after the heroine were science fiction versions of a foreigner. And that's what the alien was. But science fiction never had the kind of audience the pulp magazines had, and it always had an audience that was weirdly intellectual, and publishers were finding this very, very difficult.

Hugh B. Cave: I've been told by editors like Ryerson Johnson and other people that when a story of mine came in, they could send it right to the printer. It needed almost no editing, almost no editing at all. Well, that gave me a reputation of being the man to call on the telephone if you needed a

novelette for Friday. I remember Ken White, the editor of *Dime Detective Magazine* at that time, wanting a novelette in just a few days, and he said, "I'm sending you a photocopy" — it wasn't a photocopy; it was a blueprint, they didn't have photocopies — a blueprint of a cover. And the cover was the *Dime Detective* cover, which showed a big, open, blazing furnace and a man with a baker's peel. On the baker's peel, as I remember it now, was a body. And he's pushing the body into the furnace on this peel. The furnace is all red flame. It was a beautiful, you know, really garish cover, just the type that sold well on the stands, and Ken wanted a novelette around it. So I did him the novelette on time. I even named it "This Is the Way We Bake Our Dead." And he told me later that he sent it straight to the printer the minute it came in. He didn't even have time to read it. He told me that.

Raymond Z. Gallun: It's a lonely business and you have to get out a little bit and get somebody you can talk shop with, because they weren't too numerous around, too many people around who knew enough about science fiction. We had a little gathering at Steuben's on 47th Street at that time. We met every other Thursday. There was Julie Schwartz, who was at that time an authors' agent, and Malcolm Jameson, and Otto Binder, and Manly Wade Wellman, and Henry Kuttner was there in our group too. And we met every other Thursday. We had a nice time talking about this or that or the other. I guess it helped us all.

Hugh B. Cave: I didn't meet any of the major editors because I did all of my business by mail. I didn't like New York. I was afraid of New York. I tried, once, to go live there. I stayed about a week in a rooming house trying to make up my mind if I wanted to rent an apartment. The first editor I went to call on was my old friend Ken White. I'd never met him at that time, but he later became a fishing buddy, and we went to Canada every year fishing for salmon. I called on Ken and I said, "I'm Hugh Cave," and Ken looked at me and I think his face said "So what?" And he told me, over lunch, a little later, he said, "You know, I don't really like to meet my writers. I form a mental picture of them. I might think of Jim Jones[32] as some great big, burly fellow who would mow a cop down with a slap on the wrist. And then he walks into the office and he's a little 5 foot 2 milquetoast." He said, "I'd rather keep the illusion and not meet the writer."

So, I found that was true with all of them. They didn't care a hoot whether I lived in New York or out in East Podunk, Rhode Island. So, after about two weeks of this, I realized I could do better by staying at home in my Rhode Island apartment. And about two o'clock in the morning — my rent was paid so I wasn't holding anybody up — I got out and I got into my car, which wouldn't start, I had to crank it. You're talking about, I think, 1933 or '34 or

32 It's not clear whom Cave is referring to: a made-up name like John Doe or Marvin Smith? The voice of Darth Vader, the great James Earl Jones? Jim Jones, a heavyweight boxer at his peak in the 1970s? The guy from Jonestown? Take your pick.

somewhere in there now. And I sprained my wrist and had to drive all the way back to Rhode Island with one hand.

Robert Bloch: When I was eighteen, I was invited to a meeting of a Milwaukee group called Milwaukee Fictioneers. It was what would be called today, although the term didn't exist then, a writers' workshop, and it consisted of about fifteen local writers, all professional, who met twice a month in a rotating fashion from one home to another, on a Thursday evening, to discuss markets, to discuss their work.

There were a couple of rules. Nobody was allowed to read his story. It was a male chauvinist pig thing, there were no females in there at the time. Couldn't read his story, and you were not allowed to do any showboating or take any ego trips. Most of the time you went there, you went there with a story problem. You had a hang-up in the plot. So you describe what you were doing and get help from the other members, who might also give you a market. And the members, as it turned out, were quite science fiction–oriented. Ralph Milne Farley was a member. He was very big in the twenties. Stanley G. Weinbaum was a member, and Stan was a lovely man. We became fast friends because we both had an interest in James Branch Cabell. The third writer of that group was Raymond A. Palmer, who was a tinsmith and a roofer by trade, and not doing too well at it. All of these people were moonlighting, they were writing at night, and they were all much older than I was.

After I attended the first meeting, they decided for one reason or another, that they wanted to have me as a member. But I couldn't get any help from them, because none of them wrote fantasy, because that's all I was writing.

Is This Any Way to Make a Living?

Stanton A. Coblentz: I never relied on science fiction entirely to make a living because I always did book reviews and articles, and I sold poems too, which didn't sell for large sums, but it all helped. So I never tried to make a living from it exclusively. I think it might have been done, but it would have been a meager living.

Hugh B. Cave: As a professional pulp paper writer, you had to count on writing a lot of stories to make the kind of living we wanted to make, and that meant that you were constantly on the lookout for ideas. So I kept a notebook, and every other pulp writer I know anything about kept a notebook. And you'd get an idea in the middle of the night and reach for a pencil and scratch it down in the notebook. Then when you needed a story you had a — I still have today, I have a notebook full of ideas for any kind of story you want. And I could pick one that appeals to me at the moment. Think about it for a while. Talk to myself on the typewriter for a while about it: who the characters will be, how they'll interact, and so on. But working from that

idea, which may have been written down in that notebook four or five years ago, I've got a story. And I've got hundreds of ideas there; all I have to do is find one that appeals to me now.

Frank K. Kelly: After I wrote "The Light Bender," I got an offer from Gernsback at *Wonder Stories* for a contract to write six stories a year for his magazine. Soon after I received this offer, my father found a good job and he gave me permission to leave the box factory, so I began to write stories as fast as I could go. I wrote about a dozen science fiction stories in the years between 1931 and 1935, while the United States was going through an economic collapse, while millions of men were standing in breadlines, while Hindenburg and Hitler were fastening a dictatorship on Germany, and President Roosevelt was proclaiming that the only thing we had to fear was fear itself. Where was I? I was traveling to other worlds. I was plunging from planet to planet, leaping from star to star.

When I entered the University of Kansas City[33] in 1935, I was ruined by a professor I encountered there. He told me that science fiction was a minor form of art, not worthy of my literary talents. Unfortunately I believed him. I began to write other kinds of stories. Many of these were published too, but I stopped producing tales of the future. I regret now that I didn't go on with that, because the more I think of it now, in the light of the tremendous development of science fiction, I think that I missed a great opportunity. But I was so affected by this professor, H. Robertson Shipper. He was an Englishman who'd been to Oxford, and I thought he knew what good writing was, what literature was.

Hugh B. Cave: When the American Fiction Guild started, they made me the Rhode Island representative for it, but it didn't go very far. I never went to New York except when I absolutely had to, and that's where the meetings were. But I thought their aims were good. The idea was to get a decent fixed rate and get editors to pay on acceptance rather than publication. Many of them were paying on publication. Well, this was a terrible thing. To sell a story to an editor in June, and if he felt like it, he might get around to publishing it in December, and send you the money for it. It was a lot better to take a lower rate and get it on acceptance and move on to the next story.

E. Hoffmann Price: In the early months of 1933, I was busting my ass to get into the crime story writing. It required better writing than the fantasy or science, but you didn't have to know your ass from a hole in the ground regarding the actual facts about law enforcement, and the fantasy and the science fiction writer also didn't know his ass from a hole in the ground, and also could not write and the rates were so low that the minute a man learned to write, he got out into a field where he could make a living. So here it was. Edwin Baird was editor of *Detective Tales*. They purported to be a true-fact crime magazine. However, they ran a lead novelette of fiction. I

33 Now known as the University of Missouri–Kansas City.

sold to Edwin Baird, I'll be cover-featured, and here, by God, was an affida-vit, had to be notarized. I not only had to make a sworn statement that this fiction novelette was true, but I would also hold Edwin Baird and everybody involved safe and harmless against the lawsuits for libel or whatsoever. That cost me one dollar to a notary public to commit perjury to get my hundred and twenty five dollars.

Hugh B. Cave: When I got a reject from anyone, I put it in a pile. Then there would come a lull between stories, and a lack of an idea, and I would take the old rejects out and I would see if I couldn't change them, read them over and improve them, and mail them out again. I was my own agent at the time.

Well, I'd had a story rejected by Roy de S. Horn[34] at *Short Stories*, an adventure story about a Borneo outpost. I picked it up one day when I had a request from the editor of *Top-Notch Magazine*. I can't remember that lovely old man's name now, but he was old! I was in my twenties for heaven sakes and he was forty. Nobody lived that long. Well, he wrote and asked me for a story, so I went through the reject file and I found this Borneo story reject, and I rewrote it and I mailed it to him. Then like a damn fool I put it back in the reject stack. There were maybe ten or twelve stories in that stack at all times. *Top-Notch* bought the story, then, Roy Horn asked me something about, "Would you consider that story you sent me with certain changes?" And I picked it out of my reject file, forgetting that I had sold it to *Top-Notch*. The two stories came out in *Top-Notch* and *Short Stories* the same month, side by side on the magazine racks.

And they got letters! Oh my God, did they get letters! And both editors wrote to me, I think one telephoned me. Roy was a little more angry than the older man. Roy was a navy man and he had been a navy officer, and he was a martinet. He was a little bit tough to deal with. "Come to New York and explain this, or else!" Or else! And here's a scared kid, a really scared kid. I was probably twenty-three at the time, and just making my way and hoping to hit *The Saturday Evening Post* and all that. I went down to New York and went to *Top-Notch* first, and the old man called Roy Horn and he told Roy what I had told him, how it happened, you know. And my plea was, "Good heavens, you don't think I'd ruin my career by doing a thing like this deliber-ately. This was just plain stupidity." It was an accident. It never should have happened. So they invited me to lunch, the two of them, to talk this over at the Army Navy Club[35] and I went there with the two of them, a scared kid in the presence of two big editors, you know. And they listened to me, what I had to say, and they were quite nice and quite dear, especially the *Top-Notch* editor. But Roy was all right too. Then we agreed to this: If I would answer

34 Roy S. de Horn served as editor at *Short Stories* from 1929 to 1932.
35 At the time, it was known as the Military-Naval Club, and in 1960 became the Army and Navy Club.

every one of the hundreds of letters that had come in … and mind you, pulp paper readers wrote letters, don't you ever think they didn't. If I would answer, individually, not a form letter, not anything that you could print out on a mimeograph, so that it looked like a personal reply to the reader. And I said, "I'll do it, no matter how long it takes me."

I went home and I spent three weeks doing nothing but answering letters and I spent those three weeks up till two and three in the morning until I was bleary-eyed. And I'll tell you the funniest thing that happened. Of those more than three hundred letters, two-thirds of those people became fans of mine, and every time a story of mine appeared in any magazine, they would write to the editor and say they loved it.

Ed Earl Repp: That's one thing you have to learn how to do, how to cultivate your imagination. If you don't, well, you're a flash in the pan. There's lots of guys who write books and they write one book and that's it, no more. You get a character and you feel sorry for him right off the bat, that's what you want to do with your writing. You get somebody that you could side with. He's an underdog. Nine times out of ten, the American people will side with an underdog. You know what I mean?

Chapter Four
The King of Science Fiction:
John W. Campbell & *Astounding*

THE CONTINUING CAST OF THE BOOK
(IN ORDER OF APPEARANCE)

Algirdas Jonas (Algis) Budrys (1931–2008) Editor, novelist, and short story writer from the 1950s to the early 2000s, known to friends and colleagues as A. J. Budrys.

Harry Harrison (1925–2012) Science fiction author and editor, author of the *Stainless Steel Rat* series, *Eden* trilogy, and a host of novels and short stories.

Frank Herbert (1920-1986) Science fiction novelist best known for the novel *Dune* and its sequels.

Philip K. Dick (1928–1982) Science fiction novelist and short story writer, known for such classics as *The Man in the High Castle, Do Androids Dream of Electric Sheep?* and *A Scanner Darkly.*

Robert Silverberg (1935–) Acclaimed novelist and short story writer from the 1950s to the early 2000s.

Howard Browne (1908–1999) Science fiction and mystery magazine editor, novelist of mystery and suspense fiction from the 1940s through the 1990s.

Marion Zimmer Bradley (1930–1999) Fan who became the best-selling author of the Darkover series, *The Mists of Avalon,* and other fantasy and science fiction novels.

Harlan Ellison (1934–2018) Multiple award-winning author and critic.

In 1937, Street & Smith hired the twenty-seven-year-old John W. Campbell to be editor of *Astounding Stories*, and the science fiction world was never the same. Campbell, a successful author of space opera since 1930, transformed the genre, encouraging and offering ideas to such talents as Robert A. Heinlein and Isaac Asimov. While he continued to edit the magazine (which changed its name to *Analog* in 1960) until his death in 1971, Campbell's influence was at its peak during the decade of the 1940s.

A Whole New Ball Game

Isaac Asimov: Between 1938 and 1950, the history of science fiction is entirely the history of John W. Campbell. John Campbell elevated science fiction out of the pulps, and if it hadn't been for John Campbell, science fiction probably would have died in that form at least, with the pulps. He

produced a great many writers who are still active and important today, and who perhaps wouldn't have gotten into the field without him, and who wouldn't be the kind of writers they are without him. For that reason alone, he's important. And then he insisted on rational science fiction, on writers understanding science, and so on.

Philip Klass: Campbell had not known exactly what he was doing when he took these writers who worked for Gernsback. He took the science fiction magazine that Harry Bates had edited and done remarkable things with, and he suddenly turned people loose. While he thought he was taking them in a specific direction, instead you had the efflorescence of Heinlein, of Asimov doing totally new and enormous things, of Murray Leinster, who was an old pulp writer, of Henry Kuttner, who was known before as "Hack" Kuttner, and when he began writing good stuff he did it under the name Lewis Padgett, and they did it all for Campbell. In the great days of *Astounding*, reading the magazine was like experiencing half a dozen intellectual orgasms.

Frederik Pohl: When you think of what science fiction was before Campbell took over *Astounding* and what it became immediately thereafter, you have to perceive that something was happening, that this wasn't chance. What it was, was John Campbell. He brought into the field half of the best-known writers around. Arthur Clarke, A. E. van Vogt, L. Sprague de Camp, Ted Sturgeon, etc. The list goes on forever. It wasn't because they were there, waiting to be picked up. Many of them would not have been writing if they hadn't had the example of *Astounding* to set as a model. He worked very closely with a lot of them for years. I thought at the time, and still think, that John Campbell was the best editor science fiction ever had, which is not to say that he didn't have some strange idiosyncrasies and peculiarities.

Raymond Z. Gallun: John Campbell started out in *Astounding* at the end of 1937 and extended onward. He was really a wonderful, hard-hitting editor. He would certainly go out of his way — now, if I compare him with F. Orlin Tremaine, Tremaine was very terse in his letters, whereas John would take an awful lot of time writing a letter about what he thought about a story. This was really his thing. He really carried people along in his own way. Perhaps he intruded a little too much on your ideas, but still he had that conscientiousness, which I don't think any other editor I know of has equaled.

Stanton A. Coblentz: Campbell was more insistent upon something with a scientific basis than F. Orlin Tremaine, the editor before him, who was more willing to accept something that made a good story, even if the science was rather dubious. I think Campbell probably would have ruled out H. G. Wells as not being scientific enough. He was a little too exacting for my taste. Not that I didn't want to uphold standards, but I wanted to uphold my own standards rather than somebody else's.

Philip Klass: In the late 1930s, I became a young Marxist, and in *Astounding* for the first time there were science fiction stories that suggested social change. Most people are not aware of this when they think of Heinlein, but Heinlein's story "If This Goes On ..." was a very exciting piece of work because it dealt with history as did later Asimov's *Foundation*, which was something that interested me much more than technology.

Algis Budrys: People my age, the Robert Sheckleys, the Michael Shaaras, the Philip K. Dicks, came in on a wave that was launched by John Campbell, Jr. We were just old enough, in our teens, so that we encountered what John called modern science fiction in its perfected form, whereas all of those older writers were people who had had other careers and were writing science fiction as a kind of hobby, or as a second career after establishing some kind of business. We, on the other hand, were people who were inspired by those ideals and could dream about being full-time science fiction writers. We were the first generation, in 1950 and immediately thereafter, we were the first people who could afford to be full-time science fiction writers.

John Campbell, the Man

L. Sprague de Camp: I think John W. Campbell was about the best editor the field has ever had, and he was a good friend of mine for a long time. The first time I met him, my friend John Clark was throwing a party in his apartment. I was still in Scranton at the time, I believe, and I'd come in [to New York City] for weekend visits, and John Campbell was one of the guests who was introduced to me. The group at this time was an informal group of science fiction professionals, editors, writers, illustrators, and so on, and they included quite a variety of people like Manly Wade Wellman, Jack Williamson, Frank Belknap Long, Edmond Hamilton, Sam Merwin, Jr., John Campbell, and a few others, and we used to meet once a month and discuss literary matters, and then consume ice cream and coffee. That went on for several years, and then, as groups like that do, it sort of dissolved under the pressure of competing interests on the part of the members.

Frank Belknap Long: John Campbell was a wonderful guy, very brilliant, there's no question about that, but inclined to be a little dogmatic about his opinions. He really laid down the law to almost all of his writers, even the most brilliant ones. Heinlein, I think even. He told him what he wanted written, why he wanted it written, how he wanted it written, and so forth. He always had that tendency to be very outspoken and you felt that you had to write what he wanted, not so much what you wanted, but how he thought a story should go.

Isaac Asimov: John was always clever. You could never out-argue him or outtalk him. And to the very end, he was the kindest person you could possibly imagine.

Harry Harrison: I think John Campbell was the man who invented modern science fiction, there's no doubt about it. He once asked me to edit *Astounding* when he died. I said, "John, you're going to live forever." I felt, rightly enough, that when John died, the magazine would be dead, his magazine. He brought the field kicking and screaming out of the pulps, into what it is today, a serious examination of logic and knowledge. Having done it, the magazine slacked off in the last few years and turned it into a shadow of its former self. It was fine, but it was still a shadow, and had a shadowlike substance. But he did it, he did it himself. He invented modern science fiction, and that can never be taken away.

A. E. van Vogt: In 1939, I picked up a copy of *Astounding Science Fiction*. And I read it, in a drugstore, standing. I read the first half of "Who Goes There?" by Don A. Stuart, and at that time I decided I would buy this magazine and finish the story. It was twenty cents. It was worth the price. On the basis of reading that story, I sent Campbell an idea for a story, without knowing he was Don A. Stuart, that he was the real author of the story.

Frank M. Robinson: Campbell was God. I mean, no two ways about it. I only met John once, in Chicago. John was a somewhat bulky man, probably fairly tall, but his bulk would detract from his height, if you follow me. Always with a cigarette holder in his mouth. I met him and right away I am abashed. I am digging my foot in the floor. I am apologizing to him for not having written more stories for him. He made probably the most significant difference in my life of any editor I ever met, in one line. He said, "Frank, if you wanted to be a writer, you'd be writing." Within three months after that, I'd taken a leave of absence from *Playboy* and came out to San Francisco to become a writer.

Unknown: Campbell's Fantasy Magazine

Horace L. Gold: I was walking from the subway station to John Campbell's office on 7th Avenue and 15th Street in the old Street & Smith building, and I mean *old*, and I was walking through a dismal, dreary rain, and through my mind I was subvocalizing "Running Between the Raindrops," an old song, and I says, "Hey, how about that for an idea? How about a man whom water will not touch." So I had it half worked out by the time I got to John's office, and I told him about it, about an experiment that goes blooey, and inverted ionization to account for water not being able to touch the protagonist.

And he said, "No, I want it to be a curse."

"A what?" I said.

"A curse, put on the hero by, oh, say, a water gnome."

I said, "That's fantasy! You're *Astounding*. A science fiction magazine."

He said, "A curse by water gnome. Go home and write the story."

I went home and couldn't figure out what the devil he wanted with a water gnome and a curse. But I wrote "Trouble with Water," and I don't know if I brought it in or sent it in. In any case, John told me after the story was bought and paid for, and the check cashed, that I could have gotten twenty times as much from *The Saturday Evening Post*. I said, "But you ordered the story, not the *Post*." He thought that was silly ethics.

Later I found out why John wanted the fantasy. When the story came off the press, John handed me a copy. I looked at the cover, with "Sinister Barrier" by Eric Frank Russell, and I looked through the contents page, and there was my story. I looked at the illustration. It was nice. I handed it back and John said, "The logo. The logo!" And I said, "What's with the logo?" He said, "The title of the magazine, you idiot!" So I looked it over, and it was *Unknown*, Volume 1, Number 1. And I was in it, and I hadn't known. Isaac Asimov can't make that statement. He's still writing his way back to it.

Theodore Sturgeon: In the summer of 1939, there was an alcoholic advertising writer. I think he was an alcoholic because he always wanted to be a writer and had failed. Anyway, this drunken advertising executive, or writer — he wasn't even an executive as I recall — he talked a lot about writing. He plopped this magazine down in front of me one day. "That is what you ought to be writing for." It was called *Unknown*, Volume 1, Number 1, September 1939. I'll never forget that.[36] The lead story was "Sinister Barrier," by Eric Frank Russell, a very good story. One of the other stories was "Trouble with Water" by H. L. Gold. John had no idea that Horace would grow up to be his greatest competition later on, twelve years later.

My friend suggested that I go up to see John Campbell. "What, me, see an editor?" I was just very trembly. So I went up to this building, I was living in Brooklyn at the time, I went up to this building at 79 7th Avenue, it was an old red brick building, "Street & Smith, Incorporated," had printing presses in the same building. When they started those presses, it was exactly like being on a ship. Ching, ching, ching, ching. You had to thread your way through a warehouse floor where they had huge rolls of newsprint that they'd feed into the presses, and way in the back corner was a little tiny office with a great big man in it, John Campbell. He leaned back in his chair, 220 pounds, six foot three, and his chair would just scream for help. I don't know how many chairs ever broke under him, I'm sure quite a few. I thought him very gentle, very sharp.

I brought a manuscript with me, and he read it right there on the spot, rejected it right there on the spot. He told me that it wasn't a story because it didn't have a beginning and a middle and an end. It didn't develop anything. I recall that it was a description of what it feels like to get hit by a New York subway train, if you fall off the platform as it's rushing into the station, and

36 Apparently he did forget. It was March, 1939.

how time freezes in that moment. Very slowly, millimeter by millimeter, it crushes you as you hang there in midair and you can see your bones opening up. And this is the definition of hell, an almost infinite accident. He liked that, and he liked the writing, but that's all it said, and that was the story. So I went back and started feeding him stories. I fed him so many stories that I remember a few months later, *Unknown* and *Astounding* were both on the stands, they were both monthlies, and each had two of my stories in it. I had four stories on the stands at the same time.

L. Sprague de Camp: I wrote "Lest Darkness Fall" for Campbell for *Unknown*. Actually, I didn't know for sure which magazine he was going to run it in because it's a time-travel story and time travel is usually classed as science fiction, although it doesn't take much thinking to show you that time travel is actually a lot less probable than werewolves.

Fritz Leiber: The way I got into writing was that I first sold three or four stories over the course of as many years to *Unknown*, that second magazine that John W. Campbell edited, and then a couple of stories finally to *Weird Tales*. And then when Campbell realized, I think, that *Unknown* was going to fold, he asked me, among other people I suppose, why not try writing science fiction stories also? And it was on that basis that I wrote *Gather, Darkness!*, which was, again, a sort of witchcraft story superimposed on science fiction, or given a science fiction rationalization. So I got into the field very gradually.

Horace L. Gold: I wrote "None but Lucifer," but that's a very sad story and I won't break your heart with it. It was my story, and I was mousetrapped into splitting the byline, the check, with Sprague de Camp.

L. Sprague de Camp: What happened was that the story as it appears is pretty much Horace's except that I made a few changes here and there, and I cut out great gobs of Horace's personal experience that he had incorporated even though the episodes had nothing to do with the main thrusts of the story. They were irrelevant, but they were burning in Horace's brain so he wanted to get them down on paper, like when he was working for a mad upholsterer, and at any rate, he sent it in to Campbell, and Campbell didn't quite like it, and suggested that Horace allow me to rewrite it, which I did. Well, I can't blame Horace for having his ego chipped a bit. I know all about that sort of thing, and the story appeared in my form. I made a few other changes, and some of the names of characters were less flat, and so on. But Horace has always thought that if he could only get the original version into print, that would be his masterpiece, you know. It hasn't appeared yet. I wish him luck.

Horace L. Gold: *Unknown* lost money consistently, but they continued the magazine until 1943, which was the base year for paper rationing. When paper rationing was introduced, they killed *Unknown* and put all that tonnage into *Mademoiselle*, and made a bloody fortune.

Campbell as Editor

Horace L. Gold: I wrote "A Matter of Form" in 1938, and that was the first story I'd written in three years. And when I wrote it, it was a very dispirited, feeble effort. My heart was not within miles of it, and I sent it in to Campbell, who had been editor of *Astounding* for only one year, and he called me in and told me that I hadn't found the real problem of the story. The story is of a man who finds himself trapped in the body of a dog. I don't remember what my version stressed, but whatever it was, Campbell summed it up in one sentence. He said, "The problem of a man in a dog's body is communication. How is he going to communicate to someone who can help him out of this situation?" and I said that's all he needed to tell me. I spent several months on the story, coming into New York and going to the library and haunting the section where they kept material such as cryptography, and I went looking through all the books until I found a code that a dog could conceivably use. It consisted entirely of punctuation. Periods, commas, semicolons, that sort of thing. Campbell told me to use my own name, and I did, and was very grateful to use it. I signed it "Horace L. Gold." When he got it, he was very ecstatic, and then he wrote as a blurb, "One of the most unusual stories in years," etc. The point was that it was completely logical, he stressed the logic. And it was. I said to myself, "One day, you're going to be able to pick out the one thing that's wrong with a story, and become an editor yourself."

Isaac Asimov: I suppose that the books of mine that sort of have me most in awe are the *Foundation* books, not so much because I think they're the best things I've written, because I don't, but because I don't know how the hell I managed to put together something which was so enduringly popular. If I had set out to write something that would be enduringly popular, that's not what I would have written. When I wrote *Foundation's Edge*, I reread the *Foundation* trilogy and found that I remembered, in only a very general way, the details of all the stories. They were new to me, and I found that I enjoyed them very much. I was horrified to discover that there's no action in it, that everything was offstage, that it was virtually only conversation. This was what Campbell wanted, this is what I gave him. Purely by accident, I came across a statement by James E. Gunn in one of his anthologies, in which he talked about this, and said that there is no action in the book, and no sex, of course. Everything takes place offstage. But somehow there is the play and interplay of ideas, on which hangs the fascination. I figured I respect James Gunn very much as a critic, and I figured that that's what I happened to get as a kid without knowing it.

Harry Harrison: John Campbell was a collaborator on all my novels, the first four, five, or six, in the sense that I'd give him a one-page outline, get a seventeen-page letter back saying what I could do. One thing about John:

He never told you to do something. He told you something you might do. If you had any brains, thought about it, you'd do that.

Philip Klass: John Campbell was a great editor. He was also a dreadful editor. One of the reasons he was a dreadful editor was not because he was trying to make his writers do gimmicky stories, which he did do, but because Campbell had learned to write in the pulps, and he kept trying to make his writers think in those terms. Campbell, who I think was a very sensitive man, as you can tell from stories like "Twilight," tried to be a pulp editor and tried to make his writers into pulp writers when it was so obvious they were going into new directions and doing unusual things.

Fritz Leiber: John Campbell published my first two novels, *Conjure Wife* and *Gather, Darkness!*, in *Unknown* and *Astounding Stories*, respectively. And in both cases, he helped me in the writing. I mean, his criticism helped me. I completed three or four chapters, the first chapters in both of those novels and then sent them to him. And he gave me a lot of detailed criticism that enabled me to improve the novels. It wasn't picayune criticism or suggestions of "wouldn't this be a good idea if you did such and such." It was more suggestions about the general treatment.

In *Conjure Wife*, he kept me from overcomplicating it by introducing too many scenes in other locales. I was going to have a section that took place in Mammoth Caves. I think it would have been getting rather far afield from my college town.

And in *Gather, Darkness!*, I began to treat the villains rather satirically, making fun of them, you know, and he pointed out that it might be better to take them more seriously. He also pointed out something that I think is obvious but a very good piece of advice, and that is that every man, even the most villainous and personally, supposedly the most evil wicked person, thinks he is doing everything for the best. He's doing what must be done, either from the point of view of God or his own feelings. He is taking the only course and the best course available at all times. By and large, that is true, as we know. I'd say he had a lot of influence on me in that respect.

I remember in one of the Fafhrd-Mouser stories — he got me to arrange it in a simpler, less involuted, complicated style, by straightening out the time sequence in several places. Later on, he gave me the general idea for the novelette "The Lion and the Lamb," which was just imagining two branches of the culture, and one goes in the artistic direction and the other in the science direction. Just that notion was enough. He did supply ideas.

A. E. van Vogt: Don't forget that he gave ideas to writers. He passed them out freely. He sent me many ideas and I said that it always takes about three years for an idea of yours to reach the writing stage, John. Then I wrote him, "I don't work that fast on other people's ideas, so it's not going to be easy." So he didn't offer me too many ideas because it just took too long.

Anne McCaffery: Campbell was very stimulating. He was a marvelous guy. He used to get a couple of authors together and fling out ideas at you to see what would come back. He was a great one for having controversial editorials just to see what reaction he would get. And he'd get it, but that was what he wanted to do. But as someone to work with and for, he was absolutely fantastic.

Jack Williamson: Campbell was a creative editor. He would make suggestions and if he didn't like a story the way it was, he would make long letters of suggestions. The *Seetee* stories I wrote were largely inspired by Campbell. I sent him an outline, or maybe it was face-to-face, for planetary engineers who would terraform new worlds to make them fit for habitation. He suggested some of these might be antimatter, which were then called CT, contra-terrene, and my two *Seetee* novels developed that suggestion.

Fritz Leiber: At one time Campbell suggested the very fruitful theme of aging, the relativistic time effect. The fact that space travelers going close to the speed of light would be younger after the completion of their voyages than the people who stayed at home on the planet. And so you'd have some dramatic effects. I wasn't able to make anything of that, and a year or so later, why, L. Ron Hubbard had a series of stories that dealt with that very thing.

A. E. van Vogt: At the time that I read "Who Goes There?" I wrote Campbell a one paragraph outline of "Vault of the Beast." I really didn't know how it was going to go, or anything like that. He said, "Be sure to put plenty of atmosphere into it." I knew what he meant.

Raymond Z. Gallun: At the start of our contact, I think John bought a story from me once every week for about three weeks, which amazed me immensely because it usually took a little bit longer than that. I sent the original of "Seeds of the Dusk" to him, which he didn't like, and I thank him for that, because it turned out to be a considerably better job after his comments. Later on, I went to Europe, I went to Paris and I was there for a year and a half and contact with John sort of faded out. There was one called "Masson's Secret," which he bought, and I notice that in one script he rejected, I hadn't put in return postage on the manuscript, and this is one serious little thing. I say it with affection now, but he deducted the number of cents, I don't know what it was, a few cents from my check to pay for the postage. He bought a couple of other stories when I was in Paris.

Richard Tooker: I wrote one on order for Campbell, "Toward the Superman," we called it. The only thing I remember about it is that we did not agree on genetics. It's very difficult to direct genetics, it is. The basic genetics that John W. Campbell did not really agree with — because he was definitely what I would call conventional, see — is that the weak are bred out immediately. We don't breed out the weak. We try to save them and let them have children. But the strong are bound to survive. I wrote him an idea of it

and he went for it and he kept changing my theories and so forth. He was all right. He was probably more right than I was, but I think in the basic principles, we didn't agree very much.

Frank Herbert: The interesting thing about my dealings with John Campbell is that I never submitted an idea to him. I submitted completed stories, and by and large, he was very nice to me in editing. They came out the way I wrote them.

Robert Silverberg: The important thing with John Campbell was not your prose style, but your thinking processes, and once he approved of the way you had thought through your story, he would make no changes in your prose at all.

Frank Belknap Long: He never revised. I'll always be grateful for this. Campbell never revised a word of my stories. He always published them exactly as I wrote them. That is what a great many editors don't do today. In those days, they seemed to, more or less, take the stories just as they were. Even the terrible pulp drivel written in those days and all that, they didn't revise in those days as much as they do now. Nowadays, you can never be sure.

Horace L. Gold: As "Trouble with Water" went through the production process, Campbell told me it had to be set twice because the linotyper who was setting it, he did something that compositors just don't do. And that is, he read the story and fell off his stool and he messed up the type. And it had to be reset by someone who didn't read the story.

And then John told me Mr. Lawler [Arthur Lawler] wanted to see me. Mr. Lawler was the big high-muck-a-muck of Street & Smith. Street and/or Smith, or both, was or were dead, and Mr. Lawler ran the show, and he was so far above F. Orlin Tremaine and the rest of the editors — he wasn't in the same world. He himself wanted to meet me. And when John took me to his office and left me there, Lawler stood up behind this big desk in this huge office, beautifully, magnificently furnished, and he shook my hand, and told me how much he liked "Trouble with Water," and he had a great idea.

He said, "I want you to meet some of my editors." And he brought me to meet Tony Rud, Anthony M. Rud, who was editing the mystery stuff, I guess it was *The Shadow* he edited, and Daisy Bacon, who edited *Love Story* and *Ranch Romances*,[37] and in each case, they'd all read my story. And each one wanted a Jewish detective, Jewish ranch romances, bar mitzvah ranch. Rud wanted a character, a Shadow or Doc Savage character. I immediately thought of a title, *The Shlepper*. And he wanted a novel a month from me, sixty thousand words a month. Lawler took me all through the place, and he wanted me to do Jewish shistucheries in each field. I was outraged because they all thought "Trouble with Water" was the funniest story they ever read,

37 Daisy Bacon edited *Romantic Range*. Fanny Ellsworth was editor of *Ranch Romances* from the 1920s to 1950s.

and I had suffered with the hero, Greenberg, Herman Greenberg and his wife and his daughter, through all the agony of being unable to bathe, being unable to drink water, being unable to shave. And finally reduced to the degradation of drinking beer, nothing but beer because it has alcohol in it, and the little people don't touch anything with alcohol in it. I had suffered with poor Greenberg through the whole thing, and here they were insisting it was the funniest story they ever read.

Then I wrote "Warm, Dark Places," and I've been told that it's similar to "Trouble with Water." It also has a curse and it also has Jewish characters, and without using a single graveyard rat or any of the other clichés of horror stories, I wrote a story that Campbell told me, in his words, was the nastiest, most frightening story ever written. That was in *Unknown*, and that was my revenge. It wasn't similar to "Trouble with Water." It was identical.

Frank Kelly Freas: As far as I was concerned, Campbell was a little tin god. I mean, he oriented my thinking toward science fiction, and when I started working for him, he educated me in what science fiction illustration ought to be. Which basically not only illustrates the story, but illustrates the part of the story the author, for one reason or other — either because of space limitations or because it just doesn't lend itself to verbal description — can't put in. Ideally, the illustration and the story will be one complete package, and neither without the other will be quite complete. Sort of like Alice in Wonderland without Tenniel.[38]

Richard A. Lupoff: Frank Kelly Freas' cover for *Martians, Go Home* is probably one of the two or three best-known illustrations in all of science fiction. That was originally done for *Astounding*.

Frank Kelly Freas: The little green man looking out of the keyhole was a direct assignment from John W. Campbell. He has been pretty much all over the world by now. He's gotten around pretty well, and there are even people who accuse him of being the great granddaddy of *MAD*'s Alfred E. Neuman. The one thing he is not is a caricature of me. The model of the little green man was John Campbell's eight-year-old daughter Leslen at the time. We were babysitting for Campbell that weekend, and I was working on the interiors and I had Leslen sitting up on the head of the bed, and popping around all sorts of places where I did sketches of her to use for the little man.

Anne McCaffery: They used to say that you couldn't get a dirty scene or obscene scene in any of John's magazines — true. He didn't see any point in shocking his readers for just the shock value. But you must remember that in "A Womanly Talent," I had a specific sex scene in there, and it was an integral part of the plot. He didn't bat an eye. Neither did his secretary, who

38 John Tenniel's illustrations for *Alice's Adventures in Wonderland* were, for many years, tied to the Lewis Carroll text. That knot seems to have frayed a bit in recent years, but a quick look at *The Annotated Alice* by Martin Gardner restores the faith.

was supposed to have been the prude. Neither of them were. They just saw no point in having it thrown in as shock value.

Frederik Pohl: I'll always regard it as one of John's least attractive traits that he never bought any one of my stories. In the whole thirty-four years he was editing *Astounding* and *Analog*, I must have submitted twenty-five stories to him and except for two or three that I wrote in collaboration with somebody else, he never bought a one. I don't think because we were enemies. We were on pretty good personal terms. When I was an agent, I sold him more than anyone else combined. But he was sort of opaque to my charms. But he was nevertheless an editor I respected a lot, and I learned a lot from him. He pioneered ways of editing magazines, ways of editing science fiction.

A. E. van Vogt: What amazes me now, after reading Fred Pohl's *The Way the Future Was*, was that a story could be sent from far away as Winnipeg and find a place in a New York publisher's magazine. I couldn't have found it in any magazine other than *Astounding* because they were all being run by in-groups. The writers were all starving to death, and they would bring their story to the editor, and only those who were a member of his in-group would be acceptable. A story of mine, like "Black Destroyer," arriving on the desk of such an editor, would not get anywhere at all. That story of mine left Winnipeg, Canada, as remote an outlying area from New York as you can get, I would say, on this continent at that time, arrived there on the desk of John W. Campbell and he read it. He didn't just read the letter and say, "Oh, it's from Winnipeg, Canada," and send it back, or "it's not from a local in-group member." I imagine that in-group people could wait forever in Campbell's office and not get a check immediately.

Philip K. Dick: Campbell called my stories nuts. He said they were crazy. He bought one story. That was "The Imposter." But he told me that psi had to be a necessary premise for a science fiction story, and I had a very strong prejudice against psionics. I thought it was a form of the occult and thought it should not be allowed to invade science fiction. I've changed my mind since. But at the time I thought it was like witchcraft, or something like that.

Harry Bates: John Campbell didn't understand part of my story, "Farewell to the Master." He said, "Is this really a robot or a man?" Well, that is the point I deliberately left vague.

Frank M. Robinson: William Hamling was working over at *Amazing*, and I'd gone to see him in his office one day. I was freelancing. And we talked over a story that he wanted me to write, and I went home and wrote the story. Realizing that they always changed the title, I didn't bother giving it a title. I just called it "Untitled Story," and sent it off to Fred Pohl, who was my agent at the time. Freddie heard there was a 12,000-word hole over in *Astounding*, shipped it over there. Campbell bought it, printed it, and it came out as "Untitled Story." I didn't know that. I was on leave from the navy

one week and happened to see the issue on the stands. I picked it up and I was shocked. Campbell never gave it a title.

Raymond Z. Gallun: I met John only once. I went to see him at the old Street & Smith office down there and had quite an interesting chat. I was working at that time on a novel about miniaturization, miniature people, and he gave me some pointers about certain things which become different physically under reduced size. For instance, if you want to shape metal, you're going to have an awful time trying to pound it into shape, because for some mechanical structural reason which comes with reduction of size, which I guess is the relative strength of materials in proportion to size, when a thing gets smaller, the materials get relatively harder. So he suggested, "Well, you can't pound things into shape, but you can perhaps squeeze them into shape." And we talked about various things of that sort. I remember we had quite an extensive conversation about the nature of consciousness.

At that point, or after that point, not about this or anything, it had been growing for some time that he had a new stable of writers, and I'd been with the magazine for a long time, and my interest shifted over, more or less, to the type of stuff which was used by Ned Pines, that is, the Thrilling group, *Startling Stories*, and *Thrilling Wonder*, and so on. I did more work for them, although he did buy a couple of novelettes from me, after that. Along about 1961, I dropped out of science fiction altogether, so my contact was not very strong with John after that at all. I'd heard he'd died. I do honor his memory.

John W. Campbell's Personality

Isaac Asimov: From the very beginning I argued with him, even as a little kid, when I was so afraid, I'd go home and worry that perhaps he wouldn't buy any of my stories. So I tried to tell myself, "Don't argue with him," but then, you know, I couldn't help it. As it went on, we argued bitterly by mail in later years until Peg Campbell stopped the correspondence because she felt it might ruin a friendship. But it never did. We were always friends, and the last time I saw him, which was at a Lunacon in 1970, I believe, I remember sitting with Janet — I'd met her by then but we hadn't gotten married yet — sitting in the hotel room with him, and with a few other people, and it was just like the old days, listening to John lecture us, and occasionally getting in a word. It made me feel eighteen again, although by that time I was fifty.

Algis Budrys: Campbell and I established what amounted to a father-and-son relationship, and some of the high points of that were the day that he came to my wedding, and took me out to a marvelous Chinese dinner afterward, and the fact that he, in his own mind, and in fact out loud to me, said that when he was ready to retire, I'd be the next editor of *Astounding*. We were that close. I used to sit across from his desk for hours, batting ideas back and forth. And not just about stories, that was the difference. Camp-

bell and I used to talk editing because I was an editor by then. I'd worked for Gnome Press, which was a pioneering hardcover house, starting almost the same day that I started selling my first stories. And I was Horace Gold's assistant editor for a very brief while after that.

Harry Harrison: We had awful fights. I'm slightly left of center, he's slightly right of center, almost right of Genghis Khan politically. We had terrible knockdown things, but he would never make you put it into the work. The only time you might say I bended the knee was on a serial called "In Our Hands, the Stars," [or] *The Daleth Effect*, where they have the antigravity and you can go to the moon in three and a half hours. I turned it in, and he said, "You know, on this page, you have this guy on Mars. That's sheer propaganda." I said, "Yeah, it's sheer propaganda. I made a point in my novel." He gave me a quick little lecture, and I typed his lecture into the novel for the magazine serial rights. For the book I tore it out, because it's my book. It's the only time I ever did anything, rewrite or change, other than improvement when he'd find something that was dead wrong. I'd say, "You're right, that's dead wrong," and I would change it. That's the only time I ever knuckled under. But it's his magazine, let him give his propaganda talk.

Howard Browne: John Campbell was a patronizing son of a bitch. Other than that, he was a nice guy. He met Ray Palmer, and Palmer sat at his feet, almost literally. The air got so stuffy that I couldn't stand it. I'm sure Moses was proud of the Ten Commandments, but this guy was much prouder of his stories. Maybe he had a right to be. I never read one of his stories. I never read his magazine.

Anne McCaffrey: There have been quite a few vile canards about John which I personally resent. In fact, no one poor-mouths John Campbell in my hearing or they're liable to get a thump for their manners.

Marion Zimmer Bradley: *Astounding* was one pulp magazine I never did read. It was too technical.

Isaac Asimov: Campbell's political, economic, and social views were from my standpoint horrendous. I forget now who used to say that Campbell's views were a little to the right of Genghis Khan. He was an extreme conservative. He used to support George Wallace and I often wondered whether he was just doing that to get people to do a little thinking about it, or if he was serious. But maybe he was serious. In any case, the views he expressed were completely different from mine and in fact would drive me to distraction.

Horace L. Gold: There was an Edd Cartier illustration on "Warm, Dark Places" that was straight out of *Die Stürmer*, a Nazi illustration, the most repulsive disgusting caricature of a Jewish person. I got so mad I told John I would never ever again write for him, and I never did. Now he wasn't a

racist.[39] He was just absolutely impenetrable. It couldn't get a molecule deep in him. He was totally insensitive, that's the wrong word. It was all hide.

Robert Silverberg: In the summer of 1955, I was collaborating with Randall Garrett, an older writer who had come to New York and who had sort of collapsed on my doorstep in penniless alcoholism, and I said, "Let's collaborate." I could write, I had the discipline. He had the scientific background, he was a chemist. So we set up a kind of factory. Suddenly we were selling collaborative stories to John Campbell under the pseudonym of Robert Randall, a nice Anglo-Saxon name. But every time I brought a Robert Silverberg story in, John would reject it.

Randy said to me one day after this had happened three or four times, "The real reason he is rejecting your stories is that he's anti-Semitic. That is to say, he respects Jews as sharp mental operators but he doesn't want nasty Jewish names on the contents page, so he'll buy stories from you but he would want another name." And he said, "Make up the most Protestant name you can think of."

I said, "How about Calvin Knox? After all, those are the two great Protestant rebels after Martin Luther."

Randy laughed and said, "Make it Calvin M. Knox, the *M.* for Moses."

So I wrote a Calvin M. Knox story, took it to John Campbell a couple days later, and by God, he bought it. Then, just to test Randy's theory, I brought him a Robert Silverberg story a few weeks later, and he bought that. He published it. In fact, he put my name on the cover of the magazine.

A couple of years later, late at night at a convention, I was sitting with John in his room. Just the two of us were sitting there. He had his feet up in a very uncharacteristic relaxed position, and he said, "What's the story with Calvin M. Knox? How'd you make up that name?"

Because by that time, it was late at night and I was feeling relaxed and no longer afraid of John Campbell, I said, "Well, the rumor came to me that you wouldn't use a Jewish name on a byline, so I made up the most Protestant name I could think of."

John began to laugh and laugh and laugh, and then he said, "Have you ever heard about Isaac Asimov?"

A. E. van Vogt: I'll say this about Campbell. I only met him twice. When I went to New York in '53, I had written him in advance, and he took me out to his home in New Jersey, and from the time that he picked me up at the bus to the time that Dr. J. A. Winter and his wife came to dinner, I don't think I got in a word edgewise. He was so loaded with ideas. His first wife was called Doña Stuart, from which he derived his pseudonym, "Don A. Stuart." They got divorced for reasons which I don't know but which I could analyze if I were so inclined. I think it had to do with Dianetics. He was

39 Based on this description, in 2025 we'd call John W. Campbell a racist and anti-Semite.

off constantly at the beginning of Dianetics, with Hubbard. Never was at home. I even wrote him a letter when he reported this to me, saying "You watch out. Wives don't go for that kind of thing. The ever-absent husband." And sure enough, suddenly, there they were divorced, and he married the sister of Dr. J. A. Winter, who wrote the foreword to the first Dianetics book. Anyway, I discovered that she could control John Campbell in terms of their conversation, because her mind was just as quick as his. And between the two of them at lunch, I never got a word in edgewise.

Isaac Asimov: Well, Harlan Ellison used to say that the epitome of John Campbell was that he would say to you, "Yesterday, Peg and I were dealing with a proposition that it is no use to lecture people, and if you listen to me, I'll tell you why," as he grabs your lapel. To the end, he tended to lecture.

Harlan Ellison: John Campbell lectured, and that's all he did. He just lectured. And if you listened to him, there might have been things in there, but he was speaking way above my head, at least at that stage of my career.

Philip Klass: Campbell called up Horace Gold one day. I was at Horace's home when Campbell called up. I heard his voice over the phone, and Campbell said, "Horace, there's a terrible story going on about me, that I just heard, that I'm a dogmatic person. Horace, I AM NOT DOGMATIC!"

Campbell's Editorial Policies

L. Sprague de Camp: Campbell's editorial policy was against having two identical bylines on the contents page. Campbell was running an article by me in the same issue, so the pseudonym Lyman R. Lyon was used for one story, the story about a fellow who clones a mammoth, starting with organic molecules. It was the only story I used it on, and it was the name of a great-grandfather of mine.

Horace L. Gold: "Problem in Murder" was bylined H. L. Gold, rather than Horace L. Gold. When I asked John Campbell why I was H. L. Gold rather than Horace L. Gold, he said, "Because I couldn't fit Horace into the layout." Except that later, much later, because publishing is a first-name business, whenever I turned in a story or a book, I never knew what the byline would be, and I wound up being again and again, Horace Gold on the cover, Horace L. Gold on the contents page, and H. L. Gold on the title page. Now I think I'd like to stay with the name Horace L. Gold but I'm not being allowed to.

Frank Kelly Freas: John Campbell would just send me a manuscript with a work order for two, five, eight black-and-whites, sometimes a cover. Then I would give him color sketches, usually four-color sketches, detailing quite completely what I had in mind for the finished cover. He would pick one of those, make whatever changes he chose to make in that, and then I would go right into the finished job. I only once delivered him pencil sketches of the interior. That was for the first story I did. From then on, he

just turned it over to me completely, and never turned down a single black-and-white that I ever did. That first story was called "The Greater Thing" in which the lead illustration was a city with a giant brain sort of superimposed on the city. And there was one interesting illustration in it too, where the hero had just shot the heroine, and she was lying crumpled up against a wall. My wife posed for that one, and swore that she would never pose for another drawing. I could take photographs, but she wasn't going to have her neck broken that way again.

Isaac Asimov: The ending of *Foundation's Edge* would not have suited John Campbell. A number of the things I did would not have. As far as *The Robots of Dawn* is concerned, I'm sure much of it would not have suited him. But there was a certain feeling of freedom too, because when you wrote for John Campbell, you were really inside a rather tight straitjacket. He had his ideas and he wouldn't let you go beyond them.

Harry Harrison: He was a collaborator on all my novels, the first four, five, or six, in the sense that I'd give him a one-page outline, get a seventeen-page letter back saying what I could do. One thing about John: He never told you to do something. He told you something you might do. If you had any brains and thought about it, you'd do that. Once I came back to New York and he said, "I have a very wonderful idea for an anthology, Harry." "What's that, John?" "A collection of my editorials." I said, "Christ, that's an idea." "I want you to do it." I said, "Christ, that's an idea!" It really was a good idea. He was a great editorialist and he pulled out the good ones.

A. E. van Vogt: I have many letters of Campbell. He wrote long letters. The one thing you notice about them is that they're single-space and they run two, three, four, five, and six pages. Now receiving a letter from Campbell, in other words, is an event. Because you have to take time off from earning a living in order to read it. I wouldn't necessarily read that letter right away, but I would eventually get to it and eventually answer it.

Frederik Pohl: The way he wrote his editorials impressed me. He talked them out with people so that by the time he put them into type for the next issue, he'd heard every possible argument against them, and he could defend it.

Anne McCaffery: He didn't believe his editorials. He would make you think he did.

Campbell's Later Years

Isaac Asimov: To the very end, he was always the same John Campbell, extremely talkative, extremely.

L. Sprague de Camp: In his later years, beginning around 1950, Campbell became a little odd. He began going in for one fringe or borderline scientific exploration after another, including some that were pretty goofy. You

know, the Dean drive, F2 levitating device, and the Hieronymus machine, and so on. I suspect that the reason was that he had tried himself in his twenties to become a scientist. He'd graduated from Duke and had one or two laboratory jobs, but he found he really didn't like that sort of thing. He much preferred literary work. But he still had this hankering to become known and, I think he figured that if he couldn't be a great scientist himself, maybe he could be the discoverer of a great scientist, you see. So he went in for magnetic monopoles and all sorts of things that didn't pan out.

Anne McCaffery: We never discussed Dianetics but I don't think he believed it. I think it was an interesting story, and it certainly has had far-reaching effects, and he published the original story, but I don't think he had any idea at the time L. Ron Hubbard came out with it that it would take off as a cult. The antigravity device, that was a marvelous idea, that was a marvelous story. I liked that story. I can't remember the name of it, but they have the film of a man actually using an antigravity device about the size of backpack, and unfortunately he's killed, and so they make the government scientists, by proving that it can be done, and force them to do it. And they come out with the denouement of the story. It hadn't been done. It was an actor. This is what John liked to do. He liked to take you and shake you up and make you look at things from a different perspective, and this was his function as an editor. He was bloody good at it.

Isaac Asimov: Now nobody can remain innovative forever, and gradually the field went beyond John. By the time 1950 came around, science fiction had to some extent outgrown him and showed this in two ways. One was, of course, that *The Magazine of Fantasy and Science Fiction* started in 1949, *Galaxy* started in '50, and they marked a new mutation. And it was time for it. And secondly, in 1950, John Campbell published "Dianetics" in the magazine and somehow took what I considered to be a wrong turning. He became interested in mystical things, peculiar things, and alienated some of his writers in this way. And somehow turned *Astounding* into not quite the magazine it had been. I don't fault him for that, necessarily. What he had done in the twelve years of the Campbell Golden Age much more than makes up for the peculiarities of his later years. And even when he was no longer the great Campbell, he was still better than any of the other three [Anthony Boucher and J. Francis McComas of *The Magazine of Fantasy and Science Fiction* and Horace L. Gold of *Galaxy*. — Ed.]. He had faded only in comparison to his own greatness, and not necessarily to the rest of the field. And he was still capable of doing great things, too.

Until 1950, I was a Campbell author. I did not want to be anything else. I was a Campbell author to the extent that I was honestly afraid that if anything happened to Campbell, I would no longer be a writer because I could only write for him. After Dianetics, somehow things faded a little with me, and I never quite felt the same about Campbell and *Astounding*. Although

I still published with him. My novel *The Currents of Space* appeared in *Astounding* in 1952 and *The Naked Sun* appeared in *Astounding*, I think in 1957, so my relationship wasn't cut off. But it wasn't the same sort of idolatry that existed before, and then too *Galaxy* asked me for stories and I found a certain freedom in writing for Horace Gold. On the one hand, he too had his peculiarities, in some respects much more serious than those of Campbell, but it enabled me to do things I couldn't do with Campbell, and I seized the opportunity.

Horace L. Gold: John Campbell helped us get started at *Galaxy* because Street & Smith paid a top [fee] of two cents. They bought all rights, and Campbell was plugging Dianetics to the point where the writers didn't want to write for him. They couldn't write for him. They couldn't get their first serial rights, so they came to us. And they came to us in such numbers — new ones, old ones.

Harry Harrison: No, John Campbell didn't bring *Dianetics* to the world. He serialized it a bit, and almost apologized for it years later. He brought the Dean drive to the world, and he brought the dowsing rod. He did a lot of those things, but there was a lot of life in the magazine, I'll tell you that much. We all have our secret vices, but for his sins, which were tiny, his strengths were great.

I did Campbell's last issue, in a sense. At his funeral, Jim Gunn said that we should do something to memorialize him. So I did *The John W. Campbell Memorial Anthology*. Having been an editor at that time, I talked to all the guys and for some reason, they all wound up serious. Clifford Simak did the last *City* story. I did one *Deathworld* story, a short story, and never did another one. It was very nice collection.

Isaac Asimov: After having Campbell come up with ideas for twelve years, I was wondering if I could think up ideas for myself. In addition to that, I found that it rather a little bit spoiled the stories for me because when people talked of "Nightfall" as a classic, I knew darned well that he had suggested the idea. I used to worry about whether it was really my story.

Eventually, I settled the matter to my own satisfaction. I figured that he gave me the idea, but I was the one who had to fill the empty pages. As a matter of fact, he told me that on a number of occasions in later years, when we could talk on an equal basis, when I was no longer so in awe of him that I was tongue-tied, he would say to me that well, sure, he gave everybody ideas, but if someone wrote a story and just handed his idea back to him, he didn't give him anymore ideas. What he wanted was an idea that was a starting point and ended up with something more. Furthermore, when I said to him once when I was feeling a little bit in a lachrymose mood, "You know, Mr. Campbell, you made me what I am today," he said, "No I didn't, no I didn't. I helped fifty or a hundred authors. There's only one you."

Chapter Five
World War II & Beyond:
Science Fiction in the Forties

THE CONTINUING CAST OF THE BOOK
(IN ORDER OF APPEARANCE)

Alfred Coppel (1921–2004) Prolific novelist who began in science fiction writing for *Planet Stories* and other pulp magazines, and later wrote best-selling thrillers, many of which contain science fictional elements.

Larry Shaw (1924–1985) Short story writer, editor of *Infinity Science Fiction*, *Science Fiction Adventures*, and *If* magazines, and Lancer Books and Dell Books in the 1960s.

Robert Sheckley (1928–2005) Novelist and short story writer from the 1950s to the early 2000s, most noted for his comic satires.

Alva Rogers (1923–1982) Longtime science fiction fan and artist; author of *A Requiem for Astounding*, the definitive history of that magazine.

World War II and its aftermath dominated the decade of the 1940s. In the world of science fiction, John W. Campbell and *Astounding Science Fiction* reigned supreme but there were other magazines and editors in the field. It was a time when paper shortages dictated the size of magazines, and an entire generation came of age fighting the last great good fight.

Damon Knight: I was in Salem, Oregon in 1941, going to art classes, and Don Wollheim[40] published my first story, which I sent to my then agent, Doc Lowndes. Got a letter from Lowndes saying "Wollheim has this new magazine, *Stirring Science Stories*, but he has no budget. Will you donate the story?" Of course, I would have paid them. The story was called "Resilience." The printers introduced a typographical error in the first line, which made it completely incomprehensible. They changed "brittle men" to "little men." But I don't remember being crushed by this. I was a little disappointed but was still thrilled to have an actual story of mine, with my actual name on it, printed in a magazine. That's one of the great moments, when you first see your name in print.

40 Donald A. Wollheim (1914-1990), science fiction editor, publisher, writer. Along with his stories, known editor for two mass market paperback publishing houses, Ace Books (1962-1971) and his own DAW imprint afterward. Dick Lupoff used to say of Wollheim that for a committed leftist, he was one hell of a capitalist. From the perspective of the three of us, he was at the top of our wish list for interviews, and one of the ones who got away.

World War II & the Science Fiction Pulps

Julie Schwartz: During the war years, very few pulp magazines were being published because of the shortage of paper.

Theodore Sturgeon: Street & Smith produced millions, literally millions of books, that were done by the same presses as the pulps. They were printed in 8-point myopia type and sliced in half, and the books were therefore 4"×8", narrow books. They ran them off by the millions and distributed them to the armed forces overseas.

Frank M. Robinson: Ziff-Davis used to put out special wartime issues of *Radio News*, *Popular Photography*, especially *Flying*, *Popular Aviation*, I forget when they changed the title. They were these big 320-page magazines, just chock-full of advertising. The extra paper came from the fiction field. Both *Amazing* and *Fantastic* had been these great big thick magazines, 276 pages. *Mammoth Detective*, when it first came out, was 320. They chopped down the size to 225, eventually 178, something like that. Most of all, they cut the frequency from a monthly to a quarterly, for each of them.

Fritz Leiber: John W. Campbell had his problems at *Astounding*. He lost Heinlein and Asimov and de Camp to the war effort. They were at the Brooklyn Navy Yard doing some sort of research. And Hubbard too. And Campbell, when he had a writer going well, he tried to get as much as possible out of them at that time. So that for a while, just before the war, or before we got into it, Heinlein was turning out half the contents of *Astounding Stories* under various names, Anson MacDonald especially, as well as Heinlein. And then when they went, Henry Kuttner largely replaced them, I'd say, and was furnishing an awful lot of material for the magazine.

L. Sprague de Camp: During World War II, I was a lieutenant commander in the U.S. Naval Reserve. Robert Heinlein was a civilian engineer and a retired naval officer; he was retired early in his career for medical reasons and they wouldn't let him back in uniform. Isaac Asimov was a civilian chemist. Heinlein had a classmate from Annapolis named A.B. Scoles, with whom he kept in touch, and Scoles knew that science fiction writers had been writing all about death rays and space ships and he thought, If I could only get a few of these fellows with technical background down here to Philadelphia, maybe we'd win the war in one easy lesson. So he arranged a meeting, and I was persuaded to come down there. That is, Scoles said he would write a letter in the proper channels to have me assigned to his activity as soon as I finished my basic training, and so the three of us worked down there. We didn't work together. We were in different sections working on different projects, but of course being close friends, we got together every weekend when we could spare the rationed gasoline and socialized.

Theodore Sturgeon: There was a guy called Bill De Grouchy[41] who worked at Street & Smith and he handled their own comics line, they had a big comics line. There was a proliferation of brand-new comics at that time. World War II had just started, and one of the swiftest education things, particularly for people who didn't read very much, was comics, graphics. There were comics written on how to run a turret lathe, always with a little storyline to keep them interested. Some guy put a pipe in his mouth and was smiling. I wrote a series of books on boat building. How to do the struts and lay the gunwales and the whole bit. All sorts of expert things done like that as instructional comics. So I did a number of those for Bill De Grouchy, through my association with John W. Campbell.

L. Sprague de Camp: You're probably familiar with Charles Berlitz, the inventor of the mythical Bermuda Triangle. A few years ago, Berlitz coauthored a book called *The Philadelphia Experiment* about how there was an experiment during the Second World War at the Philadelphia Navy Yard in making a warship invisible, and if anything, it was too successful because the U.S.S. *Eldridge*, a destroyer escort, popped through the fourth dimension and reappeared in the Norfolk Navy Yard, two hundred miles away, then it popped back again, leaving the crew in a somewhat nervous condition, which I can't blame them.

When that nonsense came out, a fan wrote me, saying, "Ah, now I know what you and Heinlein and Asimov were up to." I wrote the man that I'm sure an invisibility experiment would have been more fun than running endless tests on hydraulic valves and windshield deicers for naval aircraft, which is what being a mad scientist inventing secret weapons boils down to, in practice.

A. E. van Vogt: John W. Campbell predicted the invasion of Europe, D-Day. He was wrong only within two weeks. He thought it would be two weeks earlier than it was. He wrote this letter to me, from the U.S. to Canada, and nobody stopped it, and he also described, in another letter he wrote me, he described an experiment he had seen in the atomic energy situation, and he wrote that to me, and that came through to me.

Of course, Campbell was ahead of all the others. In that 1938 issue of *Astounding* where he reported the work of those two German atomic scientists, he said, "This is it. Mark my words, ladies and gentlemen, this is the solution to the secret of atomic energy."

Robert Bloch: My character Lefty Feep came about in a very strange fashion during World War II. I had a close personal friend, I went to high school with him, named Harold Gauer. He's the Midwest regional director of CARE, has been for a long time, but back in the thirties we had an ambition to write, both of us. I was writing professionally, he wanted to, and we also wrote for our own amusement. When I first visited Henry Kuttner, back in

41 W. J. De Grouchy

'37, one of the first things he and I did was to sit down and turn out with the aid of an artist, an imitation issue of *Weird Tales*, in which we parodied the styles of all the major writers. This was the sort of thing that you did for your own amusement.

Harold and I wrote a book called *In the Land of the Sky-Blue Ointments*, which dealt with a collection of people who gathered together and like the *Decameron*, each one recounts a story. We invented a lot of characters, and one was a guy named Lefty Feep who was a writer. Had nothing to do with the character that I later developed.

But the time came when I wanted to imitate people's styles, and I did. I did Thorne Smith imitations, and I decided to do a Damon Runyon imitation for I think it was *Weird Tales*. And I wrote the story, in the first person, in the Damon Runyon style. Then I did a sequel to it which appeared in *Unknown Worlds*, and shortly thereafter, Ray Palmer said, "Why don't you do some new ones for me?" So I took that style and took the name Lefty Feep for the principle character, and told these stories in a framework. Each story had Lefty Feep coming in, getting introduced, and going off on one of these Munchausen fables. I did twenty-three of them. I gather they were popular with the readers.

They were dreadful things, by and large, but they were popular at the time, and this was the time of the war, and so Lefty Feep was always getting mixed up with Nazi spies, and Japanese spies, and war work in general, and it dated them, but at the time it seemed to work well for the readers. And I gave up on it merely because writing twenty-three of them, I was still getting a penny a word, which was what I got when I started, and frankly, it didn't intrigue me by the end of the 1940s because I was going for bigger things. I wanted that cent-and-a-half word market, you know.

On the Home Front: the Magazines Continue

Fritz Leiber: I thought I was doing amazingly well in 1943 by writing *Conjure Wife* and *Gather, Darkness!* in one year, and a few short stories besides. But I heard afterward from Henry Kuttner that Campbell was very unsure about me because I was so slow. Didn't write fast enough, dammit. Actually, that was about the biggest writing year I ever had. Two novels, wow. Most people would be happy about that.

Damon Knight: In 1943 when I was twenty-one, there was an opening at Popular Publications where Fred Pohl was working, and he told me about it. He lent me a clean shirt, a white shirt, to apply for the interview, which shirt he never got back. Many years later I bought him a couple. I spent not quite a year laboring at Popular Publications, which then had, I think, forty pulp magazines. I worked on about three-quarters of them. That was my

first editorial job. It was a liberal education. They paid me twenty-five bucks a week, which even then was not much.

But I really think, looking back, that I was not exploited. Boy, did I learn in that job! I was the assistant editor. I did all the donkey work, including reading the slush. I did the layouts and all the little bureaucratic stuff for the printers, and all the copy editing in the magazines that I worked on. The stories were selected by my boss so I was not involved in that, and I had nothing to do with covers, but just seeing what went into the magazine and what was excluded taught me so much about writing.

Popular was divided into departments, four or five or six, I forget how many. Each head of a department would be responsible for a number of magazines. Each assistant editor would have, I suppose, the equivalent of two monthly magazines to do all the donkey work on. I did westerns, I did sports magazines, which I hated, I worked on mysteries. But no science fiction. At that time, during the war, there weren't any science fiction magazines to work on.

Raymond Z. Gallun: Fred Pohl, was he working for Popular then? He bought a story or two from me at that time. He was mainly my agent for a while. I was trying to swing to slick magazines, *Saturday Evening Post*, and *Collier's*. I'd cracked into *Collier's* a couple of times on my own, and then I cracked into *Family Circle* once. I liked the slicker-type writing, but I couldn't seem to make it stick. I went a little too esoteric, but I couldn't make it go there.

Julie Schwartz: I wasn't making enough money to get by, so I was Alfred Bester's agent, and he wasn't selling much, so he had a sideline writing comics. And his main thrust was writing *Green Lantern* comics. So one day in 1944 he came over to me and he said that down at *All-American Comics* they need a script editor, and I think you ought to go down and apply for a job. I said, "Alfie, I never read a comic book in my life." He said, "Doesn't matter as long as you can plot. Go buy a comic book, read it on the subway downtown, and then be interviewed by the editor there named Shelly Mayer. See what happens."

I think I read "Red, White and Blue," and then I read "The Ghost Patrol." I didn't want to read the longer stories — they were twelve to thirteen pages long, too long to bother — so I read the six-page stories. And I was interviewed, and evidently Mayer liked me enough to hire me. So I became a comic book editor, in charge of *Sensation Comics*, *All-American Comics*, *The Flash*, *Green Lantern* monthly, *All-Star Comics*, and *Comic Cavalcade*.

Writing After the War

Hugh B. Cave: I began writing for the slicks right after the war. In fact, during the war, the only other thing I did, other than war books, were sto-

ries for — do you remember *This Week* magazine? The *New York Herald Tribune* and all the big newspapers throughout the country published it as a supplement, like *Parade* today. I wrote stories for them. That was the first slick paper magazine that I sold consistently to. I had sold to some in Canada, and then I began to sell to the big slicks like *The Saturday Evening Post*. I ended up selling forty-three stories to the *Post* and thirty-four to *Good Housekeeping,* including a number of those big long gothic novels. Which, you know, they were very nice, they paid well. I wrote some adventure serials for *Country Gentleman* based on experiences in the war, based on backgrounds that I had seen, like New Guinea.

Some of the stories in the better pulps, like *Adventure* and *Short Stories* and *Blue Book,* were every bit as good as anything published in *The Saturday Evening Post*. It was just a question of sending these slick paper editors enough material so that they knew you were consistently good. They didn't buy one-shots, they bought authors rather than stories. I remember sending stories repeatedly to the slicks and getting nice letters and finally one after another began buying stories. At that time, the pulps were still going fairly strong. But I was writing for the *Post* and *Redbook* and *Collier's* and *Liberty* and *The American Magazine.* I had stopped writing for the pulps before they died.

When I wanted to move into the slicks, my agent didn't want me to. He was a great friend, but he thought I ought to stay as what he called, "A big man in the pulps." Because it was a sure income. But I wanted to move on. I wanted to get into something that paid better, but had a little more prestige to it, I guess. So, we broke up as good friends. I decided to go my own way and I did not take on another agent. I sold to all my slicks myself. And all the books, except the first four, I sold myself.

Alfred Coppel: I'd always loved science fiction so in '47, '46, or '47, I decided that was a good way to go because it was a genre in which there were few inhibitions, except sexual inhibitions. You couldn't write about sex in those days. There was no sex in science fiction. But there's a freedom in the genre that's really quite remarkable. You can really let yourself go. The pulp magazines were a marvelous school for writers because they taught you something very important, that many modern writers never learn, and that's that when you sit down to write, you damn well better have a story to tell.

Basil Wells: I wrote one book, a complete book, that was I think 62,000 words, and I never made carbons of it, and I had an agent at that time, Oscar Friend. He tried a few places and he sent it to England. Too bad. Never came back. I can't really tell you much about Friend, except that I sent him a few stories and he sold one, I think. I never had good experience with agents.

Hugh B. Cave: I thoroughly enjoyed the South Pacific as a war correspondent, and when I got home after the war, I couldn't afford to take the

family there. I had a wife and two children, two boys. So I hit on Haiti. I got a contract to do a book about Haiti and I went down there thinking I'd spend a few months there. The few months turned into five years. Going and coming and during that time I, of course, explored the island. I wore out four Jeeps exploring Haiti. And, of course, I investigated voodoo. I got into it quite deeply, in fact, to the point where I could go almost anywhere in Haiti and attend a voodoo service. I spoke Creole. And, of course, that all led to material for books.

Damon Knight: During the '40s, I did two hitches with the Scott Meredith Literary Agency, which was then, and still is I believe, a reading fee agency. Four or five of us sat in this bullpen and they would hand out the manuscripts in the morning. These were manuscripts from aspiring writers they'd sent in with a fee, which was five bucks for a short story and twenty-five dollars for a novel. Out of the five bucks for the short story, we would get a dollar for writing this letter, and the first letter was always to explain the Scott Meredith plot skeleton, which had seven bones.

I can recite them for you: you have to have a believable and sympathetic character who has a serious and difficult problem, that's your first two bones. He makes a series of attempts to solve the problem, each of which results in merely intensifying it. Then he reaches the crisis. How many bones have we got now? Four or five? Then he reaches the crisis — which, by the way, was Jim Blish's contribution to the skeleton and a very good one. And then the protagonist solves the problem by his own efforts and not aided by the U.S. Marines or anything like that. It's certainly not the only way to write a story. I found out years later by actually examining a number of stories that this turns up rather rarely in short fiction, though more often in novels.

Anyhow, our first letter to a new client would always be this letter explaining the plot skeleton and saying that your story doesn't measure up because it doesn't have these bones. Then the next time they'd send another story, you'd report that this one didn't follow the plot skeleton either and so on. We either got a dollar for each letter, or a flat rate of twenty-five bucks a week. We had to meet a quota so it came out to about the same thing. So this was an interesting experience for me because I hadn't realized what a happy shop Popular Publications had been.

Larry Shaw: I worked for Scott Meredith for a year, that would have been 1948, and I have very ambiguous feelings about him, and have ever since I worked for him. Very mixed feelings. In many ways, I respect him enormously. As an agent he is scrupulously honest within the absolute strict letter of the law. I certainly do not approve of all of the things he has done, and again, he was a tough man to work for. He was fair, but he was very demanding and tried to discipline very strictly. I have to say that I learned a great deal while working for him about the construction of fiction and about

publishing in general. I would not want to have to work for him again, but I have to give him a lot of respect in many ways.

Philip Klass: Back in the days when I was trying to break into the pulps — this was back in the middle '40s — you were not to be considered very much if you didn't have a tremendous production and had to write under many pen names. So even though I never had a tremendous production, I had a lot of pen names. When I came out of the Army, I wrote about fifteen or twenty pieces, each one in a different area, the first one was a science fiction story under the pen name of William Tenn, and so I used it. Years later, when my first book was published by Simon & Schuster, I had by that time been using it for some time. I sort of felt that I'd like to have my own name appear on a book. I mentioned this to Simon & Schuster and they said, "Who the hell is Phil Klass? William Tenn sells books."

Amazing Stories & Fantastic Adventures: Palmer & Browne Hold Down the Fort

Howard Browne: In 1942, I went to see Mr. Davis. There was Ziff, and there was Davis, only Ziff was never in Chicago, hardly ever, he was in Washington, doing Air Force stuff. They had F *Popular Aviation*,[42] *Popular Photography*, big magazines. Ziff-Davis Publishing Company during the war was at the Diana Court Building in Chicago, on the seventh floor. You go in, and there are reproductions of covers, laminated into the wall, and you go over to the switchboard operator, who sits behind glass, and she presses a button, and the glass rolls back, and she says, "What can I do for you, please?" She looks like she just won Miss America, or something. There was never an ugly girl ever hired by Ziff-Davis the years that I was there.

Anyway, Mr. Davis sat in a big room, you had to walk across half a mile of carpet up to your knees, and here he sits behind — not a desk, but kind of a semicircle of leather, which was about two feet wide, that was his desk. The walls were in the same color leather.

He said, "Won't you sit down? I've read your new story and I was very impressed."

I'd been writing detective stories, like S. S. Van Dine. He said, "I like these very much. I hope you can be the editor of the magazine." Well, you could have laid a dead fish in my lap.

I said to him, "Mr. Davis, you're the first editor I ever met. I have absolutely no idea what an editor does."

He said, "I could teach a high school graduate in two weeks how to edit a magazine, but I can't teach him how to write. You're a writer, and I want to hire an editor who's a writer."

42 *Popular Aviation* became *Flying* in 1942.

"Well, I have another job," I said.

"May I ask what you make?" he said.

I told him, and added twenty five dollars a week. He looked at me almost pityingly and said, "Well, we can do much better than that." He didn't know it yet, but he'd hired an editor. So he said, "When can you start?"

"Well, I have to give notice," I said. "I can't walk off the job."

He said, "Well, will a couple of weeks be all right?"

"I think so," I said. Actually, I wanted to take a vacation. I had a vacation coming.

"All right," he said. "But your salary starts this coming Monday." Mr. Davis brought in Ray Palmer, and said, "Hey Ray, this boy is your assistant editor." Since my magazine was a quarterly, I would help Ray on the science fiction books, but I would have complete charge of the detective books.

Frank M. Robinson: Browne pretty much ran the mystery magazines the way he wanted to. He had very little interference from Ray. Ray didn't care much for mysteries. Browne really never cared much for science fiction. So in that respect it was a perfect match.

I started working at Ziff-Davis in 1943. I had a grandfather who was a sports reporter for the *Chicago Herald-Examiner*, and he got me a job as a copyboy in the teletype department at International News Service, which was an organization like AP. Later on they combined with United Press and became known as UPI.[43] I worked there for about a year and then heard about an opening over at Ziff-Davis. This was during the war years, where if you were ambulatory you could have most every job you wanted. So I was making $17.70 a week at INS and went over to Ziff-Davis and they offered me all of twenty-five bucks a week, plus I could be working with two of my heroes, Ray Palmer and Howard Browne. So I started as office boy and hung around Palmer and Browne as much as I could.

Palmer had started working there in '38, so he had been there a while. Nice guy. Hale-fellow-well-met. Never took anything too seriously. Browne at the time was a big bear of a man, coke-bottle lenses, balding. A more serious editor than Palmer was. Browne I liked a whole hell of a lot. He was a nice guy without pandering, just a nice guy naturally. I got along great with Howard. Both of them gave me a lot of tips on how to write.

Howard Browne: Ray and I got along, but he didn't like my highbrow attitude toward his stories. I said, "You could be a lowbrow and hate your stories, Ray."

Frank M. Robinson: A lot of the writers were local, from the Chicago area. They used William Hamling, Chester Geier, Robert Bloch, David Wright O'Brien, and William P. McGivern. McGivern was a Howard Browne protégé

for the mystery magazines, later on did some science fiction. David Wright O'Brien, Palmer considered him a second son. He went down in flames over the bombing of Berlin, which really bothered Palmer a lot, although he never really let on much.

Richard Wolinsky: William Hamling had been a science fiction fan in the '30s and began writing for *Amazing Stories* in 1939. He was soon working for Ray Palmer at Ziff-Davis. By 1948, he'd become managing editor of *Amazing Stories* and *Fantastic Adventures*.

Frank M. Robinson: At the time when I was there in 1943, Hamling was not there. Hamling and Chet Geier had gotten an office, a real writers' office, a room for each, an anteroom with a broken-down couch, and two typewriters there. And I thought this was heaven. When I was drafted and went into the Navy, I used to stop by their offices and sell 'em my cigarette rations.

Howard Browne: When my novel *Halo in Blood* came out in 1946 and sold very very well, the president of Bobbs-Merrill said to me, "We would like to make a deal with you to do at least three more and we'll give you a good advance and see that you'll get advertised," the usual lies. So I went back to Davis and said, "I'd like a two-year leave of absence because I've been offered an opportunity to write some novels." And he said, "Well, let's talk to Ray." Ray came in, talked about it, and Ray said he could hire somebody on a basis until I came back, and that was fine. So I took a leave of absence, came to California, bought a house in Burbank, and I continued to write for the magazine. I would spend a certain number of days a week on writing for the magazine, I think it was three and three, I took Sunday off, and they paid me three cents a word and I wrote *Forgotten Worlds* by Lawrence Chandler. It was a story about a flyer in World War II who was flying over Germany and he goes through a time warp and ends up at the time of Atlantis, only he lands on the coast of Africa. Gets involved with a native girl and all hell breaks loose and he ends up in Atlantis.

Ray Palmer & the Shaver Mystery

Frank M. Robinson: The first issue of *Amazing Stories* with the Shaver Mystery[44] came out in 1943 while I was still working at Ziff-Davis. Let me tell you something. Hoaxes are like tigers. You can ride them but you don't ever dare get off because legally it can be your ass. You have misled people. They have made decisions based on this, that, or the other thing. They can sue you down to your shoelaces. Palmer rode it to the bitter end.

The Shaver Mystery was about a bunch of bad little dwarves in the center of the Earth who cause everything bad that happens on this surface. They are referred to as "Deros." The legend, and this is probably as correct

44 The letter "An Ancient Language" was published in the January 1944 issue, which might well have seen the light of day in December, 1943.

as anything else, is that Browne had discovered this letter in the slush pile, with this guy who had the language of the Deros all figured out. Howard showed it to Palmer on the grounds that this guy was completely knocked out. And Palmer said, "I can write a story about that." Palmer, at least initially, wrote most of the Shaver stuff. I think Shaver later on learned enough to do some stories on his own, and I believe that not all of them are Shaver Mystery stories. Some of them are science fiction of no particular importance.

Forrest J. Ackerman: I think the publishers were thrilled with Palmer because primarily they were in business to make money, and it seemed that the circulation went revving up. But in our science fiction club in Los Angeles, we began to be deluged with all kinds of people who were primarily interested in Deros and flying saucers and occult and metaphysical things.

Richard Wolinsky: Palmer was writing this stuff. He knew it was fiction and he played it as if it was fact.

Frank M. Robinson: All the way. All the way through, and Chet Geier even published a little fan magazine about the Shaver Mystery at one time, issues of which are very difficult to get now and are worth a bundle.

Stuart J. Byrne: Richard Shaver was corresponding with me in South America when he was in Chicago. I had ended up in South America, working for the airlines, and had a chance to go up into the Andes and follow the trails of Pizarro. I wrote some articles for the pulps when I was there.

So when I came to Illinois, I zeroed in on Richard Shaver and that was when he was living south of Chicago. I was pacing around in his room, and he said, "You seem kind of nervous."

"Yeah," I said, "and I don't know what's come over me. I feel like I could take that typewriter there and throw it through the window."

He said, "Yeah, they're after you."

"What do you mean they're after me?"

He said, "Well, you see, Max, the little guy in the caves, has these ray machines and he's queer for me and I can't help it, but he wants you out of Chicago. So he's sending it to you." I thought, Is this guy hypnotizing me or something?

Later, at a party at Ray Palmer's place, I went up to Shaver and I said, "Call these guys off. I got swords up my back. I can't stand it."

He said, "I can't stop it."

That night, in my hotel room, I actually had weird nightmares like I was floating six feet off the bed and giants were crawling out my armpits with razor blades. So the next day I was going up Western Avenue in Chicago to see an author friend of mine, and I had sulfur in my lungs. I couldn't breathe. They didn't have any construction going around. So I tried an experiment. I just looked at the sidewalk and I said, "Max, lay off, will ya?" Boom, I went out of Chicago.

Let me tell you another amazing story. Ray Palmer had some property in Wisconsin and for a while Shaver lived there. I asked Ray, "Is Shaver giving you anymore stories?"

He says, "Yeah, and I can't use them."

"What do you mean?"

He says, "Well, he tossed one on my desk the other day, about a month ago, and I asked him when he was going to give me a story. He said, 'I did.' I showed it to him. He couldn't read it himself. It was written in old English, but he wrote it." Shaver couldn't read it himself. It was in Old English, the manuscript. Beowulf-type Old English and he didn't know why.

Forrest J. Ackerman: We got a phone call one time at the Los Angeles Science Fantasy Society. A lady said her brain was being taken over by Deros. We were very unhappy that *Amazing Stories* was becoming the focal point for all the fringe fans of science fiction.

Stuart J. Byrne: Once, when I was taking Palmer around the Richard Shaver stuff, I told him there was something wrong with this being under the ground in caves. He said, "What if it's in the astral? There's an area beyond the surface of the Earth that astronomers can detect, an energy layer that seems to be the astral surface, and it's beneath that astral where these caves are, and they're really above the physical Earth." Palmer always had these strange, way-out ideas.

Forrest J. Ackerman: Ray Palmer was to editing and publishing as Ed Wood was to movies. He was the Ed Wood of pulp science fiction.

Frank M. Robinson: That's very unfair. Palmer knew what good science fiction was. Palmer even sold to Campbell. He wasn't a bad science fiction editor. He was a very commercial science fiction editor. Palmer was hired at Ziff-Davis to sell magazines. The high point of Palmer's circulation at *Amazing* was 185,000. No science fiction magazine has ever equaled that.

Harlan Ellison: I just adored Ray Palmer. Ray Palmer was the P. T. Barnum of science fiction, and Ray believed there was a sucker born every minute. And he was absolutely right. I think Ray Palmer was one of the dearest men who ever lived. He was absolutely a rara avis. If you look in the dictionary under the word "unique," there'll be a picture of Ray. Ray Palmer was a three-ring circus, not to mention that he was probably one of the savviest editors the field ever produced.

Planet Stories: Pulpiest of the Pulps

Larry Shaw: The first New York editor that I met was W. Scott Peacock, or Wilbur Peacock, editor of *Planet Stories*. I had been writing letters to the letter column of *Planet Stories*, and they were published, which was a big thrill at first. Once I had the temerity to write to Peacock telling him that I was coming from Schenectady to New York City for a weekend, and I would

love to meet him if possible. He wrote back and said he'd be happy to meet me if I would care to visit him, I could find him in his room in the YMCA. I did find him in his room in the YMCA. He took me to the offices of *Planet Stories*, which was published by Fiction House, which published several other pulps too. I found that he not only edited *Planet Stories*, but wrote for the other pulps, including *Jungle Stories*. I believe he was late with a *Jungle Stories* novelette that particular weekend. I also found that the Saturday I visited him he had just received a letter from his mother urging him to get out of that horrible New York City and come home. I don't remember where exactly, somewhere in the Midwest, possibly Indiana.

Basil Wells: I think really that Malcolm Reiss and Wilbur Peacock, who worked with Reiss at *Planet Stories*, gave me the most incentive to keep writing because they'd keep writing me and say, "Send some more, send some more stories. We need 'em," and well, I only had some spare time, see. I was working full-time at the zipper factory and I had a family, so I had to keep going. They didn't offer any specific suggestions. They just wanted plenty of action. I went along with them on that.

Raymond Z. Gallun: Malcolm Reiss was a very fine chap. He used to take us out to lunch. Jerome Bixby was working there and oh gee, I used to hang around the place. That's the one place that I really hung around, and Mal Reiss was a very nice guy. I sold a few stories to him. I remember there was one called "Dawn of the Demigods" that was the longest one, and there was something called "Big Pill," and there was something called "Return of a Legend," which has been anthologized a number of times. A couple of others.

Frank Kelly Freas: I was in art school but I was also running a commercial art business on the side, sharing quarters with an advertising agency, doing television, billboards, and that sort of thing. Eventually I gave that up to go to New York because my fiancée left Pittsburgh for New York, and I saw no reason to stay in Pittsburgh. Immediately, I had to find some way of getting over this hump, and it was pure blind luck that Fiction House moved out of Manhattan at precisely that time. Now I didn't have sense enough to know that I didn't have to go to Stamford, Connecticut to see them, but nobody else in New York was about to do it. So I would drive up to Stamford, read a manuscript, do a doodle in there, come back, work up a very detailed pencil drawing of the finished job, take that back to Stamford, and get the okay on it. Come back and do the finished rendering and deliver that. Well, inside of a year I was doing all the art for *Planet Stories* because I was the only one who wanted to go as far as Stamford, Connecticut to get the job.

Raymond Z. Gallun: They paid the basic cent a word, which wasn't too bad, and there was no problem getting the money. If you got stuck, Mal Reiss was a fairly easy touch. I mean, if you needed a few bucks to get by for the next week, well, that was all right. He could do that. And altogether we had

quite a nice relationship. I remember, though, that across from the Fiction House office, there was a church. They were constantly ringing the bells over there. The chimes were penetrating the office and I think it was Jerry who said, "Yes, around here we've all become devout atheists," on account of those bells.

Basil Wells: My name is on the cover of *Planet Stories*, Fall 1946, but there's no story. It just didn't make it. That happened two or three other times when I would be listed on the cover, then it would be in a later issue, or something of that sort. I think it was crowded out the last minute, perhaps, or something. Didn't have room enough. You expected to have that happen.

Richard A. Lupoff: Wally Wood was one of the leading comic book illustrators of the 1950s. Some of his science fiction work for the EC line — *Weird Science*, *Weird Fantasy*, *Incredible Science Fiction* — can stand alongside the finest book or magazine illustrations done in the science fiction field. He did a little pulp illustration, as well, but in my opinion not nearly enough.

Frank Kelly Freas: Wally Wood and I were good friends for years, the funny part of that being that I always was interested in doing continuity and wasn't worth a damn at it, and Wally was also interested in doing single book-type illustrations and wasn't worth a damn at that. The problem was that we thought in directly opposite directions. He would take maybe five thousand words and turn it into twelve pages of illustrations whereas I had to take fifteen to twenty thousand words of story and boil them down into one illustration. It's a totally different way of looking at things. The fun part of it was that he influenced so many other illustrators. Everybody knew Wally's stuff, and his technical stuff was superb, and watching him draw was like seeing somebody pull down a curtain with a drawing already on it. He never made a false move. Fascinating to watch.

Basil Wells: "Queen of the Blue World" came along in 1941 in *Planet Stories*, with a Hannes Bok cover painting. That was in the winter of '41. Bok had made the cover and the painting didn't jibe with what the story was. He had her riding along with a bird on a sort of a sled, and the bird was pulling it, and that wasn't in it at all. So someone had to rewrite the first part of the story, and they dubbed that in, and I thought at the end of it, I'd never sell *Planet* another story. But it didn't make any difference apparently, because I sold ten more.

Richard Wolinsky: One of several magazines born in 1939 just before the Second World War, *Planet Stories* managed to survive the paper shortages and remain one of the few SF magazines to greet the boys coming home from Europe and the Pacific. *Planet* would even survive the advent of the new world science fiction order, the births of *Galaxy* and *The Magazine of Fantasy and Science Fiction*, and would eventually fade in 1955. Unlike

other magazines of the era, it never adapted to digest size, and died as one of the last of the pulps.

Thrilling Wonder Stories

Richard A. Lupoff: Mort Weisinger was succeeded as editor at *Thrilling Wonder Stories* by Oscar Friend, and then by Sam Merwin in 1945. When I was a kid science fiction fan, fifteen years old, my greatest ambition was to be a science fiction writer, and for some reason, I don't know why, I just hooked on to *Thrilling Wonder Stories*. It was my favorite magazine, and to me there would be no greater glory than to sell a story to Sam Merwin, the editor of *Thrilling Wonder Stories*. Many years went by, and eventually I wound up as a writer after all, and turned around to look for *Thrilling Wonder Stories* with Sam Merwin as the editor, but he was no longer the editor. There was no longer a *Thrilling Wonder Stories*.

Theodore Sturgeon: There wasn't much market for science fiction at that time. I think John Campbell rejected a story of mine, and who else was publishing science fiction? It was obvious the Thrilling group was doing it. Sam Merwin was a big, bluff, hearty, whiskey-drinking guy. He was a two-fisted macho type. I remember Merwin's letters column. Sergeant Saturn. That was really something. It had fan letters from these little snot-nosed kids, like Ray Bradbury.

Legacy for the Future

A. E. van Vogt: Southern Illinois University Press is going to put out a hardcover version of the July 1939 issue of *Astounding Science Fiction* in which my "Black Destroyer" is the lead novelette, the lead story. It has the cover. So you can see how far we have come. Southern Illinois University!

Theodore Sturgeon: I was at a science fiction convention a few years back, and who should I run across but C. L. Moore. I knew her way back when she lived in Hastings-on-Hudson. This is long before Henry Kuttner [her husband] died, and she had since dropped completely out of sight, and she had married again and she wasn't writing anymore. I leaned on her. I said, "Hey, you've got to write again, or at least show up at some conventions." I don't know how she got to that one. It was a bookdealer who ran it and he had found her and got her out there. She said, "Get back into science fiction? Oh. Would they remember me?" C. L. Moore said that to me. "Would they remember me?" My God. She really believed that she must be long forgotten. She never will be forgotten. When she wound up as a co-guest of honor at the Worldcon, maybe I thought that had begun with the conversation with me. I got out my trumpet at that point. She was alive and around and had said such an extraordinary thing.

Hugh B. Cave: We never thought that this stuff would ever be reprinted. Ever. I don't think anyone at that time ever thought that rights would be valuable. Later on, when I moved into the slicks, I could request a reversion of rights. For instance, every time *The Saturday Evening Post* published a story, I would automatically write a letter to the business office and ask them to give me the copyright on it. And I would get it back by return mail. Once the story was published, they had no further claim on it, and no further use for it. But no one in the pulps, to my knowledge, ever thought of that. And now they're coming out in book form, in anthologies, in reprint magazines, and all. It's coming out all over the place. It's more than a fandom, it's a cult.

Harry Bates: In those days, authors had no rights. When you sold to Street & Smith, you sold all rights. They bought all rights to "Farewell to the Master" in 1940. So Street & Smith, owning all the property rights, when they were approached by 20th Century-Fox to buy the property, they didn't have the faintest idea how to negotiate, the faintest idea of the value of the story. And you know what they sold the story for? To MGM?[45] One thousand dollars! They took out a page in the *New York Times*, eight columns wide, "Bates Sells Story to MGM." Nobody ever heard of Bates before, but there it was. You have to do that in journalism, pretend. Well, I was somebody in a way, in a little corner.

So I called up my friend, Desmond Hall, who had worked for Street & Smith for years, and said, "What's the situation over there? They ought to get more than a thousand dollars, and I ought to get a piece of it even though I'd sold all rights." He said, "Of course." He was at that time the assistant agent to a well-known agent uptown. I only asked him about the situation, but he got on the phone in five minutes, and concluded a result whereby I got half. That's five hundred dollars. Now as a personal friend of mine, he was not going to accept any fee from me. But I made him take the 10%. So I got from that $450.

You know, the funny thing is, one irony is, that in their making of the film *The Day the Earth Stood Still*, they used only two things from my story. One, the name of one character, and the other, the idea that a ship from alien parts landed right there in the heart of Washington, DC. That's all.

Robert Bloch: You've got to remember, in those days, when we were writing for the pulp magazines for a cent a word and sometimes less, that certain conditions prevailed. A magazine came on the stands, it disappeared. Nobody would see it again unless it went into a secondhand store and you bought a copy for a nickel. There was no chance, really, for motion picture sales. Once in a great while something would be done on radio. When I say "a great while," I mean maybe twice a year at most. So you

45 " *The Day the Earth Stood Still* was produced and distributed by 20th Century Fox.

didn't aim at radio sales. There were very few science fiction films, and they weren't buying them from science fiction writers per se. You wrote merely for that penny a word, you wrote to survive. You didn't think, as you were writing, that ten years from then, or twenty years from then, or thirty years from then, or God help us, forty years from then, this stuff will be reprinted all over the world. Much of it would be adapted for television. A lot of them would get onto film. And as a writer your work would be considered in universities and be incorporated as part of seminars all over the country and all over the world. You weren't self-conscious about it, and you had to write hastily. I think, had many of us known what would happen, we'd have taken more care or tried to, and done better work. But we were very naïve as a group. I don't think anybody, with the exception perhaps of Robert Heinlein, had an eye cocked to posterity. The rest of us just wrote to keep body and soul together.

Harry Bates: You know, I was ashamed of all the stories I wrote, just to get a quick buck. Just for money. I was ashamed, and eventually one editor so botched my story that nobody could understand it. I got the fan magazines sent to me in which there were whole articles, "What did you do that for? What did you do this for?" It was all because the editor botched it. He thought that because nothing much was happening in a certain scene, he decided to cut the story to get it into the last issue of the magazine, *Science-Fiction Plus*. He took out the very heart and guts of the story, the things that made the whole thing understandable. And more than that.

I started reading, from the beginning, to see what had happened, and I found that in order to save single lines of space, he would rewrite the last parts of all such short paragraphs. Think of that. Single lines. And I don't know how long that went on. I got so mad after a while, I threw the magazine to the wall, I think, and have not seen it since. So they left out that important scene.

This is literally true, but it is very hard to believe, but in the years since 1940, I never told one friend or acquaintance that I was the writer of any of those stories.

They would come to me all the time and say, "Well here, you're supposed to be a writer. What have you written?"

"Oh," I said, "it was science fiction, and it was published on pulp paper, which quickly yellows and crumbles," thereby lying in the sense that I didn't tell the complete story, that all the better stories were in anthologies all over the world, even in their imperfect form, written just for the bucks, you know.

Let this sink in. Not one time did I tell anybody in forty or whatever years it was, that stories of mine were accessible to be read, that I had written them. A couple of friends found out, but that was different. So you will see I was ashamed of them. Not the storylines, but the bad sentences. If I had a thought for a sentence, I'd write it down and then if I once thought of

a better way to say it, I'd write that down, and I'd keep them both. Because they were both worth a cent a word. What could be more stupid?

Masters of the Genre, Part One: Robert Heinlein

Forrest J. Ackerman: About a month before Robert Heinlein's first story, "Lifeline," appeared in *Astounding*, I was in a secondhand book and magazine shop and this very distinguished looking gentleman with a nice mustachio was paying out, and he said to the proprietress that he was interested in three issues of *Amazing Stories* that had a serial by Edward E. Smith [E. E. "Doc" Smith] in them. She didn't have them so I waited until he came out on the sidewalk and spoke to him. I said, "Sir, I have three garages full of duplicate material, and it's very possible that I have those issues." So he came over and I had them and he bought them. The next month I saw this byline: "Lifeline" by Robert A. Heinlein. I looked him up in the phone book. I said, "Are you the Heinlein I met? Must be, you've already spent the money."

Frank M. Robinson: Robert Heinlein was the first guy I read who could come along and, in his stories, he could make the future seem real. The only guy, or at least the first of them. In Heinlein's future, you could see it, you could taste it, you could smell it. He had all of the information that you really needed. For "The Roads Must Roll" he had the business background, the technical background. He had it all down pat. He knew.

I interviewed Heinlein for *Playboy* at his home near San Francisco. A very dignified, a very reserved, a very formal-type guy, relatively slender, balding at the time. Erect carriage from his navy days. Professionally nice. You knew better than to cross him.

Ray Bradbury: Robert Heinlein was a huge influence on the history of science fiction. He was one of the new writers who wrote about human beings and wrote about psychology. Maybe I wouldn't have started writing human science fiction stories as early as I did if it hadn't been for Heinlein. He was my teacher, and when I belonged to the Science Fantasy Society down in Clifton's Cafeteria where we met every Thursday night in 1939, he came and joined the group at the moment he published his first short story. And we became friends, and I was invited up to his house on occasion to watch him typing, and that was a magic moment. Watching an established author type, huh? He let me read some of his stories ahead while he was writing them. He encouraged me, which was very important.

Forrest J. Ackerman: I was a bachelor working for the Academy of Motion Pictures Arts and Sciences, and I became kind of the fair-haired boy up at the Heinleins'. In those days, at the Los Angeles Science Fantasy Society meeting, I would get up and give what we called "Forrest Murmurings," which consisted of what I had found out, mainly through correspondence

with Edmond Hamilton and Ray Cummings and others, and I began a thing about what I saw in the home of Robert Heinlein. I was reading these wonderful manuscripts a half year or so before they were published, "The Roads Must Roll" and so on. At the meetings at the LASFS, I'd go, "Wait till next year. You'll be reading this wonderful story by Heinlein." I got a very cold telephone call from him. "Forry, you must understand – anything that you see or hear in my home, when you pass out the door, it remains behind you."

Heinlein and I began to drift apart in philosophy and psychology. A time came when I'd say "up," he'd say "down." If I'd say "right," he'd say "left." If I'd say "white." he'd say "black." We wasted an awful lot of time trying to convince each other of anything. I said, "You have your whole coterie of fans and I have my life in fandom, and I suggest we just give up trying to convince each other of anything. We go our mutual ways. If we pass at a convention, why, we can nod to each other."

Ray Bradbury: Isaac Asimov and I met when we were both nineteen years old in New York City. He had just sold his first short stories to Campbell. I'd sold nothing. We never got to know each other. We've done a few broadcasts together over the years. But he was never an influence the way Heinlein was.

Masters of the Genre, Part Two: Ray Bradbury

Julie Schwartz: When I was an agent, a young fellow came to the first World Science Fiction Convention, 1939, and kept asking me ... he wanted to become a writer, would I please try to sell his stories. This kept on for two years till I finally agreed to try agenting his stories. His name was Ray Bradbury. When I sold his first story, he was thrilled and excited. I sold his first seventy stories until I got involved in comics.

Ray Bradbury: I went to a convention when I was twenty-six years old, a science fiction convention. I hadn't published my first book yet, but Robert Bloch showed up and I heard his voice across the room say, "Where's Ray Bradbury? I want to meet him." The voice I remember forever, because it was the first time anyone ever asked for me.

Julie Schwartz: There was hardly any market for science fiction at *Weird Tales*. One of my clients was Ray Bradbury, and I told Ray, "If you want to make it as a professional writer, you've got to branch out. You can't just live on science fiction at *Weird Tales*." He said, "What do you suggest?" I said, "I think almost anyone can write mystery and detective stories. Why don't you take a crack at it?" So Ray Bradbury sat down, wrote, and sent me a story. I looked it over. It sounded pretty good. I was about to deliver it to Popular Publications. They were paying a penny a word. And just before I left, I get a telegram from Ray and he said, roughly, "Please insert the fol-

lowing paragraph at the end of my story. I forgot to include the motivation for the crime."

W. Ryerson Johnson: I remember at Popular we published Bradbury's first mystery story at *Dime Mystery*. We got his story from an agent, Julie Schwartz, who brought it in. Beautiful story, but it was tragic. I took it in to Rogers Terrill, the editor, and recommended it. Rogers read it and he said, "This is a nice story, but it's not our pattern, our type of story. If you want to rewrite it to make it our type of story, I'll buy it." So I ruined three of Bradbury's stories to make them turn out good when they never should have turned out good.

Ray Bradbury: In 1949, my wife was pregnant, we had no money, we had forty dollars in the bank. I took the Greyhound bus to New York, which is a dreadful way to travel. Four days and four nights turning into a ball of fungus. Stayed at the YMCA, five dollars a week, and had meetings with various editors, all of whom said, "Don't you have a novel?" I said, "I'm not a novelist, probably never will be," and they said, "Well, goodbye." No one wanted to take any of my stories. Well, I had dinner finally, the last couple of nights I was in New York, with Walter Bradbury of Doubleday, no relation, and during supper he said, "Don't you have a lot of Martian stories?" I said, "Yes, I do." He said, "Well, can't you tie them together somehow and make them into *The Martian Chronicles*?" He said, "Go back to the YMCA. Type me out an outline tonight, and if I like it, I'll give you an advance tomorrow." So I spent half the night typing out an outline, went back the next day, and he says, "That's it. You get your advance." Seven hundred dollars. He says, "Don't you have a second book?" "Yeah, more short stories." He looked at the list, and on the list was "The Illustrated Man." He said, "Isn't there some way of tying these together so it looks like it might be a novel?" I said, "Well, what about 'The Illustrated Man'? All of his illustrations come to life, one by one, the stories. And that's a nice fancy, that's a nice notion." He said, "That's good, I'll give you another advance right now." So I got fourteen hundred dollars.

All *The Martian Chronicle* stories were written over a period of five or six years, without my knowing that they would be connected some day. I was influenced by *Winesburg, Ohio* by Sherwood Anderson because I loved the book, which was not a novel. It's a book of character sketches. So I made a note, and I was going to write a book called *Marsport, Mars*, and I listed a bunch of characters like *Winesburg, Ohio*. I said, "Someday I'm going to do something as good as this," so that was the basic influence. I forgot all about it. I did all these stories, brought the expedition to Mars, let them out on the planet to see what would happen. I'm never in charge, I never know what I'm going to do. Somewhere in my brain, it knows what it's doing. I don't have anything to do with it. I just open a valve and let it out.

All those early stories in that book were experiments. I just sat at the typewriter, got some characters talking, and Ylla, I guess in the prime sen-

tence, she says that she's had a dream of some sort. I don't know how far into the story it is, probably in the first page somewhere. Then the husband says, "What kind of dream?" And she says, "That's silly. There are no people like that." Once that idea got fully started, then the story ripped through, it wrote itself. It has to be a story of jealousy, doesn't it? The husband is jealous of the dream and suspects it's real, that the Earthmen may be coming. And we know of course that it is real. So all these stories wrote themselves. The Earthmen knocking on the door and winding up in the insane asylum. I didn't know that was going to happen when I started the story.

Charles D. Hornig: Look at Bradbury. He's pushing space travel and he won't go up in an airplane. I had dinner with him the other day. He was in town at this creative encounter thing we had, and he took me to dinner, and he says, "We just have to go into space." I said, "Not you personally, right?" He said, "That's right."

Ray Bradbury: I gave my first lecture at USC in early 1950 to an English class and there was a banquet for Christopher Isherwood. They asked me to come, and I was introduced to him, sat with him for a moment. And six months later, *The Martian Chronicles* was published. I was in a bookstore in Santa Monica, and Isherwood walked in, and I thought, "My God," you know, and I grabbed a copy of my book, signed it, and gave it to him. His face fell, and I could just see what he was thinking.

But three days later, I got a phone call. It was Isherwood, and he says, "Do you know what you've done?"

"What have I done?"

He says, "You've written one of the great books, and I'm going to review it. I've just been given the job of reviewing for *Tomorrow* magazine, and it will be my first review."

So up to that point, all the intellectuals of course didn't want to have anything to do with me. And when Isherwood said I was okay in a huge article, which we could use all over the place, you know, well it changed my life. It changed my life completely around. And then he introduced me to Huxley, and to Gerald Heard. I was tongue-tied half the time because what do you say to Aldous Huxley? I'd read everything of his. It was a huge turning point in my life.

Howard Browne: My favorite of all science fiction writers is Ray Bradbury. Of course, I don't care what he writes about. It's a pleasure to read what he writes. You know, poetry.

Writers of the Forties

JACK WILLIAMSON

Jack Williamson: For my Humanoids series, I first wrote a novelette, "With Folded Hands," which said essentially what I wanted to say, that is, made the point that the perfect machine can be perfectly dreadful. John Campbell bought it, liked it, suggested that we change the title to "With Folded Hands" and write a sequel called "...And Searching Mind." He was enthusiastic at that time about Dr. Rhine's work at Duke University with ESP, parapsychology, and he suggested that human beings who don't use their hands would develop their psi capacity somehow and overcome the Humanoids. But I felt that the Humanoids couldn't be overcome, so in the novel they develop psi capacities too. The novel has been my most successful work, though the ending was not very satisfactory. I was subscribing to a clipping service when it came out, and I got probably fifty reviews, and no two reviewers read the ending in the same way. I swore for years I wouldn't do a sequel, but Fred Pohl gave me a contract I couldn't resist. The sequel is called "Ten Trillion Wise Machines" [published as *The Humanoid Touch* (1980) — Ed.] and although the Humanoids remain invincible, I did try to develop an alternative for some people so I feel that the new book is probably, well, esthetically superior.

ROBERT BLOCH

Robert Bloch: There came a time in the mid-forties when my first collection was published, and it was one story short. August Derleth had twenty stories and he wanted another story. I took a deep breath, and I wrote a story in a totally different style for the twenty-first story, called "One Way to Mars," which was published in *Weird Tales* also. But it was the Raymond Chandler approach, you might say, and it triggered me into the notion that it was possible to write not just supernatural horror, but psychological horror. I was more interested in what went on in the mind, which has its own share of dark corridors and twisted passageways. I began to explore that, and I began to update my styles and my locales for the fantasy. Much of the science fiction that I wrote was, of course, fantasy in disguise. And today much of the science fiction that is being written now is fantasy in disguise.

ED EARL REPP

Ed Earl Repp: I wrote a number of stories about going to the moon. Some of those escaped big-shot Nazi Germans had disappeared, they never found a trace of them. One story I wrote, what's his name who they can't find, he went there. Bormann. Martin Bormann. They were building the rockets at

that time. Well, he had them build them big enough to take them there. That's how he escaped. He knew they were gonna hang him if they got him. In the light of present knowledge, he couldn't last very long.

Did I think we'd ever get there? Sure. Maybe a thousand years from now. Going to Mars. I thought those canals were really something, but we know now they aren't. It's just a burned-out planet.

A.E. VAN VOGT

A. E. van Vogt: When *The World of Null-A* was published by Simon & Schuster, I had a feeling the editor at that time was an English major who found the general semantics ideas about the English language a little outrageous. So he sent me twenty pages of changes, which mostly consisted of changing general semantic ways of saying things into traditional English, which I did. Because it was the first science fiction book ever published by Simon & Schuster after World War II.

Richard Wolinsky: During the late 1930s and early 1940s, van Vogt wrote a series of novelettes for Campbell's *Astounding*, that were eventually combined as a novel titled *The Voyage of the Space Beagle*. The second story, "Discord in Scarlet," reemerged on screen without credit thirty years later as the film *Alien*. This did not sit with well with A. E. van Vogt.

A. E. van Vogt: I first saw *Alien* at 20th Century Fox studios, since I'm a member of the Academy of Science Fiction, Fantasy and Horror Films. A number of us were invited there to go to a preview. When I came out of the theater, someone said to me, "Well, there goes *Voyage of the Space Beagle.*"

"Yes," I said, "I'll speak to my agent about it and have him write 20th Century Fox to tell them that the main storyline is my story 'Discord in Scarlet' from *Voyage of the Space Beagle.*"

When Gene Roddenberry of *Star Trek* discovered that one of their writers had written a story very close to a Fred Brown story, he immediately contacted the Brown family — I don't know if Fred was alive at the time or not — and bought the story from them. I suggested to Fox that they do the same thing with "Discord in Scarlet" for one use. If there's an *Alien 2* with a similar type of thing, then further.

So I talked to the principal and he said, "I'll have a final offer for you when you get back from Canada. I'll just get it all organized and I'll have a final offer for you at that time," which seemed a reasonable proposal. There has been no resistance to the idea that their storyline was too similar to my story.

My attitude was this: We'll take the money and let the credit go, because I have enough credit in other ways. Now we can privately say that we have a settlement, to other motion picture companies, but the truth of the matter is, to get credits to all those films that are out is an awfully difficult process.

It's not easy to do. You have to face technical realities of that kind. It's a nuisance.

The thing about *Alien* and "Discord in Scarlet" is the business about laying eggs inside of the individual, and then the chase through the air-conditioning system. That's exactly what occurs in "Discord in Scarlet," you see. The creature comes aboard a little differently.

I said to the scriptwriter of *Alien*, "You should have just approached me. I probably would have been available not too expensively in those days." He felt that he had evolved the thing, however he admitted that he had read *Voyage of the Space Beagle*. They tried to twist the thing around here and there, but the fact is the main storyline was there. But the thing is, they did a good script-writing job, and I'm glad in a way that they did it, because I'm going to get some money now which would never have come my way otherwise.

ARTHUR J. BURKS

Hugh B. Cave: I met Arthur Burks at his apartment. Someone took me over. There were three or four others there, including Manly Wade Wellman, and Art was busy. He was sitting in a corner at an old, big manual office typewriter, banging away the beat. He just said, "Make yourself at home." They were all doing this with Art's liquor and telling stories and swapping lies, and Art kept right on writing through the whole thing. This was the kind of man he was, I was told — I never met him after that. For the hour or so that I was in that apartment he typed constantly, and then finally he overheard something that we were talking about, how you get plots and ideas, and Art made some remark like, "Oh, there's ideas anywhere you look. There's ideas anywhere in this room. All you have to do is use what's 'up here.'" Somebody said, "Okay, Art, let me see you make a detective story out of that glass doorknob." Art sat down and he looked at it for a minute, and he came up with a perfectly complete plot for a good detective story about a diamond invisibly buried in a glass doorknob. I think he later wrote it.

W. Ryerson Johnson: Arthur Burks wrote so fast he didn't have any idea where a story was going when he started out. He wrote and it just came out. It worked or it didn't. If it didn't, he'd put it in the wastebasket and start another one. He did that so fast with no real identification to it. So he worked himself out of it, just couldn't write pulp anymore. He was frantic. I was up in his hotel room one day, and he said that he'd made a deal with an airplane company to go to Venezuela to look for a guy named Redfern who'd gone down the year before and disappeared in the jungle there somewhere. It was just an advertising gimmick for the Fleetwings people. I don't believe they ever expected to find him. He says, "You got two hundred dollars, Johnny? I need two hundred dollars more." I don't know why but he said that. I did happen to have two hundred dollars, which I loaned Burks,

or gave him. Now he says, "You can go with me." Well, that was a nice adventure. At that time, I got a letter from the girl I'd been going with in Duluth, said she was coming to New York. I had to make up my mind whether to stay and pursue my girlfriend or go to the jungle with Burks. I was afraid she wouldn't be there when I got back, so I finally decided to stay and marry Lois, and that was fifty years ago. Burks went to Venezuela to look for Redfern. Nobody ever found Redfern, but he had a good trip.

DAVID H. KELLER

Basil Wells: A good friend of ours was Dr. David H. Keller. He came up and stayed with us for a while, and we went rock hunting. He was a rock hound. This was Dr. David H. Keller, MD. He always wanted to be known that way. He was a good guy. He was a very intelligent sort of a fellow. He was a psychiatrist, and he told us about when he was in the Army, during the war, being a psychiatrist, he said that they would get recruits in there, and he knew within a minute to two minutes whether they were fit for duty or not. He said, "Other psychiatrists will take hours and hours and tests and everything, and then they won't find out what I can find out in a minute or two." He'd look at 'em and speak to them a little, and he knew. He worked in insane asylums, mental institutions, pardon me, for years in New York State, down in Louisiana, and a lot of his stories refer back to experiences he had there, contacts he had there.

HENRY KUTTNER

Robert Sheckley: At the head of my list would have to be Henry Kuttner, and especially Henry Kuttner as Lewis Padgett, working with C. L. Moore. Heinlein and van Vogt were powerful influences on me. When I say influence, I don't mean that I wanted to write like them. I just mean that for me they had — I'm sort of lumping things together now. Let's say in one or all of them I'd find clarity, I would find clever plotting, economical writing. Really well-made stuff.

Alva Rogers: I only met Henry Kuttner once, really. It was about 1950 or '51. I'd moved back to San Diego. I went to Los Angeles with Cleve Cartmill, who was an exceptionally good writer in those days, and we spent the day and evening at the Kuttners, with Hank and his beautiful and charming wife, Catherine Moore. I found Hank to be a very unassuming, very witty, very charming, very delightful person. My wife, who stayed in San Diego, was pregnant at the time, and she was a great admirer of Kuttner's stories, and entreated me, begged me, insisted that I get Hank's autograph before I leave. So in the course of the afternoon or the evening, I asked Hank if I could have an autograph which I could take back to my wife. So he said just a minute, and he went into the next room. A few minutes later he came out,

and he had a little white box and he just handed it to me and walked away. I opened it up, and inside the box was cotton, and I took that out, and nestled in the cotton was a small black fountain pen with a gold top and a gold ring that elegant ladies carried in the '20s. And then there was a little note underneath that, and the note said, "Dear Sid:[46] This is the pen that I write my short-short stories with. Love, Henry Kuttner." And I thought that he could have just scrawled his name, and that would have satisfied my wife. But no, he had to make this little gesture.

LEIGH BRACKETT

Ray Bradbury: I met Leigh Brackett when I was about nineteen. I think she was twenty-two, twenty-three. Her hair was shorter than mine, mine was longer than hers. We were an odd couple, no one quite figured us out. I met her on the beach every Sunday at Muscle Beach from some time in 1941 until 1946. I was best man at her wedding to Edmond Hamilton. He was another close friend. She criticized my stories fifty-two times a year, and I would lie on the beach and weep with envy at her beautiful prose. She wrote wonderful short stories and novels, and she tried to teach me. It took a long time before I wrote anything worth reading. And then in 1946, when she got the job of writing [the screenplay for] *The Big Sleep* with William Faulkner for Howard Hawks, she called me and said, "I have a novella half finished. Would you finish it?" So she gave me "Lorelei of the Red Mist" and I think she got 10,000 words out of it and I did 10,000. And you go back and today you can't tell where the fusion point is. She didn't influence my Martian stories, that was Burroughs, but she was influenced by Burroughs too, very much so.

Basil Wells: Bradbury, well, I always liked Bradbury's stories. Leigh Brackett? I had eleven stories in *Planet Stories*, she must have had twenty at least. Then years later, after she married Ed Hamilton, they lived just across the Ohio line from us, and for twenty-five years we were good friends. They'd come to our place and we'd go to their place. We had a pond made in our farm there, so Ed and Leigh, they had to have a pond too. The first one they dug was dry. The second one held water and it was a good one. Ed would always take me out and show me his pond. Brag a little bit. And Leigh would tell me about how it was to write scripts for the movies and that sort of thing. She'd work on a thing for months, she'd work on a script and rewrite and rewrite, and then they'd drop it. I don't know if I'd care to write scripts that way.

46 Sidonie Rogers, Alva's wife.

Richard A. Lupoff: At the first Octocon[47] at Santa Rosa in 1977, my wife, Pat, and I arrived there the first night. We walked into the restaurant, it was dinnertime, looking to see if we would recognize anyone to sit down and have dinner with. And here was this woman, sitting all alone, eating her dinner, at the counter. And we walked over and it was Leigh Brackett. Ed Hamilton had just died within the past year, and we had known her and Ed slightly some years earlier. We went over, introduced ourselves, said hello, and said, "What are you doing here, sitting at the counter?"

She said, "Nobody here knows me, nobody knows who I am, nobody remembers me, nobody cares, so I'm eating my dinner and then I'm going to my room."

We said, "Please, come with us." We went over and took a table. Marion Zimmer Bradley walked by. Marion is a little bit on the nearsighted side. She walked past, she looked, she started to go on, and she stopped and looked again. She came running over and put her face up about four inches from Leigh Brackett and said, "Leigh Brackett!" And suddenly she was Astra Zimmer, *Planet Stories* letter hack from 1947, sitting there. "Gosh, can I sit with you?" And I don't remember who else was in the group, but people just kept coming and coming for the next two hours. There must have been fifteen or twenty people, sitting around Leigh by the end of that meal.

Theodore Sturgeon: And then Leigh went off and cowrote *The Empire Strikes Back*[48] and died in harness. When she turned in her final draft, she died right after that.

THEODORE STURGEON

Philip Klass: Ted Sturgeon became my agent after I began publishing. Among the many things that Ted Sturgeon did in his life was agent for me, for A. Bertram Chandler, Chan Davis, Damon Knight, Judy Merril. He represented all of us at one time. He was the best agent any of us ever had, in that he gave good advice, he sold to markets we would not have sold to otherwise. But he couldn't keep the money straight. You have to realize what it was like to see Judy Merril, Damon Knight, Phil Klass, other people, sitting around with their agent trying to help him figure out where the money was

47 That was quite a convention. Everyone was there, even Heinlein, though to get an autograph you first had to donate blood. Lawrence and I were still newbies, and Dick Lupoff wasn't yet officially part of the program, so we missed our shot at Leigh Brackett and several other writers. I'd met Philip K. Dick in September at KPFA's "Science Fiction Day" during our month-long fund drive, and when I made my way to the bar at the convention, I met up with him, and listened as he confessed to me his interest in younger women. He seemed like an old man, but in fact he'd yet to turn forty-nine. I still haven't a clue why he chose me for his confessions, and while he was briefly on the air again by phone, I never saw him again.

48 Leigh Brackett wrote the first draft, and Lawrence Kasdan finished the script. It's still the best of the nine films.

and how the figures added up. He was terrified, but he was a great guy. He tried to persuade me to sell to many, many pulp magazines, so that I shouldn't be limited to science fiction. Ted Sturgeon spent more time trying to make a hack writer out of me than anyone else I've ever known in my life. Ted, by the way, talks hack writing but is unable to do it himself.

L. RON HUBBARD

Alva Rogers: The Parsonage was a beautiful mansion on Orange Grove Avenue in Pasadena, and I was there for about three months or so. It was owned by a man named Jack Parsons, who happened to also be the leading disciple in the United States of Aleister Crowley. Jack had a group in his house called the OTO. In order to maintain the house, 'cause it was a huge house, a beautiful house, he rented out space, rooms and apartments. So there were, oh, six, eight, ten people living at that house.

At the time I was there, we got word one day that L. Ron Hubbard was stopping by to spend a little time there on his terminal leave from the Navy. He was a lieutenant commander in the Navy. So one Sunday, this beat-up old Packard drove into the yard, with a trailer behind it. It came around to the back, the back building, there was a chalet in the back there. And he parked, and it was Ron, L. Ron Hubbard. Ron was just going to be staying for a little while, in his trailer. He eventually moved into the house and his stay became rather extended.

There were some conflicts going on that I won't go into, but I will say that in those days, when I knew Ron, he was a dynamic person. He was of medium height, flaming red hair. He wore horn-rimmed glasses, as I remember. Had a very outgoing and engaging personality. Was a marvelous raconteur, you never knew whether to believe him or not. We'd sit down at the dinner table at night, and he would go into some story that would just leave us all gape-mouthed, not knowing whether he was lying to us or telling us the truth.

Harlan Ellison: Man. I loved Ron. This is right around the time that Dianetics was getting started, and I never got into that stuff. But Ron was a wonderful dinner companion, and he was great fun to be around.

Ron was the first writer in New York, the first professional pulp writer, to get an electric typewriter because he wrote so goddamn fast and he worked so hard. He found that putting in a sandwich of a piece of bond and a carbon and a yellow second sheet just took too much time. So he went to a butcher supply store and he bought one of those racks that they have the big rolls of brown paper on, and he screwed it into the wall behind the typewriter. He put in a huge roll of brown paper, and he rolled it into the typewriter, and he started writing. When it got ungainly, he had a T square, and he would lay the T square across the paper, rip off the paper, and throw it into a stack behind him.

Alva Rogers: He was basically a kind man, I know that from personal experience. The last time I ever saw Ron, I'd made plans. The girl I was staying with at the time and I were going back to San Diego to attend San Diego State College. We were taking the San Diegan, now the Amtrak San Diegan, between Los Angeles and San Diego. It was raining like hell, it was coming down in buckets, and Marge and I were planning to take the red car, the urban train, from Pasadena to Union Station. We kept putting off slogging through the rain to the station to catch the train to get to Union Station, and Ron looked out and said, "Hell, you don't want to. Let me drive you down to the station." So we got in his car, and he drove like a madman. Here we are, sitting there, wondering whether or not we're gonna make it. Took us up to Union Station, dumped us off, waved, said goodbye. That's the last I ever saw of him. That was well before Dianetics. That was in '45.

Forrest J. Ackerman: L. Ron Hubbard came to the Los Angeles Science Fantasy Society one time and gave a talk to us. This was around 1946. I remember a handsome young man that reminded me of Howard Hughes. The one thing I remember was that he said, "You will all notice that Stalin is not getting any older." Hubbard spoke about some kind of a formula, all kinds of vitamins and things, that would virtually make you immortal. Obviously he didn't take it himself, because he's already gone.

W. Ryerson Johnson: At that time nobody dreamed that L. Ron Hubbard was going to be the Scientology/Dianetics guru that he became. He was just some other pulp writer as far as anybody knew. Didn't know he had dreams of Scientology grandeur. He was a big hearty guy on the macho side. I think he was very generally liked. He wrote everything. Westerns, science fiction. He talked a lot about his past and what he had done. Nobody knew how much of it he made up and how much of it was real. But he carried it off very well. He thought that religion — "Play the God game," is what he said.

Harlan Ellison: I was there on one of the nights when Dianetics was created. Now, I've heard other people tell the same story of other evenings. Fred Pohl will tell you of another evening when it happened, and if Lester del Rey was still around, he would probably tell you about two other evenings when it happened. Because it's a legendary story, and the only people who deny it, of course, are the Dianeticists.

But I was there one night at the Hydra Club, when Lester del Rey and Jay Stanton and a whole bunch of other people said to Hubbard, who was complaining about having to work so goddamn hard for a penny a word or three cents a word, the only way to do it is to start your own religion. Now the reason it came from Lester was that Lester had been a stump minister, like Marjoe Gortner. He was a child evangelist, if we are to believe Lester. Lester told nothing but lies so there's no way of knowing if Lester made this all up. But Lester swore he had been a child evangelist and he could preach with the best of them. He would stand there and do, "Hossana, Hallellulah,

your souls are going to hell!" He could do that and he told Hubbard. I was there in the room with Sprague de Camp and Jay Stanton, and I think Bob Sheckley was there and Budrys was probably there, and they all sat around and they all gave him bits and pieces of this bogus religion. Engrams and little bit of the orgone box and a little bit of this and a little bit of that. And the next thing we knew, boom! There was Dianetics.

Alva Rogers: When the initial article on Dianetics was published in *Astounding* in 1950 or 1951, Hubbard made the statement that this was the result of years of research and diligent digging in all aspects of the situation. Well, I have to be truthful and say that at no time when Ron was at the Parsonage did he give any evidence at all of working on anything other than getting back into the swing of grinding out pulp fiction, which he did. It seemed to me that the Parsonage was a prime ground for research because there were a bunch of weirdos there, believe me.

Howard Browne: I really had no opinion on L. Ron Hubbard except that he wrote, I understand, good science fiction a long time ago. Ray Palmer said to me — it comes secondhand and I can't verify it — that Hubbard once told him very flatly and without any fanfare, that he decided that he was going to be God. That's how Dianetics was born, I guess. And he damn near succeeded. He makes more money than God does.

Frank Belknap Long: One night I brought Lovecraft to a restaurant, and Hubbard was also there. That's about all. Howard was sitting at the end of the table, I introduced him to Hubbard, as I recall. And he said a few words, and that's it. And when I left Howard was quite impressed by this very exuberant young chap. I think Hubbard was a very brilliant writer when he wrote for *Unknown*. Very brilliant writer. I think that *Fear* is a really great book.

It's a Bird, It's a Plane, It's a Comic Book

Julie Schwartz: In 1945, Alfred Bester decided to leave comics and go into radio writing. At that point I was strapped for someone to write *Green Lantern*, so I appealed to my friend Henry Kuttner. I said, "How would you like to write *Green Lantern*?" He didn't seem much interested. He said, "Let me read a story." He read a story, shook his head, but Catherine Moore, his wife, read it. She said, "Oh, I love Doiby Dickles. You've got to write a story and get Doiby Dickles." Doiby Dickles used to own a cab, and his motto was "Soivice what don't make you noivous." He was modeled after a movie actor called Edward Brophy. So Henry Kuttner wrote *Green Lantern* for a year or so, and then he decided to leave.

Frank Belknap Long: For about three or four years I did quite a bit of comic book writing. I think I probably contributed something to most of the big comic book heroes, and made little departures which were utilized later,

but I can't pigeonhole that right now. I mean, it's impossible to remember. I wrote *Green Lantern* two or three times. I recall doing a couple of *Captain Marvels*. In *Action Comics*, I did three or four minor features. There's one, "Adventure in Africa."

Frank M. Robinson: Larry Shaw told me once why he did so much comic book stuff and what he hated about it. He said, "The comic books pay immediately but you're taking an idea that you might be able to write a whole story about, and you're spending it on this little comic."

Frank Belknap Long: The comic books paid very well of course. It was a big field for prompt payment. They paid much more than they paid for short stories in the science fiction magazines. They paid by the comic. Each comic ran twelve or fifteen panels. And the writer got very good sums for that. Manly Wade Wellman did quite a bit of that too because it was such good pay. But only for brief periods. It's erratic and the whole field went under for a while. That's mainly why I stopped. Because it's a tough grind. You get in one group and then the group collapses and you have to start in somewhere else. It was a headache. I didn't do it for too long, perhaps for three years. I did have quite an influence on the comic field at that time. Not as much as Wellman, but still. I don't think I had anything to do with *Superman*, but I remember I got a letter once from the writers of *Superman*. They were early science fiction fans. Probably about one third of all prominent science fiction and fantasy writers did comics at the time.

Labors of Love: the Specialty Publishers

Richard A. Lupoff: This was in an era when very little labeled science fiction or fantasy could get into books. If you snuck it in as a social satire, you could publish a *Brave New World* or a *1984*, but anything that had the mark of Cain by having appeared in *Astounding* or any other category magazine was almost death on getting into books.

Fritz Leiber: Generally speaking, the first appearances of fantasy and science fiction were in the small press books. And there were, at the time of World War II and years immediately following, there was a proliferation of these small presses: Fantasy Press. Shasta. Gnome. Prime Press. And Arkham House, of course. I remember it was just toward the end of World War II, that Don Wollheim brought out the Viking *Portable Novels of Science*, five novels of science fiction. As well as H. G. Wells and Stapledon, it had Lovecraft, "The Shadow Out of Time." One of the John Taine novels.

Alva Rogers: Bill Crawford was a pioneer. He was one of the first specialty publishers in an era when it just didn't pay off. His imprint Visionary Press published Lovecraft's first hardcover book in 1936, published when Lovecraft was still alive. Well, in 1945 Bill asked me to do a cover for him for Crawford Publications, and I said, "Sure, how much?" He said, "I'll give you

five dollars." I said, "Great." I was a starving artist at that time and five bucks was five bucks. And it had to be in black-and-white, so I did an illustration for Robert E. Howard's "The Garden of Fear," which was one of the stories, the title story in a small collection. I gave it to Bill, and Bill published it, and no reflection on Bill, no reflection on Bill — I still see him at conventions and he's a hell of a nice guy — but in those days he was having a rough time too. Took me two or three months to get that five dollars out of him. I'd go to his print shop and say, "Hey Bill, please, I need the money."

"So do I. I don't have it."

But Bill tried, under great handicaps of money and public acceptance, to become a full-time professional publisher and he just wasn't able to make it in those days.

Richard A. Lupoff: Crawford published a magazine, *Fantasy Book*, and he also owned and operated a company called Fantasy Publishing Company, Inc.

Basil Wells: He brought out two collections of my work, *Planets of Adventure* and *Doorways to Space*. He said "I would like to use some of the stories that you've had in *Fantasy Book*, and put a hardcover book out." Well, there wasn't enough in that, and so we took three stories from *Planet*, you know, *Planet Stories*. I got the releases on them, and then I got two more stories from Doc Lowndes, and that made up enough so we had our fifteen stories. That was *Planets of Adventure*, in 1949. The second book, a couple of years later, *Doorways to Space*, were all original stories. Two of them are sequels to stories I had in *Planet*, but I never sold them to *Planet*. I don't know if they were rejected or if I never got around to sending them.

Well, there were supposed to be two print orders of 2,000 copies each, I think. He bound them himself, and he had some of them left, I have one at home, that's bound in paper. And he could sell it for about half what he could sell the others by putting paper bindings on it.

Forrest J. Ackerman: Now that we're discussing Bill Crawford, the name of Ed Wood comes to mind again. He was not a poor man's Ed Wood. He was a rich man's Ed Wood. Bill was just obsessed with science fiction. He just loved it, and published it under any circumstances.

The Fantasy Publishing Company, Inc. was never able to equal Fantasy Press or Gnome Press. His work was always bottom of the barrel, like Ed Earl Repp's *The Radium Pool*. He did have one or two L. Ron Hubbard titles that did well and he published one of my all-time Atlantean favorites — I have six hundred books about Atlantis — which was Stanton A. Coblentz's *The Sunken World*. But basically it seemed like he was just a second or third grade publisher. I give him credit that he loved the field so dearly, you know — that while he never made a financial success of it, he contributed to it considerably.

Theodore Sturgeon: My first book was in 1947.[49] It was called *Without Sorcery*. It was published by Prime Press. Prime Press was a guy called Jim Williams [James A. Williams], now dead. It was his first book too. I remember I was out in New Jersey at the time, and he called me up and told me that he had copyright forms and he had to know if I was ever known by any name other than Theodore Sturgeon, which was my name at the time. And I told him a long and detailed story.

My parents were divorced and we moved to Philadelphia and my stepfather was a prominent educator. In those days, his feeling was you couldn't have two boys — I had a brother — in the Philadelphia school system whose names were different from his because "questions might be asked." In those days, divorce was really something. Therefore, he adopted my brother and myself, and our names were changed. My name at the time was Edward Waldo. My mother was not too happy about my father. His name was Edward Waldo. They used to call him Ned. People called me Ted. Now if my name was changed from Edward to Theodore, I would always be Ted and never be Ned. Therefore, when I was confirmed, you have the legal right to have your name changed at that point. So I became Theodore Sturgeon instead of Edward Waldo, and retained a middle name which is never used, which is Hamilton. So I explained all this to Jim Williams, and he dutifully wrote it all down on the copyright thing, and ever since, "Theodore Sturgeon" has been listed as a pseudonym. It's in the Library of Congress, and I have people all over the world pulling that card, and readers will do that once they hear the story. They'll pull out the card and stand up to the poor librarian. "This is wrong!" You know, it causes no end of trouble but I don't think anything can be done about it.

Fritz Leiber: And then I would say after about two or three years of these small presses, why, then the major publishers became interested and one by one they began to go into the field, around the late '40s, early '50s. That also saw the decline of the small presses so that just a very few of them, like Arkham House, managed to survive for a long time.

49 The book was officially published in 1948, but obviously all the work took place in 1947 and possibly earlier.

Chapter Six
The Fifties: the World Rushes in

THE CONTINUING CAST OF THE BOOK
(IN ORDER OF APPEARANCE)

Ted White (1938–) Leading (and controversial) fan from the 1950s onward, later editor of *Amazing Stories, Fantastic*, and the slick graphic science fiction magazine *Heavy Metal*.

Kurt Vonnegut (1922–2007) Best-selling author of novels such as *Slaughterhouse-Five* and *Breakfast of Champions*.

Margaret Atwood (1939–) Acclaimed novelist, short story writer, and poet; author of *The Handmaid's Tale, The Blind Assassin*, and others.

Walter Tevis (1928–1984) Author of *The Hustler, The Man Who Fell to Earth*, and other novels and short stories.

Jane Roberts (1929–1984) Science fiction writer in the 1950s, later the author of the "Seth" books, and a founder of the channeling movement of the 1970s and 1980s.

Ursula K. Le Guin (1928–2018) Science fiction and fantasy author, and a giant in the field.

Annette McComas (1911–1994) Ex-wife of J. Francis McComas, one of the editors of *The Magazine of Fantasy and Science Fiction* (*F&SF*).

Phyllis White (1915–2000) Married to Anthony Boucher, co-editor of *The Magazine of Fantasy and Science Fiction* from 1949 through 1954 and sole editor until 1957.

Roger Zelazny (1937–1995) Leading science fiction and fantasy writer from the 1960s into the 1990s, author of the novel *Lord of Light* and the fantasy *Chronicles of Amber* series.

William F. Nolan (1928–2021) Prolific author of science fiction and mysteries, author of *Logan's Run* and noted pulp historian.

William Campbell Gault (1910–1995) Mystery novelist and short story writer whose career began in 1936 and continued into the 1980s.

Ian Ballantine (1916–1995) Founder of Bantam Books and later Ballantine Books.

James "Jim" Blish (1921–1975) Fan who became a leading writer in the field; author of *A Case of Conscience* and other novels; editor of the short-lived (one issue) *Vanguard Science Fiction*.

As the '40s turned into the '50s, the magazine field exploded. Leading the pack were two magazines that focused on literary quality: *Galaxy Magazine* and *The Magazine of Fantasy and Science Fiction*. At the same time, television went from being a novelty to the leading mass-market medium. In the

middle of the decade, the magazines went bust and paperbacks began to emerge. On top of everything, science fiction speculation became reality as Sputnik 1 became the first man-made satellite to orbit the earth.

Magazines, Magazines, & More Magazines

Ted White: It was a very fecund period for science fiction from about 1950 to '55. It was a period of growth and expansion. At last all the good stuff wasn't appearing in just one magazine. There was a lot of competition to see who could publish the best. A lot of different literary standards, you might say, prevailing, but all of them high. In fact, most of the novelettes and novels that appeared in those magazines in that period would reappear within five, ten years as published books. All of the people that you think of from that era appeared regularly every month. Henry Kuttner would have a new novelette in this issue of *Thrilling Wonder* and next month *Startling* would have the next Fletcher Pratt. It was, in many respects, a Golden Age. Well, of course, what they say is the Golden Age of Science Fiction is when you're twelve, and I was within a year of that.

Kurt Vonnegut: Science fiction writers have been a family, a sort of folk society. They hang out together, they write each other letters, and they're very fond of each other. Also, they don't criticize each other, just as we don't criticize our relatives. I tried to run with them for a while, but I couldn't write as fast as they can. I'd say, "Hey, I like your story in *Amazing*," and I'd get back a ten-page letter, single-spaced. You know, they were the first guys to use electric typewriters. When IBM first made electric typewriters, they didn't know if anybody would want them. But science fiction writers understood them immediately.

Marion Zimmer Bradley: Even as I was beginning to write, somebody asked me why I wrote science fiction. I said it was a way of writing about themes that could not be written about. *Seven from the Stars* was written during the McCarthy era. Anyone who advocated in a contemporary novel that maybe capitalism was pretty corrupt would have been lynched by McCarthy and his fellows, and anybody who advocated a form of equality between the races would have been lynched as well in Texas, where I was living. One of the themes in *Seven from the Stars* was a group of aliens who were hiding out among the braceros in Texas. The point I was making was that they could have been little green men trying to take over the world. As long as they picked cotton, nobody would have noticed them. It was sort of the same point that Ralph Ellison made later, and of course much better, in *Invisible Man*.

Margaret Atwood: One of the purposes for which these stories were used was to comment on society. And for a lot of the people turning this out, particularly during the McCarthy era, it was a mode in which they could

write critiques of the society in which they found themselves, without being so overt that they would not get published. I knew Judy Merril, who moved up to Toronto with her whole collection of science fiction and fantasy and donated it to a library there. In talking with her and getting a window into that period, a lot of the people who wrote these things were really quite socially conscious, and my guy in *The Blind Assassin* [2000] is too, the alternate world that he constructs has an aristocracy and a slave class and political corruption and other stuff that was of interest to people who thought along those lines. I did grow up on Ray Bradbury, I loved Ray Bradbury, and in high school you could also subscribe to a Pocket Book-of-the-Month Club, which I did, and that's how I came to read *Donovan's Brain*.

Walter Tevis: I was teaching high school English in Kentucky at the time, and I merely wrote my stories and sent them off, and I prayed for a check. It was just the case of writing them and sending them off, sort of like entering coupons at a raffle or something, and waiting to see what happened. Those stories were the kind of thing that really charmed me at the time. I don't know if I could do them now, or want to do them now, but at the time I was very much caught up in the extrapolation of a simple "what if" idea in a science fiction story. And especially the devices that turned upon an unusual substance or an unusual invention or something like that. I really liked that. I think in a deeper way it was a way of staying away from my feelings, to write off the top of my head. I was a very good chess player in those days too, and I think the same kind of mentality was involved. You know, this is something I can do without really getting my guts involved.

Anne McCaffrey: In 1953 when I published my first story, I think the field was waking up to the fact that women could write science fiction. There was no reason why they had to hide under another name. I wouldn't have done so. If they weren't going to buy the story under Anne McCaffrey, I wouldn't let them print it. For a lot of women like Andre Norton, that have iffy names, Leigh Brackett, Marion Zimmer Bradley also — she has a male spelling of "Marion" — but they had preceded me. My timing was right, I guess.

Jane Roberts: I was one of the very few science fiction women writers then. Most of the writers were men. I never thought of myself as anything like a feminist, I thought of myself as a writer, although it is true that when I wrote stories, I had to make sure in a lot of cases that the male hero came out on top. My market at that time was *The Magazine of Fantasy and Science Fiction*, some of the other science fiction magazines, and the men's markets. Slicks were just below that. And in those magazines, the male had to win. But in *Fantasy and Science Fiction*, you really had quite a bit more freedom, as long as it was a good story. They didn't hassle you that way. At least one story I know was based on the idea of a nun who talked a war overlord out of invading the Earth from another planet. And she was a heroine. But I

didn't think of myself as stating a cause so much as writing the kind of story I was interested in with characters that rang true.

Philip K. Dick: At that time, in the late '40s and early '50s, science fiction was so looked down upon that it would be tantamount to suicide in a group of people in Berkeley to come forth and say, "Boy, did I read a marvelous story recently." And they'd say, "What was it?" "It was *The Weapon Shops of Isher* by A. E. van Vogt." They just would have pelted you with half grape-fruits and coffee grounds from the garbage. If they could have deciphered who you meant, I mean, they wouldn't have known the name. Of course, there was a kind of fandom, and I knew them, but they were all real weird freaks, and they were unpalatable to me because they did not read the great literature. There wasn't anybody that read both. You could either be in with a group of freaks who read Heinlein and Padgett and van Vogt and nothing else, or you could be in with the people who read Dos Passos, Melville, and Proust. But you could never get the two together. And I chose the company of those who were reading the great literature because I liked them better as people. The early fans, they were trolls and wackos. Being stuck with them would have been like the first part of Dante's *Divine Comedy*, I mean, up your ass in shit. They really were terribly ignorant, weird people. So I just secretly read science fiction. And then I would write it, and people would say, "But are you doing anything serious?" That used to get me really mad. And I would all of a sudden drop my posing, and I would say, "My science fiction is very serious," if I said anything at all. I was usually so mad I couldn't talk. The science fiction I wrote and sold, I took as seriously as the experimental stuff I wrote at the time.

Ursula K. Le Guin: Back then, science fiction was absolutely a ghetto. But after seven or eight years of sending out stories and novels and not getting publication, you get fairly desperate. I didn't care who published me. And the fact that I might be stigmatizing myself and getting a big red "SF" branded on my forehead among the intelligentsia, I couldn't care less. I just wanted to get my stories out there and get somebody reading them. That's what a writer wants. Since then, I've realized that perhaps careerwise, this was a risky move. But I really don't care. I would have gone ahead writing what I write anyway.

Harlan Ellison: I never felt comfortable with science fiction writers. In fact, Fred Pohl made a career of telling people I wasn't a science fiction writer, and that was a crime to him because I didn't write science fiction. I never pretended to write science fiction. I wrote stuff that happened to appear in some science fiction magazines. But I've always been at logger-heads with them. I've always been more a fantasist, more a magic realist, if you will. I'm uncomfortable in that company, and I felt more of a kinship to Poe and Kafka than I ever did to Heinlein and people like that.

The Rise & Fall of the Magazines

Richard Wolinsky: Science fiction has always operated as a boom or bust enterprise. After the boom of the late '30s, the '40s were a time of retrenchment as markets dried up and there were fewer magazines available for writers and readers. It was John Campbell's golden age at *Astounding*, but there wasn't much else out there. Then came the start of a new decade, and suddenly business was booming again. Leading the pack were two influential newcomers: *Galaxy* and *The Magazine of Fantasy and Science Fiction*. But there were also several others, most of which came and went in a flash. There was a glut, and boom turned to bust. Magazines merged, changed names, and sometimes took each other's titles. And the pulps faded from the racks, the best ones morphing into digest-sized magazines, the others disappearing into oblivion.

Frank M. Robinson: Pulp magazines in general were an old format. They were wasteful of paper. Most of them shed little bits of paper all over you. They were simply not attractive. And once they started to slip in circulation, they slid very fast.

Ted White: I started buying science fiction magazines with the July or August 1951 *Astounding*. First I was just finding a substitute for books. The next thing I knew, I was buying every magazine in sight, and going through them at an incredible rate. At first I had standards which I imposed on myself, largely the standards of ignorance. Those standards were that I would buy the digest-sized magazines, which were a very fresh phenomenon then, but I wouldn't buy the pulps because everyone knew they were kind of trashy. However, within less than a week, I had all the digests that were on the stands: *Galaxy*, *The Magazine of Fantasy and Science Fiction*, *Marvel Science Stories*, *Astounding*, *Other Worlds*, one or two others, even such oddball things as the *Avon Fantasy Reader* and the *Avon Science Fiction Reader*, which were almost paperback books of some weird sort. But what was left? Well, there were something like more than a dozen pulp science fiction magazines. And once I got past the fact that the pages were raggedy and you couldn't thumb through it looking for neat illustrations, then I discovered the writing in many cases was just as high, or higher.

Richard A. Lupoff: I was the archetypal science fiction fan back the early 1950s: all the pimples on my face, and my allowance in my jeans. And I would go down to the newsstand twice a week and look for all the new magazines, which mushroomed from seven or eight up to twenty-five or thirty. Which left me with very mixed feelings, because I loved seeing them all there, but I couldn't afford financially to keep up with them. Multiply this one kid that was me by however many tens or hundreds of thousands there were. I suppose that's part of what brought it down. The field supported a lot of writers, but the readers couldn't keep up.

Stuart J. Byrne: I was selling forty thousand words a month at the splendid rate of maybe a penny a word in those days of what I call the Roaring '50s. Sometimes I was getting two feature covers on the newsstand at the same time, simultaneously. Sometimes, within one issue, besides the cover feature, I'd also have a subfeature within and they just had to change that name to the house pen name.

Robert Silverberg: I was writing a hundred thousand words a month, that's 1.2 million words a year, just for Ziff-Davis' and Bill Hamling's magazines alone. I was twenty-two, twenty-three years old. There were no computers, I didn't even have an electric typewriter. I would just sit down in the morning and put a piece of white paper in the typewriter, start typing, and sell a story. I often would write one story before breakfast and before lunch, and another one after lunch. Write seven, eight, ten thousand words a day.

I didn't revise because it wasn't necessary. I got it right the first time. And these magazines were not interested in revisions, they just wanted the story to start here and finish there, and have things happen inbetween. Including a lot of dialogue. Howard Browne, who was one of the editors I worked with, once tacked up a story that was solid exposition that was mine and said, "This is all wrong. You've got to put a lot of quotation marks on the page. That's what the readers like." And because if you have a lot of people talking to each other, the story gets written very fast.

This went on for years until I got tired of it.

Richard A. Lupoff: Because publishers didn't always like other publishers to know what they have on the drawing board, there was sometimes a peculiar similarity in the titles of these magazines. Among them was one called *Fantastic*, a Ziff-Davis magazine edited by Howard Browne. There was one called *Universe*, an independent edited and published by Ray Palmer. And there was one called *Fantastic Universe*, an independent published by Leo Margulies. Standard Magazines was owned by one Ned Pines, who also owned Popular Library, a mass-market paperback house. Among Pines' magazines were the "Thrilling" group, including *Thrilling Wonder Stories* and *Startling Stories*. Leo Margulies worked for Pines in a high-level executive position. Sam Merwin worked for Margulies, editing *Thrilling Wonder* and other science fiction pulps. At one time, Horace Gold was Merwin's assistant. It was a great big game of musical chairs.

And it all imploded. I think 1953 was the peak year, with the largest number of titles coming out in the science fiction field. Then at least two-thirds of the titles, maybe more, disappeared in less than a year's time.

Richard Wolinsky: Lester del Rey and Fred Pohl, in their respective histories, *The World of Science Fiction: 1926–1976* and *The Way the Future Was*, blame opportunistic publishers and authors for the decline. One successful high-quality magazine would breed five or more mediocre imitations, which would then glut the market with crap, and the crap would then turn

off consumers. In any case, del Rey says the audience was too small for thirty-six magazines on the racks at the same time. So the magazines declined through 1956. For no apparent reason, there was a sudden increase in early 1957, but that turned out to be a death rattle because in June of that year, the American News Company ceased operations. That killed the magazines.

Frank M. Robinson: You had two or three things happening at once. There was the collapse of the American News Company, which used to be the biggest magazine distribution company going. All the others were known as independents. Select Magazines distributed Street & Smith, for example. But American News distributed almost everybody else since the turn of the century. Along the way, the American News Company picked up a hell of a lot of property in the form of stores for newsstands, tobacco shops, kiosks in railroad stations. So you had one of the first takeovers when some highbinders figured out that the property American News owned was worth far more than the company itself. And the company practically vanished overnight. So all these little digest magazines were scrambling to find a home, going to independent distributors who really didn't want to bother with them. They weren't selling that well, there were too many of them, they were a pestilence.

Also, the magazines were noted for being collections of short stories and the American public was turning off short stories. Short stories started to disappear from the big slicks, like the *Post* and *Collier's*. The amount of fiction that they carried began to dwindle. I think probably the most successful paperback line that came out, which really put a knife in the back of the pulps — the pulps in particular — was Gold Medal Books. That was a tremendously popular line. If you wanted to read a mystery or something, you got far more bang for your buck by buying a Gold Medal book than by buying *Dime Detective* or *Dime Mystery* or anything like that.

Ace and Ballantine began doing science fiction. You can say that Gold Medal buried the mystery pulps and Ace and Ballantine did a job on the science fiction digests. Between 1953 and 1955, you had well over forty different titles on the stands. By the end of the decade, you had about twelve.

Housebound but Not Limited:
Horace Gold & *Galaxy*

Horace L. Gold: I came out of the army as if I'd been shot out of a gun, out of a cannon, and I got involved with war surplus and took a terrible beating, and came so close to making a million dollars again and again. I really crashed a little more than a year after I was discharged. I was in terrible condition. Boy, talk about delayed-stress syndrome. The whole damn city collapsed on me. During those four years before *Galaxy*, I wasn't ready to go back to writing or editing. I did try and write a couple of stories which

I sold to Babette Rosmond, who was working at Street & Smith. One was a detective story, the other was an adventure story. They were pretty bad. My heart wasn't in that at all. I was much too antsy.

I was on twelve grains of Seconal a day. The Veterans Administration had put me on three grains of sodium amytal a day, the VA did. I begged to be taken off it because it made me helpless. So they put me on twelve grains of Seconal a day, and when I was working on *Galaxy*, I was always fighting sleep. I was psychotic as hell. I was housebound. I kept getting driven further and further back. I was living in constant flashbacks. I was living in terror, and horror, and drugged, and threatened all the time.

Richard A. Lupoff: Horace Gold was my great hero when I was a teenager. I read *Galaxy Science Fiction* from its first issue, the *Galaxy* novels, and *Beyond Fantasy Fiction*. He revolutionized science fiction, and he brought a sense of participation to his work — he had a way of making the reader feel as if he was part of some grand enterprise. Years later I became friends with Horace, and realized what a tortured man he was. What physical and emotional agony he endured.

Horace L. Gold: Vera Cerutti had worked with Ken Crossen and me on the publishing business we had before I was drafted. She was a good-looking, dark-haired, dark-eyed, slim sexy babe who got herself the most fantastic jobs and did not handle them, and she'd call me up, "How do you do this or that?" And I would tell her how to handle the work, and she would work until she ran out of knowledge. It caught up with her eventually, and she'd find herself another fantastic job.

She got involved with Edizione Mondiale, an Italian-French company. They were putting out a magazine called *Fascination*, which consisted of half illustrations, the most beautiful illustration imaginable by the best artists in Europe, and text, the most nitwit, stupid, sloppy, slushy, sentimental garbage. Vera, who was at least trilingual, did the translating and I did the editing without pay because this was her job. They put out five issues and the fifth issue sold 5%, in spite of a tremendous, at least a half a million dollar campaign. Subway ads, newspaper ads, magazine ads, radio, and so forth.

World Editions, Edizione Mondiale, couldn't possibly leave the American market with their tail between their legs, and they asked Vera if she could come up with a publishing program. What did she do? She turned to me, and I surveyed the market in every field from fashion to comics to you name it, all the fields, picture magazines, news magazines. It was enormously overpopulated. There was only one exception, and that was science fiction and fantasy, and I hadn't done any in about ten years. I presented a program of science fiction: "Start off with a science fiction magazine." I gave them two titles, *Galaxy* and *If*, and they hired Van, Washington Irving Van der Poel, Jr., as art director.

The publisher lived on the Riviera and never went to Rome or Milan or Paris. He did everything from the Riviera. Where he came, from nobody knows, but suddenly he had millions of lire and francs and deutsche marks and my guess is mob money. His representative sent the project back to the Riviera, and they must have flipped a coin because the answer was yes. And on my thirty-sixth birthday, in 1950, I was given the go-ahead. They didn't know what a galaxy was. They did know that *If* was too short a title for a magazine, but they said get a poll on it. So we borrowed Harry Harrison's apartment, and Van put out all the variations on *Galaxy* and *If*, the inverted L and all the other layouts, and then hundreds of people looked, and they all voted secretly. Almost everyone said *Galaxy* and the inverted L. *Galaxy* hit the market like the first issue of *Life*. It smashed the market wide open. *Galaxy* was in the black by the fifth issue, which was unheard of.

Richard A. Lupoff: *Galaxy's* inverted L layout consisted of a black band along the top of the cover with the logo reversed in white, and another black band down the left side with the contents reversed in white. Once *Galaxy* started using the inverted L, it became very popular. *Astounding, Science Fiction Adventures, Space Science Fiction, Rocket Stories, Spaceway, Orbit*, even a comic book called *Incredible Science Fiction,* all used that inverted L. It became a standard. If you were publishing science fiction, this is what science fiction looked like.

Horace L. Gold: I wrote a furious, a vicious, editorial, it was really cold anger, asking Street & Smith, the publishers of *Astounding*, when we can have our layout back. The readers were kind of offended because they thought I had overstepped the bounds of decency and gentle manliness and so forth. Sportsmanship. But they did abandon it. Also, that was the time of the big boom, the so-called boom. Everybody who could read, or who hired someone who could read, went into the science fiction business. And they offered top rates, sight unseen. Four cents a word and up. Sight unseen. We went right on extracting blood from writers, making them turn in their best work.

Isaac Asimov: At the time I knew Horace Gold, back in the fifties, he could not leave his apartment. He was an agoraphobe. As a result of not being able to move about freely, Gold was sometimes rather testy. His testiness turned up as rejections. He tended to write rejection letters that had to be seen to be believed. A great many writers became offended as a result, and wouldn't write for him. Including me! And I'm not easy to offend. A rejection is never pleasant under any circumstances. Once you imagine yourself to be an established writer, and you're used to having editors reject you fairly politely because they want another story out of you, to suddenly get one in which you're mercilessly berated arouses indignation, and you decide you're not going to write for him anymore. And eventually, poor

Horace was forced to write a letter to a fan magazine saying he wouldn't do it anymore.

I remember there was once an issue of some fan magazine, I don't remember which one, in which a number of writers wrote horror letters about their experiences with Horace. I felt bad, and I wrote and said I too had received rotten rejections and gotten annoyed and angry. But the fact is that one of my best stories resulted from having Horace point out obvious flaws. I said that although I hate revising and I'm always ready to insist that the way I have the story is perfect, that any suggestion of a change is just not to be endured, after he pointed out what was wrong with my story and just asked for a small change, I tore it up and wrote a completely different story from scratch. And it ended up being one of the best stories in my opinion, and that of many others, that I've ever written. It was "The Ugly Little Boy," and it appeared in 1958, I think in *Galaxy*, and I've loved it ever since. He published it under the name "Lastborn," but that was horrid.

Fritz Leiber: Most of my contact was by mail, but I visited Horace Gold in his apartment, to which he was confined by agoraphobia. He pretty much edited *Galaxy* from one apartment. When his agoraphobia got bad, it was from the bedroom. There were several New York writers, the younger writers, who went through a lot of tutelage from that center. And certainly, *Galaxy* encouraged all of us to write in a more modern manner, to tackle taboo themes. *Galaxy* was the place where we first dared to be socially conscious, and have stories that explored society and its prejudices and biases, more closely than most of us had ever been inclined to before.

Robert Silverberg: Most of the magazine editors didn't do a lot of editing. So long as it was a professional-looking manuscript, once you demonstrated that you could spell or type or punctuate, you became essential to them, and that was the foundation of my career. They just put the stuff in type. The one great exception was Horace Gold, who drove writers crazy by rewriting their prose — not well I think — after making them do rewrites.

Horace L. Gold: The function of an editor, the only justification he has for keeping his job, is to buy stories, not to reject them. Writers don't think so. They think the editor's function is to reject stories. It isn't. It's to buy stories. The other function of an editor is a symbiotic one with a writer. Between the two of them, they should produce something that neither one alone was capable of. Greater than the gestalt. Greater than either one of them can do. That was my ultimate goal.

Frederik Pohl: Horace Gold was the editor I worked with most closely, and the one I owe most to. Not that he was always right. He was often wrong. But in the conflict between Horace's hopelessly impractical demands for the way I should write a story, and the way I perceived a story, there turned out to be a synergistic or dynamic action of some sort that I think produced better work than if I had done what he wanted, or done what I wanted.

I think a writer needs to be able to bounce his stuff off somebody who is in a power position, who has to be listened to. Whether he can determine what will be published or not, he should be someone who you can't dismiss. I think that it's much easier to perceive the virtues and faults of a story when you hear it come back to you from the outside.

One of the things I regret is that I don't have that sort of editor. I haven't had that sort of editor since Horace retired because it was probably conducive to heart attacks from time to time, on both author's and editor's parts. I think it was also conducive to better writing. I don't mean to say that the stories were better then than they are now, because the world has changed. But I think that I would not have been writing as well as I did in the '50s without Horace to yell at me and try to trick me and cajole me and threaten me into doing what he wanted. God knows, Horace was a determined editor. It was hard to say no to him. It was harder to say no to him than to write the story in the first place.

Walter Tevis: My story "The Big Bounce," which was published in *Galaxy* in 1958, that was a lot of fun. That idea really got to me and I still like the idea of making a simple conversion of thermal energy into electrical energy or some kinetic energy of some kind of other. The idea of that story came from my buying my first air conditioner and realizing I was going to have to put a lot of money into this system and put electricity into this system and put energy into this system in order to put energy into my room. It seemed horrendous and I wanted to find some way around it, some way you could sell that energy or get rid of it, and I invented a rubbery compound that would cool off and deliver additional velocity each time it bounced. Isaac Asimov later told me it was impossible, that I was violating the second law of thermodynamics but I was in another state where that didn't apply.

Jack Williamson: I don't think I ever submitted anything to Horace's *Galaxy*. I still was more interested in writing for Campbell in the beginning, and then I got involved doing a comic strip for the *New York Sunday News*, which filled up about three years there in the fifties. And by the time that was up, I was feeling sort of left behind or out of the mainstream, so I went back to college and got a Ph.D. and became a college professor, and did only part-time writing for many years. All I heard about Horace sort of dimmed my enthusiasm for writing for him. He published some material that I disliked intensely, and I understood he was given to tampering with manuscripts, which Campbell didn't do, so I just didn't try to write for him.

Lawrence Davidson: Ted Sturgeon once said that Horace could turn good stories into very good stories and he could turn excellent stories into very good stories.

Frederik Pohl: I don't agree with that. I think that what was true of Horace was that he could turn good stories into very good stories. When he came across an excellent story, he didn't know what to do with it. He had no

reflexes programmed for that occasion. And I think that's why he rejected some of the best stories that were offered to him. "A Case of Conscience" was offered to Horace and he turned it down. "Flowers for Algernon" was offered to Horace and he turned it down. He just didn't know how to handle them.

But I think that when a lot of writers worked with Horace, their stories turned out better than they would have if they just sent them to some other editor who might have published them in a good, but not excellent, way. I don't want to name any names.

No writer ever wants to admit that an editor ever had anything to do with his success. When I was editing *Galaxy* and *If*, it was a source of considerable pride to me that a lot of those stories I published won Hugos. I don't know the number exactly, but I checked it in *The Hugo Winners, Volume 2*, and of the stories that had originally been published in science fiction magazines over the period I was editing, I think I had published nine and all the other magazines combined had published two, which I thought was pretty good. When I went up to pick up a Hugo for an author who couldn't be there, I felt really personally proud.

The other day, I got a Hugo for *Gateway*, and the next day I saw Jim Baen in the corridor of the hotel. He said, "Well, we did it again," and I said, "Who are you?" It had not occurred to me that since he had been the first person to publish it as a serial in *Galaxy*, he felt some proprietorship in it as an editor. From the other side of the desk, it looks all different.

Marion Zimmer Bradley: I had very nice relationships with H. L. Gold, a very nice guy, but I never really thought I was good enough for *Galaxy*. My agent sent a few of my early short stories into there, but they got rejected, one and all.

Harlan Ellison: Horace Gold kept telling me that I was a bright, brilliant talent, but he never bought anything from me, never bought a word from me, and then years later, kept trying to get me to give him money.

And I'd say, "Horace, why in the world would I give you money?"

"Because I was a pivotal . . ."

I said, "Horace, you taunted me. After I got thrown out of college, I was in Cleveland and I would call you and you would talk to me for hours because you were agoraphobic, so you spent all your time on the telephone telling me how good I was, but you bought shit from everybody else and you never bought a word from me, so I don't owe you nothing, Horace, so piss off."

Isaac Asimov: Horace Gold and Fred Pohl had one thing in common. They invariably had no taste for titles. They would substitute a title of their own that was absolutely useless. I could never figure out why they could imagine that such a title had any value whatsoever, and I always changed them back to my own title when I collected the story. But that's a comparatively benign flaw in these people, because what the heck!

Horace L. Gold: By 1959, my identification with *Galaxy* was complete, total. I was *Galaxy*, *Galaxy* was me. Any threat to it was a threat to me, any threat to me was a threat to it. I was editing with Fred Pohl. Fred Pohl was handling the slush pile, which had really slopped all over the tables, the chairs, the desks, everything. I was paying him to help me, and he was doing the reading, I was doing the buying and most of the copyediting. Some of it he did.

I didn't have a single vacation in the entire eleven years I worked on *Galaxy*. When I asked Bob Guinn for a vacation, he said to me, "Turn in six issues and take a six-month vacation." I had enough trouble turning in each issue without getting six months ahead. So Fred Pohl was working for me, or with me. I was turning over my salary to him.

Then I developed triple sciatica in the right leg. I got hold of an orthopedist, and he cured me to the point where I didn't have a crutch and didn't have a cane. But I was in a cab on the way back from the dentist, when from the right-hand lane came an ice cream truck that decided to make a left turn, and hit us, but I should say hit me. Nobody else was hurt. It smashed into the cab, and I was in worse shape than I had ever been in before. I wouldn't go to the hospital, I couldn't leave the magazine. Finally after about a year, I was down to 102 pounds, emotionally, psychologically, and physically in a state of near collapse. My brothers took over and my mother came down, and they all took care of me to the point where my older brother went to the VA hospital and spoke to the psychiatrist, who promised to work with me on my therapy, and on the basis of that, they got me to the hospital. This was on December 19, 1960. It took me three and a half years to be weaned away from the hospital.

I wouldn't revisit my life, including the years of glory and triumph that I supposedly had in the 1950s. I have no idea how many awards we won. I have only one award and two covers that were sneaked out of the office by Judy-Lynn Benjamin, later Judy-Lynn del Rey, who was then working on *Galaxy*. Guinn had kept all the artwork, all the covers, all the prizes. I never heard from him, he never called me, never wrote to me. I didn't even get severance pay. These triumphs, they were just fighting constant threats to put the magazine to death. I'd have to keep topping each issue so that he couldn't sell the magazine. If anybody wants to exchange lives with me, I'll be glad to do it.

Philip Klass: Horace Gold demanded a lot of quality, but his horizons were essentially narrow. Nonetheless, under him, science fiction bloomed into social criticism. Farce, satire became welcomed by him, and suddenly the magazine went off in directions I think that Horace — well, every good science fiction editor has held a runaway horse. Every good writer holds a runaway horse when he's doing a good story because it gets out of control. I think that many of the stories that appeared in *Galaxy* Horace did

not understand. But he did preside over them, and he tried constantly to persuade us to use formal story structure, formal story themes. Then, of course, bit by bit, *Fantasy and Science Fiction* was developing an audience, was paying a little better. Horace immediately offered more money than Campbell. He offered four cents a word when Campbell was paying three cents a word. When you went too far off, and Horace wouldn't buy it, you had a rescue market that was not a magazine with a girl having a metal brassiere on the cover. It was Tony Boucher, and Tony would throw it back at you with demands for more quality, more intricacy, more subtlety. And all of a sudden, by God, you knew you were not a pulp writer.

The Magazine of Fantasy and Science Fiction: Anthony Boucher & J. Francis McComas

Theodore Sturgeon: There's a saying that an editor is a writer who couldn't make it, and an agent is an editor who couldn't make it. It's terribly unfair, however, because some of the editors we have known were and are superb writers, particularly Anthony Boucher.

Annette McComas: The idea for *The Magazine of Fantasy and Science Fiction* began back in 1945, originally as just *The Magazine of Fantasy*. In fact, the very first copy,[50] Volume 1, Issue 1 was called *The Magazine of Fantasy*. Between that and the next, the decision was made that science fiction was very important, and that they would add that. The magazine took a long time to come to life. Mick McComas — that's what we called J. Francis — and Tony Boucher — We called Tony "A. P.," those were his middle initials. His real name was William Anthony Parker White, and that was the name he was known by, by those who knew him from way back — they were kicking things around, and the magazine evolved in their minds. In the beginning, Mick and I lived in Southern California, lived there until 1949, but since Mick was a publisher's representative, he traveled the western territory all the time, and he was constantly coming up to visit the Bay Area, so he was in Berkeley, where Tony lived, a lot.

Phyllis White: *Ellery Queen's Mystery Magazine* was one of the inspirations for this, too. Boucher and McComas wanted to parallel *Queen's* achievement in attracting better writers to this form, and reviving lost classics in the field. *Ellery Queen* was very much an example to them and Tony was writing regularly for his magazine. They approached *Queen* with the idea of a parallel magazine, also under his name, and although he was in favor of the project, he didn't believe in putting his name on anything in which he was not an expert, and he introduced them to his publisher. That was Lawrence Spivak, of *Meet the Press*.

50 That would mean it took four years for the magazine to get off the ground, because Volume 1, Number 1 was published in 1949.

Annette McComas: Lawrence Spivak was the publisher, but he was really a background figure. The person that all the correspondence took place with before the magazine actually appeared was Joe Ferman, whose son, Ed, is now the present editor of *The Magazine of Fantasy and Science Fiction*.

Phyllis White: Our own home in Berkeley was the editorial address of the magazine. Mick was traveling, and at regular intervals he would come to our house and they would settle down for a regular marathon session of editing, and then in between these visits they would work together by correspondence.

To have a nationally published magazine edited from that far away was not considered feasible before, and it turned out it worked perfectly well. There was one partial precedent. A magazine called *Ranch Romances* had been edited by a woman who got married and moved away from New York and they wanted to keep her on, so the editorial office moved out of town with her. But as my husband pointed out, the editor of *Ellery Queen's Mystery Magazine* lived in Larchmont and never came to New York. He did everything over the phone. At *Galaxy*, the editor did live in New York but he was ill and never left his apartment, so what's the difference?

Fritz Leiber: Tony Boucher was perhaps the most influential of the fifties editors. His influence was in the direction of literary polish, I would say. He wanted his stories to be well written, and he improved the language of science fiction. The diction and grammar and so on improved markedly under his editorship. Also the sophistication of the stories. He disliked, you know, slam-bang adventure in general, and a lot of blood and violence. He, by and large, passed up sword and sorcery of the hack 'em variety, the head-chopping variety. He certainly helped me shape stories like "A Deskful of Girls." I did rewrite stories for him, especially sharpened up the endings. He certainly was a source for goodness, as far as my writing was concerned.

Algis Budrys: John Campbell, Horace Gold, and Lester del Rey were the terrible emperors of science fiction. Tony Boucher used to backpedal a little bit. Tony took a much softer approach. These three guys told you exactly what they wanted. They gave you something to push against.

Philip Klass: Mick McComas and Tony Boucher really tried to develop a literary magazine and not a literary magazine in terms of velvet smoking jackets, but in terms of Dean Ing's famous comment about literature: "Literature survives best when it's half a trade and half an art." They tried to do something really good. They were limited by a lack of funds and they could not pay as well. I deeply regret not having written more for that magazine, because I think it would have done me a lot of good.

Tony Boucher was a man I came close to worshipping. I admired the man enormously, but nonetheless one thing wrong with the magazine was Tony's personal taste. I always felt that you have to be insane to be a science

fiction editor, and every science fiction editor I've known has been some-what lunatic. In Tony's case, the idea of his being a devout Catholic, which he was, and publishing science fiction somehow seemed to be me to be in conflict. It became very apparent after a while that his ideal writer was an eighty-year-old nun, and he never could find enough eighty-year-old nuns, and that ruined the magazine substantially. But he was a great editor. A literary gentleman.

Harlan Ellison: Tony Boucher told me a few things that stuck with me. One was about internal consistency and internal logic, where he said if you have something fantastic in the story, that should be the only fantastic thing. If you've got people who can fly, you don't suddenly have ghosts and gob-lins. Because people won't believe it. He was talking about, of course, the willing suspension of disbelief on the part of the reader, which is an enor-mous thing which you must constantly bear in mind if you're going to write proper fiction, and believable fiction. And Tony also said, you're not looking for truth. You're not looking to mirror reality. You're looking for verisimili-tude. Very different, akin to but very different from, the mirror image.

Marion Zimmer Bradley: My first story for one of the major magazines was "Centaurus Changeling" in 1953. I sold it in '53 and it was published in April 1954 in *The Magazine of Fantasy and Science Fiction*. Tony Boucher was the editor. Tony was a good guy. I didn't get to know him until the early sixties when I moved to Berkeley. I had never met most of these people, you realize. I was living at that time way out in the wilds in Texas.

Theodore Sturgeon: Tony Boucher once ran a kind of a contest in his magazine, *Fantasy and Science Fiction*. He had some stories that were writ-ten by children, eight-, nine-, ten-year-old children, and he got a hold of a bunch of — by that time — highly professional writers, which by that time I was, to see if we could imitate the writing of a child. So I wrote a story, "The Man Who Told Lies," under the pseudonym of Billy Watson, and I think the child came out ahead in that.

Phyllis White: There's a story about the first publication of Richard Matheson. His first published story was the famous "Born of Man and Woman." I don't remember whether Mick or Tony read it first, but whoever it was passed it on to the other, saying, "Of course we can't publish this, but you must read it." The other one said, "Of course we can't . . ." and then they began looking at each other, and thinking, Well now, why couldn't we? So Matheson was launched.

Annette McComas: Tony always read when walking down the street. Incessantly, always. Never had his nose out of a book. I remember meeting him on the street, seeing him at a distance, and seeing that when he was just about ready to cross the street, there was a car coming toward him and he never looked up. But he led a charmed life. I don't think he was ever in

an accident, but he never looked up. I don't know why he didn't fall into the gutter, but he never did. It was fascinating.

Phylllis White: He also walked around the house barefoot all the time. Now the address of the magazine was our home address in Berkeley, which gave a false impression to many people. Along with manuscripts, we received many job applications. Jobs, if any, were in the New York office, where they were publishing a number of other things aside from *F&SF*. The staff and editorial office consisted of the editor, his wife, the office cat, and two small boys who were constantly being dispatched to the mailbox.

In addition to my duties of filing and flushing was the duty of deflecting. People would call or turn up on the doorstep, as well as sending mountains of manuscripts through the mail, and I had to dispose of these people without bothering the busy editor if possible. But there were times when I wasn't there, and he told me once about having answered the door to see, standing there, an elderly man. My husband shuddered to see that he had under his arm the familiar box of Eaton's Bond paper. It turned out that this man had written a full-length novel in verse. It took a long argument to persuade him that it wasn't exactly the thing that *The Magazine of Fantasy and Science Fiction* was looking for. Finally, my husband said to him, "I'm afraid, sir, you've written yourself out on a limb." The man drew himself up and said, "I eat three square meals a day, and I wear shoes."

Tony had a routine. He slept twice a day. He would work through the morning to a late lunch. After lunch he would retire to bed with at least one review copy and continue reviewing until his eyes closed. I would wake him up for dinner. In the evening he would go back to work, and work into the small hours. He figured this out as a way to do two days' work into one. I don't think he required a tremendous amount of sleep. He was a very high-energy person.

Annette McComas: He paced incessantly. When you came to call on him, he never sat down. He always reminded me somehow of a tiger or a lion in a cage, going back and forth, holding forth very well, very entertainingly. But incessant movement.

Phyllis White: He was a heavy smoker at one time. Of course that's what killed him. A chain-smoker.

Annette McComas: Mick was the opposite. He'd sprawl in a chair with his legs dangling, roaring with laughter. That's the thing most people remember about him. A very very hearty laugh. And so the two of them bounced off each other. One of them sitting, the other sashaying around the room.

Phyllis White: Mick wouldn't smoke his cigarettes far down. There would be these half-smoked cigarettes all over, and half-full cups of coffee would be all over the place after these marathon editorial conferences.

Annette McComas: They got an enormous amount done. It's incredible how much they got done, and you could not eventually tell who did what. That's a true collaboration.

Phyllis White: I remember once, in the course of my deflecting duties, taking a phone call from somebody who peremptorily asked me, "When does the magazine go to press?" Well, it seems he had just written a story and he was going to send it to whichever magazine was going to press first. Of course, going to press was a continuous process. If a story was bought, it went into inventory, and when the table of contents was being put together, the editors would go into inventory and make a selection of stories that would go together and make a nice balanced issue. Not too much of one kind or too little of another. A nice balance of length, careful counting of words. So this man who telephoned had a rather strange picture of the situation.

Annette McComas: Mick left the magazine in 1954, four years before Tony Boucher did. He resigned because of personal health problems. We moved to Mexico where he tried to regain his health, and was writing *True Crime* articles, several of which were published. That was another magazine that the two men did in common.

Phyllis White: *True Crime Detective* was another magazine from the same publishers which was not doing well, and in a last-ditch attempt to save it, they dropped the editor they'd had up to then. They asked Boucher and McComas to take it on and see if they could revive it, which they did for a few issues. It turned out to be no use.

Annette McComas: Part of that effort was while Mick was in Mexico, and that broke up the team, and then Tony had the entire responsibility eventually because Mick had to quit in 1954. Tony left in 1958. You see, there was terrible pressure doing this on the West Coast. When Mick got better, he went on to be a publisher's representative, but I can't tell you too much because we were divorced in 1961 and went our own way. Friendly, though quite separate. He died in 1978, but he had a stroke in 1966, and was in a convalescent situation. He couldn't talk, which must have been agony for him. He was really out of it for those last years.

Richard Wolinsky: Philip K. Dick once said that when Tony Boucher died in 1968, it turned his world, and Ted Sturgeon's world, upside down. They kept asking, "What kind of a universe is it when somebody as good as this dies at a fairly early age of cancer, and other people just go on and on?" That, in fact, prompted Phil to write a number of later works that were a little more fantastic, *A Maze of Death*, specifically.

Jane Roberts Gets Published

Lawrence Davidson: Jane Roberts said that she had a story out to Tony Boucher that had been sitting on his desk for months, and nothing had happened with it, and then she met Cyril Kornbluth [C. M. Kornbluth].

Jane Roberts: I had sent exactly one story to *Fantasy and Science Fiction* and it was two or three months, and I hadn't heard a thing. I found out because of an article in the paper that Cyril Kornbluth lived maybe ten miles away. So I wrote him a letter. He wrote back and said, "C'mon out." I went, I brought him a copy of the story. I said, "Look, you're published in this magazine. I haven't heard a thing. I need the money. If they don't want it, they can send it back, I can send it out." He said, "I'll tell you what we're going to do." He snapped a photograph of me. I had shorts on and a halter, it was in the summer, in sort of a sexy pose in this great big huge chair. He sent the picture with a note saying "This girl sent you a story and you never even replied." About a week later I got a check. They took the story. From then on, I sent my stories in and I got decent replies. The fact that Cyril intervened, picture or not, was important. It made a difference. It was a sweet gesture. I think the picture was more of a joke than anything else. At the time, I don't know what my reaction was to the note. I just can't remember. I mean I know I was glad the story was taken.

I wasn't overly bothered with sexism, mostly because I thought of myself as a writer first. But I did go to a science fiction writers' conference where I was asked whose wife I was, and that made me utterly furious. I mean, I was *furious* and I swore up and down the line. At that time, at least, I thought that if you were a good-looking woman, you had to play it rather cool, and I guess I grew up believing that. As far as my writing was concerned, I thought that I did a great job, I really did and I still do, with male characters and female characters as well. And I thought that a lot of the male writers did lousy jobs when they were portraying women, and that a good writer could identify with either sex and learn human motivation regardless of, you know, what sex is involved. I did run across some sexism I suppose, yeah, but I just thought that was one of the particular problems that I had, like if you had trouble with poor composition or something. It was part of a game.

Frederik Pohl: Cyril had quite a crush on Jane Roberts at one time. I don't know whether it was platonic or wholly platonic,[51] but I know that he thought she was the ultimate woman. I've never seen her. A friend of mine who's an editor at Bantam and edits her *Seth* books says she's a gnarled up tiny little old lady, and I don't know what she looked like twenty-five years ago.

51 To hear Jane Roberts tell it, the relationship was wholly platonic. In her forties, she developed what appeared to be rheumatoid arthritis, an autoimmune disorder, and died in 1984 at the age of fifty-five.

Lawrence Davidson: She'd gotten very arthritic and very skinny, very very skinny. You could see in the structure of her face and her eyes that she was probably at one point very beautiful. There's a story I'd love to track down, but there's only one man alive who can really give the answer, and that's A. J. Budrys. In the piece in *The Futurians* Damon Knight talks about five people – Jane, Damon, Jim Blish, Kornbluth, and Budrys – she went into trance and they got some kind of gestalt experience where they all got very close to one another, and he dismisses it in the book as "I cried and felt all these emotions but I don't remember a word she said."

Algis Budrys: It was at the very first Milford Conference. Cyril Kornbluth came in with this young, intense, thin woman named Jane Roberts. There was a lot of emotional intensity and a lot of fatigue, because we were working twenty hours a day and we were partying the other four hours, and by the time Thursday rolled around, we got into a contact high such that we were all brethren and sistren. Particularly with Jane, Damon, Jim, Cyril, and myself. We got into a feeling of spiritual affinity so close that we were literally able to finish each other's sentences. It was almost a telepathic situation. Since then, I've experienced it in other combat situations. You really buddy up with people, and you get pushed past the point where conventional society exists. You get to the point where your minds are interpenetrated, and you get these spiritual affinities.

Jane Roberts: All I remember from that trance thing was that I apparently tuned in on a time when Cyril was about five years old, he was Jewish, it was Christmastime, and he was crying when he saw a Christmas tree in a shop window, and asking his parents about Christmas. It's all I remember.

Algis Budrys: I wouldn't call it a trance. It never occurred to me, or anyone else in the group at the time that she was in a trance. She just became very emotional and began speaking in a manner that alluded to supernatural forces and supernatural affinities.

Amazing & Fantastic:
Howard Browne Goes for Class

Howard Browne: Before my two-year leave of absence from *Amazing* was up, Ray Palmer decided he was going to go into business by himself.

Frank M. Robinson: Ziff and Davis never really cared for Palmer's attention to the Shaver Mystery. That was because fans made such a big hullabaloo about it that they felt it reflected badly on the publishing company. So by the time Palmer left them, it was more or less an amicable parting. He wanted to leave and they were glad to see him go.

Howard Browne: Davis came out to the West Coast. He looked me up and said that Ray was leaving in September, so we'd like to call you back a little ahead of time. They gave me a raise, and said come on back, and I

would be the boss. So I came back. I was never happy with the pulps' look so almost immediately I tried to get them to change the makeup of the magazine to go with digest-size.

Frank M. Robinson: It was Howard Browne's ardent desire to take *Amazing* and put it out in the same format as *Blue Book* at the time. *Blue Book* was a big, 8½-by-11 magazine. Once the Korean War started, Ziff-Davis promptly freaked because of their fear of a paper shortage, like during World War II. They knew what they wanted to spend paper on — their technical magazines. So it was then that Browne finally got permission to take one of the magazines and throw it out as a digest, and that became *Fantastic*, published in tandem with the last two issues of *Fantastic Adventures*. They did not kill *Fantastic Adventures* at that time. They killed it four or five issues later.

Howard Browne: I'm not being modest but I'm not being immodest either, but I think that the first issues of *Fantastic* were as good a publication in that field as has ever been. Of course, man, I had writers in there.

Philip K. Dick: Howard Browne, the editor of *Amazing* and *Fantastic*, he was very nice. He was a lot of help to me. I found him a very good editor. He defined the kind of story I could best write, and he was quite correct. I did a lot of stuff for him. I did meet him in '54 and liked him immensely.

Isaac Asimov: Oh yeah, I did stories for Howard Browne. He was editor of *Amazing*, and for a few issues he managed to persuade them to let him put out a high-class magazine which paid a nickel a word. We had never heard of that. I wrote a story called "What If" for him, and then I wrote another story, but by the time the second story got published, *Amazing* had gone back to its usual format. The second one I called "Flesh and Metal" or "Mind and Iron," something horrible. I don't usually say that my titles are horrible, but this one was, and he changed it to "Satisfaction Guaranteed," which was a perfect title, which I kept all the time. I don't invariably change back to my own titles. Every once in a while, an editor chooses a better title than I had, but I can't recall any cases where Horace Gold or Frederik Pohl did.

Stuart J. Byrne: Howard Browne for some reason didn't take to me. I couldn't sell him anything. One time he had the feature art for the front cover and he sent it to Ray Palmer. He said, "Listen, write me a feature story on the cover. We'll give you a house pen name." Palmer sent it to me on the q.t. and said, "You write it and I'll send it to him and say I did it." So I wrote a 30,000-word novelette called "Land Beyond the Lens" under the pen name John Bloodstone and pretty soon Browne sends a letter to Palmer and says "What are you trying to do to me? Everybody wants a sequel." So Ray says to me, "Do the sequel." So I did "The Golden Gods," still with the hero Michael Flannigan in it, and Browne says, "What are you doing to me? They want

another sequel." So along came "The Return of Michael Flannigan" and that became the *Flannigan* trilogy.

I think it was in 1953 at the Worldcon in Chicago [1952], where Ray Palmer and I were sitting there with Browne at a table. And that's when Palmer confessed to Browne that I was John Bloodstone. Browne practically turned purple. He had thought that the Flannigan trilogy had been written by Palmer.

Robert Bloch: I had written a story for *Famous Fantastic Mysteries*, which was called "The Man Who Collected Poe," and in it I took "The Fall of the House of Usher," used that as a framework for my plot, but I also incorporated in the story sentences and sometimes whole paragraphs from Poe's story. My story was set in modern times. I would insert these things just for kicks, see what I could get away with. The story was printed. Pretty soon I got a letter from a professor at Hunter College, in New York. He was a Poe scholar and he was getting a definitive collection of Poe's work out for use as a college textbook. In the course of that, he said, he'd run across the manuscript for Poe's last, unfinished story. He'd read my story. He said, "Do you think you'd be particularly interested in finishing this story?" Well, how could I possibly refuse such a challenge? I'd try my hand at this thing, and the idea of collaborating with Edgar Allan Poe a hundred years after his death was doubly appealing because I wouldn't have to pay him half. So I sat down and wrote the story, which then went to *Fantastic*, which paid a fabulous five cents a word for a few issues after Palmer left and Howard Browne took over and it went to digest-size, and no reader that wrote in to comment on it was able to tell where Poe left off and where I began. But it was a big challenge to figure out what he had started, where he was going to go, what kind of plot he was going to involve, and how he was going to resolve it. So it was a lovely opportunity.

Howard Browne: After we had brought out the first issue of *Fantastic*, Bill Ziff called me down to his office and said — this was when Spillane was at his hottest — "Why don't you use a story by Mickey Spillane?" I said, "Mr. Ziff, Spillane is a detective story writer and he gets the kind of money that pulp magazines don't dream of spending." So he said, "Well all right." Now when a boss makes a suggestion, you try to find a way to handle it. So I called up an agent that I knew quite well, and said, "Can you tell me who Spillane's agent is?" and he said, "By a strange coincidence, I am." I said, "What will you charge to write a fantasy story for me?" He said, "Howard, you couldn't afford it. However, Spillane wrote a fantasy story that's been turned down by everybody in the business." So I said, "Let me see it," and he sent it over to me.

It was one of these stories where a guy is sitting in a man's study, and there's a picture on the wall of a woman with green skin. He tells his friend about the woman and goes on and on and on for six hours, and the end, the

big surprise, is that he draws the curtains and you see the real woman, who has green skin. And the title of the story was "The Woman with Green Skin." He gave away his story in the title, but that wasn't Spillane, it was somebody else. So I read it and I went down to Ziff, and I said, "I got a story by Spillane. You're going to have read it, though."

He begins to read, and by page four, he had gone about as far as he could. He said, "Well, too bad it's not very good." He gave it back to me and I left and called the agent and said, "How much do you want for this story?" He said, "A thousand dollars." I said, "I'll pay you a thousand dollars for it if you give me a letter to the effect that I could make any editorial changes I think necessary." Well, cupidity got the better of good judgement. He said, "All right."

So he sent me the letter and I sent him a thousand bucks. And I came in with a 15,000 word Mickey Spillane story called "The Veiled Woman." I killed, I think, fourteen people in it. This came out on a Tuesday. Thursday we begin to get telegrams, phone calls, from distributors all over the country. We want more, send us more. It sold out in the morning. Anyway, I now get a call from the agent, terribly upset. Spillane called him up, just raised hell over this thing and he was going to release the information to all the news services. I said to the agent, "Look, let me see if I can smooth it over." Then I called Spillane and I said, "Mr. Spillane, this is Howard Browne. I understand you're upset." Man, I heard cusswords I'd never heard before, fascinating. He went on and on and on. Finally he began to repeat himself, and then I got back on the line and said, "I can understand how upset you were by this, now let me tell you my side of the story. We were going to run the story, I loved the story," God forgive me. "But I happened to pick up a copy of *Life* magazine and they had a five- or six-page spread telling a story, and the story it told was 'The Woman with Green Skin.' So we no longer had first rights to the story — you had sold it to a national publication."

I had seen this magazine just before we published it, and I knew I had my ace in the hole if anything went wrong. I said I was shocked, worried: "Now we were going to have to run a repeat on what was hailed as the never-before-read masterpiece by Spillane. So I tried to reach you but you were in Jersey someplace." His agent had told me in a previous conversation that Spillane spent days with cops, riding around, and you could never get to him. I didn't know whether he was or not, but he couldn't say I was wrong. "We tried to reach you, and in desperation I sat down and wrote this thing myself, doing my best to match your inimitable style, and I did the best I could." He said it was horrible. I said I'd done some writing, I wrote under the name of John Evans.

"You wrote the *Halo* books?"

I said, "Yeah."

He said, "I got a couple of them on the shelf here." Now we were two pros, which made a big difference. So he said, "Well, I can understand your

problem and I'm sorry it happened that way. Of course, when I sold that to *Life* magazine, I had no knowledge the thing was going to sell because it was around so long. Why don't we just forget it, okay?" Our attorney was listening in on the other line. "Good," he said, "because he could have made it tough on us." Not really, because I had the ace in the hole.

Successors to Howard Browne:
Paul W. Fairman & Cele Goldsmith

Howard Browne: Paul Fairman could write damn near anything. I don't know what Paul died of, I think he had ulcers because he was, on the surface, the most relaxed guy in the world. I discovered him, if I may say so. He was a janitor at the big theater on Michigan Avenue. He wanted to be a writer, and he wrote some detective stuff and sent it to New York, and New York sent it back. So he sent me one called "Late Rain," which was a beautiful story. I bought it and sent a check and a letter, and here comes this painfully thin man in a ratty suit — he had no money — and we talked a while. He sent me some other stuff, and I wrote him a couple of letters, and then I began to give him springboards for plots, and he would write them. Then when I went to New York, he came to New York and wrote for a while, and then when there was an opening, I hired him as an editor for *Amazing*. Paul never really cared about editing. He knew the mechanics of editing. Cele Goldsmith did most of the picking of stories after I left. When he left, then Cele took over the magazine.

Robert Silverberg: Cele started as the secretary and inherited the magazines and did very well. I wrote for her in the '60s. But Paul Fairman and I were not especially simpatico. I didn't know what it was, but we didn't like each other very much. I wrote some stories for Paul but it was plain that he wasn't enthusiastic about having me around and I wasn't comfortable there, so during Paul's time I stopped writing for them.

Isaac Asimov: I think Cele Goldsmith was the first editor I ever worked with who was not a hypnotic male. She was a sweet, pleasant, and beautiful female, which was sufficient to hypnotize me. I remember best that she asked me to write a story in response to a satirical article that appeared in *Playboy* called "Something-something of the Slime Gods,"[52] making fun of science fiction, and using as their inspiration some stories that appeared in *Marvel Science Stories* in 1938, which at that time published what we considered very daring stories, but which were really very mushy porn, if you know what I mean. So I wrote "Playboy and the Slime God" and it was, I thought, a very funny story. Cele changed the last couple of paragraphs without telling me, and instead of being furious with her, which I would

52 The title was "Girls for the Slime God."

invariably be if anyone else did that, I was pleased because it was a big improvement over what I had. It's been one of my favorites since, only I call it "What Is This Thing Called Love?" which is a perfect title for it. What happened was that when Groff Conklin wanted to anthologize it, he said, "Haven't you got a different title than 'Playboy and the Slime God'?" and I said, "Sure. How about 'What Is This Thing Called Love?'" and so that was perfect.

Richard A. Lupoff: I think that Cele Goldsmith was one of the great unsung editors in our field's history, because she published not only Roger Zelazny's early works, but Tom Disch's and Ursula Le Guin's as well. Her *Amazings* and *Fantastics* were really remarkable magazines. She had a particular capacity for finding young writers who didn't have any name value yet.

Ursula K. Le Guin: Cele Goldsmith and I never met, but she was a good editor, and she did edit. Sometimes it was a bit disastrous. In the first story that she accepted for *Amazing*, in 1962, called "April in Paris," and it's a fantasy, she added a lot of words to the last sentence. It takes place in Paris you know, and the Seine is flowing by, and when I read the story in print, it said "The Seine was flowing by in all its rippling grandeur." And I went through the roof. This was my first publication, but all the same, I did write her and said, "Where did that 'rippling grandeur' come from?" And she said, "It was a widow and I had to fill out the line." And I said, "Well, next time, don't do it with the last sentence of my story," and she said, "Okay." And she really was very nice.

Roger Zelazny: I actually never met Cele until years later, briefly once. Certainly I have a great soft spot in my heart for the person who bought sixteen out of my first seventeen stories.

Fritz Leiber: It wasn't until Cele Goldsmith became the editor of *Fantastic* that I began to be successful in selling Fafhrd-Mouser stories. She was very enthusiastic about the characters and I must have sold about six of the stories to *Fantastic* during her editorship. She was a very charming and perceptive woman. It was when the magazines were sold to Ultimate Publishing Company under Sol Cohen that we lost Cele as an editor.

Dead on Arrival: *Worlds Beyond*

Philip Klass: Damon Knight said to me, he said, "Phil, I think John Campbell is ripe for the plucking." Campbell at that time, remember, had gotten involved in Dianetics. He'd also gotten involved in the Hieronymous machine and telepathy and so forth and so forth.

Damon Knight: *Worlds Beyond* was just a shot — well, I suppose it was my version of *Fantasy and Science Fiction*. *F&SF* came out in the fall of 1949, the first issue. *Worlds Beyond* appeared in 1950, I forget what month.

It started when I said to Fred Pohl, who was then my agent, "Who do you know who might like to publish a science fiction magazine?" He sent me to Alex L. Hillman. Fred has done these tremendous favors for me over the years, at least three times. This was at the point when there was a little explosion of science fiction magazines: *Galaxy*, *F&SF*, *Other Worlds*. And Hillman thought he might be getting in on the wave of something which was going to make money, and so he went for it. But I was so naïve, I didn't ask for a contract or anything. The returns on the first issue were bad, and he killed it. Three issues were published, but it was effectively dead after the returns of the first one came in.

Hillman Periodicals was not a cheerful place to work. There was an atmosphere of gloom in that place. Hillman would lumber down the hall, a half-smoked cigar in his mouth, and if you said "Good morning" to him, he'd look right through you and walk past.

Harry Harrison: I illustrated almost all the illustrations in the first volume and second volume of *Worlds Beyond* in 1951. Really nice magazine. For the second issue, I had the flu or a throat infection. I couldn't draw. Your hand shakes, you can't draw very well, but you can still type. If your shaky finger hits the typewriter key, it doesn't really matter. So for some reason I wrote a short story. The next month with a few drawings, I said, "Damon, I've got a short story here with a great title, called" — it's really a rotten title if I think about it now — "called 'I Walk Through Rocks.'" I said, "Damon, what do I do with it?" He read it, said, "I'll buy it. Give you a hundred dollars." A hundred dollars! It was seven dollars each for illustrations. Better than drawing. He retitled it "Rock Diver." I mentioned it to Fred Pohl, my agent at the time. Fred read it and said, "I'll put it in an anthology. It's a good story." He put it in *Beyond the End of Time*. That was the beginning. The next story, it was about four years later before I sold anything else. But it helps to start off big, you know.

Larry Shaw: The story of mine that people seem to remember best is "Simworthy's Circus" in the very early '50s, which Damon Knight bought and published when he was editor of the magazine *Worlds Beyond*. That story has been anthologized a couple of times and most recently, by Isaac Asimov in his anthology of humorous science fiction. The last time I was at a science fiction conference of any sort, I autographed a copy for a young fan who said that he thought it was a fine story. I always loved the feeling of having written something that I think is at least satisfactory, or possibly good. But I hate sitting at a typewriter and writing.

Running with the Pack:
If: Worlds of Science Fiction

Richard A. Lupoff: In the early 1950s science fiction magazines sprang up like desert spores after a rainstorm. James L. Quinn was a publisher in Kingston, New York, who just decided, out of the blue, to get into the game. He started this rather quirky little magazine with good editors – Damon Knight, Larry Shaw – who did a very nice job. Larry bought James Blish's great story "A Case of Conscience" that seemed to scare off everybody else. Finally Quinn got tired of *If* and sold it to *Galaxy*, where it became Fred Pohl's – what should I call it? – okay, "B label."

 Larry Shaw: How did I get started with *If: Worlds of Science Fiction*? Around 1953 there was a job open for a science fiction editor in Kingston, New York, a village about eighty or ninety miles up the Hudson from New York City. A publisher named James L. Quinn had started a couple of magazines. One of the magazines was *If*. The first editor of that was Paul Fairman, very well-known in the field. He left after four or five issues because he was primarily a writer. He didn't really need any full-time editing job, and Quinn turned out to be a very hard man to get along with.

 However Quinn did want an editor to continue in Fairman's place. I don't really remember how I heard about the job. I can't really imagine a publisher advertising in the *New York Times* for a science fiction editor, but it's just barely possible that it did happen that way. In any event, I applied for the job by letter. At that time I was the full editor of an automobile magazine named *Auto Age*. So I wrote to Quinn. He invited me to come up for an interview. I went. The interview was satisfactory. He hired me. I moved to Kingston. When I got there he informed me that my title was not to be "editor," but "associate editor," which was a letdown but not the most important thing. In actual fact, I really did edit *If* for perhaps half a dozen issues.

 Richard A. Lupoff: Quinn claimed the editorship for himself. I remember that as a reader at the time it was obvious, very obvious that this guy was the publisher, and for some ego involvement, he wanted to take the title "editor." He had people working for him who actually put out the magazine...

 Larry Shaw: ... and making most of the decisions, though not all of them. If it had been entirely up to me, I would have enlarged the letters to the editor section, and I would have gotten rid of the news in science ["Science Briefs"] section, which always struck me as a waste of time. And things like that. But I did choose the stories. An important one that I chose – in fact I took it with me when I went up to Kingston for the first time – was "A Case of Conscience" by James Blish.

Richard A. Lupoff: An instant classic. I remember Blish also speaking of that and of having just a devil of a time selling it because too many people were scared to touch it.

Larry Shaw: Campbell wouldn't touch it at all. I believe Sam Merwin would have published it if Jim had taken all the religion out, but of course the religion was the whole point of the story. So Jim was very pleased that I bought "A Case of Conscience." He thought that automatically proved I was a great editor, and it was the real beginning of my friendship with Jim, although I had known him earlier in the Futurian days.

Frank Kelly Freas: The only editor I ever worked with who really had illustrations down pat was Larry Shaw, when he was with *If* magazine. He could write three sentences and describe exactly the picture that the story called for, and he was the only editor I knew who could do it. He had a tremendous visual imagination.

Larry Shaw: One day Quinn fired me. He stormed into my office and told me I was not really an editor and that I should get out as soon as possible. If it had happened today, I would have dug in my heels and asked him for specifics, but in those younger days I didn't. I got out. I discovered much later when I became friendly with Paul Fairman that he had found Quinn impossible to get along with. And later on, for a short period, Quinn hired Damon Knight as editor, and Damon only lasted about three or four issues.

The List Goes On:
Infinity & Science Fiction Adventures

Larry Shaw: After I was fired from *If,* I went back to New York and edited magazines again, mostly automobile magazines, until my friend Irwin Stein, who had become a publisher on a shoestring, decided to start a couple of fiction magazines. What he started with was a pair of magazines, one science fiction and one mystery, *Infinity Science Fiction* and *Suspect Detective Stories*. Everybody told him that starting a detective magazine was a smart move. Science fiction was in a slump, and they told him he was a fool for starting *Infinity*. It worked out the other way around. *Infinity* sold quite well. *Suspect Detective Stories* did not sell at all, possibly because potential readers suspected that the stories were not very good. *Infinity* and *Suspect* were not pulps, they were digest-sized. But it was the same kind of audience, the same kind of magazine. The digests were really a continuation of the pulps, as far as I was concerned.

Suspect lasted five issues and was not selling. Irwin Stein decided to turn it into a science fiction magazine. Now the one thing that *Suspect* had achieved, or had obtained, was its second-class entry with the post office. Irwin Stein wanted to keep that second-class entry, so he claimed that instead of starting a new magazine with science fiction adventures, he was

simply changing the title of *Suspect Detective Stories*. So the first issue of *Science Fiction Adventures* was numbered Vol. 1, No. 6. Well, the post office didn't go for it, and neither did anybody else. But thus was born *Science Fiction Adventures*, which was a space opera magazine, pure and simple, and a lot of the stories for it were supplied by the very young Harlan Ellison and Robert Silverberg, who were just breaking into their writing careers.

Robert Silverberg: I did everything for Larry Shaw. Stories and book reviews, odds and ends. It was a kind of communal magazine. Harlan and I and A. J. Budrys, we all kept going in and out of the office, doing whatever was necessary. That was for *Infinity* and the companion magazine, which I wrote almost single-handedly sometimes, *Science Fiction Adventures*. Not to be confused with the earlier *Science Fiction Adventures*, which was a John Raymond magazine. It was a nice time. It was an interesting time to be young and prolific.

Larry Shaw: We ran some stories by one Ivar Jorgenson. He had been a mainstay contributor to the pulps *Amazing* and *Fantastic Adventures*. He was, in those days, actually our friend Paul Fairman. But Bob Silverberg had always wanted to write stories under the name of Ivar Jorgenson. So I simply asked Paul Fairman, who I knew pretty well by then, "Would it be all right if Silverberg used the name?" and he said, "Sure, I don't want to anymore."

Robert Silverberg: This was, I think, one of the causes of the coolness between Paul Fairman and me. Ivar Jorgensen was Paul Fairman's pseudonym, spelled "s-e-n" at the end. I was a Ziff-Davis writer and I wrote stories by the bucketful for Ziff-Davis under all sorts of their regular pseudonyms, Alexander Blade, Robert Arnette, God knows what all else. And then Larry Shaw, when he began *Science Fiction Adventures*, said, "Since you're a Ziff-Davis author, we can put your name on one of their famous bylines. Let's do an Ivar Jorgensen story." And I did one called "Thunder Over Starhaven" by Ivar Jorgenson, and in my haste, I spelled it "s-o-n". A forty, fifty thousand word story, something like that, and it was published

The next time I was in the Ziff-Davis office, Paul said, "What the hell are you doing, Bob? That's my pseudonym."

I said, "I didn't know that. I thought it was a house name." Well, it wasn't a house name although I had liberated it, and suddenly it became a house name over at *Imagination* and *Imaginative Tales* and even *Amazing Stories*. It's the only Ivar Jorgenson book I ever wrote. Paul wrote a number of them and they're often presented to me for autographing at conventions.

Richard A. Lupoff: Larry Shaw published some good stories in *Infinity*. There was "The Star" by Arthur C. Clarke, which was a sensation in its day, sort of a latter-day "A Case of Conscience."

Larry Shaw: I published a story called "But Who Can Replace a Man?" by Brian W. Aldiss, which I could almost claim predated the New Wave as

a New Wave story. I published some of Damon's stories that I thought were among his best and a couple of Jim Blish's that I did not think were among his best but were good solid science fiction. I was definitely not trying to compete with John W. Campbell and *Astounding*. I saw *Infinity* as being more on the level of *Thrilling Wonder*, perhaps a little more sophisticated. But there were definite indications a couple of times that Campbell was very aware of *Infinity* and considered it a competitor.

For instance, when Robert A. Heinlein wrote *Citizen of the Galaxy*, he was somewhat on the outs with Campbell. He did not particularly want that novel to go to Campbell, and as a result I was able to persuade his agent to let me look at *Citizen of the Galaxy* before Campbell saw it. I wanted to buy it and publish it. Heinlein and his agent wanted four cents a word. We did not come up with four cents a word, so I lost the novel. I still think it might have really put *Infinity* on its feet if we had published it, but that did not happen.

There was also another incident. Randy Garrett, who wrote a lot for *Infinity*, wrote a novelette that was designed to be the first in a series about a man named Leland Hale, a sort of interstellar con man. He submitted a story to Campbell; Campbell bounced it. And Randall brought it to me. He was pretty sure I would like it, and he would get a fairly quick check for it. I did buy it, and scheduled it for publication. Randall, meanwhile, went home and wrote the second story in the series and naturally took it to Campbell, somehow letting it drop that he had sold the first story to *Infinity* and *Infinity* was going to publish it. Campbell tore his schedule apart apparently — unless he just happened to have a hole in a very early issue — and managed to publish the second story in the series before I came out with the first one.

Richard A. Lupoff: I understand there's a sort of unwritten law that if you sell someone the first story in a series you at least give him first option on succeeding stories.

Larry Shaw: I suppose so. Randall has had his occasional slips in obeying laws, both written and unwritten.

Richard A. Lupoff: In the early 1950s, when *Infinity* was getting started, I was a science fiction fan, and I had been a letter hack in magazines like *Other Worlds* and *Amazing* and *Imagination*, and when the first issue of *Infinity* came out, I sent a letter to the editor and I thought maybe there was a chance that I would hit the letters column. Instead, I received a personal reply with a postcard from Larry T. Shaw, the editor. To me, this was far better than having my letter published in the magazine. A personal response from the editor was the first inkling that I had that editors were real human beings too, and not towering demigods who strode around the uppermost stories of glass skyscrapers.

Larry Shaw: I don't remember what I said on the postcard, but I was still pretty much of a fan at heart, I felt at the time. I wanted to get a good lively letter column going in *Infinity*. I never succeeded to any great extent,

and I'm still not sure why. I don't know if a change in attitude had taken place with the coming of a new decade, but *Infinity* just never got a lot of fannish mail. Got a few good letters, and I tried to stir up some controversy occasionally, but I can't say that the letter section ever was much to brag about.

I'd say that our circulation reached a top of maybe 50,000, out of a print run of 80,000. Probably on the first few issues we printed 100,000, very optimistic, and gradually cut back the print run to be somewhat more realistic. But rarely if ever sold much more than 50% of the print run. But 50,000 would have been the tops and it would have been close to the beginning of *Infinity's* lifespan.

What happened was that another boom started, and a lot of other people started bringing out digest-sized magazines, and they all perhaps had a tiny piece of the pie but not enough to be self-sustaining.

First, Stein scuttled *Science Fiction Adventures* about two issues before *Infinity* died, which left us with a couple of soap opera-ish Calvin Knox-type science fiction adventure novels, which had to be used up as lead novels in *Infinity*. They did not, of course, fit the previous policy at all. The other thing that happened was that for the two final issues of *Infinity*, to fill up the short-story space, I had to call up the well-known agent Scott Meredith and make a package deal for several short stories, many of which I had rejected earlier when we were paying a cent and a half or two cents a word. The package deal probably came to less than a cent a word on account of the wordage. *Infinity* and *Science Fiction Adventures* died in 1958 and I went back to editing automobile magazines, until the early sixties, when I became involved with Regency and then Lancer Books.

Ray Palmer Goes It Alone:
Other Worlds & Universe

Frank M. Robinson: Around 1948, while he was still editing *Amazing*, Ray Palmer started a magazine called *Fate*. He had rented a little office around the corner from Ziff-Davis, and worked at *Fate* during his lunch hour. The next year, he left *Amazing* and put out his own science fiction magazine, *Other Worlds*, as a digest-sized science fiction magazine printed — and this is very important — printed on a high-bulk newsprint. That meant that for 160 pages, his magazine was at least twice as thick as either *Astounding* or *Galaxy*. That's the difference between a hard-surface newsprint and a high-bulk newsprint.

Stuart J. Byrne: Ray Palmer just took anything I wrote for *Other Worlds*. What opened the door with him was when I saw him in Chicago after I came up from South America. I gave him a feature, "Prometheus II." That

was my second-biggest story check in those days. He gave me a splendid shining check for $750 and I really thought I was getting somewhere.

Harlan Ellison: Ray Palmer was a smart, clever editor who worked on a shoestring and managed to put out some of the best-looking digest magazines. Even when they were filled with crap, they were never less than fascinating. You go back and read issues of *Other Worlds*, you'll find, for instance, "Myshkin" by David V. Reed, which is a short novel or long novella. Nobody else would publish it. That was David Vern, who was an addict and who was a madman but he was brilliant — Ray had to lock him in a hotel room and put bars on the door to get him to finish writing the story.

Frank M. Robinson: At a convention, Palmer met Bea Mahaffey and offered her a job and she accepted. Bea became chief cook and bottle washer. One time in his Evanston home, Palmer fell on the steps to the basement and landed on his back on the concrete floor. He was hospitalized for a long time and Bea put out *Other Worlds* in his absence.

Richard Wolinsky: When Palmer returned in 1953, he suspended *Other Worlds* and started two new magazines, *Universe Science Fiction*, edited under the pseudonym of George Bell, and *Science Stories*. The latter folded quickly and the former was renamed *Other Worlds* in 1955 and then *Flying Saucers from Other Worlds* in 1957. But during its two years of operation, *Universe* did have one major distinction. It published Theodore Sturgeon's groundbreaking story, "The World Well Lost."

Frank M. Robinson: "The World Well Lost" was the first story with homoerotic overtones in science fiction. Sturgeon had submitted it to Howard Browne. Whether Browne was at the digest *Fantastic* or the digest *Amazing* at the time I don't know. The story goes that Browne so hated the story that he wrote all the other editors in the field warning them against printing it. Presumably Palmer got one of the letters and immediately inquired about the story and went ahead and printed it, primarily to get Browne's goat.

Stuart J. Byrne: Ray Palmer fell in love with *Tarzan on Mars*. At the time, I was two personalities as a writer, my styles at least. S. J. Byrne was science fiction, but because of the success of the Flannigan trilogy and the name Bloodstone, I tried to slant my Bloodstone stories toward fantasy, which began to approach the Burroughs style. So it began to creep up that I was so much like Burroughs that I was being touted as a possible successor. J. Allen St. John, who was a chief illustrator of the Burroughs stories, began to illustrate my stories. So I thought it was only fair to do a showcase novel, *Tarzan on Mars*. I began to send Ray Palmer chapters. He said, "What are you doing to me? Where's the next one? I can't stand it." So he fell in love with it and began to publish some articles about it, and he claimed from all over the world to have potentially 20,000 orders for it, which apparently interested the Street & Smith people to finance the publishing of it. They approached the Burroughs people. My agent got in on it, Forry Ackerman, and we went

over to Burroughs and offered them what Street & Smith offered: 25% royalties to the Burroughs people if they just said yes. It wasn't my fault, but it went wrong. It went wrong because it was the idea that Stu Byrne should succeed Edgar Rice Burroughs. For forty years it's been in the underground and I've autographed about fourteen different versions of *Tarzan on Mars*.

Later on, a Burroughs lawyer said, "Well, why do you have to fool around? Why don't you create your own Tarzan-type stories, and make your own Burroughs-type stories?" And that was the birth of *Thundar: Man of Two Worlds* [which was published in 1971 — Ed.].

Imagination & *Rogue*: the Publishing Empire of William Hamling

Frank M. Robinson: Ziff-Davis moved from Chicago to New York in 1950, and Bill Hamling decided to stay behind. He started *Imagination*, with Palmer as a front. And then with the second issue, it was revealed — ta-da! — that Bill Hamling was actually the editor. I got to know Bill rather well. Used to have dinner at his and Frances's house quite a bit. Frances was the widow of Leroy Yerxa, who had been a big supplier of fiction to Palmer. She was a real looker at the time.

Richard Wolinsky: William L. Hamling's *Imagination* began in 1951, and a companion volume, *Imaginative Tales*, started publishing in 1954. Hamling was on his way.

Robert Silverberg: Hamling wanted *Imagination* to be as good as John Campbell's *Astounding*. But he couldn't do that, partly because he wasn't John Campbell and partly because he wasn't paying much for the stories.

Eventually, he transformed both of those magazines, *Imagination* and *Imaginative Tales*, into action-adventure pulps in digest-format magazines, in the mode of the old Ziff-Davis *Amazing*. The way he did that was to hire a bunch of energetic hacks and say, "Turn in 70,000 words a month. I'll buy them sight unseen. So long as the stories don't stink, and sooner or later I'll discover that they do, I will go on giving you a monthly retainer."

Since I was writing for everybody in every level of the spectrum, from *Astounding* and *Galaxy* and *F&SF* at the top, down to *Amazing* and whatever at the bottom, I was gobbled up into Hamling's stable of writers. Every month I would send him a package of 50,000 words of fiction and get back $500. I was doing the same thing for Ziff-Davis at that time.

Frank M. Robinson: Somebody once said about Hamling, "All that engine and no steering wheel." He had enormous energy, all of it misapplied. Hamling was the only publisher on God's green Earth who would go into a printing plant and call for color corrections while wearing his sunglasses.

Harlan Ellison: Bill Hamling had a blinding, blinding envy of Hugh Hefner, because the two had started out together. They had both worked over

at *Modern Man*, which was a nudist magazine, a men's magazine out in Skokie, long before *Playboy*. But when Hefner started *Playboy*, Hamling's head damn near exploded from envy.

Frank M. Robinson: So in the early fifties, Hamling was coming out with his science fiction magazines, *Imagination* and *Imaginative Tales*. Hugh Hefner and Hamling had worked together for an outfit called Publisher's Development Corporation in Skokie. Hefner [who had started *Playboy* in 1953] said, "I tell you what. If you have an idea for any other magazine, I'll introduce you to my distributor."

So Bill and I sat down at his kitchen table and we talked about putting out — what else? — a men's magazine like *True*, *Saga*, *Argosy*, all the rest. They were obviously successful magazines. We even had a title. We were going to call it *Caravan*.

Bill goes out to lunch with this guy, he'd been distributing *Bare* and distributing *Playboy*, that was all he knew. Typical guy with big stogie. And Bill tells him about our great plan for a magazine to be called *Caravan*. The guy takes the cigar out of his mouth and looks at Bill and says, "What the hell is it going to be about, camels?" It was then that Bill, ever thoughtful Bill, he had another title warming up in the bullpen called *Rogue*, which would be a lot like *Playboy*. So that's what he sold.

But Hefner didn't want Bill in the same distributing company, putting out a duplicate product. So Bill could only go with this guy on the grounds that (a) he not print on slick paper, (b) he not have foldouts of pretty girls, (c) he not have full-page cartoons. For Hefner, these were the things that made *Playboy*. He didn't want to see Hamling duplicate them.

Richard Wolinsky: During that same period, *Playboy* gained a reputation for also publishing science fiction, though most of its readers still went right to the centerfold.

Frank M. Robinson: When they first started, *Playboy* reprinted some stuff from *Imagination*. They bought the rights from Hamling for a hundred a pop, or whatever it was. Later on, with Ray Russell on board, they began to publish their own stuff, picking up Bradbury, Matheson, Charlie Beaumont. I have always characterized fiction in *Playboy* as being little-known stories by well-known authors and well-written pulp. And they picked up a lot of well-written pulp.

Richard Wolinsky: And, of course, all written by men. Women had no place in the *Playboy* universe, except of course as centerfold fodder.

Algis Budrys: From the middle of '63 to the end of '65 when I was editorial director at Playboy Press, I was also reading the science fiction short stories that came in the magazine. Jane Roberts had sent one in. I kind of liked her story for *Playboy* but it had a female byline on it and she wouldn't take it off, and *Playboy* was frankly chauvinistic.

Ursula K. Le Guin: I was either the first woman to have a story in *Play-boy*, or the second. Françoise Sagan may have been the first. *Playboy* was not printing anything but men at that point. The story was submitted by U.K. Le Guin and they accepted it, and then my agent Virginia Kidd said, "Nyah Nyah Nyah," and they were really scared, and they said, "Can we continue to use the initials?" and of course we had to say yes, because we'd submitted the story with initials. They wanted a statement about myself from me. Having to hide from their audience that I was a woman, yet they asked for a personal statement. So I just said, "The stories by U.K. Le Guin actually were written by another person of the same name." Very soon after that, the policy changed and they were printing lots more women.

Richard Wolinsky: Meanwhile back in the '50s, *Rogue* was plodding along, up until 1959 when it tried to compete head-on with *Playboy*.

Frank M. Robinson: Around about 1959, *Playboy* sold their distribution franchise to another outfit for a cool mil. So the old distributor asked Bill immediately to throw *Rogue* on slick paper, use foldouts, use four-color car-·toons, all of this. Bill, thinking he needed a bigger staff, hired me.

Harlan Ellison: If Hamling had any ability at all as an editor, it was to imitate that which was successful at a lower, less expensive level, and to hire as editors, the people who could do the job. Frank Robinson and me and a couple of other people were hired, and we did all the scut work, and he took whatever credit there was as publisher.

Frank M. Robinson: Harlan had written for the semi-slick *Rogue*, and he had the cover story for the first slick *Rogue* in '59, and was on the cover for the second, in June of '59. I think Bill hired Harlan as editor because he admired Harlan's writing talent immensely.

He also hired Larry Shaw on the book end of things. He hired A.J. Budrys. Bill Hamling's experience was in science fiction so he was cropping all the science fiction people he knew for non-science fiction material. We published Arthur C. Clarke, we published J.G. Ballard. We had columns by Alfred Bester and Robert Bloch. Mack Reynolds was doing travel articles.

Harlan Ellison: The only time Hamling ever got in our face was when he was giving opinions. We would kind of hold our heads in pain and pray he would go away. He insisted on picking all the cartoons because he thought he had a great sense of humor, and of course, all the cartoons are coarse, crude, badly drawn, and stupid. And any time we would try to elevate the products in any way, we would have to fight our way through Hamling. He was more a roadblock than any kind of great mentor or amanuensis. He was definitely not John Campbell, he was definitely not Horace Gold. He wasn't even on the level of the least editor who ever edited, I don't know, Sam Merwin maybe.

Fantastic Universe & *Satellite*:
Leo Margulies & His Publishing Empire

Richard Wolinsky: Leo Margulies left Standard and the Thrilling group of magazines after World War II. Pretty soon afterward, he started another publishing company, King-Size Publications, which during the boom in the early '50s began its own science fiction magazine, *Fantastic Universe*, which was first edited by Sam Merwin, who had left *Thrilling Wonder* and *Startling Stories* in 1951 and Merwin was replaced at the Thrilling group by another Sam, Sam Mines.

Theodore Sturgeon: And Sam Mines is really one of the nicest people I ever met. He was a very quiet person and extremely nice. And totally different from Sam Merwin. Mines was a very scholarly gentle guy. Mines, however, had the courage to turn the entire history of science fiction around. He published a story by an unknown writer called Philip José Farmer, called "The Lovers," and it was August 1952, *Startling Stories*. He wrote a story in which a guy who came back from a long space voyage wanted to get laid. Wow. What about that! On top of that, the girl that he fell in love with wasn't human. More than that, she wasn't even an animal. She was an insect. And those two things just went WHANG! POW! And the whole liberation of science fiction — I'm not saying today's science fiction stories should be about sex, although a lot of today's writers seem to think so — but that was the one facet that was unreal about science fiction. I began cracking that series of taboos myself, but it was really Sam Mines and Phil Farmer who did it.

Ted White: *Thrilling Wonder* and *Startling Stories* were first-class magazines by the early '50s, I think unfairly ignored when people are talking about what Gold did with *Galaxy* or what Campbell did with *Astounding*. People have ignored what Mines and Merwin did with *Thrilling Wonder* and *Startling*, I think because the titles had a kind of trashy implication to people who didn't read them.

Richard Wolinsky: Merwin stayed with *Fantastic Universe* until 1953, and eventually Leo Margulies himself took over the editorship, with Frank Belknap Long as uncredited associate editor.

Robert Silverberg: I sold a lot of stories to *Fantastic Universe*. I was writing so fast I certainly didn't take time to read my published stories as they appeared in the magazines.

At the science fiction convention, the Worldcon of 1956 in New York, there was a huge table with manuscripts from the recent magazines heaped up on it. The editors and publishers had all contributed them, and they were for sale at, I think, a quarter apiece to anybody who wanted. I bought some myself, a Jack Vance manuscript, a William Tenn manuscript. I still have them somewhere as talismans. And then I noticed a Robert Silverberg manuscript from *Fantastic Universe*, and I picked it up and began idly leafing

through it. I noticed, to my amazement, that about every other word had been changed to its synonym. If I said "introduction," the editor had made it "preface." If I said "books," he made it "volumes." And so on. Right through. Hundreds and hundreds of penciled changes that made no sense because they did not in any way change the narrative but certainly changed the style.

While I was staring at this in wonder, Frank Belknap Long, the venerable, sweet, old-time writer, came wandering by. He was the editor of *Fantastic Universe* then, and I said, "Frank, what is this? Why did you rewrite the story in this way?"

"Well," he said, "Leo Margulies pays me to edit the magazine, and he looks at the manuscripts to make sure I'm really editing them. So if the story doesn't need real editing, I just change the words around and Leo sees a lot of penciled marks on it, and figures I'm doing my job."

Harlan Ellison: Frank Belknap Long got paid by Leo Margulies on how many corrections he made on the manuscripts that went into *Fantastic Universe*. Everybody in those days was just dead fucking broke. Forty-five dollars was just about two weeks' rent for New York, or was seven or eight or ten good meals, and $45 meant the difference between starving and not starving. Frank Belknap Long would just change shit arbitrarily because he was getting a penny per correction. So if he could make ten dollars' worth of corrections for each manuscript, he could make a decent wage. So that's what Frank Belknap Long did, and he butchered people's writing.

Robert Silverberg: Hans Stefan Santesson became the editor of *Fantastic Universe* after Frank Belknap Long stopped. Hans was an odd roly-poly kind of man, high-pitched voice, in his fifties, I would say, and still living with his mother. Very pedantic, very scholarly, very nice. And basically just interested in detective stories. Funny guy, an odd duck, very likable. He took the magazine to the end of its days in the late '50s.

Harlan Ellison: In 1959, *Fantastic Universe* was sold to a man named Henry Scharf, who had a publishing company called Great American Publications. Scharf was stiffing everybody, including poor Hans Stefan Santesson, who was near the end of his life and near the end of his career. Hans was a great man, a great man, and a very good editor indeed. They were doing a magazine, a pulp magazine, for a while, called *Tightrope!*, which was based on the television series that starred Mike Conners. They did a few issues of that and they were buying mystery stories. So Hans solicited me and he bought a terrible story, absolutely terrible, probably the worst story I ever wrote, "Only Death Can Stop It." It was about 2300 or 2400 words and it was a penny a word, and I was supposed to be paid. Hans wanted to pay me out of his own pocket, but he didn't have the money because Scharf was stiffing him. So I went up to collect it myself. And I knew that I wouldn't be able to get in to see Scharf unless I managed somehow to finagle my way in.

So I put on my one good suit, a gray flannel suit, and I wore a hat, and I had my umbrella, and I looked like a businessman. And I came in and I said to the receptionist, "Henry Scharf, please."

And she said, "Whom should I say is calling?"

I said, "Tell him it's Mr. Dieterle from the Internal Revenue Service, Manhattan branch." And I was inside in about three seconds. And when I got inside, he reached across and grabbed my hand to shake my hand, and I grabbed him and I said, "I ain't Dieterle, my name's Ellison. You owe me thirty-two dollars, motherfucker. Give me my money."

And he started screaming and yelling and hollering. There was a huge bullpen outside with all kinds of secretaries typing away madly on things, and I went dashing out one door of his office on one side, as everybody came running in the main door of the office around the other side. By the time I got around out into the bullpen area, there was nobody left. Everybody had run in the other direction. So I grabbed the typewriter, one of those great big ones. It was the Mosler Safe Building on Fifth Avenue downtown, right around 37th Street,[53] something like that. And I ran down, I don't know, ten or twelve flights because I couldn't take the elevator. I ran down the stairs, then I ran up to Seventh Avenue, Eighth Avenue, Ninth Avenue, and I found a hockshop and I pawned it for fifty-something dollars, and I made a clear profit of thirteen, fourteen bucks.

Richard Wolinsky: Soon after Leo Margulies sold *Fantastic Universe*, he began Renown Publications, which put out *Satellite Science Fiction*, which had the same editorial policies as the old *Startling Stories*.

Frank Belknap Long: I went with Leo to the Renown group after he broke with his partners. That was *Satellite Science Fiction*. They also published *Mike Shayne Mystery Magazine* and they revived *Short Stories* for a brief period. I worked for the Renown group, you see. I was assistant editor there. We got some very good writers in those days. *Satellite* didn't last as long as some of those other magazines, but probably about one third of all the important writers in the field contributed to the group.

Doc Lowndes: Editor Without a Budget

Basil Wells: Doc Lowndes, he was the editor of *Future* and *Science Fiction Quarterly*. He was a good guy. I always enjoyed writing him. We had correspondence back and forth. He was a swell fella. I think we had more swell editors back in those days than you get today. They had more time too, that's true.

Robert Silverberg: I knew Doc Lowndes quite well. Lowndes, a particularly endearing, somewhat ineffectual man, was not only an editor, and a

53 Harlan was on a roll. The address of the Mosler Safe Building was 320 Fifth Avenue (at 32nd Street).

very good one, though he was able to pay next to nothing for his stories, but a collector of old-time science fiction magazines, and that interested me, and a very serious collector of classical music records, which I also was and still am. So despite the fifteen- to twenty-year difference in our ages, we became very good friends. I would frequently go to his house in the country on weekends and spend whole weekends out there with him and his wife. He and his wife gave me my first cat, much to my surprise. In 1956, we were leaving — that is, my wife Barbara, at that time, and I — we were leaving the Lowndes place after a nice weekend, and Dorothy Lowndes came up to me and said, "Wouldn't you like to take this kitten home with you?" And I blinked, and Barbara said, "Of course we will." We took the cat, and I've had cats ever since.

Frank Kelly Freas: It was a lot of fun working with Doc Lowndes, and also with Milt Luros [later a Los Angeles publisher — Ed.], who was his art director at the time. I learned a lot from Milton, I learned even more from Lowndes, and there again, it was usually an assignment given with a pretty free hand as to how I finished it up. The difference between working with him and Campbell was that most of the time he would give me a paragraph and tell me to do an illustration fitting a paragraph, rather than the whole manuscript. In some ways, this is a very difficult way to work.

Robert Silverberg: Lowndes could pay no more than a cent a word on publication, which even then was the bottom. But he was a man of taste and scholarship. He knew science fiction very well. He knew poetry and literature very well. And he had a great many friends. So he would cajole these friends to do stories for him, despite the fact that he would pay them next to nothing a year from now. As a result, he made, I think it was Damon Knight's phrase, or maybe Jim Blish's, he was expert at making bricks without straw. Good magazines. Later on, he got permission to run one big-name story an issue, and that meant Isaac Asimov. For that he would pay three or four cents a word.

Richard Wolinsky: That was *Science Fiction Stories* or *Future*?

Robert Silverberg: That was *Science Fiction Stories* by the time he got that. But the two magazines kept combining and uncombining. It was very hard to tell which was which.

Bottom of the Barrel:
Rocket Stories & John Raymond

Harry Harrison: John Raymond was a super crook. He had a publishing operation that I came into maybe six months after it started, back in 1953. There are two ways of paying for publication. You pay on acceptance or on publication. He had a third way. You pay on lawsuit, only on lawsuit.

We were doing imitation *Picture Week* magazines, sold for ten cents.[54] Teeny little things for a dime. We were doing imitations of that, called *Clink* or *Stink* or something. There was a small Black magazine, *Jet*. He wanted to do an imitation of that and decided to call it *Brown*.

"John, what are you talking about? You can't do a magazine called *Brown*." He had a guy from Amsterdam, working full-time on *Brown*. "Brown? Why don't you do a ten-cent Jewish magazine called *Kike*? Or a Puerto Rican one called *Spic*?"

"Do you think it would sell?"

There was nobody home there.

He started these big pulp magazines. When I came in, Lester del Rey had already gotten his finger in there. Raymond was doing *Rocket Stories*, he was doing *Science Fiction Adventures*, and then *Fantasy Fiction*.

Robert Silverberg: Harry Harrison, who had by then had replaced Lester del Rey as editor of the magazines, commissioned an article by me on fandom when I was eighteen, which was probably the first time any professional magazine had paid me for anything.

Harry Harrison: I thought a good way of saving money was to commission an issue of a fanzine called *Fanzine*. In each issue I'd pay a half cent a word. There was a kid out there with a fanzine called *Spaceship, Rocketship*. Bob Silverberg. I unleashed on an unsuspecting world this kid fan out in Brooklyn, eighteen years old, and somewhere in my office I have a little note saying "Dear Mr. Harrison, Thank you so much. I always wanted to be a writer."

Robert Silverberg: I spent a lot of time up at the office and I got to know various members of the staff. We're talking about forty-seven years ago, but basically from what I remember, the office was in a loft somewhere down around Church Street[55] or that part of Manhattan, which was then rough-and-ready office space for not-ready-for-prime-time companies. A lot of windows, a lot of battered old desks, a lot of papers, and a lot of stacks of magazines all around. Three or four rooms, all strung out. Not a great office, but to me as an eighteen-year-old, a place of romance and wonder. I was awed by the whole thing.

Harry Harrison: It was one big office, and because I was a commercial artist, I was illustrating the magazines, doing pasteups, editing, writing half the stories. One of the editors never came in at all, never showed. We had to create a pen name for the books. Cameron Hall was an invention to cover the fact that the editor wasn't there. Everyone was Cameron Hall at

54 There is nothing about this story that has aged well. But it serves as another example of the ways in which common decency has moved forward in the 21st Century. At least in this respect.

55 Harry Harrison, later in this chapter, goes into greater detail about the office and its location,, which was at 14th Street and Fifth Avenue (which puts it either across from Union Square or nearby).

one point. One of the editors, whenever he showed up, was running a serial under a pen name, which he never delivered, which left big holes in the magazines from time to time.

That's the first time I met Harlan Ellison. Harlan Ellison came up, an eighteen-year-old kid, with a copy of a fanzine under his arm and terminal acne. He came in and I was running a half page short. I was running fillers, complete fiction, like this flying saucer landing in South America and getting up to Mexico and getting up to New York. A complete farrago of nonsense. I was showing this thing to Harlan.

He said, "That's not true. You're making this up."

I said, "Yeah."

He said, "I will blacken your name throughout all science fiction." I'd just met this kid five minutes before. I remember that Milt Machlin worked there, who was editor of *Argosy* for a hundred and fifty years. Milt was six foot tall and six foot wide. And Milt and I grabbed this kid and threw him in the freight elevator so we could get rid of him.

Harlan Ellison: Not true. I was thrown out of several offices, but it was never John Raymond's office. Howard Browne had me thrown out of Ziff-Davis. I was bounced out of there, probably for being brash and demanding they give me an assignment, something like that. They didn't know who the hell I was. That was before I became a professional. I've been thrown out of any number of offices. I was thrown out of *The Outer Limits* office here in Hollywood and I've even written about it in a new book. So I have no stake in saying "No, it didn't happen."

The only time I went up to John Raymond was when I was still a fan, I was still in high school. I was with A. J. Budrys and in fact, everyone treated me very nicely. Lester del Rey was editing some magazine there, Harry was editing some magazine there, and A. J. was helping them. Everybody was very cordial to me. I was a kid and I may have been a nuisance, but no, that's a misremembrance on Harry's part.

Harry Harrison: We were in a penthouse on top of an office block, a factory block, on Fifth Avenue and Fourteenth Street. The publisher never paid his bills, ever. Some successful magazines failed because he didn't pay the bills. We lost a lot of good magazines. They were selling very well, they went down the drain. He hated to pay bills. I learned how to spot a process server at a hundred yards, one eye closed, midnight in a storm. He had about four process servers a day come up there. You could tell. No matter what. Umbrella, wig. We knew it, could recognize it.

This is the penthouse, L-shaped, and the roof was outside. The window looked out on the roof, only on the roof. You couldn't see the street. One day in the wintertime, I came up there, and things were normal. No big thing. We had this pile of broken chairs. Milt Machlin weighed about four hundred pounds. He'd sit on a chair and break it. So we had a pile of broken

Milt Machlin chairs, piles of old magazines, returned covers. One half of the office was broken chairs, the other ripped-up covers of old magazines returned from the distributor. I walked through all this. There was snow on the roof outside. I looked out and there in the snow was the publisher, sitting there in the snow. What was the publisher doing in the snow? He saw a process server, he went and sat in the snow and forgot where he was. He was absent-minded. This was one of the quieter days there.

Richard A. Lupoff: Strangely enough, those publications published a pretty high percentage of good stories. That's the wonder of it.

Robert Silverberg: I thought at the time they were terrific magazines — despite the fly-by-night aspects of them.

Harry Harrison: I once talked Raymond into giving me two cents a word. That's a thousand dollars an issue, 50,000 words in an issue. That time, I got across my table in a slush pile Frank Robinson, Poul Anderson, all the better writers who came in through the slush pile. I printed the first stories of forty different authors, including James Tiptree, Jr. and Tom Scortia. Two stories from Walter M. Miller, Jr., the guy who wrote *A Canticle for Leibowitz*, came in across the desk. I printed a lot of old authors, a lot of new stuff. The publisher never paid, of course, unless they sued.

The stuff was lying around waiting to be picked up. At that point, the editors were all mad, as they always are. Campbell, perfection itself, printed only Campbellian stories. Horace Gold printed only Horace Gold stories. Anthony Boucher only Tony Boucher stories. In between all these guys, all of whom were great editors with perfect taste, there were a lot of other stories that we printed that were there for the taking, credit more due to the authors than the editors.

I got Fletcher Pratt involved in one issue of *Fantasy Fiction*. He sued the publisher to get paid. I took over the next two issues and did them myself. I did *Rocket Stories*, the very first issue. There was someone else's name on it, but whoever was supposed to be doing it didn't show up, so I did it under another pen name. I did *Sea Stories*, wrote half of it myself, did all the illustrations for the thing myself. Laid it out. They paid fifty dollars a week, or seventy five.

Raymond never paid us. On Friday afternoon he wouldn't show up. He had the paychecks. He'd call in.

"Where are you, John?"

"I'll be in Monday."

"No. We want our money."

We'd chase him around town. I had a car, a little Crosley. A Crosley was smaller than the smallest Honda Civic, and Milt was bigger than the biggest guy, and there was three other guys as well. Milt broke the door getting out. One time, we chased Raymond down to 42nd Street, got him in a sports shop, had him signing checks in the window. All Friday we'd spend chasing

the publisher down to make him sign our paychecks. That was a whole-day operation once a week. Of course he fired everybody before Christmas, and he never paid any bonuses or anything. We all were fired, nothing in the envelope of course.

Robert Silverberg: I sold that article on fandom to Harry in the summer of 1953. When I went to the Philadelphia Worldcon that Labor Day, Harry, who was eight or nine years older than I am, meaning that he was an adult and I was still a kid, said, "Would you like to have your thirty bucks right now?" And I of course said, "Gosh, wow, sir, yes!" So he peeled off thirty dollars and handed it to me at the convention. This was like getting three hundred or five hundred in modern money. I was quite elated.

About two years later, maybe three years later, I was by then an established professional writer and no longer quite such a gosh-wow kid, and I ran into Harry at a party and he said, "Do you remember that thirty bucks that I advanced you at the Worldcon two, three years ago? Well, John Raymond just wrote the check for it. Would you mind endorsing it so I can reimburse myself?"

Harry Harrison: It was a very interesting operation. It finally stopped when the publisher didn't pay the bills. The printer closed it down. It's that simple.

But Wait, There's More: *Marvel, Cosmos* & the Rest

Lawrence Davidson: Then there was *Marvel Science Fiction*, which published stories that were vaguely erotic back during the "boomlet" before the Second World War. It disappeared in 1941, but was revived from 1950 to 1952, for six issues.

Raymond Z. Gallun: Fred Pohl was my agent, and he sold *Marvel Science Fiction* my story "The Restless Tide." That is a story that is more or less a favorite of mine. In fact it was originally written for *The Saturday Evening Post* because at that time a couple of our boys were getting into *The Saturday Evening Post*, and I thought, well, why don't I follow suit? I got a nice letter from the editor back over there and he says a very interesting idea but not quite our cup of tea. Well, I suppose if I'd submitted it a few years later it would have been all right, but at that point they were not very interested. Then Fred finally placed it with *Marvel*.

Richard Wolinsky: *Marvel* had the distinction of being one of the few magazines that went from pulp format after two issues in 1950, to digest-sized for three, and then back to pulp for its final issue. *Super-Science Fiction* was another of those little magazines, barely remembered today.

Robert Silverberg: *Super-Science Fiction* was published by Crestwood Publishing, which was a magazine outfit out near Columbus Circle that did

a lot of detective magazines and men's adventure stuff. Big magazine outfit. Harlan Ellison, who was writing for their mystery magazines, *Trapped* and *Guilty*, somehow inveigled the editor of *Trapped* and *Guilty*, W. W. Scott, into taking on a science fiction magazine. This was a time when such magazines were being founded right and left. Scotty was a little old guy — he actually seemed like a little old guy, he must have been forty-five or so, wore green eyeshades and false teeth, bad dentures. He looked like some newspaperman out of a movie from the 1930s. He sat behind a desk piled high with manuscripts, and bought a lot of stories from Harlan and me. Harlan and I wrote most of the magazine between us.

Richard Wolinsky: Then there were the magazines that were planned, organized, named, and never actually came out.

Philip Klass: Damon Knight and I and about a dozen other writers all almost had magazines of our own during this period, and my magazine folded before it reached publication. *Project Science Fiction*. It was not my title, it was the best I could do in terms of my backers. It was one hell of a lot better than *Big Bang Science Fiction*, which is what my backers wanted. I am serious. The title came about because my backers, who knew nothing at all about science fiction, felt there was money to be made in the field.

Robert Silverberg: During that time, there were also magazines packaged by the Scott Meredith Literary Agency. One was called *Cosmos*, I believe, which was put together in the Meredith office, but it folded just as I became a Meredith client to my great sorrow, because I figured here's a way of selling stories. I think it was one of the chain magazines, probably edited by some old friend or former employee of Scott. And Scott said, "Well, I'll send over fifty thousand word manuscripts every other month." And he paid five hundred dollars for them. That's all. However, what he sent over was Arthur Clarke and Poul Anderson. It was a decent magazine.

The World of Small Presses

Algis Budrys: I learned how to pick a Yale lock because my first boss never showed up on time, never. That was Marty Greenberg. There are two Marty Greenbergs.[56] This is Marty Greenberg, who was in the early fifties the proprietor of Gnome Press, which published I think more than its share of the early major science fiction books, not just anthologies but the novels of Robert Heinlein, A. E. van Vogt, the *Foundation* stories of Isaac Asimov, and on and on and on. *Typewriter in the Sky* by L. Ron Hubbard. George O. Smith's

56 This Marty Greenberg (1918–2013) co-founded Gnome Press with David Kyle, who left in 1954. Budrys worked there in 1952. The other Marty Greenberg, Martin H. Greenberg (1941–2011) was an anthologist in many genres, but most notably in the realm of speculative fiction, and a close friend of Isaac Asimov.

only good novel, *Nomad*.[57] When you start in editing of course, just about the last thing anybody lets you do is put pencil to paper. When I started in editing, I learned how to sweep a floor, I learned how to make out a shipping label, I learned how to fake a royalty statement. Oh, I learned all those useful tasks. I learned how to answer the phone and deduce that the fellow on the other end of the line was somebody my boss didn't want to talk to.

Fritz Leiber: *Conjure Wife* was going to be published by Arkham House, and I had signed a contract. I had also signed a contract for Arkham House to publish *Gather, Darkness!* And then came 1950 and a decline in the status of the small presses, and Arkham House cut back a great deal. August Derleth, who was Arkham House, arranged for Pellegrini & Cudahy to bring out *Gather, Darkness!* He not only relinquished it, it was all done at his suggestion because they were publishing anthologies of science fiction and fantasy that he was putting together. As far as *Conjure Wife* went, well, he figured that Arkham might eventually publish it, but he'd have to hold it up for some years because of this bust situation in science fiction at that time, in the early 1950s. They just tried to start too many magazines and too many little presses, and so a bunch of them all failed. The others had to cut back production for two or three years.

The Hydra Club & the Milford Writers' Conference

Robert Silverberg: The Hydra Club was the social, and to some degree, business organization that all the science fiction writers belonged to in New York. And in those days, science fiction was almost entirely a New York City activity. There were some writers like Bradbury and Heinlein based in California, but nearly everybody was somewhere within a twenty mile vicinity of Manhattan. The Hydra Club was a monthly party. It didn't take any positions on publishing. It passed a lot of gossip around. They passed a lot of wives around. I came along too late for all of that. A lot of marriages were made and broken in the Hydra Club just before my time. When I began selling stories regularly in '55, I was invited to come down and join. I was the youngest member, by far, I was twenty years old.

Harlan Ellison: The Hydra Club was fabulous. Most of the meetings that I went to were held at the apartment of Jay Stanton. It was a large loft building down along First Avenue in mid-Manhattan, and subsequently it moved over to Willy and Olga Ley's place. Anybody who was anybody was there. Gee, the factional fighting — Harry Harrison was on one side, with Fred Pohl and Lester del Rey on the other. There were all of these internecine wars that were going on with these people over matters that were so picayune, so

57 According to Wikipedia, *Nomad* as published by Prime Press. Gnome published three other books by George O. Smith.

miniscule, that in retrospect most people can't even remember what they were about. But the things that were done, and the guerrilla warfare, was so bloody fascinating. A. J. Budrys wrote a gossip column for *Dimensions*, my fanzine, under the name Harold Van Dall, as in vandal, in which he passed along all of this stuff.

Lester del Rey was the guy who was the manipulator. The only thing that ever kept him in line was his wonderful wife Evelyn. Everybody adored Evvy. She was just spectacular, one of those great women that you'd see in *All About Eve*. If you were part of that clique, with Fred and del Rey, you got to do a book for Ballantine. If you look at all the first books that were done by Ballantine, except for the ones that were bought from Scott Meredith or Arthur Clarke, who were outside the loop, you will see that they're all pals in the Hydra Club. Look at the first two dozen Ballantine Books, the stuff in *Star Science Fiction*, and they're all people, either their reputation is so well established — like Henry Kuttner on the West Coast — who couldn't be kept out of the book, or they're members of that clique. It was the hub and center of the science fiction genre all through the fifties.

Robert Silverberg: The Hydra Club had been organized, circa 1950, by people like Ted Sturgeon and Phil Klass and James Blish, Damon Knight, Judy Merril, that whole crowd — what was thought of later as the Milford crowd, though that's a very loose description of those people.

Damon Knight: In 1956, Judy Merril and I got together and said, "Why don't we have a writers' conference in Milford and put it on the map?" And we were so naïve and so dumb that we didn't know that writers' conferences are a bunch of famous writers lecturing little old ladies in tennis shoes. Instead, we just invited science fiction writers, sat them in a circle, and kept them talking. And this was some kind of innovation, I think. But it was based on something that went on in the Futurians during my days there, something called the Inwood Hills Literary Society, which consisted of three or four Futurian writers getting together in Kornbluth's apartment or Wollheim's, and discussing their stories. Then there was a split between Milford and Red Bank. Red Bank was where Fred Pohl and Lester del Rey lived. So it was like two adjacent colleges, the rivalry.

Algis Budrys: Milford was an emotionally intense experience. It was the first time that the science fiction writers of the world, that is to say of the English-speaking world as descended from Hugo Gernsback's creative impulse — we were it, we felt we were the universe — it was the first time we had all gotten together and discussed that we had common problems and common desires. Up to then it had been a very piecemeal thing. Also, at the Milford conference, for the first time, we invited down a bunch of New York editors, and they came. And we discovered we could push them around. A certainly unheard-of experience,

Damon Knight: Kurt Vonnegut turned up at Milford one year with his teenaged son, very amiable, and he sat in some discussions and workshops, I guess. Probably not the workshops. And then he turned it into *Mr. Rosewater* [*God Bless You, Mr. Rosewater, or Pearls Before Swine*].

Kurt Vonnegut: Milford was the one gathering of science fiction writers I went to. I liked all the people and I listened to what they were saying. And what I remember is the guy who eventually wrote *The Sand Pebbles*, Richard McKenna. He had just been discharged, a career guy, I guess, in the Navy. And he just married a librarian, and they had come to learn about writing. And he was listening most respectfully to all of us pros, and then just after that, he wrote that really wonderful book. The family feeling they had, I didn't feel like part of the family. It didn't seem to me the discussions were really very serious, just enjoying each other's company. Sort of a Sunday school picnic.

Science Fiction for Fun & Profit: Writers of the '50s, Their Ideas, Their Books & Their Stories

WILLIAM F. NOLAN

Alva Rogers: In the early fifties, a young, gosh-wow-boy-oh-boy teenage fan in San Diego got in touch with me because in those days I was a well-known fan, and sort of latched himself on to me. He'd come over to the house two or three nights a week. And every weekend he would drive up to Los Angeles and spend the weekend almost, you might say, at the feet of his idol at that time, Ray Bradbury. And he would come back from his trips to Los Angeles all bubbling over with enthusiasm about his latest visit with Ray, and tales of Ray's newest stories, and anecdotes. He had a wire recorder at that time, and we used to wire extemporaneous short stories. That fan later grew up to become a well-known writer, William F. Nolan.

William F. Nolan: The *Ray Bradbury Review* resulted from my meeting Ray in 1950 when I was twenty-two, which tells you that I'm getting along. Of course, you can't write for forty-two years without getting along. Anyway, I met Ray in 1950 and I was a great reader of his. I grew up in Kansas City reading *Weird Tales* with Bradbury stories in them. So when I met Ray in 1950, I decided I would start collecting all of his work and find out as much as I could about him. So within two years I had edited and written the *Ray Bradbury Review*, which was a booklet, which later became a hardback book many years later when Gale Research[58] did an updated edition.

58 It's not clear what Nolan means here. Graham Press published the updated edition. It's possible that the edition was updated by Gale Research.

I can just go right from Bradbury into my first sale because two years later, when Ray was in Ireland working on *Moby Dick* for John Huston, he had told me, "Bill, when you ever get a short story you think is really good enough for professional publication, I want you to send it to me and let me critique it." So I wrote a story called "The Joy of Living." I said, "I think this is it." I'd been writing since I was ten years old. I was twenty-five. After fifteen years I thought, Well, this is really going to be publishable. Sent it to Ray in Ireland, and very briefly, it was about a man who fell in love with a robotic servant that he'd hired to take care of his children. He fell in love with a robot. And in my version, he took the robot back to the factory at the end and turned her in because he realized that it was perverted and unnatural for him to really be in love with a robot. Bradbury said, "Nolan, it's a terrific story but your ending is all wrong. Emotionally this man cannot turn this woman in. You've built her up in the whole story to be loving and kind and gentle. You can't suddenly do that to your reader. He's got to start to take her back to the factory, almost get there, realize he can't do it, put his arm around her, and drive back under the summer sun home with her." And that's the way I wrote it, it sold, and it became my first sale, and I started my career.

Alva Rogers: Before Bill ever became a writer, he came to me and said, "Let's collaborate on a story. Let's write a story together." So we picked an idea, and instead of collaborating on a story, we each wrote a separate story on the same idea, which is nothing new. And we sent it off to Forry Ackerman to see if he could sell it. Unfortunately, he couldn't sell it, and I pretty much gave up any thought of being a writer at that time. Bill, of course, kept writing away and achieved a considerable success.

ARTHUR C. CLARKE

Frank M. Robinson: Arthur C. Clarke is a great man. He thinks like no other man I ever met in the field. Arthur is a conceptualizer of the first order. He is capable of standing outside of humanity and looking at it, and commenting on it. Arthur gave me about a dozen things which always stuck with me.

Arthur says, "What is the one thing that a fish could never conceive of?" The answer is fire. In other words, fire would be totally outside of a fish's ability to handle or deal with. The connection being made is that there really are limitations in your being human because you are human. We're not willing to accept that.

He would come up and say, "What was the value of spectacles?"

"I don't know," I'd say.

"It multiplied the lifetime of the scholar." Extremely important because most scholars spent their time in monasteries transcribing manuscripts. By the time they were twenty their eyesight was shot.

It's Clarke's ability to do that. Clarke is fascinated by these little advances. We went up to the top of the Chelsea Hotel in 1972. Clarke had a handheld laser, which he was anxious to demonstrate. So he flashed it down on the street, a coherent beam of light, so that you ended up with this little spot the size of quarter on the sidewalk, and he had a drunk dance with it. I was absolutely enchanted by Clarke. I really was. The man thought like a science fiction writer should think and so few of them ever do.

Horace L. Gold: I got Arthur C. Clarke's novel *Prelude to Space* for Galaxy novels in the damnedest way. Scott Meredith, his agent, handed it to me. Meredith used to send stuff around in wheelbarrows until I yelled that I wanted this stuff screened, but he sent me *Prelude to Space* and I totally went crazy.

"I don't need this story, I can only pay five hundred bucks. You can sell it for more than that."

"It's been around for three years, nobody wants it. Take it. You'll be doing the guy a favor."

So we printed it, and of course I couldn't get what I wanted, which was the paperback format. They insisted on putting it out in magazine format, digest sized. We sold enough to more than break even, but with *Prelude to Space*, when that hit the stands, it hit the fan. I think it was Ballantine later took it over. A hardcover edition.[59] Anyhow, there was such a tangle of tigers clawing for the book, and whoever took it sold umpteen number of times as many copies as we sold. They had all turned it down.

PHILIP K. DICK

Philip K. Dick: Back at the time I was starting to write science fiction, I woke up and there was a figure standing at the edge of the bed looking down at me. And I grunted in amazement, and all of a sudden my wife woke up and started screaming. She could see it too, and started screaming and I recognized it, and reassured her and kept saying that it was me that was there, and not to be afraid. Let's say that was 1951. And in the last two years, I've dreamed almost every night that I was back in that house. And I have a very strong feeling that back then in 1951 or '52, I saw my future self that somehow, in some way we don't understand — I wouldn't call it occult — in some way we don't understand that I had passed backward as my future self in one of my dreams now, going back and seeing myself. That would be the kind of stuff I would write as a fantasy in the early '50s, something like that.

Ursula K. Le Guin: I think it's likely people will be reading Philip K. Dick in fifty years. There's a lot to Phil Dick, and I can imagine he can be reinterpreted. To stay alive a book has to have enough complexity that another

59 The hardcover was published by Gnome Press, and the paperback by Ballantine.

generation can read it differently than the last generation. I suspect that Phil would be a good candidate.

Philip K. Dick: In 1953 I published twenty-seven stories, and almost as many the next year. In June of '53, I had seven stories on the stands simultaneously, but no American publisher approached me to do a collection. This was before I'd written any novels. Rich & Cowan in England approached me with the idea of putting out a collection of stories. They were incredibly primitive. I sent them several fantasies that had been published in *F&SF* and because the fantasies dealt with children, Rich & Cowan said they were stories for children, so I suppose for Agatha Christie's mysteries, the audience should be axe murderers, by the same token. My original idea for the collection included more of the *F&SF* fantasies that I had written for Tony Boucher, that I thought were of a higher standard than the science fiction, but Rich & Cowan rejected all of those and the ones that were picked were substantially science fiction rather than fantasy, I think.

Ursula K. Le Guin: I don't think Phil's short stories are as good as the novels on the whole. He needed the novel length to get as complicated as he was.

I taught *The Man in the High Castle* last spring at San José State. That is a very interesting book. I had smart kids working on it, and they were getting layers and layers that I'd never seen in it. That's the kind of book that lasts.

HARRY HARRISON

Harry Harrison: I was a commercial artist for endless years, and I wrote *Flash Gordon*, for God's sake. I broke in with Wally Wood, a comic artist, an illustrator, we worked together. I was a fan, that's how I knew all the artists and all the authors in New York. So I was a commercial artist to begin with. Commercial artist, you work for money. The art director'd say "Harry, I want a six-by-nine twelve-armed tentacle getting a girl with big boobs, black-and-white, by tomorrow morning."

"Yes, sir."

So I started writing commercially. I felt the same way. I'd rather write freelance than work at some rotten job. I wrote everything in the world, and in my secret heart of hearts, science fiction was okay. I had the idea for a novel. I couldn't face Manhattan so I took the wife and the baby and went to Mexico, where we lived for $100 a month for everything, including a bottle of tequila a day, full-time maid, all the food you could eat, gas for the car. I started *Deathworld* there. I never had a job again. That was 1956.

ALGIS BUDRYS

Algis Budrys: My novels hardly ever go out of print. There's one that I hate and will not allow people to reprint, it's called *Man of Earth*, published in

1955,[60] and it was a mistake. It was, in fact, my third novel. It was published after *Who?*, which was my second novel, disproving the old canard that your second novel is always a dog. My first novel, which I like, was originally released as *False Night* in a severely cut version, and it had to be cut in type by about 25% and no book is going to survive that without bleeding a lot. But about ten years later it came out as *Some Will Not Die* and we had restored the original wordage, plus, under the direction of Harlan Ellison, who was the editor of Regency Books at the time, we had interpolated a novelette that wasn't originally part of the novel but seemed to fit, so that *Some Will Not Die*, which has now gone through three American editions and is alive and well to this day, is a book that I'm pretty happy with. But *Man of Earth* is a dog, a D-O-G. I'm delighted to tell anybody that no, you cannot have the American reprint rights, they don't exist fellas. I renewed the copyright just so I can tell you not to print it.

MARION ZIMMER BRADLEY

Marion Zimmer Bradley: My first published novel[61] was called something like *Bird of Prey*. I don't remember the original title. I think Forry Ackerman gave it the title *Bird of Prey* because the original title was a disaster, whatever it was. I've never been good at titles. So he sold it to a German publisher, and it came out in not precisely hardcovers, but those stiff cardboard covers. Then, at the same time that he was marketing the novel, I did a somewhat shorter version for *Venture Science Fiction*. And it was published in *Venture*. Then I lost the original of the novel, and when Don Wollheim said he would publish it, I had to retranslate it from the German. That's the silliest publishing history of any book I did, I think [*Bird of Prey* was finally published by Ace in 1961 as *The Door Through Space* — Ed.].

THEODORE STURGEON

Theodore Sturgeon: *More Than Human*, the chronology is so strange. It was written in three different parts. The middle part was written first, and the other two parts, the beginning and end, were written more than a year later, as freestanding novelettes. Horace Gold first bought the story, "Baby Is

60 A serial version of *Man of Earth* was published in *Satellite* in October, 1956, and the novel was published by Ballantine in 1958.

61 Marion Zimmer Bradley (1930–1999) was revered during her lifetime for her *Darkover* novels, which were among the earliest science fiction books that directly dealt with gay characters, and *The Mists of Avalon*, a feminist retelling of the Arthurian legend. In 2014, it came out that Bradley enabled or even aided her husband, Walter Breen, in procurement of children for sexual abuse, and that she herself was an abuser. In 2016, Amazon Studios said it was moving forward with a *Darkover* TV series, but then came the #metoo movement, and there have been no announcements since.

Three," which was a blockbuster. It really knocked people over. It was called an instant classic, among other things, and I had no idea at the time it would ever ever have the impact it had.

W. Ryerson Johnson: I remember one time Sturgeon was a speaker to the mystery writers' organization. He was telling everybody they should quit writing mysteries and start writing science fiction. He did it very well. He just about convinced half of them. He writes a good story, doesn't he?

Kurt Vonnegut: People ask me who Kilgore Trout was, I say it was Sturgeon. Of course, at the end of his life, he was a very successful writer. Years ago, when I was living on Cape Cod, someone said that Ted Sturgeon was on the Cape. Someone had loaned him a beach house, so get in touch with him. And so I did. And he was in terrible shape, very pale and all alone in a beach cottage in the wintertime. I'd say, "Ted, come on, let's go for a walk on the beach," or "Ted, come on over for supper." But he couldn't. He had to write, had to write. And he was making a fraction of a penny a word, and he was a swell writer and not about to write anything else but stuff for *Amazing Stories*, and so forth. But in the end he was quite successful.

Richard Wolinsky: Philip José Farmer eventually wrote a book under the name of Kilgore Trout, *Venus on the Half-Shell*.

Kurt Vonnegut: Farmer was after me for a long time to do this, and we'd never met. I had the dream of giving a whole lot of people permission to write Kilgore Trout novels so that at church sales, twenty years from now, there would be all these books by Kilgore Trout. Farmer and I only talked on the phone a couple of times and I wanted no money from it, and didn't want to look at it before it was published. It turned quite ugly as he got quite mad at me, and wanted to write more Kilgore Trout novels, and I got some very unfriendly reviews as if I'd written it, and the publisher, who was my own publisher, published it, giving every possible impression that I had written it. Farmer was quite bitter at me in some of the fan papers, wanting to write more. You know, he never called me up and said, "Let's have a cup of coffee," or "Let's have a beer," or anything. So it was quite unsatisfactory all around.

FRANK M. ROBINSON

Frank M. Robinson: After I got out of the service a second time, I went to journalism school at Northwestern University, and took an advanced writing course where the object was to write a novel. So I started on one that I called *The Power*. The title came from a jump-rope rhyme that had been told to me by Bea Mahaffey that went "You remind me of a man." "What man?" "The man with the power." "What power?" "The power of hoodoo." "Who do?" "You do." "Do what?" "Remind me of a man." So I used that. That was actually a routine from *The Bachelor and the Bobby-Soxer*. I got halfway through the book when the instructor called me into his office and said, "Have you ever read any George Bernard Shaw? *Man and Superman*?" I

said, "No." Well, it seems that my name of Tanner is also the name of the protagonist in *Man and Superman*. I never knew it. Strictly serendipitous.

I finished the novel and I got an A- in the course. By this time I had acquired Curtis Brown as my agency, through Bob Tucker. I should point out I was doing a lot of writing for the local magazines, for *Other Worlds*, for *Imagination*, etc., etc. And my biggest fear — I had this thing all wrapped up in a box. I was going to ship it off to the agency, and I desperately didn't want Bill Hamling to know that I'd written a novel because I knew he would inveigle it out of me at a penny a word for *Imagination*. So I'm running down to the post office and who do I meet? Bill. Now, it's very difficult to disguise a manuscript box. He asked. I lied. And later on of course, the magazine rights sold to *Blue Book* and the book rights to J. B. Lippincott.

JACK WILLIAMSON

Jack Williamson: I enjoy collaborations. While I never regarded what I wrote as absolutely engraved on tablets from heaven or anything, the result is generally subject to revision. Jim Gunn and Fred Pohl are both people I respect in many ways for literary ability and stylistic ability, and most of my collaborations with them have come from projects of my own that I ran into difficulties with, and called on them for help.

The thing with Jim Gunn began with a story of mine called "Star of Empire." I'd worked out a setting, background, and wrote a lot of a novel and saw it wasn't going right and just quit it. Eventually I told Jim Gunn about it and persuaded him to come in and reread part of it, and he wrote most of the final draft. That came out in 1955 as *Star Bridge* and I think it's been moderately successful. Once I met a Spanish fan who told me that the pirated version of that had been important in launching science fiction in Spain. They stole the Ace version of it, even to the cover and credited it to Hector Parl as author, though there was a thing about the series in the back of the book that gave us credit for authorship, so it was not a very complete piracy. I would have liked to have been paid, but it is nice to be read whether you're paid or not. So I felt more honored than bitter. I did get in touch with an agent who was going to Spain. He said nothing profitable could be done about it.

Considering Fred Pohl, he was once my agent, he was my editor for many years, and I had an unfinished novel called *The Conquest of the Abyss* about the colonization of the sea that I'd got about a hundred pages of and worked out the background very elaborately, pinned the bedsheet on the wall, and covered that with descriptions of settings and characters and so forth. That had apparently used up all the creative juice, and I discussed that with Fred and we got three juvenile novels out of it. This was first published as *Undersea Quest, Undersea Fleet,* and *Undersea City*, and then I had another long novel called *The Iron Collar Mine* that I wrote four hundred

pages of, and there was obviously something wrong. I showed that to Fred and we got the Starchild Trilogy out of that. We have another series going now. Fred suggested the original idea and *Farthest Star* has been published and Fred assures me that *Wall Around a Star* will be finished this year. I don't know if there'll be a third volume or not.

"THE COVENANT"

Robert Bloch: "The Covenant," now that was a round-robin story which each writer contributed an episode, and when they got completely stuck, they gave me the thankless task of finishing it. I never heard anybody comment on it, but that was one of the toughest jobs I ever had, was to follow these disparate styles in a story, because a lot of them were goofing off, you know. They were painting the next writer into a corner, and adding things out of left field that didn't belong. And I had the whole accumulation and somehow I managed to complete it, but no one's ever nominated that story for the Science Fiction Hall of Fame because there's nobody out here that's even heard of it, let alone read it.

Richard A. Lupoff: Just for the record, the other authors of "The Covenant" were Poul Anderson, Isaac Asimov, Murray Leinster, and Robert Sheckley. They certainly did put a lot of fishhooks in it, and leave it for poor Bob Bloch to finish up.

JANE ROBERTS

Jane Roberts: I believed in each one of my science fiction stories. I did one on freezing bodies that I sold to *Topper*. I'd start with the highest-priced male magazine that would take science fiction and just keep on going down the list. *Playboy* didn't take it, they never did. I'd end up with *Topper*.

Besides that, some of them took damn good stories. It was the only way you could get your stuff published. I didn't compromise myself for anyone. You've got a frame of a certain size and you want to do a painting, you think, Well, I'll make a painting to fit that frame. But every once in a while you'd do one that wouldn't fit for the frame, and you'd say, "Well, to hell with it."

I lived in Elmira, and I'd go down to the newsstand to pick them up, and the man who ran the store didn't want to give me the magazine. He'd get a newspaper and then a bag. He was going to wrap the magazine in the bag. He was embarrassed that I would ask for it. There were a whole bunch of businessmen, it was around 9:30 in the morning.

I'd say, "What are you doing?"

He'd whisper, "I'm putting it in a bag."

"What are you putting it in a bag for?"

"That's not a very good magazine."

"For God's sake, I wrote for that magazine. My name is right on the cover. I'm not ashamed to take the goddamned magazine home."

And he was really embarrassed. "Oh, lady, what are you doing?"

The Rise of the Paperbacks

Louis L'Amour: I wrote pulps for several years and at the end of the time I was making a very good living at it. Then, overnight, they were gone like snow in the desert.

Hugh B. Cave: Why did I get out of writing for magazines and into books? Mainly because the slicks just folded. One after another. *The Saturday Evening Post* folded. There is one on the stands now but it's not the same magazine by any means. And *American* folded; *Country Gentleman* folded; *Woman's Home Companion* folded. *Collier's*, *Liberty*, they all folded, one after another. TV killed them. And so there wasn't any slick-paper market left, except maybe *Ladies' Home Journal* and *Good Housekeeping*, both of which I sold to. And *Good Housekeeping* I stayed with for quite a while longer. But at the same time, that wasn't enough to keep me busy all the time, so I got into the books.

William Campbell Gault: I stopped writing for the magazines when they folded. The pulps folded, the *Post* folded, even *Collier's*. People say it was TV that ruined them. It wasn't, I don't think, because in Montana where there still wasn't TV, the magazines were also folding. It was the original paperback books. Now for two bits — *Dime Detective* had run up to two bits by that time — you get F. Scott Fitzgerald.

BANTAM & BALLANTINE

Ian Ballantine: Fifty percent of all the books on the paperback racks in the early '50s were mysteries. Bantam wanted to make sure none of the mystery readers cheated themselves by not buying *Shot in the Dark*, which was a science fiction anthology edited by Judith Merril. So we identified the book as having mystery in it. I've forgotten the weasel words, but the words worked. They moved the copies. That just came at the time my wife, Betty, and I were about to take off and leave Bantam Books and go set up our own firm, and in our own firm we set out to publish original science fiction. Bantam was a reprint house, but we wanted to do all kinds of things that hardcover publishers said didn't work, such as science fiction. The only hardcover science fiction that was going on was from oddball publishers. I sold my stock in Bantam and had sufficient wherewithal to start a paperback book-house. I have to say to you, if people say, "Why do you keep failing at everything you do?" I have to keep pointing out that the two strongest paperback publish-

ers in the field right now are both firms I started, and if it happened twice, it wasn't entirely an accident.

We had an idea of what it was we wanted to do at Ballantine Books. We liked westerns, we wanted to do original westerns. We wanted to do original science fiction. We refused to accept the distinction between fantasy and science fiction that was very popular in those days. The science fiction people looked down on fantasy. We did, at the beginnings of our program, a Fletcher Pratt fantasy novel. We were also interested in topical books, books of reportage, and we were interested in straight novels. Our first science fiction book was number sixteen, *Star Science Fiction Stories*. Fred Pohl. We didn't expect all the girls to be virgins, however, and many of the books we did — *Gravy Planet, Space Merchants*[62] — had, of course, appeared serially in the pulps. We were after authors that nobody else would publish in science fiction, and they were absolutely the cream of the cream.

Fritz Leiber: Ian Ballantine got me started, you might say, in the science fiction book field. I expanded *The Silver Eggheads* for book publication for them.

ACE BOOKS

Richard Wolinsky: Along with Ballantine and Gold Medal came Ace Books, which also published science fiction, though its pay scale was at a much lower level.

Fritz Leiber: Ace published my first paperback novel, which was *The Big Time*, and that was when Don Wollheim was the editor at Ace.

Robert Silverberg: Wollheim was an extremely prickly, difficult, touchy man. I liked him a lot anyway. He knew science fiction inside out. He had very conservative tastes. I knew him from *The Pocket Book of Science-Fiction*, which really turned me on to the whole business when I was twelve or so. And 1956, I won a Hugo for being the best new writer of the year at the New York convention, and Don came up to me and said, "Well, if you're so good, why aren't you writing for me?" which was his general tone. So, of course, the following week — I had just been married — the following week I was in the office of Ace Books with the outline for a novel, *The 13th Immortal*, that I called something else — he always changed titles — and we got along extremely well. It was another business where a much older, and famous, science fiction fan and pro figure befriended me. And then, after a couple of years, I got to be a really good writer and suddenly I began selling books to Ballantine, who paid twice as much as Don, and he really couldn't forgive me for that. It was years before he spoke to me again. Oddly, he went through this with many of the young writers he developed: Delany, Brunner, Phil Dick. He would publish their first novels, pay a thousand dollars apiece.

62 The serial *Gravy Planet* became the novel *The Space Merchants*.

Then they'd move on to more comfortable publishers, and he'd regard this as betrayal. Nevertheless, beneath it all, he was a wonderful guy. I was reconciled with him late in his life, and I'm very happy to have known him.

Frank Kelly Freas: I had just come back from Mexico when I started working with Ace. I got a letter from Don asking me to stop in and see his art director, and immediately started to work with him, and had a very good working relationship there for a long time. I did about a hundred, hundred and twenty covers for them.

Harlan Ellison: Don Wollheim published my first science fiction book, *The Sound of a Scythe*, which was published as *The Man with Nine Lives* in an Ace double, backed with my first science fiction short story collection, *A Touch of Infinity*. I was wild about Don and I would go up to the Ace offices and just regale him. When I'd come up there, everything would stop and we'd sit and I would tell stories and anecdotes and jokes, and Don just loved it.

Don would take me to lunch at the Steuben Tavern, which is where, of course, in earlier days, Julie Schwartz and Ed Hamilton and Manly Wade Wellman and that whole gang hung out. The Steuben Tavern was a famous science fiction watering hole. It was a wonderful, wonderful German restaurant, all dark oak and wonderful food and schnitzel, and Don was up the street, maybe one block over and up the street toward Broadway from the old A. A. Wyn offices, the old Ace Book offices. Don, since he was on a company credit card anyhow, he would take me and maybe two other people up there — there was another guy, Bernard Baily, the guy who created the Spectre for DC Comics, that's how I met Bernie Baily — we would all go up to the Steuben Tavern and sit there. I don't drink, but they would all have huge steins of beer and I would sit there and get a cup of coffee and have my schnitzel. I was very close with Don, and I liked him and admired him and thought he was a good guy.

Ursula K. Le Guin: Don Wollheim was a very canny editor. He really had a nose. He started a whole lot of us. He didn't pay us very much, and royalties were a concept that nobody really grasped very clearly at that point. But he put us in print, and distributed us.

Harlan Ellison: I thought that many of the publishing practices that he learned at the knee of A. A. Wyn were pretty schlockmeister when you come right down to it, but he always treated me very well, liked me, liked my stuff. But Don was a contentious man who would hold a grudge forever, and he passed it along to his daughter, Betsy, and his wife, Elsie, and Elsie was worse than Don in that respect. So when things went sour, they went very very sour, and I never spent any time at all with Don in his last years.

AVON BOOKS

Stanton A. Coblentz: *Into Plutonian Depths* was brought out by Avon as a paperback. It was not a book dealing with sex or dealing with illicit relationships or anything like that, but on the cover, what would you see but a practically nude woman? It has nothing to do with the theme, nothing at all to do with the theme. I had a neutral sex [gender] who didn't have anything to do with sex acts at all, then the normal male and female. The way they can exaggerate and distort.

UNIVERSAL PUBLISHING

Fritz Leiber: My novel, *You're All Alone*, the publisher tried to disguise it as a sex novel in 1953, gave it another title, *The Sinful Ones*. It was Universal Publishing [and Distribution Corporation]. Bad business. They wrote some sex scenes into it, those semi-liberated sex scenes where they could just get a little sexy. They'd seem dreadfully tame today. In any case, they were artificial.

 Richard A. Lupoff: I imagine a copy of that edition would be worth a fair number of bucks today, as a collector's item. I bought it at the time on the newsstand, and even after I bought it, it scared me off and I never read it. I don't know what became of that copy, lost somewhere in the sands of time.

REGENCY BOOKS

Richard Wolinsky: Then there was Regency Books, begun by Harlan Ellison, which started in 1960, and was a continuation of Bill Hamling's publishing empire. It started as a sideshoot of Nightstand Books, a soft-core line of pornography.

 Frank M. Robinson: I don't know why Hamling decided to publish porno, but he might have been taken by the success of Bee-Line books. Hamling would certainly have been impressed by the fact that this was a genre with no returns, that people buy them outright. There was never a price on the books, so they could charge whatever they wanted, and sold them usually out of the backroom. So he started Nightstand Books, with Harlan Ellison as editor.

 Harlan Ellison: I made Bill Hamling a lot of money. I created the Nightstand book line of what we call "stiffeners," you know, one-handed paperback reading matter. I started out doing two a month, then within two months we did four a month, and then we were doing six a month, and I was writing all the plots, I was doing all the titles. I would describe the art for the cover. I designed the format, what they were going to look like. In fact, all the other paperback lightweight porn, you know, they were all pretty

lightweight compared to what's available now, but at the time they were very daring. I created all of that. I created the format for that entire genre, which still exists to this day.

Then I split and I left. Bill wanted me to come back and do Nightstand, because it was now up to eight a month, and they were being done all through the Scott Meredith Agency, five hundred, seven hundred dollars a book, and they were written in one week by that whole gang who were all part of Scott Meredith's stable. He said, "You can have your own paperback line, and you'll do Nightstand." So I created Regency Books, where I published the first Cordwainer Smith book, published a Philip José Farmer novel, published Bob Bloch's *Firebug*, the first collection of B. Traven short stories.

I was hired as the figurehead editor for a phony corporation called Blake Pharmaceuticals, and the president of Blake Pharmaceuticals was Richard S. Shaver [of the Shaver Mystery], who lived out on a farm somewhere. Hamling knew him, and used him as a figurehead so the cops never came because Hamling was not involved. I would either get busted for being the editor, or they would go and find Richard S. Shaver and arrest him. He was paid a weekly salary, I don't know how much it was. I was making a thousand a week, which was enormous money in 1960, '61, and I was able to publish good books.

I would spend one or two days a week, probably one day, doing Nightstand Books. I would literally plot out eight or ten books at a time, fire off the goddamn plots to Meredith. Meredith would give out assignments and take his cut of 10%, and the authors would sit down and in one week write them. I would lay out eight covers, and Bill would take them to one of the hack artists who worked for him at *Imagination*. The guy would do eight covers and they would come in and I would send them off to the printer and proof the pages.

And the other four days, three days of the week, I would do my stuff for Regency, which was a wonderful line of books. In fact, those paperbacks to this day are some of the highest-drawing titles in paperback auctions.

When I left there, I wound up with an almost ex-wife and her kid, driving cross-country to California with no money at all. The last three hundred miles we had money only for gas or food, and since we needed the gas, we didn't eat. I blew into L. A. on January 1st, 1962 with exactly and precisely ten cents in my pocket. Everything I am and everything I'd done and everything I've managed to gain in my career since 1962 has been done from absolute ground zero.

Richard Wolinsky: When Harlan Ellison left Regency, he turned the editorship over to his former mentor, A. J. Budrys. Meanwhile, Hamling became more and more involved in pornography, and by the late '60s, both Regency Books and *Rogue* were long gone. Then President Nixon's Commission on

Obscenity and Pornography released a long and detailed report and Hamling came up with a brilliant scheme.

Harlan Ellison: Hamling, thinking that he was safe in doing it, decided to publish the Illustrated President's Report, because, you know, the president's report was public property. So he took a copy of the report and he went to all these really heavy, extreme, triple-X porno magazines from Sweden, and he published all of these photos in the president's report on pornography. He got busted, and he got busted along with Earl Kemp, who was one of the two guys who had founded the small press that had published Damon Knight's *In Search of Wonder*, Advent. Kemp, who had been a fan for years, had wound up taking over the publishing of Nightstand Books, Blake Pharmaceuticals. And the both of them were convicted for sending pornography through the mail.

Frank M. Robinson: Earl Kemp told me that the book never actually came out. Before its publication, while Kemp was out of the country, Hamling had produced and mailed a foldout flyer for the book. Inside the flyer, he reproduced the pornographic photos along with a coupon, and the only text was on the coupon. The book would have had redeeming social value, but the flyer did not, and they nailed him.

TELEVISION

W. Ryerson Johnson: I think television took right over from the pulp magazines. You could sit and watch a half-hour television show and just look and drink your beer without turning pages. They were essentially pulp paper, in the beginning, anyway.

Richard Wolinsky: As television replaced radio as the country's mass medium of choice, science fiction found itself on the little screen. *Captain Video*, *Tales of Tomorrow*, and *Science Fiction Theater* all hit the airwaves. Where better to look for writers than in the field and in the pulps?

Damon Knight: I was involved in *Captain Video*. It was produced by a marvelous woman named Olga Druce, who had a contract with a scriptwriter who she didn't like, I've forgotten why. So she canceled the contract and got rid of him. Had to pay off his contract, he was still getting paid every week and therefore she had to go to nonunion people for scripts. She went to Scott Meredith and he collected various people he thought might like to do this for what to us was magnificent pay. I forget what it was, $500 a script or something. No, it couldn't be that. They were doing six-episode serials. I think it was $500 for the whole serial, but it was a lot of money to us, and an interesting chance to work in television. One thing I found out is that actors are much taller than writers. It was a nice thing to try. Jack Vance did marvelous things for it. He was then a young, stocky but not large fellow. You would never recognize him now. Jim Blish did some, and several other people. A little crawl came at the end: there was your name.

James Blish (in *Xero*, January 1961): Olga had heard of s-f somewhere and began to bring in s-f writers to do the scripts. For a long time she depended on Bryce Walton, who did — as she gradually came to recognize — a very sloppy job. She began scrounging around for other s-f writers.

During the succeeding year she used three-week scripts by R. S. Richardson, Walter M. Miller, Jr., and me (and this is by no means a complete list). Some of these stories were good, and the Miller, if I can trust my memory, was downright distinguished. Furthermore, they were fun to do — which was lucky, for the pay was not precisely princely: a hundred dollars for each half-hour script, or fifteen hundred for a three-week story.

Theodore Sturgeon: I got involved with *Tales of Tomorrow* and became essentially their story department. I got together a whole bunch of writers and we supplied scripts and story ideas and so on. Gosh, it was so different in those days. It was all live television, for one thing, and it was a half-hour show. It ran for seventeen, eighteen months on the ABC network [actually DuMont]. We had a $40,000 budget. That's everything: script, actors, production. We had stars, we had all kinds of stars. I remember particularly Lon Chaney, Jr. We did things, strange things. I can't claim any credit for this, but we did a two-parter, a documentary. What it was doing in a science fiction series, I'll never know.

I got really tangled in the gears, I was so utterly completely naïve. My group was known as the Science Fiction League of America, and ultimately we stopped getting paid. It's kind of a sore thing for me to remember because I never asked for credit, I never asked for screen credit. There's a lot of work being done now to bring up some of those kinescopes, and some guy who is trying to do a book of it, and there's very little credit to me, because the credit is the Science Fiction League of America. I never asked for personal credit on it at all. Ultimately, we had to go to court to get our money. My lawyer didn't feel that he wanted to handle a courtroom situation, so we hired another lawyer, who was a very good courtroom trial lawyer, and we won the suit, and it just took forever to get the money. It was a totally unhappy situation.

It was so unhappy that I left New York and didn't touch television at all until I heard that a young guy by the name of Rod Serling was going to start a science fiction fantasy-type series, so I wrote to him, I told him all the trials and tribulations I had, begged him not to get into the kind of difficulties I had. A lot of accurate hindsight. He wrote back a lovely letter. He said that he was enthusiastic about my work and could I send him some material. I said gladly, and I sent him a pack of material. In due course it came back to me with a big rubber stamp on the back of the envelope which said, "Returned unopened. Unsolicited manuscripts are not used." So I wrote to Serling and told him what had happened. He wrote back an ardent apology and said,

"I'm coming east. Don't leave town till I get there." That's the last I ever heard from him. Never heard from him again.

Stuart J. Byrne: My first assignment in television was in 1959 with ZIV TV. They were selling Camel cigarettes. The series was called *Men into Space,* starring William Lundigan, and that was my first — hello, hey, I got it — TV assignment, a one half-hour script they bought, and they produced. That sponsor, Camel cigarettes, they were bragging that the series was under the auspices of the United States Air Force, and the writers had to be university graduates with degrees. They even took us down to San Diego and showed us the ICBM Atlas program.

So here I am writing this thing and the producer calls me in and wants to cut my throat because he put a red line around a little line of dialogue in the script. Somebody was trying to explain to somebody else how artificial gravity works under centrifugal force. The producer said, "You can't do that."

"Well, this is under the auspices of the Air Force and is supposed to be scientific."

He said, "We're selling Camel cigarettes to eighty million people and the psychological center of eighty million people is a little old guy in the back row with a can of beer, or his wife next to him who can't even hear. And they're gonna switch over." I really had to realize that. It was a shame.

To make it worse, in the studio bar one day, Bill Lundigan himself came over to me, and he said, "Hey, are you one of the guys who writes these turkeys?"

I said, "Yes."

He said, "I want to ask you a question. Why is it that I always have to fight the elements and never get to work with a babe or something?"

And I said, "If I told you the answer to that, you'd have another drink."

"What do you mean?"

I said, "Well, this whole thing is under the auspices of the Air Force, and they won't allow women in the story because they have not yet produced a space suit with a catheter tube for a woman."

He said, "Oh my God. Give me a double scotch."

Science Fiction Comes of Age: the Hugo Awards

Richard Wolinsky: Some can argue that an art form has finally come of age when it begins giving itself awards. Some can also argue that the first awards presentation is also the beginning of the end. While there were fan awards going back to the 1930s, the first major science fiction award was the International Fantasy Award in 1951. But the big one, the Hugo Award, was first given in 1953 by the World Science Fiction Convention. Some folks thought it was a gimmick, which is why no award was presented the follow-

ing year. The outcry was so great that the Hugo was reinstituted the following year, 1955, and has been awarded every year since.

Frederik Pohl: I don't know what the validity of an award is. So much of it depends on feeling that it's this person's time to get an award. There was a long period when you could measure the effect of things like being in the Milford Writers' Conference or the willingness of a publisher to send out free copies and see that these were reflected pretty closely, particularly, the Nebula Awards, which began in 1965. I don't think it's quite as true anymore. I think what I once called the Milford Mafia has dwindled and may not exist anymore. It never was a conspiratorial group, it was just a bunch of people who knew each other and liked each other, and voted for each other. It's a lot like the Futurians, except we weren't giving any awards. Didn't have anything to give them with.

But I think that, by and large, it's a fair world and if an author doesn't get an award he's entitled to, sooner or later he does get one he isn't entitled to. It's not fair in the sense that there's no point-by-point correspondence between virtue and achievement, but it balances out over a period of time.

At least, I think so.

Chapter Seven
From the Science Fiction League
to the Futurians: Fans For All Seasons

THE CONTINUING CAST OF THE BOOK
(IN ORDER OF APPEARANCE)

Terry Carr (1937–1987) Fan during the 1950s; became a leading editor and writer from the 1960s until his untimely death in 1987.

Organized science fiction fandom has played an enormous role in the history of the genre. As readers discovered the pulps, they sought out those with like-minded interests and ideas. Many of them later became writers, and then became stalwarts and stars in the field. Others with just as much promise died young or simply faded into middle age. But more than the writing or editing, fandom reflected the dreams and prejudices of each science fiction era.

Alva Rogers: I think the most important thing about fandom are the lifelong friendships that have lasted for thirty, forty years. I think in the long run, stripped of all of its trapping and its allure, fandom boils down to interpersonal relationships. Plus the stimulation of occasionally talking with people about your favorite subgenre of literature. But I think essentially it's been the friends I've accrued over the years.

The Origins of Fandom

Charles D. Hornig: The Science Fiction League started out with Hugo Gernsback. At that time, he had just started the Radio League [of America]. He put out a few radio craft magazines. In the twenties he had a radio station, but I don't remember if he still had it when I was with him. This radio league gave him the idea that he could have a science fiction league, so he told me about it, and asked me to do the work on it. So I worked it out and started chartering chapters all over the world, and I had a bright idea there that had a legal reaction. We had a lawyer on our necks very quickly. At one time, I was writing the magazine and we were going to publish a test, a science fiction test. If you could answer these questions, you could win yourself a degree, bachelor of science fiction, master of science fiction, or doctor of science fiction, depending on how you came out on the test. And you could put after your name D.Sc.F. and so on. Well, it sounded great until it was published and then the company lawyer saw it and said, You know you just can't hand out degrees that way. So I had to cancel the whole thing.

Julie Schwartz: In the early 1930s, we were simply young kids who were teenagers, very interested in science fiction, and we got together to talk about it. I joined a club called the Scienceers. There was Mort Weisinger, who became my lifelong friend. Allen Glasser was a big letter writer, had actually sold a story to *Amazing Stories*, called "Across the Ages." That was a big deal, which I'll tell you about in a second. There was Will Sykora, who was a keynote speaker at the first World Science Fiction Convention, and some other members who I don't remember too well these days.

When we got together and talked about stories, Mort and I said, "But who are these people who write these stories? What do they look like? We'd like to get to know them." So Mort and I wrote letters to all the writers of the day. Edward E. Smith, who wrote *The Skylark* [*of Space*], David H. Keller, and so on, and they wrote back. So this built up. Eventually in hearing from these celebrities, we invited them to come to our little club meetings, which they did. So all of a sudden the audience grew. And in 1936 we had a convention in Philadelphia, that was only fans. But by 1938, we had a big Newark convention, and many of the celebrities were there. There was Otto Binder, there was Otis Adelbert Kline, Manly Wade Wellman, L. Sprague de Camp, John W. Campbell, and other people. And the fans were very interested. That eventually led to the first World Science Fiction Convention.

Oh, these writers, they were thrilled. They were working in obscurity. They didn't know people wanted to know about them. Doc Smith wrote me a letter, giving his biography. I said to Mort, "Why don't we put this some place so our fellow fans can see it?" So Mort and I sat down at the typewriter. In an inspiration, I called it *The Time Traveller*, and that eventually became the first science fiction fan magazine. That was in January, 1932. Neither Mort nor I had confidence in ourselves to run the magazine, so we asked a professional, Allen Glasser, to become the editor. He was maybe two or three years older. I was, at this time, sixteen or seventeen. So Al was nineteen or twenty, and had sold a story to *Amazing*, which I must keep telling you, because at one point a few months later, I picked up a magazine from 1925, and started reading a story called "The Heat Wave."[63] And I thought this story seemed very familiar. I checked back. It was the same story that Allen Glasser had sold to *Amazing* called "Across the Ages." I realized he was a plagiarist. So that scared Mort and I and we decided we'd have nothing to do with Glasser, and we got involved with a new fan magazine, called *Science Fiction Digest*, which later became *Fantasy Magazine*, which Sam Moskowitz says to this day is still the best of all the fan magazines which came out, and that was over fifty years ago.

63 "The Heat Wave" was published in 1929, but Schwartz is discussing events from 1932, so he was still reading an older magazine, though not quite as old as he remembers.

Robert Bloch: I didn't know anything about fandom in 1934. I didn't realize, although I'd been printed in several amateur publications, that there were actually people out there who were interested in collecting this material and knew all about it and were familiar with the works of every one of the writers. In those days it was possible to do this. There were only a few films. As I say, very few books. If you got into science fiction, you could read H. G. Wells, Jules Verne, a couple of others. You got British books. You could read Olaf Stapledon, who was reprinted in the States, but not widely. You could get all the fan magazines and keep up with everything that was going on, and all the prozines and spend a grand total of about a dollar and a half a month. You could be a complete fan for eighteen dollars a year and if you wanted to publish, that might cost you another eighteen dollars a year. You could publish your own fan magazine. Postage, in those days, was two cents first class. It was raised to three cents first class and there was a terrible row about that. But most of the fan publishers were able to survive this tremendous one cent increase in the cost of mailing. I got into science fiction and science fiction fandom. It was a mixed blessing. Into each life some rain must fall. I was off and running.

Charles D. Hornig: Farnsworth Wright helped me with *The Fantasy Fan* by accepting little ads and putting notices in his columns so I'd get more subscriptions. Because oddly enough this *Fantasy Fan* magazine ran eighteen issues, the one I had printed. It might have run only two or three if Gernsback had known about it. He didn't think I was continuing with it. And once I got to be editor of *Wonder Stories*, I decided it wouldn't be ethical to call it *The Science Fiction Fan Magazine*. As long as I was editor of *Wonder Stories*, I'd call it *The Fantasy Fan Magazine*, and I emphasized the weird side more than the science fiction. When I had just finished my eighteenth issue and was going out of business, a couple of months after that, Gernsback said, "You're not still publishing that fan magazine, are you?"

"No"

"Good, because I wouldn't want you to." He didn't know about it, he thought I'd dropped it right away. Fortunately I didn't give him any future issues.

War with the Futurians

Charles D. Hornig: The Futurians, that was quite a story. They were the evil ones. That would include people like Donald A. Wollheim. He was the leader. And Doc Lowndes and William S. Sykora and Fred Pohl. These people I didn't know very well because they lived in Brooklyn, which was way out. They used to get together in fields in Queens and shoot off rockets and things, you know. They did some of the early rocket research, but they were still teenagers. In those days, a lot of people were flirting with Communism

in this country because of the Depression, people became disillusioned and this is when you had all this, the inroads into Hollywood, then McCarthy came along and persecuted those people. It was the same thing going on in science fiction, and the Futurians were flirting with Communism. This was still a pretty awful thing for those of us who didn't go in for it. So they were kind of out because of this.

Damon Knight: Most of the Futurians were Marxists of one shade or another. In the early 1930s, Don Wollheim and Johnny Michel tried to introduce Marxist concepts into science fiction through a manifesto written by Michel, or written by Wollheim and bylined by Michel, I forget which. They just wanted progressive thought and ideas in science fiction, which was kind of a mild proposal. But they got a lot of flack for this, from the rest of fandom, which was non-New York, non-Jewish, non-Marxist.

Frederik Pohl: I was into the Young Communist League in '36. It's a matter of public record. I've never tried to conceal it. I can tell you exactly when I was out of the League, once and for all, although I stopped being very active before that. The last moment[64] when I conceived it as possible for me to be involved with them at all was the day after the fall of Paris in the spring of 1940, a friend of mine offered to drink a toast to the liberation of Paris by the freedom-loving forces of the People's Republic of Nazi Germany, and I didn't want to play that game anymore. That was more than I could handle.

Charles D. Hornig: At that time, we had the Science Fiction League, and we had a local Manhattan chapter, and I was holding a meeting in a local high school for a bunch of members, and quite a few turned up and early in the meeting, a whole big troop of guys came in. It didn't look at all like science fiction fans. Tough guys. And they all sat in the back of the room, sitting there looking glum. And with them was William Sykora and Donald A. Wollheim. The whole thing was about Wollheim being unable to collect the twenty-five dollar fee for a story he'd sold and I had accepted and published. And Gernsback was simply late on paying back, he always was, and Wollheim was no exception. Either you had to sue Gernsback or make a noise like you were going to sue him before you got any money out of him. Unless you were a favorite of his, like David H. Keller or Fletcher Pratt. They got their money. But others had to simply wait, and Wollheim didn't like this. So they came in, and Will Sykora walked up to me and he said, "Okay, Charlie, you can have a seat there and you won't get hurt." I said, "Can I hold my meeting afterward?" "Yes, you can hold your meeting soon as we're finished." So I sat down and Wollheim got up and he gave this long diatribe

64 Fred Pohl's Wiki page claims that he made the switch at the time of the Molotov-Ribbentrop Pact of 1939, based on Pohl's memoir, *The Way the Future Was*, likely a paperback reprint. However, the August 1978 hardcover first edition tells the same story as noted here

against Gernsback, all the terrible things he was. Some of them were, you know, quite true. About cheating authors and one thing or another.

Then when Wollheim was finished, they left, but they didn't go away. There was a report that this gang of toughs was waiting outside for us, me and Julie Schwartz, who was holding this meeting. Julie was particularly nervous about it. We saw the janitor and told him it looked like they were going to tear us apart when we got out there, and he said there was another exit on the next street, through the basement. So we went out another way, went to the subway, hoping to get on a train before they realized what had happened.

Damon Knight: Sam Moskowitz was running the first World Science Fiction Convention in New York. He barred six members of the Futurian society, wouldn't let them in the door. Jimmy Taurasi was standing at the door, a very large man. So they repaired to a saloon or something and issued a manifesto. They all took themselves so seriously. They were trying to do European politics in a teacup, and they were just intensely ferocious about it.

Today, in 1982, there's still a lot of bitterness about this in surviving members of fandom. Sam Moskowitz is still carrying this tremendous grudge. It appeared in his review of my book, *The Futurians*. He used my book to put Wollheim down. After all this time, that seems extraordinary to me. I can't carry a grudge that long.

Charles D. Hornig: The Futurians were banned from the first World Science Fiction Convention. Donald Wollheim wasn't allowed to walk into the place. Even those of us who didn't like the Futurians didn't like that ruling, and of course neither did Forrest Ackerman and the West Coast people who came out for the first World Convention. Sam Moskowitz, I guess, made the ruling.

Isaac Asimov: I remember that 1939 convention very well because several of the Futurians were going to just walk in, and I was one of them. There were Sam Moskowitz and James Taurasi and Will Sykora barring the way and the others stopped as they didn't feel they would win a fight. And I kept on walking because it was clear that they didn't know me, and were paying no attention to me. So I just walked in. I felt pretty guilty about it because I felt that solidarity required that I stay with the rest of the Futurians. On the other hand, I was dying to attend the convention. And so I suppose selfishness won out over my sense of loyalty.

None of the others at the convention knew about it. As a matter of fact, Leslie Perri, who was going with Fred Pohl — she may have already been married to him — motioned to me in some kind of improvised sign language that I should get up to say a few words and give an impassioned address on the injustice of keeping the Futurians out. But I hadn't the faintest idea what her signs meant. And so I didn't, and then she scolded me afterward,

and all I could do was look sort of pained and helpless. I found out decades later when Fred Pohl wrote his autobiography, called *The Way the Future Was*, that she was very non-fond of me. In fact, when he wanted to talk to me, he couldn't have me in the apartment. He had to talk to me outside — something I was never aware of. I thought he just wanted to walk, but I suspect that perhaps one of the reasons she didn't like me, and there were many reasons I presume, and I'll never know because she died long ago, was because I had failed her at the convention. That was not my deliberate doing.

Charles D. Hornig: Isaac Asimov, I had never met him as far as I knew, and he was one of the guys I wish I had met back in the thirties when he was a fan. But he again was out in Queens somewhere, which was way out in the sticks as far as we were concerned. And I never did get to see him, as far as I knew. So just about two years ago I was picking up some books in the library and decided that I'd read an anthology that I hadn't seen before, of Isaac Asimov's. And he put little stories in between the stories, about how they came to be written and all. In one place in this book, he said, "It seems I never got to meet Charles Hornig although I intended to," etc. etc. "Over the years, well, maybe I'll get to meet him intentionally. I'll go out of my way to meet him."

So I said to him I was going to be in New York in the next spring. He said fine, call him up, drop in. So I did. Going back to his diary — he kept diaries every year back to the early thirties. He showed me a long shelf filled with nothing but diaries — and he said, I found out in one of these diaries that I did meet you, and I know exactly the date and time in 1939. Well, it was very brief and I didn't remember meeting him, he didn't remember meeting me. But now he's writing his autobiography and he showed me he had a stack of paper that deep on his desk, and he was just starting to write.

JOHN MICHEL

Isaac Asimov: I remember John Michel. He was the most political of us. One of the reasons why the Futurians split away from the Greater New York Science Fiction Society was that they were considered by the others to be left-wing. This was before I joined. I joined after the split. I had been invited by Fred Pohl to attend a meeting of the Greater New York Science Fiction Society, and in between the invitation and the time I got a sort of modi-fied invitation, the split had taken place. And I attended the meeting of the Futurians under the impression that it was the Greater New York Science Fiction Society. I found out later on. I wasn't cheated, though. Had I been there before the split, I would have gone out with the Futurians. But John Michel was the most obviously political one in the group. Don Wollheim may have been next. We never discussed politics, however, except with

respect to science fiction. That is, science fiction had to be anti-fascist. And since I was anti-fascist, that sounded pretty good to me.

Frederik Pohl: There was a deliberate attempt to make Johnny Michel a legendary figure in the late '30s or so, in 1938, when the political movement that we called Michelism arose. We were trying to portray Johnny Michel as the Marx of America in the twentieth century. The Michelist Manifesto and stuff like that. That was sort of half-tongue-in-cheek, but also sort of half not. Half was an attempt to show a cohesive political philosophy that was sort of Marxist, sort of collectivist and Socialist, but also future-oriented. Reading the sort of things that were published at that time now, they all look pretty bizarrely immature, but that wasn't our intention at the time. Johnny Michel was one of the brightest and most talented figures I ever knew, and if I had been asked to place betting odds on who was going to be remembered fifty years later in that group of people, he would have been one of the ones who I would have been quite sure would be a memorable figure, and nothing came of it all. There's not a word of what he wrote that's in print anymore. There's no effect visible of his presence except the memory of a few people who knew him at the time. I never have been able to understand how, in a group of a dozen people, all of whom looked bright and intelligent and creative, one or two will stay with it and achieve some sort of success, a few others will dabble at it, and a few will self-destruct. Johnny is not the only one. There were two or three others who were in the Futurians who were immensely talented who did nothing.

Larry Shaw: Michel was always Donald's follower, to a certain extent, although not to the extent of having a steady job. Politically, I was leaning pretty far left myself at the time, and I began to be really somewhat puzzled, even then, because Donald and Johnny would espouse these frankly communistic principles but they would also tell jokes about how the party lines kept changing to suit the convictions of the day. On one occasion, when I wanted to take some political action myself, and go to Washington to help picket Senator [Theodore] Bilbo, who was the right-wing demagogue of the day, Johnny was very vehement in trying to talk me out of it. He actually said, "Larry, we talk about these things, we don't do them."

Richard A. Lupoff: Johnny Michel was already a legend in his own day when I was a young fan, and by the time I got really heavily involved in the community, he was dead. So to me he's this strange figure who glows out of the past in a peculiar, enigmatic way.

Larry Shaw: Johnny, when I first met him, was a comparatively suave and sophisticated individual, or so he seemed to me. One drawback to this was that he had a speech impediment which occasionally interrupted the flow of what he was saying while he stuttered and stammered for a bit, and then continued. He wanted to be a writer, but not a commercial writer. He did sell some pulp stories but this did not satisfy him. He wanted to be

a serious writer, and he wanted to be recognized as a serious thinker. His health in general was rather poor, and this may have interfered. As far as I know, he never completed a big serious novel, although I have read portions of serious novels that he wrote. They were turgid. But his dislike of commercialism was very, very strong.

When I first met him, he was working as an assistant or associate editor with John W. Campbell, Jr. Everybody knows that Campbell edited *Astounding*, which later became *Analog*, and most people know that he edited *Unknown* and *Unknown Worlds*, but for one year, he took over a magazine, an airplane magazine Street & Smith had been publishing for some time, called *Air Trails*. He promptly renamed it *Air Trails and Science Frontiers*, and made it what was probably the first attempt at an aerospace magazine to be published commercially in this country. It didn't go over, it lasted for about a year, and then went back to being *Air Trails*. It got a lot of advertising from the airplane model-makers and went on being an airplane magazine. The relevant point here is that the day Campbell took over as editor of this magazine was the day that John Michel quit because he hated Campbell so much. Campbell representing the height of commercialism and the belief in technology and all of the things that Johnny professed to hate.

I don't know if Johnny ever loved science fiction or not. I don't think he ever would have claimed to. I think he thought science fiction should be some sort of a wave of the future, but not quite the future that he wanted. He wanted a future that was at least socialistic, I'm sure. And he saw science fiction fandom as a very fertile ground for indoctrinating people with his kind of political thinking. Michelism. CPASF. The Committee for Political Action in Science Fiction. That was the root of it.

The Futurians Begin Growing Up

Isaac Asimov: There were several reasons for my move away from the Futurians. One was that I did start selling science fiction, so I felt ill at ease simply being a fan. Especially since I was the first one to start selling. But secondly, they were a lot more mobile than I was. They lived as a group together and I was in my father's candy store and I couldn't get away easily because I worked there. I had no way of getting to them by any easy way except walking, since nickels for subways and buses didn't grow on trees. So I couldn't be associated with them as much as they were associated with each other. Gradually I drifted apart, but the break didn't come until 1942 when I moved to Philadelphia because I got a job there, and then the break with my New York life was for a period of time complete. Until I went to Philadelphia, I'd been visiting John Campbell every month certainly, sometimes more than once a month. After I went to Philadelphia, that came to an end. For a period of time, I stopped writing science fiction. My break with

the Futurians was gradual and didn't have any one reason, and it was not exactly voluntary. It was circumstantial.

Damon Knight: The Futurian magazines, Don Wollheim's and Doc Lowndes's, were very low-budget things and naturally and inevitably published a lot of Futurian material. They published stuff by other people too, but they were paying a half a cent a word, or a quarter cent a word, and were not getting first look. The other magazines bought occasional stuff from Futurian authors. Wollheim, for example, had at least one story in *Unknown*, maybe more than that. I'm not sure about Michel. Lowndes and Blish a little later sold several stories to Campbell. There wasn't any absolute barrier. Futurian magazines were sort of an in-group thing.

Richard A. Lupoff: These magazines were *Stirring Science Stories*, *Future Science Fiction*, *Science Fiction Quarterly*, *Cosmic Stories*, *Astonishing*, *Super Science*.

Frederick Pohl: I didn't really think that it would happen, that the Futurians would get to be the Establishment, instead of being the people trying to tear it down. I suppose that if I thought a little bit in historical terms, I would have seen that it was inevitable. From outside, the Establishment always looks impregnable and eternal. I thought John Campbell would edit *Astounding* until the year 2600, and I didn't think that anybody would replace Captain S. P. Meek as one of the leading writers of science fiction. But we sure were trying. Everybody in the Futurians was sure trying hard to write, seriously. We weren't the idle butterflies at any time. There was a lot of typing going on in that ivory tower, day and night.

Damon Knight: How I came to New York and the Futurians was, in a way, Fred Pohl's doing. He was then the seventeen-year-old editor of two magazines called *Astonishing* and *Super Science*, and he got paid fifteen bucks a week or something like that, and he had a budget of, I don't know, a hundred and fifty dollars. To fill space, he ran a fanzine review column in *Super Science*. This is how I found out about fandom. I wrote away for some of the magazines and got into correspondence with various people, contributed drawings and articles to some of the other fanzines. In my senior year in high school, I produced an issue of a fanzine of my own called *Snide*, which came to the attention of the Futurians. They liked my adolescent humor and as a result, I got a correspondence from Robert A. Lowndes, who was then a sort of half-assed agent. He agreed to look at some of my stories, which he mostly sent back with patronizing remarks like "Put some plot in here" or something. I was in Hood River, Oregon, which is about sixty miles from Portland. Otherwise it's nowhere.

These people in New York seemed very grown up to me. In fact they were mostly older than I was, though Cyril Kornbluth was a year younger. The others were in their twenties, except for Don Wollheim who was the old man of the group. He was about thirty. They seemed an entirely sophis-

ticated bunch to me. So as a result of "Snide," somehow or other, I can't remember, they must have written me a letter suggesting that I come to New York and become a Futurian. So I did.

Fred Pohl: By the time that Damon Knight had arrived in the Futurians, I had more or less ceased to be active in it, and the organization was sort of withering away. Or maybe it just seems that to me because I was no longer active. But when it began, it was a pretty cohesive group that involved twenty or thirty people, and most of the people got together fairly frequently. By the early 1940s, when Damon moved from Oregon to New York, it was down to maybe half a dozen people who, more or less, ran a commune together, sort of a cooperative apartment, so that it was more a housing arrangement than a society.

Damon Knight: I was shocked when I arrived in New York, I think, because the Futurians were not very good-looking people. They were all odd-looking people, and no doubt I was too. I was a gawky six foot, ninety-seven-pound teenager with a funny haircut. We were an unlovely group, all misfits. The only thing that kept the Futurians together was the fact that nobody else could stand them.

Larry Shaw: When I got out of high school in Schenectady and moved to New York, I became very friendly with the group known as the Futurians, particularly Damon Knight, but also with Donald Wollheim on a somewhat different level. That was in 1944, and none of the original Futurians were even very interested in keeping the club alive, they just let it die on the vine. I think the only reason it was revived to any extent at all was that there were three of us, Judy Merril, Virginia Kidd, and myself, who all just loved the idea of being Futurians and we made such a noise about it that the elder Futurians did allow it to be revived to some extent, even though they no longer took it very seriously.

Donald Wollheim was a year or two older than most of us and he was married and he had a steady job. This was quite unusual. At the time, he worked for A. A. Wyn, and exactly what he was editing, I'm not sure. For a long time I guess it was not science fiction but other kinds of pulp magazines. In fact, now that I think of it, I remember definitely he was editing a couple of detective magazines because Johnny Michel would send him stories occasionally. Wollheim was just a little bit old chronologically but considerably older and more settled in his attitudes. He liked to gather the younger fans around him and be a sort of mentor to them. He would have meetings in his apartment in Queens every other Sunday afternoon, and it was pretty much kids who I won't say idolized him but looked up to him as an older experienced man.

Meanwhile, I was living in Manhattan. I lived with Johnny Michel in a one-room apartment on West 9th Street, but I was becoming quite friendly with Damon Knight, who shared a larger apartment with Chester Cohen,

and these three were all much more bohemian types. They did not work at regular jobs if they could help it, they tried to write and paint and do more arty things. Their general attitude toward life was certainly somewhat more liberal than Wollheim's.

Richard A. Lupoff: It's hard to think of Wollheim as being the straight middle class-type person with everyone else being bohemian and radical. Don always passed himself off as a radical, and espoused all sorts of radical theories, all the while pursuing absolutely straight-down-the-middle, conventional middle-class, materialistic life.

Larry Shaw: I also knew James Blish in the Futurian days. He was one of the people who hung around. In fact, he shared an apartment with Doc Lowndes and came to all of our Thursday night suppers and so forth. Blish did consider himself quite superior intellectually, and he didn't see anything in my intellect in the Futurian period, didn't discover it until later [in the 1950s, when Shaw bought Blish's story, "A Case of Conscience," for *If* magazine — Ed.].

Fred Pohl: Judy Merril became a part of the Futurians during the war, toward the end of the war, at a time when I was no longer connected with it. I met Judy for the first time I think in 1946 or so, at a party, and that's when I discovered that there still was something that called itself the Futurians. I've always considered that incarnation a sort of zombie, reincarnated, walking and shambling around, but without the soul that made the original Futurians what struck me as a good thing to be in.

Robert Silverberg: The Futurians were basically a wartime group, and by 1943, '44, they no longer existed as an organization. They were split by terrible feuds involving Donald Wollheim and Jim Blish, primarily.

Damon Knight: My relationship with the Futurians ended in a nasty threatened lawsuit in 1946, though later on, in the '50s, I published Kornbluth and Larry Shaw in *Worlds Beyond*. Fred Pohl got me that job too.

Robert Silverberg: The Futurians as individuals were all still hanging around New York when I arrived in science fiction in the '50s but there was no such organization. In the late '50s, perhaps even very early '60s, another group was formed. I remember going to Dick and Pat Lupoff's penthouse apartment in Manhattan to attend meetings. It was largely a fan group that overlapped some of the younger professionals. Terry Carr didn't come to New York until '61 perhaps. '60, '61, and then of course he became part of the gang. Ted White appeared at the same time after having lived in Washington. This was the ancestor of the Lunarians. I forget the name, the Fanoclasts it might have been. There were a lot of ephemeral groups.

Writing About the Futurians

Richard A. Lupoff: Damon Knight wrote a memoir called *The Futurians*. It was a rather controversial book, though highly readable, like a 200-page gossip column, and who could resist it? But at the same time it was criticized, perhaps for dwelling too much on the seamy, juicy aspect of these people and their lives.

Damon Knight: I have very strong feelings about that. I hate sanitized biographies. I think if someone is going to lay out money for a biography, you ought to get the truth as far as it's publishable without running into libel laws. I like finding out that famous literary figures are human beings, and I'd like to know what their failings were. I think it's a great mistake to clean up our heroes. What you do, instead of inspiring the youth of the country to emulate them, is discourage them because they know they can never be as faultless as that. They can't be pure in virtue. I think it's just a matter of literary honesty to describe people the way they were, and that's what I tried to do.

Frederik Pohl: Shut off your tape recorder. Damon is a very sweet guy in person, but put him in front of a typewriter, you should cut his fingers off at the knuckles.

Damon Knight: Fred has a different attitude about this. He doesn't believe in saying anything disparaging about anybody he knows, in print, although he will say terribly cutting things in correspondence or in person. I respect his beliefs about this, but I don't share them. Fred's autobiography I think is highly readable, very entertaining, but it's sanitized and doesn't have the flavor.

Isaac Asimov: Fred Pohl is sort of a multi-threat person. He's an excellent science fiction writer, he was an excellent science fiction editor, he was a very good science fiction agent. I suspect that if there was anything else he wanted to try, he'd be very good at that too. I would say that of the people in science fiction that I've met, very few I'd be willing to admit were more intelligent than I was. I always thought that Cyril Kornbluth was more brilliant than I was, but he was very erratic. I honestly used to worry that Fred Pohl might well be more intelligent than I was. I tried not to think about it. I remember once when we both got out of the Army, he said to me, "What was your AGCT score?" and I said, "A hundred and sixty," and he said, "Oh shit." Because his had been a hundred and fifty six. He had hoped he had beaten me. I didn't realize why he was asking me and then I burst into a cold sweat 'cause I figured he might've beaten me. I think one of the nicest things I can recall was that not for one instant did he doubt me. It never occurred to him that I was making up a figure just to beat him. I appreciated that ever since. As I explained in my autobiography, he probably did more to help me than probably anybody but Campbell in the early days.

Frank M. Robinson: Fred Pohl always had overtones of fandom around him. I don't know how else to explain it. If I talk about Heinlein, I'm talking about a professional science fiction writer. If I talk about Freddie, I'm talking about a science fiction fan who became a professional science fiction writer.

Nice guy. Easy to talk to. Knowledgeable on a lot of subjects. Very honest. He ran an agency that owed thirty grand by the time it collapsed, and he paid off every dime of it. I remember in Chicago at one time at a convention, he owed me money and he pulled out two hundred-dollar bills from his wallet and gave them to me on account. Those are the first hundred-dollar bills I'd ever seen in my life. I didn't know what to do with them. I didn't think anybody would cash them.

Fandom Outside New York

Forrest J. Ackerman: It was October 1926 at the corner of Santa Monica and Western in Los Angeles, and I was standing in front of a newsstand, and the October issue of *Amazing Stories* jumped off the newsstand and grabbed a hold of me. In those days magazines spoke, and that one said, "Take me home, little boy, you will love me."

Three years later, I was living in San Francisco and I started a correspondence club called The Boys' Scientifiction Club. I had nothing against girls but they were as rare as a unicorn's horn in those days. By the time I was fifteen I was corresponding with a hundred and seventeen science fiction fans around the world, including one in Hungary and one in Russia. And only one of them was a female. She lived in County Cork, Ireland.

In 1935, I attended the first meeting of the Los Angeles Science Fantasy Society. I'm one of the five remaining charter members as we speak. In my time, I was director of the club, secretary, treasurer, publisher of the club organ, editor of the club organ, librarian, and janitor.

Frank M. Robinson: I don't know where the hell I met the other Chicago fans. There may have been little gatherings in Chicago that I read about. Charlie Beaumont, who was known as Charlie McNutt at the time, read *Amazing* and I read *Astounding* and wherefore I nominated myself as naturally being smarter than Charlie was. Charlie, I buddied with because he was pretty much my own age. Walt Liebscher was older. Niel De Jack and another guy were old magazine dealers in the city. We formed a little club called the Windy City Wampires, with a W, don't ask me why.

Before I went into the service, I and a guy named Edward C. Connor, otherwise known as "Ecco Connor," we inherited a little postcard-sized fanzine called "Fannewscard Weekly." We inherited it from Bob Tucker. I was putting that out at the time I was a copyboy at International News Service. Everything was reduced to abbreviations. The editor at INS thought I was putting out a tip sheet, you know, horse racing.

The 1940 World Science Fiction Convention was more or less a product of Bill Hamling and Mark Reinsberg. They more or less put it on. Like a lot of organizations that put on a convention, Chicago fandom disintegrated immediately after the convention. Everybody went their merry way and then came the war. We had little rump conventions down in Bloomington. Then Slan Shack[65] started over in Battle Creek, Michigan, sort of a communal living arrangement of five or six guys, and we used to hold conventions there. The furthest we went beyond that was at one time we held a Midwest convention in Buffalo, New York. Among the people there was Damon Knight, back when he had a full head of red hair. That was pretty much my first meeting with anyone from the East Coast.

During the war years, I drove with some guys who were hauling a car up to Los Angeles, and I met all of the Los Angeles fans, about whom I remember virtually nothing.

Forrest J. Ackerman: It must have been around 1935. This young chap, Ray Bradbury, came to a meeting of our Los Angeles Science Fantasy Society and thereafter wanted to put out his own fan magazine. I financed that. He did four issues of *Futuria Fantasia*.

Ray's four years younger than I, and as a teenager when he wanted to take a girl on a date, it could be done for a dollar. I was good for it, a buck for a book, to finance his date. It was twenty-one cents for a first-run film, and they'd go for a streetcar ride to the picture palaces in downtown L.A., five cents for bottomless popcorn with real butter.

One night in 1935, apparently he had an extra hot and heavy date because he wanted two dollars. What was the excuse for the extra dollar? He brought me a copy of the novelization of *King Kong*, theoretically written by Edgar Wallace, who was the leading mystery author of the day. Actually he wrote about three words and dropped dead, but they kept his name on it. So Ray says, "Look, look, it's signed by Edgar Wallace. That would be worth an extra dollar." So I was young and naïve. I didn't stop to question how did this high-school kid got the autograph of this famous author six thousand miles away. I gave him the extra dollar.

Many years later, at one of my birthday parties at my house, Ray's eyes fell upon that copy of *King Kong* that he had sold me many years ago, and he hesitantly took it off the shelf and opened it up. He said, "Oh boy, I have a terrible confession. I wrote that 'Edgar Wallace.'" I said, "You dirty dog, give me back my dollar!" I realized he probably regretted he ever sold me that. It was one of his favorite books, a rather expensive collector's item. I managed to get hold of one. I sent it over to him and I inscribed it: "To Ray Bradbury, from the real Edgar Wallace."

Alva Rogers: I grew up in San Diego, which was a backwater as far as fandom was concerned in those days, the late '30s and early '40s. I became

65 Slan Shack was located at 25 Poplar Street, Battle Creek, Michigan.

acquainted with two or three like-minded people at that time. We traded, subscribed to a few fanzines. My goal was to make the long, long trip to Los Angeles at some future date, where, as far as we could tell from reading fanzines, all of the hyperactivity was going on. Either there or New York. It was not until I received a discharge from the Air Force in 1941, '42, that I began to really make plans to move to Los Angeles, and it wasn't until 1943 that I went up to L. A. with the intention of going to art school. The very first thing I did in going up to Los Angeles was get in touch with the Los Angeles Science Fantasy Society, the LASFS, and from that moment on, I was deeply involved in fandom.

Forry Ackerman, of course, was there. Ray Bradbury was just on his way out, more or less. Frequent visitors in those days were people like Jack Williamson, Robert Heinlein, Henry Kuttner. All had been at one time or another active members of the LASFS.

Harlan Ellison: After I discovered science fiction, I started shoplifting science fiction books from a bookstore in downtown Cleveland near the public square because I didn't have any money. My mother was working at a B'nai B'rith thrift shop and I was doing odd jobs, I was working as a soda jerk and other things and I just couldn't afford books, even as inexpensive as they were in 1950, '51. And so I began shoplifting, and one of the times that I was busy boosting some books out of this bookstore, I saw a 3×5 little file card, stuck up with a thumbtack on a side of the bookshelf where the science fiction was. It said, "The Cleveland Science Fiction Society is forming. Anybody interested call this number." Well I called, and the people were Nan Hanlin, Steven Schultheis, and Alice Mary Norton, who is, of course, Andre Norton, who was one of the originators, and all of these people were the first people I met as science fiction fans and I became a fan.

We began doing a newsletter called "The Bulletin of the Cleveland Science Fiction Society," and because I had a typewriter and was interested in writing and had the energy for it, I became the editor. It was first done as a newsletter and then it became a little magazine and was very, very badly reproduced. I bought a mimeo, and then I got better with the mimeo and it got better looking and better looking and better looking, and we changed the name to *Science Fantasy Bulletin*, and then I changed it from *SFB* to *Dimensions*. It went in incremental stages where it became my personal fanzine. The Cleveland Science Fiction Society continued, and I was a member of it until I left Cleveland and went off to college. I never really got the last few issues done. They live on in legend, I am told.

Frank M. Robinson: For all of its pretentions at being liberal, avant-garde, and all of this, science fiction fandom by and large is fairly well educated, practically all white and middle-class, with everything that that implies. At least back then, you should not look for any enlightenment among science fiction fans. In the late '40s, Francis T. Laney, I believe, in

the book called *Ah! Sweet Idiocy!*, blew the whistle on the gay guys in the LASFS, Los Angeles Science Fantasy Society, and this was supposed to be a huge scandal. One of them was Jimmy Kepner, poor little eighteen- or nineteen-year-old Jimmy Kepner, who later on established the main library of material dealing with homosexuality down in L. A. and became a patron saint of the homoerotic field. But he blew the whistle on Kepner. I'm pretty sure he blew the whistle on Walt Liebscher, which meant that for these guys, most of their friends immediately ostracized them. It was criminal.

I never met a Black science fiction fan for decades. You have to consider the country at the time. I remember in high school once, inviting a Black kid to come down and go swimming with me at the local Y. He looked at me like I had holes in my head. The Englewood Y was a Black Y. Black people could not go to any other YMCA in the city of Chicago. I never knew that.

Richard A. Lupoff: There's a quotation from Sprague de Camp in a book called *Science Fiction Handbook*, originally published somewhere around 1952, in which he mentions one of the early very prominent fans as being Black and says that fandom has, almost from the outset, been relatively free of racial prejudice. His theory as to why that is the case is that for people whose stock in trade is dealing with nine-limbed green octopods from Neptune, the fact that another normal human being just like himself except his skin is a different color doesn't really matter.

Frank M. Robinson: De Camp attributes the lack of Jewish prejudice to people with six arms, crap like that. The fact is that science fiction was, by and large, a New York magazine phenomenon, and there were a number of Jews connected with it, both as editors, publishers, and whatnot.

Let's Join a Rock & Roll Band
'Cause the Groups All Live Together

Harlan Ellison: I was publishing my own magazine, *Dimensions*, for a number of years, and it had become the number one fanzine in the country in science fiction fandom at the time. I always had aspirations and I always had a professional outlook, and so I was getting not just fan writers but I had Poul Anderson writing for me, and L. Sprague de Camp and Lester del Rey and Alfred Bester and Bob Heinlein. All of the big pros of the time were writing for me as well. So that's how I made friends and connections with Algis Budrys, and A. J. became, in some ways, my mentor.

He invited me to New York while I was still in high school and I hung out with the Hydra Club a few times and got to know everybody. Bob Silverberg and I were fellow fanzine publishers. He had been doing *Spaceship* and I was doing *Dimensions*, and we got pretty close. We had even in fact gone to the convention in Philadelphia where we had shared the cost of a huge suite and we rented out floor space to other fans so we could make some

money, and in fact we came out ahead. Bob and I were always pretty good businessmen and entrepreneurs.

Robert Silverberg: From 1952 to '56, I had a room, not an apartment, in what had been a fine old apartment house on 114th Street, just across the street from the Columbia campus. The apartments had been broken up into single-occupancy rooms and I had one.

I think it was around Christmas of 1954. Harlan Ellison had just flunked out of Ohio State and he came to New York to challenge the big city, as people from the Midwest would do. I never had that because I grew up in the big city. He knew I lived there, so he came uptown and we went out, had a pizza together. He saw the place where I was living, and he moved in right next door. He got a room there, and we essentially had a kind of roommate relationship with private rooms next door to each other, for a couple of years.

Harlan Ellison: By the time I got to New York, which was when I got thrown out of college, which was 1954, late '54, and I wound up going to New York, I wound up living very near Bob. Bob was going to Columbia at the time, he was I think in his final year at Columbia. He was living at 611 West 114th Street. I moved into the same building. I was paying $10 a week. And I would sit there and write.

I had a marvelous mixed bag of jobs in New York. I painted the Brooklyn-Manhattan Bridge[66] from underneath, hanging upside down in a leather cradle, painting with rust-resistant paint. They painted year-round because the steel from below in the salt water rotted, so they had to keep painting. I picked up garbage in Bryant Park, right next door to the Public Library on 42nd and Fifth Avenue, with a stick with a nail on the end of it. I worked at the Broadway Bookshop between the Victoria and Astor Theatres. That was also a time when I ran with kid gangs. I did all of that and got the background for my first novel and the three or four books of juvenile delinquency stories I wrote.

I would work the shift from 7:00 in the evening until 2:00 in the morning when Times Square would shut down. I would go home on the IRT, the Seventh Avenue Uptown Broadway Local, and I would sit and read and catch up on all my reading. Then I would get home and I would start writing. I would write from 2:00 in the morning, 3:00 in the morning till about maybe 9:00 or 10:00, and then I would crash for three, four hours. Then I would get up and take the stories I'd written, take them to editorial offices and sell them, and then go straight to work. And this went on for about a year or two.

Robert Silverberg: Then six months after Harlan arrived, perhaps, Randall Garrett, who had been living with Phil and Bette Farmer [Philip José Farmer] in Peoria, and who was not really a housebroken kind of guy,

66 Does he mean the Brooklyn Bridge or the Manhattan Bridge? We can't ask.

was asked by the Farmers to leave. He got on a train and came to New York, and the first guy he called was Harlan, whom he knew from Midwest fandom. Harlan said, "Oh, I'm living near Columbia, right next to a guy named Bob Silverberg. C'mon up and see the place." So Garrett did so. That added to the hive.

Harlan Ellison: One night, I was working at the Broadway Bookshop, and here comes Randy Garrett, who I had not seen in years. I knew him semicasually from Midwestcon conventions, and Randy was a big, bluff garrulous charming, kind of a roguish fellow. The first time I ever saw Randy was at a Midwestcon in 1951, I believe, where he was being chased out of a bedroom by a husband who had caught Randy with his wife. Randy was buck naked except for a blanket that he was trying to wrap around himself, and the wife was naked and chasing after the husband, who was trying to kill Randy.

He had been run out of Peoria, Illinois, because he'd been caught stealing an unemployment check from Phil Farmer and his wife. He fled the city. He didn't tell us that, we didn't know any of that.

"Hi, I'm here, I'm in town. I have no place to stay. Can I bunk with you?" Well, I had a room that was about as wide as a kitchen sink, and I had one bed, I had a single bed.

"There's no room for you to stay," I said, "But you can sleep on the floor if you want, or maybe I'll sleep on the floor and you can have the bed." He went out and he got drunk, and he came back to my room and was so drunk that I got out of bed and I made a little pallet on the floor for myself and he fell down on my bed and vomited on my bed.

The next day, Silverberg, who was always very quick to see the main chance, took him on, got him a room there, and the two of them started writing together. And that was how Bob broke into *Astounding* because Randy was writing for John Campbell, who was very big on the Übermensch Aryan superman image, and that's what Randy looked like. He was a big, tall, blondish kind of guy, and Bob was a little Jew. But he went in with Randy and he ingratiated himself and they became Robert Randall.

Robert Silverberg: Two very well-known fan publishers of the day named Ron and Cindy Smith, a married couple from California, from Los Angeles, moved to New York a while later to tackle the big city, and they wound up down the hall also. So we had a sort of commune. It was within one former apartment but we each had individual rooms. That was quite a lively time.

Harlan Ellison: The big difference between Bob Silverberg and me was that Bob came fully formed out of the egg. He knew how to write, he wrote well, and he got better very, very quickly. You look at Bob's first stories and they're already very professional quality. I was crude and had to learn the hard way. Bob had his trials and tribulations, as we all do in life, but in that

area, Bob always had it pretty easy. He was able to sit down and write. He was fluid, he was proficient, and he was businesslike enough right from the get-go to know how to sell, and he did. And I was always behind him by at least a year.

The early stuff I wrote, for at least the first year or two, was no better than competent, with one or two few exceptions. There were a few stories that showed a flash of whatever it was I was going to bring to the work later. But I had to learn my craft the hard way. A joke I always tell is, "Before you I stand, an example of a self-made man, thereby demonstrating the horrors of unskilled labor."

Robert Silverberg: It was a painful time for Harlan. I was a year or so ahead of him with my professional career. We had both come up out of fandom, and I was selling stories right and left, incredible numbers, and he yearned to do that. But they all got rejected. And he would come limping back from an editorial visit, and he'd had a story rejected on the spot. He went through some very ugly stuff indeed. People were quite cruel to him.

Harlan Ellison: There was an enormous amount of childish and mean-spirited rancor throughout fandom from person-to-person. It wasn't just directed to me. Everybody was forever sniping at everybody else. Fans have always liked to do that. They make themselves a big frog in a little pond by causing bogus controversy, and I came in for my share of it. But the fact that I was not particularly humble or unassuming about my intentions or my talent or anything else was no bar to their coming after me. I was a pretty good fish for them to go harpooning.

Robert Silverberg: Then suddenly it began to change for Harlan and by the final year, couple of years, we were living there, he had joined me as one of the hot young professionals. But that period from January '55 through the middle of '56 was extremely rough for him, and he still has the scars from it.

Harlan Ellison: Bob's right. It was very tough for me. I couldn't break in very quickly, and when I did break in, it was sporadically. I wasn't earning a lot of money. But once I got going, I went hell-for-leather. I sold, I think, two or three stories the first year, and I sold a hundred twenty or so the second year.

Fandom Goes On

Richard A. Lupoff: The Futurians were revived in the late 1950s by a later generation of New York fans. I'd just got out of the Army, got married, started work at a very conventional, corporate job, but I was still interested in science fiction, and I got a postcard announcing the first meeting of the new Futurians. I was thrilled to be invited. The new Futurians had a slim connection with the old ones — Larry Shaw was a member. The others included

Ted White, Bob Silverberg, Terry Carr, Algis Budrys, Lin Carter, Dave Van Arnam, Steve Stiles, and Andy Reiss.

We'd meet every other Friday night and talk about science fiction, about politics, do a little drinking, then head for Chinatown on the subway, and have a feast around two o'clock on Saturday morning. It's amazing how many of the people in the group became professional writers or editors. Of course, some were already started on their careers. The ones who didn't become writers or editors wound up as successful cartoonists or illustrators — Stiles and Reiss.

The new Futurians must have lasted into the 1960s, maybe even longer, then split off into several other groups, the way fan groups do. Those of us who had become professionals by then, went on with our careers. The fans stayed fans.

Ted White: I think of fandom as having played a key role in my adolescent development. I was a typical reader of the era, I was a loner, an only child. I tended to be by myself a lot, introspective. Had a typical combination of inferiority and superiority complexes. I knew I was better than anyone else but I knew there were more of them than there were of me, and that sort of thing. I believe that if I had not found fandom or something comparable, that I would have gone off the deep end of being what they now call antisocial or sociopath. I would probably have, by the time I was in my mid-twenties, ended up doing something that would put me in jail for a long time. Not necessarily holding up a bank, but something destructive, who can say? I was sufficiently alienated from what was going on around me in that period, which was the early '50s, a pretty grim period of McCarthyism and whatnot, stultifying blandness in the culture. If I had not found fandom, where I found people like myself who encouraged me to be a creative person and who judged me by what I did rather than the fact that I wore glasses and looked silly, as most of my peers in school did, I would probably have become pretty embittered and pretty alienated and done something I would regret for the rest of my life. So I think fandom was real fine. Of course, the people I started hanging around with in fandom, increasingly all of us as we were "growing up" were moving in the direction of becoming SF pros one way or another. My peers were people like Harlan Ellison and Bob Silverberg — who were about two years ahead of me. Terry Carr was about one year ahead of me but actually we were contemporaries. Dick Lupoff was one of my contemporaries. All of us, each in our own way and in our own time, just inevitably became professional in the field.

Marion Zimmer Bradley: I had been reading fantasy, though I didn't know what it was called, almost all my life. When I was about eleven years old, I was crazy about the books of H. Rider Haggard, *She*, *King Solomon's Mines*. I had read the Rohmer fantasies, things like — not the Fu Manchu books, but his fantasies — *She Who Sleeps*, and I was also crazy about things

like Chambers' *The King in Yellow*. But I had never gotten into reading pulps when I was a kid because my mother thought they'd give me nightmares. So once when I was on a train trip — I'd been working all summer as a babysitter, mother's helper in the Thousand Islands — I took a train trip home and I happened to pick up a copy of a magazine called *Startling Stories*. And it had this terrific novel in it by Henry Kuttner, and I thought, Oh wow, this is fabulous. And then I turned over the back of the magazine, and they had the fanzine reviews, and they had letters from other fans, some of which were exceedingly silly in those days. And of course, I had just turned sixteen years old and I was quite young for my age. I was a very misfit sort of teenager. I liked to read, I wasn't interested in football — well, they didn't play football then like they do now. I wasn't interested in baseball or cars, or class pep rallies or basketball, or any of that crap. I couldn't have cared less for school spirit and all that nonsense. And so here I found kids who seemed, some of them, to be about my age, talking about intelligent ideas. So I wrote to the magazines, and I wrote away for fanzines, and I started writing for the fanzines, and things like that. I had a lot of fun with it.

Ted White: I was, I think, in every respect, typical. I don't think I was in any respect outstanding or unusual. I was just one of a whole lot of teenage kids who were not only turned on to science fiction but were turned on to talking about it, and by extension getting into frenetic, active correspondences with each other and putting out fan magazines with each other and just doing all the things which it never occurred to me to question their inevitability. When I was first getting fanzines in the mail, I wasn't putting one out yet but I was subscribing to them, writing letters to them, doing cartoons and drawings for them which were pretty bad: I would read things like — Marion Zimmer Bradley had a column in one fanzine, *Vega*, called "The Neo-Fan's Guide" or something like that, "Whatever the Young Fan Should Know," a regular series. She'd take one topic per issue and explain it, and maybe if I went back and reread those now, I would think how obvious, how simple, I don't know what I ever saw in them. But at the time they were exactly what I needed. They described to me the next steps I was going to go through before I got to them, and I just looked at this and saw that this was lined up in front of me, was something as inevitable as going through my adolescence I was going to go through. So that by the age of fifteen, I was putting out a fanzine of my own, and doing all of the typical adolescent running around making a jerk of myself things that kids of that age tend to do.

Marion Zimmer Bradley: There was a magazine called *Planet Stories*, and it happened to some degree too in *Startling Stories* and *Thrilling Wonder Stories*, where the editors ran fan letter columns and they had a lot of fun with the kids, and would give them nicknames. And we used to give ourselves nicknames, if nobody else gave us them. One fan used to call himself "The Hermit of the Gate" because he lived way out all by himself in South-

gate. I was something of a musician and I was thinking of the Queen of the Night, whose name was "Astrafiammante" in the opera *The Magic Flute*, so I picked the name Astra for my nickname. I published a fanzine for a while called *Astra's Tower*, and it just stuck to me for a while. I had quite a time getting rid of it in the fifties when I was in my middle twenties, sort of outgrew it. I grew up in the upstate rural wilds of New York, then I married a railroad man and I moved out to the wilds of Texas. I met my first husband through the letter column of *Planet Stories*.

Terry Carr: In 1952 I started a fanzine. It was called *Vulcan*, and its editorial page was called "Lava from the Volcano." That tells you a little bit about the general level of the magazine.

Ted White: I ran my fanzine off on a postcard mimeograph. The sheets of paper measured four inches by six inches, and the most appropriate title for a fanzine of that size I could think of was *Zip*. This was in the era of vest-pocket magazines like *Quick* and other newsstand magazines, so that in a sense is what it was modeled on.

Richard A. Lupoff: When I was a fan, there was a legend that the worst fanzine in the universe was called *Thurban* and it came out of Cleveland, Ohio. I never saw a copy. It was legendary because it was so bad, but it was also legendary because it was produced by a kid who grew up to be a pretty good science fiction writer, Roger Zelazny.

Roger Zelazny: Let me put it this way: *Thurban* would not compare with modern fanzines. I lived in Cleveland and I was a fan. In the early 1950s — 1953 to be precise — I was associate editor of it. I didn't do that much. I believe I only wrote one piece for it. I was acting in an editorial capacity at that time. The one piece was a story I had rejected from *Planet Stories* which we decided to serialize. We ran the first installment and the editor of the fanzine got drafted, so the second half of my story never appeared. Its title was "Conditional Benefit."

Terry Carr: In the mid-fifties there was hardly any fandom in San Francisco. There was a group there in the early fifties which sort of fell apart. Most of us went off to college, different colleges at the same time, and we didn't really regather until we all — or a good number of us — ended up at the University of California in the late fifties. In the mid-fifties it was just a bunch of different people in different places, writing letters to each other. It was called the Golden Gate Futurian Society, but in the mid-fifties there was no name at all.

Julie Schwartz: Though I helped start and organize the first World Science Fiction Convention in '39, I attended very few after that. But I did attend one in 1953 with my wife. I found out later that many teenagers who are now celebrities in the field were there. There was Robert Silverberg. There was Harlan Ellison. Donald Wollheim. He wasn't a teenager, he was about my age. Fred Pohl was there too.

Marion Zimmer Bradley: The conventions today in 1981 are too big. I started going to conventions when there were three or four hundred people and we all knew each other. You never get to see people you want to talk to.

I didn't get mobbed at the Boston Worldcon as I did at MidAmeriCon, but I did meet with about two hundred Darkover fans. It's nice, but I wish we were back in a state where the fans and pros were not so much separated. I think the Star Trek conventions separated celebrities on one hand and fans and groupies on the other. It's sort of irrevocably damaged the feeling that we were all just lovers of science fiction together.

Ed Earl Repp: Are you fellows science fiction fans too? Are you really? They're not the dumbest critters in the world, I can tell you that. We were called out to make a speech at a meeting of about five hundred of these people. And the questions they throw at you, and you can't answer, and I'm not a scientist. I don't think you are. They want to know how you can write that stuff. You got to research it a little bit, know what you're talking about. I got an idea for you, for either of you fellows if you want to do it. Been there on my desk.

Appendix I

Origin Stories: Reading & Writing That Crazy *Buck Rogers* Stuff

What does it take to be a writer, particularly a writer of commercial science fiction? Was it an obsession from the start, or maybe just the first story that sold? Or maybe it came after years of reading about robots and spaceships and of course, seeing that girl in the brass brassiere on the cover of a science fiction pulp magazine. Some of these reminiscences also appear in the main body of the text.

Frank K. Kelly: I began writing science fiction when I was about thirteen years old, I guess, and I gave my first story to my father's father, an old Irishman, Grandpa Mike. He gave it back to me with my first literary criticism. He said, "Francis" — that was my baptismal name, although I wanted to be known as Frank — "It's a fine story but it's got too goldarn many superfluous words." So I cut out a lot of the adjectives. Thought that was pretty good literary criticism, you know.

I was living in Kansas City, where I was born, and I attended Catholic schools. My first teachers were Catholic nuns, who taught me that an immensely powerful God who had made the stars had also made me, and this God loved to make stars and people and millions of other things, and loved everything he made, but there were perils that had to be faced. The nuns taught me that there were angels and demons around at all times, invisible warfare going on.

My favorite teacher was a beautiful nun who was not frightened by the questions I asked. She liked questions. Many teachers don't, you know. She encouraged me to write stories, and to let my mind run freely, and to leap toward the stars if I felt like leaping. And since one world has never been enough for me, I did want to travel to other planets and she assured me that I might reach the castles of heaven if I persevered. But I might have to go through a long night of the soul. I might be tested, I might be disappointed. I might have to suffer great pain. And I think these stories I wrote in my teens reflected these ideas and my own absorption in the possibilities of science.

Larry Shaw: For me it all began quite literally with that crazy *Buck Rogers* stuff. I encountered the daily *Buck Rogers* newspaper comic strip sometime in the late 1920s. I could date it exactly if I had a volume of *Buck Rogers* strips here because I remember it was at the beginning of the "Tiger Men of Mars" sequence. I just loved that kind of rocket ship — a rocket ship not a space ship — that they went to Mars in. That was the beginning.

I encountered science fiction magazines sometime in the early '30s when I saw some second-hand copies of *Astounding* and I remember that I bought my first copy off the newsstand some time in 1936. I was twelve years old then. The newsstand proprietor asked me if my mother knew I was buying this magazine. Well, she did, so I could tell him honestly, "Yes!" The first copy that I bought contained a story called "Finality Unlimited." The lead novelette by either Howard or Donald Wandrei [Donald Wandrei, September 1936 issue of *Astounding* — Ed.] was a rather confusing time-travel epic and almost floored me for a little while. I was really looking for more spaceship stories, and I really did have a hard time understanding the time travel concept. But I bounced back quickly and started buying science fiction magazines fairly regularly after that.

I was living in Schenectady, New York, which had about over a hundred thousand population. I tried to find other people who read the magazine, with very little success. Considerably later I discovered that *Astounding* had a remarkably high circulation in Schenectady because Schenectady was the home of General Electric, but they did not seem to be fan types at all. I went so far as to type little cards to insert in magazines on the newsstand, asking other readers to get in touch with me, but nothing ever came of it.

The one great discovery I made while I was still in high school was that P. Schuyler Miller lived in Schenectady too, and he worked for the Department of Education, some sort of office job. But of course I knew this man as a science fiction writer. Once, when I had the assignment of getting someone to speak to our High-Y Club, I thought of asking him. I approached him with some trepidation, asking him to speak to the club, and he did so, and somewhere along in here, he read a couple of short-short stories I had in the high school newspaper, and encouraged me to go on writing. That really set me off, obviously.

Robert Bloch: About 1933, I was sick in bed and somebody presented me with a copy of *Weird Tales*, which I'd read on and off after 1927, and there was H. P. Lovecraft. I read in the letter column about stories that had been published in previous issues. You've got to remember that in those days that there were no paperbacks, there were no hardcover anthologies during that entire decade. From 1930 to 1940 there were all of three collections of fantasy fiction published in the United States, one of them edited by Dashiell Hammett, one of them by Phil Stong — God knows why; he was the man who wrote *State Fair* — and a third one, the editor whom I forget. But there was no place where you could find this stuff. It would appear on the stands one month, then disappear forever into limbo. So I decided I would write my first fan letter and I wrote to Mr. Lovecraft care of the magazine, and asked whether he knew where it was possible to secure back issues. He wrote back to me, said: "Here is a list of all my stories that are in print, or were in print. I'd be happy to lend you tear sheets of any or all of them to read." That

was pretty heady stuff for a kid my age, that an important world-famous author living in the fabled East, rather than the Midwest, responded to my letter. I took him up on it. Along about the fourth exchange of letters, he said in effect, "Something tells me you might want to try your hand at writing some of this material yourself. If you do, I'd be very happy to read it and comment on it." Again, I was very flattered and thrilled, so I sat down, wrote a story, sent it to him, and he didn't rewrite it. He noted a couple of errors in geography because I knew nothing about New England. He corrected them. But instead of criticizing, he encouraged me, and that's what I needed. Over the next year, I wrote maybe four other stories, sent them to him. Two of them were published in fan magazines in 1934.

A. E. van Vogt: My father was an attorney. We lived for a while in the town of Morton, Manitoba when I was in my teens, and I really started to try to write a little bit there, but for the most part, when we moved to Winnipeg, which was a large city, there I really made the effort because I had no friends. I moved to a new area, and I was reading two books a day and trying to write on the side.

Howard Browne: I had read a copy of Jack Woodford's book, *Trial and Error,* and he said the easiest people to write for were the newspaper syndicates, so I sat down on a Sunday and wrote two short-shorts for *The Chicago Daily News.* I sent them out and got a call from the editor, who said he'd buy them for fifteen dollars apiece. That's thirty bucks for a Sunday's work. But then he says, "Don't write anymore for me," which is kind of a kick in the ass, so I asked, "Why not?" He said, "You write well enough for the pulp magazines, and they'll pay you better." This was in '34, or it may have been '35. I had been an avid reader of Edgar Rice Burroughs, so I thought I'd write a *Tarzan* book. But I had to prepare myself for it, so I took his books and I made lists of adjectives of his writing, as he was describing jungles, as he was describing animals, as he was describing action, and categorized them. So if I was writing and I wanted to describe a jungle, I turned to this list of adjectives. And I finished it and I sent it out to a magazine and bookseller, who gave it to a publisher. The publisher allowed me to see a copy of the reader's report. The opening of the reader's report was "Take the typewriter from this man before he hurts himself." That didn't exactly fill me with confidence.

Ed Earl Repp: When I was a youngster I loved to climb trees. There was a tall one in my backyard that was my favorite. One time I was climbing, put my weight on a dry limb that I heard crack from my weight. So I went up about thirty feet high, and when I came down, I came down headfirst with both hands. Compound fracture of the right arm. Multiple. Busted arm right here. Spent a year in the hospital. They were going to take it off. And my mother spirited me out of the hospital and took me to a specialist in Cincinnati, Ohio, and he told me, he said, "Earl, you'll never be able to do manual

labor. So you have two choices in your life. You're going to be a bookkeeper, a newspaperman, or a writer." I chose to be a writer and that's how it happened. I couldn't get in the service in the First World War. Five states I tried and I'm glad I didn't.

I became a newspaperman in Philadelphia. I covered Camp Dix and Camp Lee for draftees. Came to L.A. and *Blue Book* was having a contest, and I wrote a story for them and I won it. An African story. "Mudrush." It was a story of diamond mining. I know for a fact that sometimes they hit water and they hit the underground stream, and it will pour the mud down in the hole and the men can't hardly escape with their lives. That's what they call a mudrush. I happened to see it in the newspaper once.

I won the contest. My wife's dad got the check, it went to her place, he threw it in the wastebasket. I was expecting it. I thought I'd look in the wastebasket, and there it was. He thought some magazine was trying to get a subscription out of me. That was about 1927 or '26.

Robert Bloch: I graduated high school in June of 1934. I was faced with a choice. There were no jobs. This was the depth of the Depression. Everything was exactly the antithesis of what it is today. Young people were put down, older people were very much in control. What few jobs there were would be given to somebody who had a family to support and needed that fifteen or eighteen or twenty dollars a week. You couldn't get a job without experience. You couldn't get experience without a job. It was a Catch-22 situation. So there was one alternative. They had something called the Civilian Conservation Corps, the CCC, which had been set up for young men. In Wisconsin, they were sent up north to a work camp, pretty near a labor camp, to build dams, roads, bridges, all sorts of construction work. There was no union clout in those days. You would live in one of these camps, and get up at six in the morning, work until six at night, seven days a week. You'd be paid thirty dollars a month. Well, that was pretty attractive, thirty dollars a month. That was a princely sum. Then I learned they sent fifteen dollars home to your parents, so I decided no. I had a choice: work or starve. I decided to combine both by becoming a writer. So I sat down, I got myself a secondhand typewriter that cost ten dollars, put it on a one-dollar secondhand card table, bought some paper and carbon paper at the dime store, and thumped out stories, learning to type as I did so. And six weeks after I graduated from high school, I sold my first story to *Weird Tales*, the very magazine in which Lovecraft appeared. Of course, from then on, my doom was sealed. I didn't know enough to quit. That first year I wrote four stories, and I earned a hundred dollars. Second year I did even better.

Hugh B. Cave: I had a brother four years older than I who later became known in the pulps as Geoffrey Vace.[67] His name was Geoff Cave and he was editor of his high school paper. I always envied the stories that he wrote for his paper. So when I got into high school in Brookline, Massachusetts, I started writing for the high school paper there, the *Sagamore*, and they published the stories that I wrote. And I thought I might try to sell some stuff outside. I didn't sell to the high school paper, of course, but I thought I might try to sell something. And the only other thing I knew anything about were these little Sunday school papers that were put out by the Cook Company, I think it was. I remember writing a long short story for them, and mailing it to them, and getting a letter of acceptance back. The editor said, "We like your story and we'll run it as a serial because it's too long for our little magazines, and when you send the next one would you kindly double-space it?" That got me going, and then from there I tried the various pulp magazines. I remember trying *Action Stories*, and *Jungle Stories,* I think was one. Some of them began to sell and finally a lot of them began to sell.

A. E. van Vogt: I read two books on writing, one of them called *The Only Two Ways to Write a Story* and the other one *Narrative Technique*. And those two were my bibles as to how to write a story, and I learned how to do that, and I tried to tell other people but they'd misunderstand me and never seemed to hear that when I talked about my 800-word scene, it wasn't mine, it came from *The Only Two Ways to Write a Story*. The book breaks down twenty stories written in *The Saturday Evening Post, Collier's, Cosmopolitan* of that period of time, by famous writers of the period, and finds their cycles, the 800-word scene automatically, it was there by the intuition of the writer who was writing without ever knowing what this was.

At that time, during the Depression, the Macfadden Publications, publishers of *True Story* magazine and *True Romance* and various things like that, had huge contests — at least they seemed huge at the time. They offered prizes of five thousand dollars for first prize and so on, for the best true story. I wrote a number of stories for these people. I don't really remember how many anymore, and it was quite a few. And I won one of their first prizes, with a story that I called, "My Mother Ran Our Family," and they called "The Miracle in My Life." You can see right away, but the point is that in writing confession stories, I observed this in them: that every sentence has an emotion in it. You never say in a confession story, "I lived at 324 Brant Street." That's a dead sentence, emotion-wise. You say, "Tears came to my eyes as I thought of my little room at 324 Brant Street." Every sentence has to have emotion in it.

67 Three of the Geoff Cave/Geoffrey Vace stories were collected in *The Death Head's March and Others*, from Black Dog Books. Geoff gave up writing to be an accountant, but Hugh continued to use the pseudonym in the hope that his brother would return to writing.

Are the five steps in it? Hidden, you know, hidden. The five steps are: Where's this taking place? What is the scene's purpose? What does the person have to accomplish in this scene — what is the action in the accomplishing of it? And then step four, Did he or did he not accomplish — you have to make it clear, either he did or did not, see, in some way. Maybe it only takes a sentence, but it has to be in there. Otherwise the story fails a little bit. And the fifth step is, in all the early scenes, you have to sort of make clear that things are going to get worse. Then, where is all this taking place? Now you do this subjectively in the best stories, you know, from the viewpoint of the main character.

So that's my confessions magazines story. I wrote a whole bunch of those stories, then one day I was in the middle of one, and I thought: What am I doing this for? And also I wrote a large number of radio plays for ten dollars apiece. That proved to be, you know, write fifty of those and you get five hundred dollars and after a while it sinks in that this is not the way to make a living.

Basil Wells: For two years after I graduated from high school, I worked at all sorts of odd jobs. This was during the Depression. I graduated in 1929, which was a beautiful year to graduate, and so I worked for two years at odd jobs and saved enough money to go one year to college. That was it. That's all I managed.

My father ran a gristmill, and I went and worked for him for about two years. And then I borrowed some money and I started a mill of my own, about seven miles to the west, over near the Ohio line. And I ran that for, I think it was three years. But I kept reading all that time, and I would keep writing along a little bit, here and there.

The way I came to get into writing more steadily was, I sold the gristmill and I bought into a service station, a gas station, and I was going to make a fortune out of that. Well, there came a price war, and one year it finished me out. I was bankrupt, I was broke. I was married, I had two kids, and I just didn't have anything. So I had to get a job in the factory over in Meadville, working, making zippers. And I worked three months and I just got money enough to buy a new set of tires to my Model A coupe, and I was laid off for a year. So I borrowed my mother's typewriter and when I couldn't find any work, I started writing stories. I sent one off to *The Saturday Evening Post*, and one off to *Collier's*, I believe it was. Which, of course, was the dumbest thing I could do. And then I sent one off to *Super Science*, and the editor there, Fred Pohl, took it. That was "Rebirth of Man." That was the first sale.

Stuart J. Byrne: My first sale was 1935, I was nineteen. I sold it to *Amazing Stories*. I was living in Los Angeles and was just an average reader of the science fiction pulps in those days. I guess I happened to ring a bell with the editor, T. O'Conor Sloane. It was just a little three-page story, a personal sacrifice to save a large passenger ship. I used to be fascinated by the stories of

space ships that became great passenger ships for people to travel among the stars, and this one was trapped by the sun's gravitation and just needed a little push-pull, according to Newton's laws of physics. A passenger offered himself to give the push. "Music of the Spheres" it was called, and that's what he heard when he went out there.

I was a young man going to college, planning to get married and then did get married, had a couple children. Working your way through college and graduate school, and working all night as a janitor and going out to school in the daytime, keeping awake during classes with coffee, and trying to maintain a B+ average for graduate school is a little tough. So I didn't have much time for writing. It was 1947 before my next one came out, which happened to be a cover story.

Philip Klass: I'd read science fiction as a kid, but I'd stopped reading it. Then I went into the army. The war ended. I knew I was enormously talented, and I was going to give the world the benefit of that talent. I was going to make a million dollars out of writing, and I wrote love stories, detective stories, all these things were active in the pulps. I wrote anything that was commercial, and the first thing that sold was a science fiction story called "Alexander the Bait." I remembered I'd liked science fiction. I'd stopped reading it for years. I wrote it because I met Ted Sturgeon. It intrigued me. He sold some science fiction. I wrote it because it seemed like one of the forms to write in, and as far as I was concerned, I was above all this stuff. They were all commercial. But when I wrote it, something happened, and that is perhaps crucial because it appeared in a magazine, in the May 1946 issue of *Astounding*, and I was very pleased to have sold a piece. But I knew that I'd been writing a piece for a commercial market. It appeared in the magazine, and damn it all, it was not the best story in the magazine, not by a long shot, there were several stories better. Some nonentity by the name of Arthur C. Clarke had published his first story in the same issue. It's called "Rescue Party." I was very deeply hurt when I read it, and I felt my story was a stinker.

E. Hoffmann Price: I'd always wanted, since I was a beardless boy of about, oh I don't know, twelve, I was going to be an adventure story writer like Captain J. Cutcliffe Hyne,[68] H. Bedford-Jones, J. Allan Dunn. So I had a card engraved, E. Hoffmann Price. It wasn't until ten years later that I wrote two stories, sent them in, and sold both. However, I did not resign from Union Carbide, and I'm fucking lucky I didn't. I didn't sell another thing, mind you, for many a month. I was learning. *Spicy Adventure Stories* was one of the most useful pulps. It was pure horseshit, I grant, but it was a good market and it was an opportunity to learn how to write. I researched every *Spicy Adventure* as though I was slanting it at *Adventure* magazine or at

68 C. J. Cutcliffe Hyne was the name, though he wrote about a character named Captain Kettle, as noted in the main text.

Short Stories. I busted my ass to do a good, honest, sincere, well-researched thing for a bunch of meat beaters who wouldn't know the difference anyhow. But I would know the difference.

Hugh B. Cave: My English teacher, her name was Selena Lewis. She was for me all the way. She thought that I could write fairly well and encouraged me to keep on trying to sell to various publications. And then, by golly, when the stuff appeared in print in these publications, she would correct it for me.

Algis Budrys: I was a bright kid. There's no sense in hiding the fact that I voluntarily applied for a membership in Mensa a few years ago and made it, so I must have been a bright kid. I was interested in thousands of things. Through circumstances I was living in a very small chicken farming community full of upright folk in southern New Jersey, and they were interested in maybe ten or twenty things. I discovered pulp magazines through the offices of a very nice lady who ran the general store and post office, and slipped me this time bomb full of pulp magazines. One thing pulp magazines were was a medium that was interested in ten or twenty thousand things, and getting into science fiction — for which I already had an affinity — but getting into pulp magazines in science fiction saved my bacon. I would have turned into some kind of vastly antisocial creature that would have had to be caged up and destroyed. I'm not kidding. My very first credits in the field are lost to history. They're filler stories in comic books. They're the little two-pagers that nobody ever read but they were required by postal regulations. Shortly after I started doing those, I began selling science fiction short stories to what were then the top magazine markets, *Astounding Science Fiction*, edited by the legendary John W. Campbell, Jr., *Galaxy*, edited by the legendary H. L. Gold, and *Space Science Fiction*, edited by the legendary Lester del Rey.

Frank Kelly Freas: I had been reading science fiction since I started reading. I had first been exposed to fantasy with a little book called *The Brownies and the Goblins Visit Mars* and that hung me up on Mars. The next step was *Buck Rogers*, and from there to the old *Argosy* magazine which my uncle subscribed to but would not let me borrow, so I had to go sit in his kitchen and read the magazines after school. There was Edgar Rice Burroughs, of course, and A. Merritt. Otis Adelbert Kline. Lord Dunsany. All of the old-line writers from *Weird Tales* and *Yellow Book*. It fascinated me, and immediately, I started drawing illustrations for the stories and copying things out of *Buck Rogers* and selling them to my classmates for a penny or a nickel apiece, depending on what they were worth. That was in Canada, Crystal Beach, Ontario. I grew up in Canada and was educated there until 1939, when I came to the States.

Raymond Z. Gallun: I don't know how many times when I was a little kid I read Burroughs' John Carter of Mars stories over and over again. Edgar Rice Burroughs was not what we would call a very hard science fic-

tion writer at all, but he had something going for him. He knew how to keep a story moving. There were things I couldn't figure out. John Carter mates with a woman who lays eggs and still has a child. A lot of people wonder about that. A lot of little things didn't pan out, even the way he divided up the hours, xats or whatever they were called for seconds,[69] that didn't work out right mathematically. Still, I was enchanted by his stuff, and that's where I really got interested in science fiction like a lot of other people did too, through Edgar Rice Burroughs.

Frank M. Robinson: We lived in a suburb of Chicago called Forest Park. Like any young kid, I'd gone to the library and read H. G. Wells, Jules Verne. When I was about thirteen, my brother, who was three years older than me, was reading a lot of sports stories pulps, and he would give me money and send me to the little secondhand magazine store and say, "Bring me back something I haven't read." And I would do that because I remembered the covers of what he had read. One time early in 1939, he said, "Well, I think I've read everything. Pick up anything you think I might like." So I went to the store and rummaged through the bins and stumbled across *Astounding Science Fiction*. There was a Clifford Simak story in it, and something about Mars on the cover, a guy staggering away from a space ship. I brought it back to my brother, knowing that I'd get a chance to read it afterward. He punched me once or twice because he had no interest in science fiction whatsoever and I wasted his quarter. So I read them, and I was promptly hooked.

Later, when I was an undergraduate in college, around twenty-two years old, I tried to enroll in a course on article writing. I really wanted fiction writing but I was too afraid to go directly into it for fear I'd find out I couldn't write. Well, the article-writing course was full up and I had to go into the fiction writing course. One time when the professor was away, the substitute professor, a grad student, said, "I want everybody here to write a horror story." He picked out the best ones to be read aloud in class, and they read mine, and suddenly I noticed something. Everybody in class was all wound up in the story. They were listening intently. I'd captured them. That got to me in a very big way. I decided right then and there I'd be a writer.

I was in the same writing class when I wrote a story for John Campbell at *Astounding* called "The Maze." Sent it off, and it came back with Campbell's statement, "Well, I'm overstocked on this length." I showed my writing professor. He said, "Take a couple of thousand words out of it and submit it again." So I took a couple of thousand words out and sent it back, and John bought it. I immediately told everybody I knew, including all my brothers in the fraternity, and the months went by and the fucking story never came out. The story came out in the June 1950 issue of *Astounding*, two weeks before I graduated, and I bought all the copies.

69 See main text. Xats are minutes.

Ray Bradbury: I think the first science fiction story I read was around 1928, in *Amazing Stories*. "The World of the Giant Ants," I think it was called, by A. Hyatt Verrill. Now there's a name. That's an author's name. It has status and class to it. And it had illustrations by Frank R. Paul, who did all the covers and interior illustrations of *Amazing Stories* in those days. I couldn't afford the magazine. It came into the house, my grandmother's boarding house, with one of the boarders. And it cost twenty-five cents. Who had twenty-five cents in 1928? But it was instant love, and I still have that copy put away somewhere in the basement. I've saved everything from the time I was three years old. I'm Mad Miss Manton when it comes to my great loves.

The first story I wrote was the sequel to *The Gods of Mars* by Edgar Rice Burroughs. I was twelve years old and I couldn't afford to buy any of his books. Twice a year I got one of his books for Christmas and my birthday. They were seventy-five cents apiece. My dad was out of work for years and we traveled to Arizona, and we finally came to L.A., but we had no money. So I wrote the sequel instead of buying it. It's lost somewhere, but a lot of other stuff I did when I was twelve is still around. It's all lousy, like everything I wrote for ten years.

I wrote every day of my life. In high school, I went without lunch in order to go to the typing room. I had a deal with the teacher. She let me sit in the empty typing room and use one of the typewriters, and write my terrible stories. I didn't have a typewriter until my last year in high school. I bought one for about twelve bucks, as I recall, and it took me twelve weeks to pay it off, a dollar a week. So everything before that was done on a toy dial typewriter, one of those things where it takes half an hour to do six words. So all that early stuff, though, and everything in high school — I have a lot of high school stories put away, and they're dreadful. Dreadful. Someone recently asked me, "How did you keep going, in the midst of being so bad?" I said, "Well, if you're in love, you don't notice how bad you are. It's like your first love affair. You're in love with her, and you get over thinking about you because if she thinks you're okay, you must be." So it is with writing short stories. You love the field, you hyperventilate about it all the time.

Robert Sheckley: I was planning to be a writer from the earliest time I could remember, certainly from the age of six or seven or so. I just really knew it was the only thing I was after. I lived in a town called Maplewood in New Jersey, about thirty-five miles out of New York City, a commuter town, very much small-town American-apple-pie life, I would say. My father went to work every day. He took a train into the Wall Street district. I read endlessly. I was reading throughout my early teens in two different ways. I was reading many classics and I was also reading every word of science fiction I could lay my hands on. I'll include fantasy in that also, because one of my very first loves was a magazine called *Famous Fantastic Mysteries*. I remember reading A. Merritt probably in *Famous Fantastic Mysteries*, books like

The Ship of Ishtar, John Taine's work. This single magazine, in a sense for me, was the opening to worlds of wonder, and I knew at a very early age that what I wanted to do was to create worlds of wonder like those which had been crafted for me. This starts in the late thirties, and high school for me was in the forties. When I started reading *Famous Fantastic Mysteries*, at the age of eight or nine, I probably was not aware these were reprints. I would say that by early teens, I knew that this was older work and I differentiated from this and the science fiction magazines of that time, such as *Astounding*, *Thrilling Wonder Stories*, *Startling Stories*, *Planet Stories*. These were the work that was being done now. There was still *Unknown Worlds*, and I would have loved to have written for *Unknown Worlds*. I felt that we would have made a fine marriage. But they collapsed, they went out of business before I went into business.

Robert Silverberg: I was attracted to reading science fiction through my childhood scientific interests. I wanted to know more about dinosaurs and the far future and the far galaxies. And, wow, suddenly I discovered that people like H. G. Wells and John Taine had written novels about this. So I went through the library, reading the hardcover stuff, such as it was, and finding in the library Wollheim's *Pocket Book of Science-Fiction*, and discovering from the copyright lines that there was such a thing as science fiction magazines. I went and looked for them, and they seemed quite vulgar. Tawdry, to my very austere young self. They had names like *Amazing Stories* and *Thrilling Wonder Stories*. I wasn't going to read that. But somehow, I think it was about January '48, so I was just about thirteen, somebody brought a copy of *Weird Tales* to school. And *Weird Tales*, for some reason, looked more respectable to me. So I read an issue of *Weird Tales* and then said, What the heck, let's try this *Amazing* stuff, and a few months later read *Amazing*. Well, you know, you get hooked, and I was that.

The first story I wrote, which was a collaboration with a classmate of mine who is still a good friend, early 1949, was a terrible, terrible story. But what the hell, I was a kid. And I went right on writing until suddenly — what seemed like centuries later, but was only about four years, I started getting published.

Harlan Ellison: I taught myself to read when I was about four years old, and I read virtually everything in the Painesville, Ohio library. It was a very small town, about thirty miles northeast of Cleveland. I had almost no one to play with, and since we were the only Jewish family in the town at the time — there was a lot of anti-Semitism — I was fairly well cut off from any kind of social congress. My escape was into pulp magazines, comic books, radio, and movies.

The first example of science fiction that I recall encountering was a pulp magazine, an issue of *Startling Stories* with a story by Jack Williamson called "Twelve Hours to Live!" Jack had taken "The Lady, or the Tiger?" by

Frank Stockton, and he had redone it as a science fiction story back in the '30s and it had been reprinted in the early '40s as a Hall of Fame classic in *Startling Stories*, and I somehow or other bought that pulp magazine and read it. But I didn't know it was science fiction and I didn't know the term *science fiction*.

I came to the actual knowing of science fiction, the term "science fiction," from two sources. When my father died in '49, my mother and I moved to Cleveland. I was at Cleveland Heights High, and I was in the library and I saw a book, an anthology, that interested me, and it was August Derleth's *The Other Side of the Moon*, and it contained Ray Bradbury's "Pillar of Fire" and Nelson S. Bond's "Conquerors' Isle" and an amazing group of wonderful stories. That was *The Golden Age of Science Fiction* anthology right around that time. It fascinated me to the extent that I stole the book from the library. I still have it to this day.

Shortly thereafter, when going to get my teeth fixed at my uncle's — because as we all know, if there's a doctor or a dentist in a Jewish family, all the relatives get taken care of for nothing but they have to wait until the end of the day after the paying customers are done — so after I'd been through a whole day of school, I had to sit for two or three hours in the office waiting to get my teeth fixed and I'd always buy a magazine. I read mostly sports magazines, but I'd read all the sports magazines on the newsstand and I found myself staring at all the rest of the magazines on the rack to see if there was something that interested me. And all of a sudden I'm looking at an issue of *Thrilling Wonder Stories* [actually *Startling Stories*] and it was an Earle Bergey cover of Grag, Captain Future's robot, with Captain Future's girlfriend Joan in one arm, firing light bolts of energy out of the other hand. And I looked at this thing and said, "Holy shit, what is this? Mamma mia!" And I bought it and it was an issue that had A. E. van Vogt's "The Shadow Men" in it, and "The Return of Captain Future" by Edmond Hamilton. And I was hooked. I thought it was wonderful stuff, and I liked it, and I understood it. And that was 1950, and by 1955, I was a selling professional.

Ursula K. Le Guin: I read a little science fiction as a kid, when I was ten or twelve or thirteen. My brother and I had a phase of reading what was then *Astounding* in the big format, with Kuttner and people like that writing for it, so very good stuff was coming out then. And then I really wasn't reading science fiction for a long time. I was going to college, and I missed the whole Heinlein glory days. I had a friend who put me on to Cordwainer Smith along in '56 or '57, I suppose, and Ted Sturgeon, and I said, "Hey, this is different from what it used to be. This is a lot of fun." And Cordwainer Smith, particularly. "Wow. Look what this guy can do." My friend Mac was subscribing to the magazines, and then he'd pass them on to me. *Amazing, Fantastic, Galaxy, F&SF* is what we were passing around in those days.

I guess I was sending out stories and novels for seven or eight years before I placed anything, any fiction, commercially. I could place poetry. If you just hang in there and keep sending your poems to poetry magazines, you can get published because poetry magazines always need poetry.

I wrote quite a lot of mainstream, or realistic, fiction, then. But often there was something slightly quirky about it. I finally broke into publishing fiction with two stories. One went to a literary magazine. It's a perfectly realistic story but it's set in an imaginary Central European country, so there was often a little oddness about my stories which I think frightened the market. The same week, I had a story accepted to *Amazing Stories*.

Roger Zelazny: In the late '40s and early '50s. I did write a great number of stories which I submitted all the way around to everything on the stands, but at that time didn't sell any. I was still a school kid. Ray Palmer [editor of *Amazing Stories* and later *Other Worlds* – *Ed.*] once scrawled a nice sentence on one of them, and someone else did too. I forget now whether it was Fletcher Pratt or Harry Harrison. Between the ages twelve and sixteen, I must have sent off a couple of hundred stories, none of which sold. After a point when a story had been around and exhausted all possible markets, it seemed a shame to just keep it, so I turned them all into scratch paper. My first sale was in March of '62. My first appearance was in the April 1963 issues of both *Amazing* and *Fantastic*.

Ted White: I started reading science fiction essentially with Heinlein's *Rocket Ship Galileo* in the year that it was published, which was '46, '47, somewhere in there. As soon as I read it, I knew that this was for me. It was like recognizing something familiar that you've never seen before, but recognizing that this is something you want to see a great deal more of in the future. From that point on, I scoured the libraries and read all the science fiction I could find. By the time I was thirteen, I had discovered what was then a very burgeoning market of science fiction magazines, many of which had not only twenty pages in small type in the back publishing letters from readers, but also published those esoteric little columns called fan magazine reviews. As a direct consequence of reading all this stuff, I was turned on to the next inner circle or whatever, as you move towards the ultimate pinnacle of science fiction, which is writing it, which is becoming a fan of it.

My first professional sale, literally my first professional sale, was a convention report for Hans Stefan Santesson, the editor of *Fantastic Universe* magazine. He wanted a review of the World Science Fiction Convention of 1959, and I did a thousand words or something for him. I believe it was published and I believe I got maybe half a cent or a cent a word. But my first impressive professional sale was to *Playboy*, and that was my second sale. It sounds real good if I tell you that I made fifty cents a word. It sounds less good if I tell you I got a hundred dollars. That was for one of their little *Playboy* "After-Hours pieces. I'd been to the apartment of somebody in New York

who was a professional — I had moved to New York in 1959 — and they had shown me a flyer that they had gotten from Ray Russell at *Playboy* requesting submissions for this new feature they were starting up. Algis Budrys had told me a real good story about himself, and I said, "Do you mind if I write this up and submit it to *Playboy*?" He said, "No, go right ahead." And I did, and I got a check back from them, but they never published it. I later asked Ray who, irony of ironies, later sold stories to me, what happened. I was looking forward to seeing it in print even though it wouldn't have my name on it or anything. He said that somebody higher up had killed it. So my first big sale to *Playboy* never even made it into print. I cashed the check, and that was fun.

Margaret Atwood: I was born in 1939, so some of these pulp magazines were still lurking around in granddaddy's attic. Of course, I was not allowed to purchase such. But it was the age of comic books, and a lot of the very same motifs got into the comic books, and then they got into stuff like *Star Trek* and before that, they were in things like H. G. Wells' collected works or Jules Verne or in Rider Haggard, who was big on the two-thousand-year-old woman motif. The motifs have been around for a while, and the pulps basically raided them. Change the clothes and it's science fiction fantasy adventure. But we're still talking about people who can fly.

Appendix II

List of Interviews

FORREST J. ACKERMAN, recorded in Mission Hills, California, March 26, 2000.
Interviewer: Richard A. Lupoff

POUL ANDERSON, recorded at KPFA in Berkeley, June 10, 1978.
Interviewer: Lawrence Davidson

ISAAC ASIMOV, recorded at Murder Ink bookstore in New York City, August 10, 1983.
Interviewer: Richard Wolinsky

MARGARET ATWOOD, recorded at KPFA in Berkeley, September 14, 2000.
Interviewers: Richard Wolinsky/Richard A. Lupoff

IAN BALLANTINE, recorded in San Francisco, November 1984.
Interviewer: Richard A. Lupoff

HARRY BATES, recorded at his home in New York City, late 1970s.
Interviewer: Lawrence Davidson

ROBERT BLOCH, recorded in front of an audience at FoolCon 5, April 2, 1982.
Interviewer: Richard A. Lupoff

RAY BRADBURY, recorded at his home in Los Angeles, February 7, 1992.
Interviewers: Richard Wolinsky/Richard A. Lupoff

MARION ZIMMER BRADLEY, recorded at her home in Berkeley, September 8, 1980.
Interviewer: Richard Wolinsky

HOWARD BROWNE, recorded in the early 1980s.
Interviewers: Richard A. Lupoff/Lawrence Davidson

ALGIS BUDRYS, recorded in Sacramento, California, July 6, 1985.
Interviewer: Richard A. Lupoff

STUART J. BYRNE, recorded in Mission Hills, California, March 26, 2000.
Interviewer: Richard A. Lupoff

TERRY CARR, recorded in Oakland, California, early 1980s.
Interviewers: Lawrence Davidson/Richard Wolinsky

HUGH B. CAVE, recorded on Whidbey Island, Washington, June 23, 1989.
Interviewer: Lawrence Davidson

STANTON A. COBLENTZ, recorded in Monterey, California, July 7, 1978.
Interviewers: Richard A. Lupoff/Lawrence Davidson

ALFRED COPPEL, recorded at his home, May 4, 1983.
Interviewer: Richard A. Lupoff

L. SPRAGUE DE CAMP, recorded in San Francisco, Spring 1984.
Interviewer: Richard Wolinsky

PHILIP K. DICK, recorded in Sonoma County, February 27, 1977.
 Interviewer: Richard A. Lupoff
HARLAN ELLISON, phone conversation recorded October 2, 2000.
 Interviewer: Richard Wolinsky
FRANK KELLY FREAS, recorded at Westercon, July 5, 1987.
 Interviewer: Richard A. Lupoff
RAYMOND Z. GALLUN, recorded on Long Island, New York, 1981.
 Interviewer: Lawrence Davidson
WILLIAM CAMPBELL GAULT, recorded in Santa Barbara, November 2, 1984.
 Interviewer: Richard A. Lupoff
HORACE L. GOLD, recorded in Los Angeles, August 6, 1983.
 Interviewer: Richard A. Lupoff
HARRY HARRISON, recorded at KPFA in Berkeley, 1984.
 Interviewers: Richard Wolinsky/Richard A. Lupoff
FRANK HERBERT, recorded in San Francisco, 1981.
 Interviewers: Richard Wolinsky/Lawrence Davidson
CHARLES D. HORNIG, recorded in San Jose, November 26, 1978.
 Interviewers: Richard A. Lupoff/Lawrence Davidson
W. RYERSON JOHNSON, recorded in Sonoma County, April 29, 1989.
 Interviewers: Richard Wolinsky/Lawrence Davidson/Richard A. Lupoff/
Bill Pronzini
FRANK K. KELLY, recorded in Santa Barbara, August 12, 1979.
 Interviewers: Richard A. Lupoff/Lawrence Davidson
PHILIP KLASS, recorded in San Francisco, October 30, 1980.
 Interviewers: Richard A. Lupoff/Richard Wolinsky
DAMON KNIGHT, recorded in San Francisco, July 3, 1983.
 Interviewers: Richard Wolinsky/Richard A. Lupoff
LOUIS L'AMOUR, recorded in San Francisco, 1986.
 Interviewers: Richard A. Lupoff/Lawrence Davidson/Richard Wolinsky
URSULA K. LE GUIN, recorded at KPFA in Berkeley, September 20, 2000.
 Interviewers: Richard A. Lupoff/Richard Wolinsky
FRITZ LEIBER 1, recorded in San Francisco, approx. 1980.
 Interviewers: Richard Wolinsky/Lawrence Davidson
FRITZ LEIBER 2, recorded in San Francisco, June 10, 1977.
 Interviewer: Richard A. Lupoff
FRANK BELKNAP LONG 1, recorded in New York City, March 1, 1980.
 Interviewer: Richard Wolinsky
FRANK BELKNAP LONG 2, recorded in New York City, date unknown.
 Interviewer: Richard A. Lupoff
ANNE McCAFFREY, recorded at KPFA in Berkeley, June 29, 1992.
 Interviewers: Richard Wolinsky/Richard A. Lupoff
ANNETTE McCOMAS, interviewed with Phyllis White in Berkeley, 1982.

Interviewers: Richard Wolinsky/Lawrence Davidson
WILLIAM F. NOLAN, recorded in San Francisco, May 8, 1994.
Interviewers: Richard Wolinsky/Richard A. Lupoff
JOYCE CAROL OATES, recorded at KPFA in Berkeley, May 4, 2000.
Interviewers: Richard Wolinsky/Richard A. Lupoff
FREDERIK POHL, recorded in San Francisco, September 8, 1978.
Interviewers: Richard Wolinsky/Lawrence Davidson/Richard A. Lupoff
E. HOFFMANN PRICE, recorded at his home with WANDA PRICE, late '70s.
Interviewers: Richard A. Lupoff/Lawrence Davidson/Richard Wolinsky
ED EARL REPP, recorded in Paradise, California, November 29, 1978.
Interviewers: Richard A. Lupoff/Lawrence Davidson
JANE ROBERTS, recorded in Elmira, April 1977 & recorded by phone, October 1977.
Interviewer: Lawrence Davidson
FRANK M. ROBINSON, recorded at his home in San Francisco, March 9, 2000.
Interviewers: Richard Wolinsky/Richard A. Lupoff
ALVA ROGERS, recorded in San Francisco, approx. 1980.
Interviewers: Richard Wolinsky/Lawrence Davidson
THEODORE ROSCOE, recorded in Sarasota, Florida, June 20, 1989.
Interviewer: Richard A. Lupoff
JULIE SCHWARTZ, recorded in San Francisco, January 30, 1987.
Interviewers: Richard Wolinsky/Richard A. Lupoff
LARRY SHAW, recorded August 6, 1983.
Interviewer: Richard A. Lupoff
ROBERT SHECKLEY, recorded in Berkeley, April 29, 1982.
Interviewer: Richard A. Lupoff
ROBERT SILVERBERG, phone conversation, recorded September 14, 2000.
Interviewer: Richard Wolinsky
THEODORE STURGEON, recorded in Orinda, California, 1983.
Interviewers: Richard A. Lupoff/Richard Wolinsky/Lawrence Davidson
WALTER TEVIS, recorded in Berkeley, 1981.
Interviewers: Richard A. Lupoff/Richard Wolinsky/Lawrence Davidson
RICHARD TOOKER, recorded in Phoenix, Arizona, May 2, 1987.
Interviewer: Richard A. Lupoff
A. E. VAN VOGT, recorded in San Francisco, February 23, 1980.
Interviewers: Richard A. Lupoff/Lawrence Davidson
KURT VONNEGUT, recorded at KPFA in Berkeley, September 23, 1991.
Interviewers: Richard Wolinsky/Richard A. Lupoff
BASIL WELLS, recorded July 23, 1990.
Interviewer: Richard A. Lupoff/Audrey Parente
PHYLLIS WHITE, interviewed with Annette McComas, Berkeley, 1982.
Interviewers: Richard Wolinsky/Lawrence Davidson

TED WHITE, recorded in Berkeley, July 7, 1981.

Interviewer: Richard A. Lupoff

JACK WILLIAMSON, recorded at Lake Tahoe, June 24, 1979.

Interviewers: Lawrence Davidson/Richard A. Lupoff

ROGER ZELAZNY, recorded at Dark Carnival Bookstore, Berkeley, October 5, 1979.

Interviewers: Richard Wolinsky/Lawrence Davidson/Richard A. Lupoff

About Richard Wolinsky

Richard Wolinsky cohosted and produced *Probabilities*, a half-hour program devoted to science fiction, mystery, and mainstream fiction. The show ran from 1977 through 1995, and then continued until 2002 as part of a weekday series, *Cover to Cover*. At that time, Richard took the program solo and renamed it *Bookwaves*. Along the way, he has spoken with most of the English-speaking world's leading authors, including Peter Carey, Joseph Heller, Richard Powers, Margaret Atwood, Anne Rice, Gore Vidal, James Ellroy, Joyce Carol Oates, Norman Mailer, Salman Rushdie, E. L. Doctorow, and many others. In recent years, in a companion program, *Artwaves*, and later in the hour-long *Bookwaves Artwaves* program, he's also interviewed playwrights, directors and actors in theatre and film. The half-hour *Bookwaves* is now syndicated through Pacifica Audioport and can be heard on several stations across the country. Bookwaves Artwaves is also a podcast, along with *Radio Wolinsky* (extended interviews and features) and *Bay Area Theater* (featuring theatre reviews heard on KPFA), which can be found at kpfa.org and via iTunes.

Lillian Ross of *The New Yorker* called her interview "the best I've ever experienced that sounded interesting to me and that sounded true to me." Richard Powers called Wolinsky "a great interviewer" and Jeffrey Eugenides said his discussion was "a great interview."

Richard Wolinsky's interviews have been published in numerous venues, including the *San Francisco Bay Guardian, Heavy Metal, Mystery Scene, Guernica, Feast of Fear: Conversations with Stephen King, The Louis L'Amour Companion*, and *Stephen King & Clive Barker: Masters of the Macabre II*.

During the 1980s, Wolinsky's programs on the American musical theatre won accolades in the local Bay Area press. His documentary on the life of Leonard Bernstein was honored with an award from the National Federation of Community Broadcasters. In 1998, he served as Associate Producer for a segment on the Broadway musical that appeared on CNN's *Entertainment Weekly* and *Fortune* magazine programs.

Born and raised in New York City with a BA (Philosophy) from SUNY Binghamton and an MA (Philosophy) from the New School for Social Research, NYC, Richard moved to the Bay Area in 1975 and began volunteering at KPFA in May, 1976.

From November 1978 through September 1992, Richard Wolinsky was editor and chief writer of the KPFA-FM (Berkeley) publication *Folio*, the flagship program guide of the Pacifica radio network. Since that time, he has served as freelance commercial copywriter, marketing consultant, website coordinator and copywriter, and election booklet specialist. This is his first book.

About Lawrence Davidson

Lawrence Davidson was the science fiction and mystery buyer at Cody's Books in Berkeley. He was the founding host of Probabilities, a science fiction radio program on KPFA-FM and the co-author of Pulp Culture: The Art of Fiction Magazines (1998, with Frank M. Robinson).

Davidson began hosting *Probabilities* in 1977. The guests on that first program were Richard A. Lupoff and Michael Kurland. Richard Wolinsky was at the board. By the second show, an interview with science fiction writers Chelsea Quinn Yarbro and Marta Randall, Richard had joined Lawrence on the mic, and *Probabilities* was born.

Within a few months, Richard A. Lupoff had joined the team, and the three co-interviewers, singly, in pairs, and as a threesome, interviewed most of the major science fiction writers of the day, including Ray Bradbury, Isaac Asimov, Frederik Pohl, A. E. van Vogt, Joan Vinge, Marion Zimmer Bradley, and many others. An interest in old pulp magazines prompted Lupoff and Davidson to get competitive: who could find the most obscure (or formerly famous) science fiction pulp writer still alive. Among their discoveries were writers Stanton A. Coblentz, Ed Earl Repp, and Frank K. Kelly, and editors Charles D. Hornig and Harry Bates. The interview that Lawrence conducted solo with Bates, an early editor of *Astounding Stories* and the author of the original story which became *The Day The Earth Stood Still*, was the only extant recording of Bates' voice, talking about writing and editing in the 1920s and 1930s. Portions can be heard on the Blu-ray disc of the 1951 film in a brief documentary in the Extras section, titled *The Astounding Harry Bates*.

As time went on, interests changed. The program enlarged to include all genre fiction, with Lawrence specializing in western fiction, including interviews with Louis L'Amour and a handful of writers only western fans would recognize. Lawrence retired from the program in 1989.

Born in New York City in 1949, Lawrence spent most of his adult life working in bookstores, first in New York and later in Berkeley, coming to Cody's in 1976. He continued working at Cody's Books until the store folded in 2008, at which point he retired. His later years were devoted to teaching the work of Jane Roberts, a former science fiction writer who was the first "channeler" in the New Age boom of the final quarter of the twentieth century. He died in 2016.

About Richard A. Lupoff

Author, editor, publisher, and essayist **Richard (Dick) Allen Lupoff** was born February 21, 1935 in New York. Before becoming a full-time writer in 1970, he worked in the computer industry, including for IBM. His debut novel was science fiction adventure *One Million Centuries* (1967). He published numerous novels in the 1970s, including *Sacred Locomotive Flies* (1971), Nebula Award finalist *Sword of the Demon* (1977), *The Triune Man* (1976), *The Crack in the Sky* (1976; as *Fool's Hill*, 1978), *Sandworld* (1976), *Lisa Kane* (1976), and *Space War Blues* (1978), the latter expanding his Nebula Award-nominated story "With the Bentfin Boomer Boys on Little Old New Alabama" from *Again, Dangerous Visions* (1972). *Into the Aether* (1974) was adapted as comic *The Adventures of Professor Thintwhistle and His Incredible Aether Flyer* with Steve Stiles for *Heavy Metal* in 1980, collected in 1991.

In the 1980s, Lupoff wrote the *Twin Planet* series, *Circumpolar!* (1984) and *Countersolar!* (1987). His *Sun's End* series had *Sun's End* (1984) and *Galaxy's End* (1988). Standalones include alternate history *Lovecraft's Book* (1985) and science fiction *The Forever City* (1988). An early version of *Lovecraft's Book*, long thought lost, was discovered and published as *Marblehead* in 2007.

A master of pastiche, Lupoff wrote a series of short parodies of other science fiction writers under the name Ova Hamlet, collected as *The Ova Hamlet Papers* (1979). Notable stories include Hugo Award finalist "After the Dreamtime" (1974) and Hugo and Nebula Award nominee "Sail the Tide of Mourning" (1975). His time-loop story "12:01 PM" (1973) became short film *12:01 PM* (1990) and TV movie *12:01* (1993). Some of his stories were collected in *Before ... 12.01 ... And After* (1996), *Claremont Tales* (2001), *Claremont Tales II* (2001), *Terrors* (2005), *Visions* (2009; expanded 2012), *Dreams* (2011; expanded 2012), *Dreamer's Dozen* (2015), and *The Doom that Came to Dunwich* (2017).

Lupoff was an expert on the work of Edgar Rice Burroughs, writing about him extensively and helping to bring his work back into print in the 1960s. He also wrote *Buck Rogers* tie-ins under the name Addison E. Steele. He contributed novels to the shared world project *Philip José Farmer's The Dungeon* and to Daniel Pinkwater's *Melvinge of the Megaverse* series. His nonfiction includes *The Reader's Guide to Barsoom and Amtor* (1963), *Edgar Rice Burroughs: Master of Adventure* (1965), *Barsoom: Edgar Rice Burroughs and the Martian Vision* (1976).

Lupoff also edited numerous collections and anthologies, including *The Comic-Book Book* (1973, with Don Thompson, expanded 1998), *What If? #1: Stories that Should Have Won the Hugo* (1980) and two additional volumes in 1981, and *The Two-Timers* (1981, with Fender Tucker). In 1977, he began

cohosting the literary-focused radio show *Probabilities* (renamed *Cover to Cover* in 1995). Lupoff left the show in 2001.

In 1957, Dick Lupoff met his future wife Pat on a blind date, and they were married the following year. The Lupoffs settled in Northern California and they had three children.

They were active in comics and science fiction fandom starting in the 1960s, hosted meetings of the (Second) Futurian Society in Manhattan, and helped to found the Fanoclasts. In 1960, they founded the seminal science fiction fanzine, *Xero*. *Xero* featured art by Roy G. Krenkel, Eddie Jones, and others, and contributions from Jim Harmon, Ted White, Harlan Ellison, Ron Goulart, James Blish, Lin Carter, Avram Davidson, Wilson Tucker, Walt Willis, and more. *Xero* ran for three years and won the 1963 Hugo Award for Best Fanzine. A series of Dick Lupoff's articles on comics from *Xero* became the basis for essay collection *All in Color for a Dime* (1970, coedited with Don Thompson). An illustrated collection, *The Best of Xero*, edited by the Lupoffs, appeared in 2004 and was a finalist for the Best Related Book Hugo Award.

Richard Lupoff was predeceased by his wife in 2018 and passed away in 2020.